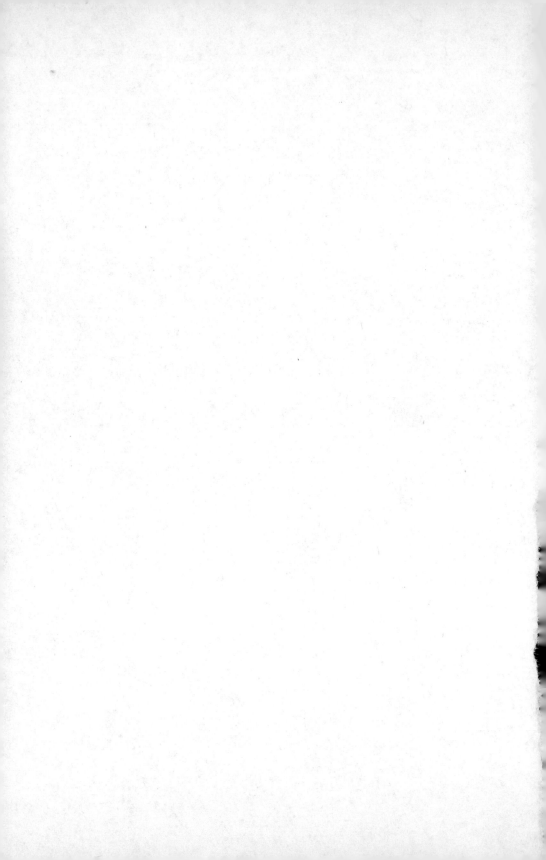

LOT SIX

LOT SIX

A Memoir

DAVID ADJMI

HARPER

An Imprint of HarperCollins*Publishers*

HarperCollins books may be purchased for educational, business, or sales promotional use. For information, please email the Special Markets Department at SPsales@harpercollins.com.

FIRST EDITION

Designed by Leah Carlson-Stanisic

Library of Congress Cataloging-in-Publication Data
has been applied for.

ISBN 978-0-06-199094-6

20 21 22 23 24 LSC 10 9 8 7 6 5 4 3 2 1

This book is for my mother.

CONTENTS

AUTHOR'S NOTE

THIS IS A work of nonfiction. That said, memoir is not documentary realism, and subjective impressions are, well, *subjective* (and filtered through one's own biases, both conscious and not). I have, in the writing of this book, tried to give the most accurate, good-faith accounts of the events of my life as I experienced them or as they were told to me by people who were present. In some instances, I compressed timelines or altered the chronology of events for the sake of economy or to help with narrative flow. Some dialogue is verbatim, but other conversations were reconstructed. I wrote dialogue not for historical, recordable accuracy but rather to distill the essence of relationships or events as I perceived them.

Most character names and some identifying characteristics have been changed in order to protect the privacy of individuals involved. In some cases, composite characters have been created. The names of my family members, childhood friends, and classmates and teachers from my yeshiva have all been changed. The names of my shrinks and people from my undergraduate and graduate-degree programs have been changed as well. While I have confirmed the details of events with many of the people who experienced them with me, this is my story, and reflects my feelings and memories.

BOOK I

GIMME FICTION

WHITE LIKE A GHOST

I WAS FROZEN SOLID in the bucket seat of my mother's Impala. It was summer, a Wednesday afternoon in the year 1979, and I was eight years old.

"What the hell is wrong with this *drivah*?"

My mother honked her horn. She was short and had to rig her seat so she was practically bumping up against the steering wheel. She honked the horn again. "Come on, *jerk*!"

We were driving down the Prospect Expressway toward The City to see a play called *Sweeney Todd*. I'd seen the commercial on television—thirty wildly persuasive seconds of Angela Lansbury jouncing around with a funny hairdo and a bunch of people screaming for pie—and begged her to take me. She'd taken me to my first Broadway musical for my fifth birthday, and after that it became a regular thing. We'd get discount tickets at the TKTS booth for whatever was on that day—usually tourist-baiting stuff, people tap-dancing and singing about chasing the blues away or doing the hanky-panky. I loved seeing Gregory Hines tap dance, and Ann Miller canter across the stage of the Mark Hellinger Theatre in a cherry-red-spangled girdle. I loved the booming sounds of the orchestras. I sobbed uncontrollably at the ending of *The Wiz*. I was enamored of intensity and greatness, and I ached to be in Manhattan.

I cracked the window open a peek.

"Roll that window back. Aren't you hot?"

"No, I'm freezing!"

"It's so *muggy* out." My mother held her cigarette limply with the tips of her fingers so it tilted slightly downward. Every so often she would flick it into the ashtray. She'd spent the whole morning blow-drying her hair into a series of au courant flips and folds that were now dismantled by the blast of air conditioning, but she still looked beautiful. She was forty-three but looked a decade younger. "I can't take this *heat*," she said before taking a drag.

When I was small, my mother was my ambassador to the outside world. She tried to bring me up as cultured—even if she didn't know what culture was, exactly. In some respect, she liked the idea of culture the more she was deprived of it: attrition lent it a mystique. She dropped out of high school at sixteen to marry my father and have kids, but always felt a lingering sense she'd missed out on something, some vital part of the world. She called this thing Culture, and it became a North Star for her, a guiding notion for what life could offer.

My father didn't care for her formless acquisitions of culture and art. He resented her for wanting to eat at nice restaurants, ceremonies he thought absurd. "You can't eat atmosphere," he'd admonish. "*I* can," she'd rejoin, momentarily possessed by a sudden imperial calm.

I took after my mother in this way. I was strangely epicurean from a young age: I could eat atmosphere. My father never took me on his fishing trips from Sheepshead Bay with my older brothers but I was glad. I hated the green murk and stink of oceans. Nature affronted me; I wanted *culture*. But I had the same problem as my mother: I didn't know what culture was, and I never sought clarification. Asking questions felt like a breach of etiquette and I wanted to have good manners.

Together, we wandered the halls of museums, the lobbies of

fancy hotels. With her last pennies my mother took me to vogu-
ish restaurants uptown, places like Sign of the Dove and the
Quilted Giraffe. As we sat in beautiful straw-backed chairs
sharing a meager pasta dish (she couldn't afford two entrées) I
felt lifted above my station, away from the hoi polloi, a citizen
of the world. Other times, culture bestowed a different sort of
gift. Near the entrance to the Met was a statue of Perseus dis-
playing the beige disembodied head of Medusa, writhing with
snakes. Seeing it for the first time—I was no older than six or
seven—I felt something stir awake in me, something that felt
like a soul or a spirit. The statue was strange and frightening,
but I knew it meant something. I knew there was a reason it
was being displayed in this magisterial palace of art, even if my
powers of discernment were too puny to figure out why. *Why*
did people paint these paintings, and sculpt statues from beige
blocks of marble? Were they depicting something about life
and the world? Was it a kind of reality? An escape from reality?
"Medusa," said my mother somewhat approvingly after check-
ing the title. "From mythology." I knew mythology was a kind
of history, a momentous doctrine—was that history mine? She
took my hand and ushered me through atriums lit with sky-
lights leading to rooms and tranquil hallways that led to ad-
joining rooms and tranquil hallways. We glided from marvel to
marvel, past pagan images of gods and thunderbolts, cherubim
and angels weeping for humanity. As a child I had a tendency
toward the occult—I believed museums were repositories of sa-
cred holy things. I developed an almost worshipful craving for
anything urban, which I associated with God.

Each time my mother drove us down the Prospect Express-
way I could feel my tiny fishbowl existence begin to open and
expand. My excitement manifested as sickness: a queasy feel-
ing of dread, like my insides were being spun through a centri-
fuge. Impressed by my sensitivity, my mother broadcast aloud

her affirmation at each phase of my mounting anxiety, charting it as if monitoring an EKG: "Your face is all flushed." "You're excited, huh." "You *love* The City, don't you!" If my anxiety was pitched too high she'd warn that I was getting "overstimulated," a word she used a lot. I couldn't tell if being overstimulated was a good or a bad thing, just as I couldn't distinguish between excitement and dread: I was still learning to map physical sensations. Everything was foreign to me, even my own intimate life.

My mother parked the car at a lot on Forty-Fifth Street, and we walked next door to a hole-in-the-wall named Mackey's where we picked up our tickets. She was right, it *was* muggy. We waded in the steaming heat up Broadway toward the Uris Theatre—past the Paramount Plaza and the Winter Garden Theatre and the foreboding-sounding Zum Zum. Past giant marquees of women shimmying in towels, and storefronts bearing porno placards of nude people with fig-leaf pasties. Streets billowed exhaust from steel grates, litter flapped and flew in small vortexes. There was garbage everywhere. A putrid stench rose from sidewalks. But it all felt exalted. Even in the grime there was a sensuous brilliance and life. I couldn't help but measure myself against the grandeur of Midtown. In Brooklyn I felt hidden—even on the vast colonnades of Ocean Parkway I felt camouflaged—but in The City things pulsed almost too intensely with life. I felt my own sickly pallor against bright orange scaffoldings. I felt my tininess against its monuments and massive architecture. I saw myself reflected in the blind gaze of buildings, the unforgiving blank stare of glimmering black glass: I was a faded spirit, barely a person.

Inside the theatre, the usher led us to our orchestra seats and I could tell right away something was off. Instead of the usual big brassy overture, creepy organ music played. Instead of a curtain hung a giant burlap map that, with the earsplitting shriek

of a factory whistle, came crashing to the ground. In the sudden blackout human specters emerged. My heart jumped. I felt dizzy, like I might faint. The specters sang a song about a man named Sweeney Todd who was a homicidal maniac. Was this the right play? Where was the pie lady from the commercial?

When the specters finished their terrifying song I started to calm down. The story began to unfold. We learn that Sweeney was a man set up by a corrupt judge. The judge trumped up charges that would get him imprisoned for life, giving the judge free rein to rape his wife. The wife then killed herself, and the judge made their infant daughter his ward while Sweeney languished in prison. But now Sweeney is out of prison. He rents a barbershop above Mrs. Lovett's floundering pie shop (the part from the commercial, I was in heaven) that hasn't been rented in ages, not since the past tenant, Benjamin Barker.

We find out Sweeney *is* Benjamin Barker: he's given himself a new identity. If Benjamin was a victim of cruel uncaring humanity, Sweeney will dispatch *revenge*. He finds his old razors and gets Mrs. Lovett to help him murder the evil judge by luring him to the upstairs room for "a shave"—but the plan gets botched, and when it does, Sweeney starts to splinter with rage and anguish.

In a song called "Epiphany," he sings about a hole in the world—he describes it as "a great black pit." The pit is filled with "people who are filled with shit." And in the song, he proceeds to eviscerate in a single sweeping gesture *all* of humanity— insisting that human beings are "vermin" and "full of shit" and that every single person in the world deserves to die. I didn't know what I was watching exactly, but I was mesmerized. I watched Sweeney inveigh against humanity, tracing the shifting contour of his emotions with the same EKG precision my mother used to chart my own: rage morphing to anguish and then grief, feelings lapping and bleeding imperceptibly into one

another like waves in a violent storm. One second he was shrieking about killing everyone, the next he was practically sobbing in despair. The music kept changing, the tempo kept slowing and speeding up, like he was running frantically toward and away from something at the same time. It was a dirge, a death march, a nervous breakdown. The whiplash shifts in it reflected Sweeney's brokenness—but who could blame him? It was stressful to be imprisoned on false charges, and to know that your wife was raped and then committed suicide. It was stressful to know that the rapist who caused all this was an incommensurably powerful judge who was holding your increasingly nubile daughter prisoner in a small room.

Midway through "Epiphany," Sweeney began to swagger down the length of the proscenium. He brandished his razor and started mocking all the people who'd paid good money to see this play: Did *we* want a shave too? Because we could have one and he'd give it to us gratis! But he wasn't saying it as a favor, he was screaming it derangedly: the cords in his neck were popping as he called us names like "bleeders" and screamed, "WELCOME TO THE GRAVE!" Even as the giant razor glinted and his breaking of the fourth wall violated and scared me I was able to extend myself in some wordless salvo of sympathy. Sweeney threatened to slash my throat, he made sickeningly inappropriate eye contact with me, but it was because his dignity was tarnished. He was *hurt*—hurt and emasculated by a corrupt, uncaring, morally bankrupt world. I knew that from how he sang "Epiphany," from how the booming insistence in his voice melted into strains of raw grief and desperation, from the alabaster mask of his face, bled white and seared with pain. The world had broken its compact with this man. The world deformed him with its blatant injustice. But just as I found myself sympathizing with Sweeney, he'd lash out again with violent rage and my heart would pound with terror.

By intermission the vomit was rising in my throat. "I don't feel good," I said. My mother felt my perspiring forehead to check for a fever and her face became engorged with panic: "You're white like a ghost!" She proceeded to hector me for the next several minutes about leaving. "I don't want you *watching* this thing," she said. "It's too intense for a child!" But as sickened and terrified as I was, I couldn't bear to miss any of the second act. I grabbed inveterately onto the guardrail and threw a tantrum until she relented.

After the intermission things got darker and crazier. Judges whipped themselves in frenzied obbligatos of self-disgust, people were made into beggars and sadists and whores and lunatics, and everyone ended up insane or shoved in an oven. When it was all over my mother dragged me out of the theatre and down Broadway by my elbow.

In the car ride home she was uncharacteristically silent. She lit a Kent 100 and the car filled with gray smoke. The play did not tender for her the pleasure, the escape she seemed to want, and I was hurt that she was incapable of seeing what was good in it. "I loved it," I said, clenching defensively onto my as-yet-unformed aesthetics. "Good for you," said my mother in a staccato voice, puffing on her cigarette. It was the first hairline crack in our airtight relationship. *Sweeney Todd* made me physically sick, but somehow the ugliness in it was exquisite. It was like a magic trick: the ugliness was made into something achingly beautiful.

I wanted that beauty in my life. I wanted to keep the experience of the play alive inside me. I carefully held my playbill on my lap with just the very tips of my fingers, anxious to keep my only artifact unsullied and unwrinkled. But as we crossed the bridge back to Brooklyn the golden spell cast by The City wore off—I could feel it fading, I felt it in me like a death. My temporary bond with culture could be severed in an instant. I belonged to something that didn't belong to me. When I looked

out at the dissolving skyline it was like a gate slamming shut—a kind of exile.

In some way, exile was my native state. Exile was embedded in my very name. The word *adjmi* derives from the Arabic *ajam*, which loosely translates to "outsider" or, more specifically, "exile from Persia."* Before that exile my ancestors had been exiled from Spain during the Inquisition, at which point we threaded ourselves through the Middle East—Persia, but also Syria, Turkey, Lebanon—and then we were exiled from *those* places too. My ancestry is muddled by these multiple exiles. I could never quite grasp where I was from, what I was, and no one in my family bothered to explain my own provenance to me.

From eavesdropping I learned I was something called SY and that S and Y were the first two letters of the word "Syrian." I inferred that SY had something to do with being from Syria, but it was a sort of mongrel identity (because they were Jews and also Arabs and also Spanish, sort of) and I knew that none of the SYs lived in Syria presently: that the SYs only became SYs once they got to America, when they were deposited on the concrete shoals of Ocean Parkway between Avenues I and V—concourses on which, over the course of the twentieth century, they built a tiny but potent subculture.

The SYs were geniuses of retail. With this genius they built small empires of electronics and textiles that grew into bigger empires: Crazy Eddie, Guess jeans, Duane Reade. The empires made them very rich, and, with the money they made, they

* The literal definition of *ajam* is "one who is illiterate," "silent," or "mute"— a pejorative term used by Arabs conscious of their social and political superiority. Over time *ajam* evolved into the modern and more neutral definition of "stranger," "foreigner"—those whom Arabs in the Arabian Peninsula denoted as non-Arab.

built million-dollar mansions. They had an enclave of summer homes in a glamorous part of New Jersey called Deal. They ferried themselves in Jaguars and Bentleys and Ferraris. They developed their own slang—a combination of pig latin, Arabic, and Brooklynese. They anointed themselves The Community. I knew at a very young age that The Community was a kind of terrible royalty, one with which we all had to curry favor. The rules for inclusion were tightly circumscribed. You had to dress and act a certain way. You had to consort with the right people. There was always the threat of exile: if you didn't adhere to the rules you'd be Out of The Community—which to me seemed a fate worse than hell.

My family was part of this community but we existed in the wafting margins. We weren't Out of The Community exactly, we were on a cusp—but we couldn't afford Jaguars and Ray-Ban sunglasses. We couldn't afford holidays to Acapulco. My parents owned their own home, but the paint was chipped and the shingles were rusted and it was piled from ugly red brick. My neighborhood, Midwood, was the main hub for SYs, but we lived in an unfashionable part, on a side street near a sad-looking nursing home, and just behind our back fence was a bizarre abandoned railroad that seemed to go nowhere. Before I was old enough to grasp things like status I knew we were considered poor, and I knew our poverty was a source of shame. I'd catch glimpses of well-off Syrians in diners beaming with gold and silver; I'd spot them driving down Ocean Parkway in Porsches with slicked-back hair and sunglasses, decked out in Armani and Prada, and feel I was a barbarian, devoid of even basic humanity.

My family had once been rich. I knew the lore from over-hearing snippets of conversations. In the fifties, once they were married, my parents relocated from Brooklyn to Nashville. Dad partnered with his brother Joe to open a Walmart-type store

across from the Grand Old Opry. The store was an instant hit. My father was a wealthy man. There was so much money he was swimming in it—piles of uncounted money spilled from drawers all over the house. My parents had three kids in rapid succession, my older siblings, and raised them as upwardly mobile Jewish Southerners. Fifteen years later, Dad wanted his kids to be part of The Community so he left the idyll of Nashville, moved to Brooklyn, and opened a new store in the Bronx. It was in an "up and coming" area called Fort Apache. But Fort Apache turned out to be not merely a *bad* neighborhood—it was the most crime-infested area in the *entire country*. In the late seventies it became infamous for its degeneracy; it was the subject of big-budget Hollywood movies, national news stories.

In his first year of business, Dad's store was robbed *seventeen* times—and not just minor thefts, he was completely cleaned out each time. Early on, my mother tried to get him to shut down, cut his losses, but he refused. The *hushos* (the SY word for "thieves") were relentless. They got in through the vents, through ceilings, and over transoms. After each robbery my father would lick his wounds, restock the merchandise, and reopen, but after a few rounds of this, insurance companies refused to cover him and he eventually went bankrupt. Dad surrendered to the *hushos* and resorted to painting window signs for stores on Fifth Avenue and Broadway, signs with prices drawn in neon red positioned next to figurines and Persian carpets. The sign painting business wasn't terribly lucrative so my siblings were conscripted to get jobs after school to help out, and this cemented their status In The Community as second-rate. Where other Syrians lived lives of conspicuous leisure, we had only our nostalgia for past wealth. My mother rubbed it in: he ruined her life and she wanted to impress upon him the magnitude of this failure. To cope with her battering criticisms my father started to drink more. He'd enjoin the bar-

tender at the local bar to hit him up with shot after shot of "Prune Juice"—his pet name for hard liquor. He had Prune Juice in the liquor cabinets at home too. He was downing more and more of the Prune Juice, getting ripped most nights, which infuriated my mother and made things much worse between them. It wasn't ever a happy marriage, but the money had been a buffer and now that buffer was gone.

I was born once the money was gone and the family sank into ruin. I understood my family's lost wealth only as a remote fact, but I believed I could one day recover that wealth and inherit it. I told myself I was a noble scion in the process of reclaiming his birthright—like a pauper in a Victorian novel who one day would claim his escutcheon, his coat of arms.

My parents knew a few people with money; sometimes they'd take me with them to beautiful homes while they had cocktails. It was in these houses I was able to glean firsthand wealth and its effects. I was often left alone in dens while adults in another room discussed numerology and Bob Dylan and Kahlil Gibran. The dens were thickly carpeted, darkly draped and strewn with small bibelots—the funeral-home style was ubiquitous then. I was impressed by all the solemnity and dark majesty, but the majesty felt remote, not something meant for me.

When I was six years old I locked myself in Frieda and Murray Cohen's guest bathroom in their house on East Seventh Street. The bathroom was completely covered in mirror, which created a terrifying mise en abyme of doors and sinks and mirrored toilets, and I couldn't get out. As I grasped for an ever-elusive crystal doorknob I could see myself in disorienting facsimile: rows of panicked little boys in a cold sweat, paddling the air and flicking with their hands, lost in a prism of parvenu wealth.

My uncle Al had gotten rich selling yarn in a shop just near the Aqueduct Raceway, and with the money he made he and

my aunt Sylvia bought a house in Sheepshead Bay. Their house was like a palace. The rooms bulged with furniture, the walls were lined with soft quilted fabric in lieu of paper. The pillows on the sofa were tall, and when you sat they collapsed in slow deflation like giant marshmallows. There were needlepoints on the wall: Renoirs, girls in pastoral settings blowing large translucent bubbles that gleamed in the composite of tiny stitches. Two clay-white Grecian busts stood in the foyer on tall pediments. Everything was marble. Everything was cold and gentle at once. Everything resonated with antiquity, with a kind of sacred glamour that was just out of reach.

In my house carpets were not plush and soft: they were cheap and worn down. The wallpaper was not quilted, it was flat and metallic and peeling at the seams. The tiles on the floor were cracked. The steel banister was half-collapsed. Hallways were claustrophobic, bedrooms were tiny. Lampshades, however, were hypertrophically gigantic—their bodies all flecked with a lurid, ersatzly gold gold-leaf. Nothing matched from room to room; each was its own demented cosmos. There was a deco sofa and giant faux-oriental vases. A Degas needlepoint (the sister needlepoint to my aunt's Renoir) abutted some odd garage-sale-type portraitures with languid unhappy women at markets or Japanese cats chasing balloons. Some rooms were so overworked they produced an impression of disorientation bordering on nausea. My sister's room was a phantasmagoria of fluorescent yellow and orange flowers. Her shag carpet with its matted orange and yellow flecks matched the wallpaper, which matched the low-hanging chandelier, itself adorned with matching yellow and orange petals into which were nestled candle-shaped plastic cylinders meant to be stamens. It was all too much, but my parents kept adding more. For a while my father got some job that entailed trips to China (I never figured out what it was) and the house filled with even *more* crap: dim-

pled Asiatic sculptures and dime-store baubles, fake flowers and silk slippers, embroidered placards woven from silk and framed. My mother didn't know what to do with all the crap my father brought home, she had no acumen for decorating and nothing went with the already incoherent decor, but she kept trying to be resourceful: she put a mirrored glass tray on her dresser and on it interspersed Lalique swans with pyramidal Lucite sculptures and miniature elephants and tiny ivory geishas in kimonos. She couldn't order the disparate styles into a unified whole, so it all floated like a swamp of fragments.

The house was like an ideogram, a visual impression of my family. We were all sort of shoved together, and the rules were inscrutable. If you wanted to be heard, you had to scream. If you were hungry, you had to grab food before it disappeared. There were no chores, no punishment or discipline or order—everything was hanging by a thread.

One morning, I woke to a loud popping noise and violent shouts. I came down the stairs to the kitchen where I saw my older brothers screaming heatedly with my parents standing between them. The kitchen wall had a huge hole in it; there were pieces of wall* on the floor. Everyone was screaming over each other. I couldn't make out what they were saying.

At one point Richie called Stevie a *husho* and screamed *GIORGIO ARMANI* in a tone that gave me chills. Then Stevie screamed I DIDN'T TAKE YOUR UNDERWEAR, COTO.† When my father called Stevie a bad kid, Stevie screamed I'M NOT BAD! so loud I thought his lungs would burst, and he ran out of the house.

* A few years later, through feats of electrical wizardry, the hole was turned into a functionable light switch—which worked out pretty well for us, as the kitchen hadn't ever really been well lit.

† SY slang for imbecile.

"Where's he going?" I asked my father, but he ignored me.

Stevie did not come home that night, or the next. A policeman came to the house one afternoon. "Where's Stevie?" I asked my mother. "Don't worry about it," she replied curtly, which I took as a sign that he'd killed himself—because people in my family talked about killing themselves all the time. If my sister could "pinch an inch" like they said in the television commercial she'd threaten to kill herself right in the middle of the den.

Then, one afternoon, Stevie walked in the front door, plopped down on the sofa, and started watching a rerun of *The Odd Couple*. "Hello, brother," he said, eyes transfixed to the television screen. A dead man had come back to life. That night we had dinner, and I kept waiting for someone to bring up the fight with Richie—or that he'd been gone, or that he came back, but no one said a word. Stevie's absence and odd reappearance was the first time I began to feel something was horribly wrong— and not just with my family, but with *life*.

I clung in desperation to anything resembling a family ritual: family dinners, television nights—but being with my family mainly reinforced the feeling that I was separate. The age discrepancy between me and my siblings was glaring. They were more like young parents than peers. When I was eight, Stevie was nineteen, and Richie and Arlene were twenty and twenty-one. One night after dinner my brothers joked about how I was a mistake—and I caught the look between them. I knew right away there was something filthy about me. My existence *felt* like a mistake; I was born into the wrong world, the wrong life.

Every so often we'd sit together in the living room and sift through old photo albums, grids of tiny square photographs with white borders preserved in sheets of etiolated plastic. The photographs illustrated a family history that wasn't mine, a

story of the past—a prequel to my family's ruin: how in Nashville my father was a wealthy man. How the local sheriff insisted, despite his virulent antisemitism, that my father run for mayor. And how they all ate at Shoney's Big Boy, and jumped on the trampoline in the backyard—the same backyard my sister, Arlene, accidentally burned down, but that was funny and amazing and indelible too. Even the instances of antisemitism they'd recount in moments of doleful retrospection—the "No Dogs or Jews" signs, interrogations on playgrounds about when their horns would grow in—those were also wonderful, because it bonded them, just as it excluded me, just like *all* the memories from their halcyon past excluded me—the past that eclipsed our miserable present, the one I had the misfortune to inherit.

I'd sit at the edge of the sofa, laughing along in vicarious remembrance as they relived the past of which I had no part, turning pages of the photo album as if unwrapping an ancient tablet or scroll. Every so often my sister, steeped increasingly in nostalgia, would stop at a particular photo and rub her thumb transversely across its bordered corners. *Remember this?* she'd say to no one in particular, and the dreamy look in her eyes made me feel as though I did remember. Somehow the stories filtered and impressed themselves into me. The stories formed pictures in my mind like travelogue images from a slide camera—static scenes from a life that seemed to be mine, with the mental picture a kind of trophy or souvenir of the experience, an object over which I could take permanent ownership. But the mental pictures would every so often reveal themselves as implanted and false, and I would feel confused about who I actually was.

I memorized any details people used to describe me so I could feel connected to something. From a very young age, I was told that I was a Genius. I was a child prodigy, they said—my I.Q.

was off the charts! I could read the *New York Times* by the age of *two*! Sometimes The Genius made me feel like a prince, I was so happy to be in possession of it, but at other times it was presented as a kind of ugly distinction—even a basis for discrimination. I caught my mother more than once regarding me like I was an *objet* my father brought from one of his transcontinental trips, a jewel with strange terrible facets. "I don't know how to take care of you," she lamented in a moment of sad candor. She was staring at me from a gauzy remove, like I'd been orphaned and was grievously immune to any help or love she could offer. I felt so separate from my mother then, but I was supposedly a Genius, so on that basis alone I had to accept the fact of my separateness. My mother characterized my very conception as a Christlike annunciation. If I ever complained about my lot in life she'd start speaking with cryptic foreboding: "You *wanted* to be born!" she'd say. "There was no *way* it could have happened otherwise! Trust me—it was *impossible*!" She gave these utterances a mystical air, like she was channeling from a deep font.

My inner life began to organize itself not so much through feelings as attributions: I was someone who read the *New York Times* when he was two, someone who *desperately wanted to be born*! I became more and more fixated on external cues for who to be, but the cues shifted constantly, and when adults stopped paying attention I was like a machine suddenly unplugged, there was nothing to animate me.

The one thing that made me feel alive was culture, so I wanted to drench myself in it: I believed that with repeated exposures to The City my life would change. I held the belief that culture was like a vitamin you could ingest by merely looking, a kind of protein that would make you bigger and stronger by its additive.

A week or so after *Sweeney Todd*, I stood in the kitchen as

my mother did her crossword puzzle. She had her hair up in an irrepressible ponytail and wore her reading glasses. She was imperially robed in pink satin, drinking her savarin from a china cup whose rim was embossed with a pattern of lime green flowers.

"Can we please see *Elephant Man?*"

My mother reclined her head against the wall, just below the hole Richie punched in it. "What *now?*"

"It's a play," I said.

"Elephant *who?*"

"It's about a man who becomes an elephant."

"*Honey*"—she set down her pencil—"I can't afford to take you to the theatre every single second. You think your father gives me that kind of money?" Her cigarette was expressively charged with orange and white embers.

"Can we go to the city and walk around?"

"Parking is expensive, honey."

"We can take the train."

"We're not taking the *train*."

"*Why?*"

"Because the train's dangerous, that's why. You wanna get mugged?"

"No."

"So go watch television."

She swiveled her chair and went back to her puzzle. Her sudden indifference to culture was jarring. My heart sank—it was like someone cutting off my oxygen supply. *Sweeney Todd* was the end of a golden period.

For the rest of the summer I was stuck at home. I worked on developing my occult powers. I saw *Escape to Witch Mountain* on television and spent weeks trying to communicate telepathically with my dog. Inspired by a segment on *Ripley's Believe It or Not* I sat in a corner of the basement and tried to levitate. I

tried bending utensils with my mind. In the mystic religious joy of childhood I searched everywhere for God, for some lyrical expression of the divine. I wanted to unlock the secret of existence—the way Hayley Mills did in *Pollyanna* when she refracted light through a prism, breaking it into brilliant bands of color. I was desperate to go to the Magic Kingdom. I sent away for pamphlets and made a giant scrapbook itemizing all the worlds inside it. I felt in my tiny soul that Epcot Center with its silver galactic spikes and fractal cubes was a secret mirror of the universe, a totem of spiritual intelligence.

On weekends I trailed people in my family around. I looked for ways to insert myself in their lives. I sat in the backyard with Arlene as she worked on her tan, drenched in baby oil and holding a giant reflector to her face. I sat alongside her as she flipped through the pages of *Cosmo*, attacking all the models for their imperfections and mediocre looks.

Now that I was eight, I was given new responsibilities. Arlene would have me pinch different parts of her body to see if I could feel any fat, and she'd conscript me to assess her body parts: her nose, her eyes.

One day, we were watching television together when she lifted her bare feet up onto the coffee table. "Don't you think feet are nauseating?" she said.

"Why?"

"I hate my feet." She wiggled her toes and made a face. "*Ert!*"* she said. "Feet are *disgusting*."

I looked down at my own bare feet, and could see what she meant. I felt a solidarity with my sister that day. I felt discriminating and grown-up.

Arlene wrote a song that summer called "Run Beth Run,"

* SY expression of revulsion.

about a woman named Beth who was at the end of her rope and was going to die unless she ran for her life. Richie was writing songs that year too. He played one for me on his guitar called "The Better Way," which was all about how people could achieve more if they tried harder and made better choices. I thought my siblings could start a band. Earlier that year, Richie started his own DJ business, Musique Magnifique. Every couple of weeks he'd come bounding into the house with some brand-new disco record and we'd squeeze into his room and dance together as he blared music on his giant Cerwin-Vega speakers. That summer turned out to be more fun than I'd imagined. We threw dance parties for Stevie and Arlene's birthdays. We had barbecues and television nights. We'd cluster in the living room where my father would get happily drunk on amaretto and my parents would dance to Frankie Valli and Neil Sedaka. We'd tell funny stories and joke around.

Sometimes strange pageants materialized in the living room in which everyone would playact being small children—which, being a child myself, I found hilarious. Dad would be the one to instigate it: he'd raise the pitch of his deep voice to sound like a little boy. When he did the voice he'd float into some delicious purgatory where he was neither adult nor child. With the little boy voice he'd make promises and lionizing boasts to his children. He'd tell us about trips we'd take together, things he would make available to us from his position of limitless agency: "Who takes care a everything? Who gives you everything you need? *Daddy! That's* who!" He'd work us up like he was whipping a bowl of cream into peaks, and we'd affirm his boasts, his strength; we'd get more and more excited—almost dizzy—like we were at an impossibly high altitude taking in rarefied air, delirious from his promises: "*You,* Daddy!" "*You* do, Daddy!" "*You* take care of us!" "*You* give us everything!" And with each

affirmation we were *lifted*, ascended up from the sphere of the everyday, the ordinary, the lives we didn't want into this magical place. With each chorus of affirmation, we were more and more bound by this invisible purgatory, this fantasy place my father could project with his child's voice: Arlene would become a stuttering little girl; Richie and Stevie were prepubescent children, they were back in Nashville—they even slipped back into Southern accents. It was all so entertaining for me. In some crazy way, the pageants made me feel I was part of a family.

That fall, the energy in the house changed. My siblings started saying frenzied things about getting out of the house, they couldn't wait to leave. *Get me out of this house,* they'd say. *Get me out of here.* They would scream it from inside their locked rooms. They'd repeat it over dinner like an incantation. *Get me out of here. Get me out of here.* They were all suddenly possessed with some terrible energy, and I could feel the energy coursing through my body like volts of electricity. Stevie ran away from home again. Richie became bitter and angry, he barricaded himself in his room and started playing screechingly loud rock music.

A few weeks after I started second grade, Arlene swallowed half a bottle of sleeping pills. When the drug took effect she called her friend Sandra, slurring into the receiver that she was dying and wanted to say goodbye. Sandra insisted on speaking to my mother, and Arlene (who was probably at this point waffling about whether she really wanted to die) shouted to my mother downstairs that Sandra wanted to talk to her. My parents promptly drove Arlene to get her stomach pumped, and when the doctors finished, drove her back home. I was watching television in the living room when they returned. Arlene walked up the stairs to her room and shut the door. No one

asked her why she wanted to die, or if she might try it again. The next morning during breakfast I felt my sister's anguish reverberating in all the quiet. But I didn't dare say a word. I sensed that remarking on it was a kind of violence, a pinprick in a helium balloon. I stopped asking questions, because silence seemed like a kind of etiquette.

In the middle of Thanksgiving dinner that year a violent argument erupted between my parents. Their fights were getting nastier, and my parents no longer went to any perceivable lengths to shield me from them. My mother screamed at the top of her lungs that my father was A PIECE A SHIT and she broke a dish. My father screamed at her to DROP DEAD. I crept invisibly up the stairs to my room, locked the door shut, and listened to the cast recording of *A Chorus Line* on my orange-and-white plastic Victrola. I went into my closet and pulled out the plastic briefcase where I kept my stash of saved playbills. The *Sweeney Todd* cover had a grotesque caricature of Mrs. Lovett and Sweeney. They had giant heads and small bodies. Their mouths were huge, and Sweeney bared his teeth like some wild animal—he appeared to be growling or screaming, and was swinging a bloodied razor. I stood in front of the mirror to see if I could stretch my mouth and make it half the size of my face, like his.

By the end of the year, Arlene had a new boyfriend, Charlie. They worked together at a store called Record Explosion. Charlie bought me the double album of *Sweeney Todd* as a gift, and I spent hours listening to it in my room on my Victrola. I'd sing quietly along, mimicking the declension of staccato notes slicing at the long sustained ones in "Epiphany." I'd try to work myself up to feel all the feelings Sweeney felt, I'd trace over the feelings in my mind like I was drawing a stencil. Playing the album reanimated the experience of watching it in the theatre. It was a little like a séance, only I wasn't the boy in

the audience anymore, I was Sweeney himself, singing along in an atonal jag how I was "alive" and "full of joy." But after a certain point I'd inevitably become overstimulated and frightened and would have to shut off the Victrola. I tried telling myself it was just a record, and that these were the sounds *this* particular record made, but it was too terrifying. Even the name he chose for himself was frightening—*Sweeney*—as opposed to the Anglican-sounding, consonant-heavy *Benjamin Barker*. The *sw* in "Sweeney" was the sound of a blade: a guillotine that cut to the gush of blood, to the final breath of the *ey*, a soul breaking free of its contours.

A few months after they started dating, Charlie wanted to marry Arlene, but my father forbade it. My father hated Charlie. Charlie was a deadbeat—he listened to someone called Frank Zappa, he wore an earring. Dad did everything he could to break them up. If Arlene was talking on the upstairs line with Charlie my father would intercept her conversation from the downstairs line and scream that Charlie was LOWLIFE SCUM and A PIECE A GARBAGE. He would curse Charlie out and threaten to beat him up. And Arlene would violently shout back that she was TAWKING ON THE PHONE over and over until she burst out in sobs of intense humiliation. I remember Arlene running up and down the hallway in hysterics, slamming doors and wallowing in despair that her love for Charlie would never be sanctioned by my parents. My father's worry that Arlene would ruin her reputation with this Lowlife Piece of Shit Charlie caused him to turn to the Prune Juice. He was getting drunker and drunker. And on one of these nights he'd drunk a bit too much of the Prune Juice, and when Arlene locked herself in my brothers' room (to vouchsafe her love for Charlie on Richie's private line) my father tried to cajole Arlene, in his slurring stupor, to open the door, because he didn't

want her talking to that Lowlife Scumbag, he wanted her *off the damn phone*, but Arlene wouldn't open the door, and though he wasn't generally violent when he was drunk* my father slammed his body repeatedly into the door until it came flying off its hinges, and there were splinters of wood and pieces of door frame everywhere. Once the door frame was busted he tried to make casual conversation with her, but Arlene was terrified and weeping. I was in Arlene's room directly across the hall, camouflaged by its citric yellow and orange flowers. I saw my father beat the door in, I saw it collapse from its hinge. I saw my sister scream and lunge dramatically backward on Richie's bed like a figure in an oil painting. The next morning we ate breakfast together, and no one mentioned that Richie no longer had a door, or that my father was drunk and maniacal. We pretended it never happened.

After that night, the fighting stopped for a while. I didn't understand the turn of events, what made people happy or mad, but I was grateful for the reprieve. One night, we all clustered together in the living room, and Dad put on a Barbra Streisand album. Everyone was in a good mood. We had a spirited conversation. Arlene began singing along to the Barbra Streisand record while we all sat on the sofa and watched her perform. She was obsessed with Barbra Streisand, and had every single nuance and cadence of her vocal quality down pat. When Barbra Streisand belted a high, impassioned note, my sister belted with her in a way that both mocked and embraced the baroque emotion in the song.

At some point, Richie made a joke about a woman named

* In Nashville, he'd once repeatedly bashed a man's head in a car door for flirting with my mother; he was known to be a hothead, but at this point he was in his late forties, he'd calmed down considerably.

Geraldine.* I'd never heard of Geraldine, and when I asked who she was the mere question instigated wild laughter. "You never saw Flip Wilson?" said Richie.

"That was before he was born," said my mother.

Stevie stood up from the sofa. He lifted his hand and let his wrist drop, then began to sashay across the living room. The room exploded with laughter. "He's doing Geraldine! That's Geraldine, Dave!" My father smacked his knee with the heel of his hand. My mother's face was frozen in a wide mirthless smile. Then I heard it emit a hard, granular noise that I recognized as a kind of laughter. Richie followed Stevie's lead—he began to flounce around and speak with an exaggerated lisp. My father slapped my brothers five, then began to swoosh and flap his limp hands along with them, which only made my mother and sister break up even harder. "He's acting like a Lot Six!" said Arlene, and she clapped her hands together and threw back her head, laughing so hard her face turned red.

I laughed along with them, but as I was laughing and having fun, I could feel my tiny heart pounding in my chest. My face was hot. I felt like I was burning. The room around me dissolved, and I was shaking uncontrollably.

"What's a matter, honey?" My mother's eyes were fixed on me. "Why are you shaking?"

"Why's he shaking?" said my father.

"Are you coming down with something?" My mother felt my head. My heart was beating so hard I thought my rib cage would break.

"What's the *matter*, Dave?" said Arlene.

When I tried to answer, I broke down sobbing.

* Geraldine Jones was a character portrayed in drag by the comedian Flip Wilson on his 1970s variety show.

"Are you tired, honey?" said my father. "You want to go to bed?"

"He looks tired," said Stevie.

"*Hazit**—what's the matter with him?" said Arlene.

My mother stroked my hair. "Do you want to go to sleep?" she asked.

I nodded and wiped my eyes.

I kissed my parents good night, walked up the stairs to my room, and climbed into bed. When I was safely alone, I buried my head in my pillow and let out a series of anguished, racking sobs. I'd heard the term Lot Six before but I didn't know what it was—only that it was something freakish, that a Lot Six was someone who had no place in the world. I couldn't let myself be that. I wanted to be part of life. All that night, I cried myself to sleep, hugging my pillow to my chest, silently vowing over and over to never become a Lot Six.

* Poor thing.

THE GREAT BLACK PIT

IN THE LATE seventies there was a craze for grisly horror films. Though I'd never seen one, the images were everywhere—on newspaper ads and marquees of theatres, on posters that festooned the intestinal tunnels of New York subways: *Maniac, Dawn of the Dead*. The very names sickened me; I had no defense against the darkness they portended. I didn't believe the films were an expression of reality—they were over the top and fake—but they were still terrifying, and I couldn't understand how my siblings would watch them of their own free volition. They viewed the horror as a kind of entertainment. They talked about how funny and sick the horror was, how they had to clamp their eyes shut when it got too gruesome. How people would wear the skins of their murdered victims as masks and little children were possessed by devils. I listened in fascinated revulsion, envious of the strength they possessed—strength that rendered them capable of withstanding horrors I was too weak to stomach. The remotest vaguest descriptions of scenes from the films would make me physically ill, as if the words tapped some invisible meridian in me.

My emotions always manifested as physical symptoms. Maybe generations of trauma left their impression in me, like teeth marks. My mother's mother, Grandma Franco, had terrible phobias, and those too had physical manifestations. She

grew up in Aleppo, as did my father's family—the Adjmis and the Francos knew each other, everyone knew everyone—but my grandmother was taught to be wary of the Adjmis as they were known to be not particularly nice. The Adjmi boys knew about her phobias. They knew of her peculiar terror of snakes. They thought it was funny that a girl could be so frightened of a harmless garden snake. When she was eleven, as a joke, they hid behind a tall hedge and when she passed pelted her with tiny snakes. The snakes ran through my grandmother's hair and under her clothes. She screamed and went into shock. Her terror was so intense it turned her hair white, then it fell out completely. She became catatonic. She couldn't walk or speak for a full year.

When I first heard this story, it sounded like a dark fairy tale, some ugly moralistic parable to dissuade bad marriages. Surely any union produced by these two sets of people could only end in disaster: my origins were blighted from the outset. Decades later, when, at the age of sixteen, my mother announced her engagement to an Adjmi, my grandmother was *livid*. She wouldn't allow it. But she was a woman, so her refusals meant nothing.

My grandmother, like my mother, had a life that resembled a Dickens novel or woman's weepie. She was always forced into circumstances not of her choosing, then forced to summon resources to make the best of these circumstances. Once her family immigrated to the States she fell wildly in love with a doctor—a J-Dub,* yes, but he was handsome and a good person and he'd proposed marriage, and they were really in love. But her father made her break off that relationship. He arranged for her instead to marry my grandfather, an SY man she

* The SY term for an Ashkenazi Jew.

barely knew. Within a few years, after bearing four children, my grandfather was diagnosed with tuberculosis and sent to a sanitarium, and my grandmother was forced to support the family. She found a job stitching umbrellas in a factory but the work took its toll: she'd get so exhausted she'd pass out right on the sidewalk, right in front of her kids. And when he was released from the sanitarium my grandfather became impossible to be around. He was an intractable presence in his chair near the front window. He'd wheeze with his one lung, moaning like a ghoul for her to bring him food, bring him medicine. The illness left him unable to work—he couldn't do anything really, so he became furious at life. His fury led him to bouts of intemperate violence. He'd explode in tantrums: smashing plates, throwing food, screaming and yelling in Arabic until his face turned color. When my grandmother's cherished younger brother died in a car accident, my grandfather couldn't bear the sight of her dressed in her lugubrious black clothes. It depressed him to see her in mourning. He demanded she change clothes, and when my grandmother refused, he ripped the clothes right off her body, as she screamed and wept in protest. For her children, who witnessed the screaming and the smashing of dishes, who were surely troubled by their mother's slow deterioration, her fainting spells on the sidewalk—for them my grandmother was Mildred Pierce, or one of any number of characters Joan Crawford excelled at. It was a role at which women were forced to excel. She became an emblem of sacrifice, and for her children this elevated her suffering, it gave her misery a kind of logic. Life was something inflicted on a person, yes, but suffering could be its own reward.

By the time I was old enough to register her as a presence my grandmother had lapsed into senility and her body was eroded by disease. People were always plying her with plastic cups of orange juice so she wouldn't go into shock. They were con-

stantly injecting her with needles. My mother and her two sisters would gather every Sunday in her apartment off Kings Highway to help organize and collate her seemingly hundreds of pills into the cells of small plastic trays; the trays brimmed with pastel-hued pills for different times of the day to keep her heart from giving out, or the blood from solidifying in her veins. She'd become a collection of symptoms and physical ailments, and though the ailments were physical it was always clear that somehow this was the product of her life experience—that the pain and sadness abraded at her spiritually, and this spiritual trauma manifested in physical decay. In the shadow of this bleak erosion my mother and aunts would reminisce about how she *used* to be; how before she met my grandfather she was a flapper and a singer and an artist and bohemian; how she was full of fire and life and defiance, and that I *couldn't know*—I couldn't know how great a woman she was because her mind had been eaten by senility.

I never knew what to make of their long panegyrics, the claims about her greatness. I was forced to accept people's testimonies about whatever glorious heyday preceded me, but by the age of nine I was starting to doubt the reliability of my narrators. They spoke about my grandmother like she was an icon in some far-reaching Italian peninsula where people made pilgrimages to visit, a saintly woman calcified in her sacrifice like a stone pillar.

I didn't see her in that way. Her attempts at playing with me were pleasantly anodyne ("I'm gonna eat ya *up*," she'd deadpan, tugging my fist to her mouth and making small, affectless chewing noises, like those zombies in midnight movies) but she seemed hollowed out to me, barely a person. She wore long thick woolen cardigans and stared expressionlessly out windows, picking at her emerald tray of intractably sticky and unmeltably hard licorice candies. She shuffled stiffly in her

slippers, rotating her false teeth around in her mouth, her jaw retracting and resurfacing and endlessly blurring the planes and shapes of her face. When my grandfather was alive he would sit by the window with his little pot of Turkish coffee, and shout and make noise. But when he died it was quiet and she merely resumed his mantle at the window, as though picking up a long-burning torch—a phantom: dead and also waiting to die. Was that my destiny too? Would I become like her—my face a meaningless grid of planes and craters and contours? A ghost staring blankly out a window, drained by traumatic experiences?

My entry into the social world was not auspicious. My parents enrolled me at a yeshiva—a school for religious Jews—which posed a problem because my family was not religious. We were barely observant. We worked our way around the rim of Jewish ordinances as almost a formality. We ate kosher, sort of, and celebrated the main holidays, but that was the extent of it. My mother had wanted me to go to a French lycée: it was her dream to go to Paris and she ached for a Francophilic child. She wheedled and fought, but it was useless to fight my father, who felt my older siblings had been corrupted by Nashville and cheeseburgers. He told my mother he'd deprived them of a heritage but wasn't going to make that mistake with me—that not only would I become holy by my teachings but I would provide everyone else in the family with a proxy Jewishness, and they would absorb my Jewish teachings by osmosis, a kind of religious trickle-down.

When I got to the yeshiva I'd never been to synagogue or even opened a Bible. My father never explained the responsibilities I'd been assigned, the holiness I was meant to embody. There were no prefatory remarks of any kind—I was simply deposited in a classroom and left to figure things out. I didn't

know Hebrew. I didn't know prayers, or who I was praying to, or why in my prayers I had to thank God for not making me a woman. I didn't know why people kept kissing things: they kissed books, they kissed their clenched fists, they kissed slim silver rectangular boxes that hung near every door of every room. Boys kissed morseled bundles of satiny strings that hung from weird diaphanous shawls we were forced to wear under our shirts. There was something holy about all the kissing, but what? I knew this was my heritage but it felt alien to me.

For a brief spell, I put the Old Testament in the same category of *Escape to Witch Mountain*—a diversionary entertainment with supernatural elements. But I soon came to realize the Bible was a kind of history, a doctrine of belief, which disappointed me. Its stories rang false, and I found God very off-putting. He was a bully who inflicted psychological torture on people. And the Bible wasn't spiritually edifying. It didn't fill me with emotion, it didn't make me want to bolt up and start singing or dancing or sobbing the way I did watching *The Wiz* and *42nd Street*.

I knew, however, that people took these stories extremely seriously. A whole society was sprung from these stories—with schools and teachers and synagogues and holidays. An entire language was devoted to disseminating religious information, and there was a place called Israel where people made pilgrimages because it was holy and the epicenter of our heritage. Even though the religion and the biblical evidence marshaled by my teachers were patently unconvincing, they was effectively presented as *reality*, as something immutable and eternal, and I didn't want to disturb that which preexisted me. Who was I, a small child, to dispute the colossus of Judaism, with its history and towering permanence? I began kissing things. I kissed doors and my fists and articles of clothing, I kissed the motes of dust

in the air. I'd begun to accept that living would be a kind of honed falseness—that, like a broken bone locked in a cast, one's inner self only existed to be grafted and reshaped.

I tried to fit in but didn't know even very basic things about being Jewish, so I made gaffes, like eating an unkosher candy bar in front of people, or mentioning a plotline on *The Love Boat.* By the end of second grade I was revealed to be a heathen. There was something flimsy about all my fakery and the other children could smell it. They enjoyed their heritage, they were growing and thriving in a soil that nourished them, but that same soil was acrid and life-choking to me and they could see it. Once it was clear I was the rogue element in the class they began to ostracize me. Like colonies of insects building their invisible societies, structures began to form, hierarchies emerged—and I was at the very bottom.

My mother went through a period of neglect around this time, and my father, who was often gone for long stretches on business trips, was gone for longer than usual. No one checked my homework; my hair was overgrown and uncut. Lunches were pell-mell or simply went unpacked. One day I was hungry and approached a circle of girls to see if they'd share their afternoon snacks with me. One girl dropped a fistful of potato sticks onto the floor. "Here you go," she said, prompting giggles from the others. I knelt down and ate the potato sticks. The other girls shrieked and laughed. Then the first girl threw another handful of potato sticks. I ate those, too. Soon my classmates were all standing in a semicircle, throwing food at me—dried fruit and potato sticks and Twizzlers, and I ate whatever they threw. It didn't feel like a compromise or humiliation, it didn't

* Which aired on Friday nights, Shabbos, when television watching was forbidden.

feel like anything. I was like a bottom-feeder obliged to lick the scum from the bowels of the earth. I was required to grovel and beg. I was indentured to the whims of other people and it was pointless to ask why: it simply *was*. So I laughed with them, laughed at the absurdity of a boy eating off a dirty floor. A boy who had become a kind of animal.

Just after my ninth birthday the house emptied out. Arlene defied my father's suffocating mandates and married Charlie. Stevie met a girl named Debbie; they got engaged in a matter of months. Richie was still living at home but he was almost always working or out with friends—and I had no idea what had become of my father, who'd been gone for at least a year, though my sense of time was probably distorted. He'd always been a flickering presence, I wasn't overly attached to him, but a part of me wanted him back. When I asked my mother where he'd gone, her response was tantalizingly indirect. "On a business trip," she said, lying badly, but I pretended to believe her like I pretended with everything. It seemed impolite to probe further when she'd gone very deliberately out of her way to lie. I silently congratulated myself on my capacity to withstand chaos. I saw my steely autonomy as a kind of brilliance. A few weeks after that my sister was over at the house and I asked if it was true (though I knew the prospects were slim) that Dad was on a business trip.

My sister's expression turned grave.

"A business trip?" she said. "*That's* what she told you?"

After a brief, uncertain interval, Arlene proceeded to fill in the bare outlines of what I already intuited. My parents were separated. My father had moved in with his brother, Meyer—it happened right after her wedding. "Oh," I replied, downplaying my shock, "I thought they got a divorce." I wanted my sister to believe I could easily assimilate whatever information she

imparted even as it was being imparted—that this swiftness and facility was a gift I had, part of the Genius for which I had been so lauded. I wanted her to see that I could master preemptively any hairpin turns in life; that I was numb and strong, the way she'd been when she laughed so blithely at the psychotic killer in *Maniac*; that I possessed no wish or need for anything, and that my absence of need was further evidence of my adamantine strength, the miracle of my existence, which was a kind of unrecorded sainthood.

And just as the conversation was winding down and I felt reasonably assured I'd been successful in my aims, my sister abruptly took my hand. "Come with me," she said. She walked me down a small corridor to my room, then latched the door behind us. Once we were alone, she leaned in close. "You're too young to understand this," she said, almost whispering, "but I don't know what to do, because I can see you're getting damaged, and I have to *do* something."

"I'm not getting damaged," I said.

"Yes you are," she said, her tiny voice cracking. "You don't know you are because you're too young to understand what's happening to you, you're too young to even understand what I'm saying, but I have to *say something*." Her lip was quivering and shaking; her face had turned a bright pink color and her pink eyes were brimming with tears.

"I went to see a therapist," she continued, "and when I told him about Mommy and Daddy he said they were crazy. He said Daddy is a pathological liar, and that Mommy has something called narcissism. . . ." She tried to continue speaking but her words got broken up with juddering sobs.

"I *know*," I assured her, trying to take all this in with my studied absence of sentimentality.

"You're too young for me to be telling you this," she repeated, "but I just don't want them to screw you up."

"But they won't."

"They're already screwing you up! I can see it and I don't know what to do!"

I hated to see my sister so despairing, so mired in helplessness; I hated that I was the cause of it. "I already know they're crazy! I don't *care*!" I said, almost swearing it like an oath.

"You're not having a normal childhood."

"I don't *need* a childhood," I said and believed absolutely, as I only understood childhood as a sort of exhausting performance. Since I was a Genius, and was known by then to have a kind of suppleness and acuity and intelligence that belied my years, I could see my sister trying to absorb this statement: Did people really *need* childhoods? Maybe I was different. I could see my sister trying to ascertain what I did and did not need, what the limits of my prodigious abilities were. As she looked at me I could see the pain in her eyes start to congeal into a kind of haze, a grayish blur.

When my father left, his absence triggered a jarringly intense depression in my mother, even though I later learned that for years she'd been planning to divorce him—she'd been plotting her escape but white-knuckling it. If she divorced, she'd be a fallen woman like my Aunt Nina, and no SY would want to marry the child of divorced people. So she decided to wait until her kids were married off. For twenty-five years she lived in a terrified camouflage of modern appliances and B'nai B'rith meetings and fur coats and hairdos. She gave herself leisure activities: she joined clubs, played tennis. She learned to compensate herself for sacrifices she'd been forced to make. When those dilatory tactics wore thin, her survival instinct began to manifest in spasms of wild anger. At the slightest infraction she screamed at the top of her lungs. She wildly smacked my brother with the heel of her slipper until it broke in half. She roughly

pulled my sister's hair as she brushed its knotty tangles into a more manageable frizz. She'd subject my father to nonstop querulous litanies like a pianist practicing scales. Decade by decade, her isolation and misery grew more and more intense until she couldn't take it—she didn't care if she'd be a fallen woman, she told my father she wanted him out.

But now that my mother had the freedom she prayed and pined and wished for all those years, she was rudderless. She couldn't simply resume who she was. There was no self to resume. She was married at sixteen; it was a child's folly. When she turned seventeen she came back home in tears, the bubble of her teenage fantasy pricked. She told her parents she'd made a horrible mistake, that she couldn't stay married to this man, that it was awful and unbearable, but her father was unmoved. "This *isn't* your home anymore," he said. "Go home to your *husband*." So my mother had to wipe her tears and go back.

Now she was in her forties. She was just a space in brackets, a placeholder with nothing to fill it. My father's absence stared back at her like a mirror. More than once I overheard her sobbing alone in her room with the door closed, or on the phone, weeping bitterly and saying, "What am I going to *do*? I don't know what to *do*!" She was usually careful about shielding me from her tears—not so much for me as for the sake of her own privacy—but she did cry in front of me, once, in a moment of fleeting intimacy. I hugged her, and my heart melted with empathy. I felt her suffering as if it were my own. My mother wasn't used to being hugged, but she was so worn down, so grateful that someone could see and empathize with the suffering she was no longer able to conceal, that she let me. Her sobs were like loud claps of thunder. I felt swallowed and rocked by them like we were both at sea and lost in a violent storm.

After that she never cried in front of me again. Instead of being sad my mother became moody and erratic. The terror and

loneliness all hardened into rage, like a kind of cement. Her moods frightened me, and I hid in my small room with its garish red-and-black shag carpet. I hated the peeling wallpaper—the buff patches of empty wall depressed me—but at the same time I found myself mesmerized by its ragged patterns. When I was bored I'd make a Rorschach in my mind out of the cracks in the paint and rips in the wallpaper. I'd trace animals and birds from the negative space, little uneven chimeras that could be anything. I was lonely, but I couldn't identify the source of my loneliness. I craved some kind of family life but families made me anxious.

I started to think about swallowing pills, as my sister had done. At the time there was a celebrated play on Broadway called *Whose Life Is It Anyway?* I'd seen a portion of it on the Tony Awards broadcast. It was about a man who wanted to kill himself and felt this was his moral right. *Maybe it could be my moral right, too*, I silently opined. I locked myself in the bathroom, slid open the door to the medicine cabinet, and panned through the different medications in preparation for my suicide attempt. Would Ex-Lax do the trick? Milk of magnesia? Ultimately, I was too scared of getting my stomach pumped like they did to my sister, and a part of me still wanted to live. The bleakness and extremity of suicide felt less empowering the more I imagined it as a reality.

As I was deliberating whether to kill myself, my mother felt a sudden urgent need to start *living*! She made plans to go on dates—restitution for those teenage years she wasted on my father. She had divorced friends, friends who wouldn't besmirch or look down on her for her marital problems—Sonia, Stella, Sonia's cousin Barb—they could go out together! She was going to dance and socialize and drink cocktails and have a good *time*!

Night after night, I'd watch my mother at her makeup mirror

as she feathered her hair or tested new permutations of eyeshadow. Her friend Claudia Terzi started her own makeup company, Highline Cosmetics, and gave Mom in-home lessons. She taught my mother about lip liners and contouring sponges; now my mother used contouring sponges all the time. She bought a new makeup mirror with different tinted settings that correlated with how you might wear the makeup: to a disco, to a bar. Daytime makeup, nighttime makeup. My mother was on the cutting edge of makeup. My mother was the toast of the town. Every night she was out at some hot spot: Regine's, Stringfellows, Maxwell's Plum. I'd glean information as I often did from eavesdropping on phone conversations—or after the fact, from matchboxes she left around the house. I hated having a babysitter and told my mother I could take care of myself, so she stopped hiring one. When she did, I was terrified: I didn't think she would actually listen to me or take anything I said as an actionable directive.

One night I heard her heels angrily clacking down the hallway to the front door and made the mistake of asking where she was going. "*Out!*" she shouted in reprisal, slamming the front door as angry punctuation. She didn't have to answer to anyone now, certainly not to a nine-year-old boy. Her rages were mysterious, but I was determined not to confront her about them. I wanted to project complete autonomy. And I knew she was too fragile and beleaguered to care for me. She had to defy someone and I was the only one around.

With no one around to look after me I learned to care for myself. I bathed infrequently, checked my own homework. I taught myself to cook using whatever ingredients I found in the cabinet; I made my odd decoctions with Wesson oil and garbanzo beans and red-wine vinegar. I'd watch television for hours on end, locating myself in identifiable fragments from various shows, forging a sentient life in the kiln of popular cul-

ture. I mainly watched sitcoms, many of which involved om-
nipotent children who were cleverer than all the adults. There
was a power in their not needing things, not needing explana-
tions or intimacy or attention. *Power* could compensate you
for the anguish of feeling unloved. I wanted that power and
autonomy.

But then I wanted the opposite, I wanted to saturate myself
with anguish and loss and powerlessness—and these cravings,
too, could be satisfied by television. I'd watch the movies of the
week and act out scenes that mirrored my own sadness back
to me.

For weeks, I replayed and relived Ricky Schroder's climactic
scene in *The Champ*, in which his father, played by Jon Voight,
lies on a gurney after having been brutally pummeled in a box-
ing match. The father is a washed-up prizefighter who devolves
into an inveterate gambler and raging alcoholic. In a low point,
he gambles away his son's beloved racing horse but, as an act of
redemption, attempts to win back the horse with the prize money
from a fight. Voight wins the fight, but in winning he is beaten
so badly it kills him. In the last scene of the film Voight is mori-
bund, barely conscious. "Where's my boy?" he mutters. "*Wake
up, Champ,*" Ricky cries, stuttering in a panic. "W-w-wake *up.*"
He shakes the Champ to resurrect him, but the Champ is gone,
leaving Ricky alone, neglected and orphaned. Ricky's face is
stained with pink splotches, snot running down his chin in
clear gouts—and as I acted it all out in the den for the first time
I found I too could cry real tears spontaneously, I too could
produce snot in clear gouts! "*Wake up, Champ!*" I cried, again
and again. When I was finished I ran to the mirror in the bath-
room to see my red, tearstained face: was it sufficiently im-
printed with trauma? *It was.* The depth of my pain carried a
tremulous power that surprised even me. By imitating the feel-
ing inside the film—using it almost as a kind of stencil—I was

able to give expression to feelings inside me I'd buried, that had no other outlet. Unlike the pretending and imitating I had to do in other parts of my life, this didn't feel false—it felt truer than life, a distillate of what it felt like to be alive. The movie transformed Ricky Schroder's pain into something beautiful, like the weeping angels in quattrocento paintings at the museum. And because it showed the beauty in the human experience, I was able to see something beautiful about my own pain, my own life. Like Sweeney embracing his cache of lost razors, I embraced my hidden anguish and held it to my breast like an old friend: *I know you, I see you.* I didn't need to pretend to be indestructible, the way I did with my sister. I could feel my broken feelings. And I was not alone: millions of other people were watching the movie that night. I imagined myself fused together with them, as if a circuit hummed between us. The TV movie of the week was a way for us to be together. We were in life together. We shared a common humanity. I felt like those people at concerts when a singer sings their favorite song, and they light their cigarette lighters as if to announce to one another that this song is the Song of Myself, and the galaxy of tiny lights sways in the firmament of a darkened stadium, lit with communion.

I'd have moments where I felt connected in this way to some pulse, some essential part of life, but then all at once the feeling of wholeness and communion would vanish and I'd be paralyzed by fits of acute terror and worry—anxiety I couldn't numb or expel. There had been a spate of robberies in the neighborhood: our house was robbed the previous year in the middle of the night, we were all asleep. I'd predicted it in a sort of vision I had one night just before falling asleep: a cheesy premonition from a B movie, replete with smoky fog and bad lighting. In the vision two faceless men held axes and peered into my room. The next morning the doors and windows of the house were wide

open; the television was gone, they'd taken some expensive crystal vase. My mother asked my father to install an alarm but he didn't want to spend the money. And once he left, it happened twice more in swift succession. What would deter them from coming back? What would stop them from coming to murder a nine-year-old boy home alone? What would stop them from coming with an ax to murder me in my sleep?

I'd call my sister and tell her I was afraid, and she'd call my father to lash out against him, against both my parents—but then I would defend my mother: it was my fault, I was the one who said I didn't want a babysitter. My sister just wept and said, "It's all screwed *up*! They're *screwing* you *up*!" I'd begun to latch every door once my mother was gone for the night. I patrolled the house with Richie's baseball bat, the one he kept under his bed. I manned all the windows, the doors—always latching, always checking, reinforcing the house like it was a bunker. As I sat watching television, eating my impromptu meals of garbanzo beans and Wesson oil, I could feel the paper thinness of the walls; it was like a foldout house in a child's book. There was still the crumbling lathe in the kitchen wall from the hole my brother punched in it. The whole house was like that—people could punch their way in, punch it down with their fists. At midnight or one in the morning, like a torpedo on radar, I'd instinctively feel my mother's car pull up to the curb. Through the tiny window in the front door I'd see her emerge, the gleam of all her jewelry set off by the flare of acid-red brake lights. I'd hurriedly unlatch all the doors, quickly bound up the stairs, jump into bed and, when she'd check in on me, fake sleep. Eventually I'd drift off into real sleep where my fears carried over unaltered, and in my dreams, men attacked me with axes and thick knives.

Sometimes the family would come together. My brothers would from time to time take me to the odd (and mercifully

infrequent) baseball game and try to make me jingoistic about sports. On weekends in the summer my sister would drive me to the Golden Gate Inn in Bay Ridge (which I discovered years later was a hotbed of prostitution) and pay the five dollars admission so we could have access to the pool. She'd get us Sprites, slather herself with baby oil, and hold the giant reflector to her face until she was burnt to a crisp.

From time to time, my siblings would take me out for dinner, just us, without my parents. One night they took me for Italian food at Michael's in Marine Park, and over dinner conversation turned to the robberies. Stevie's wife, Debbie, mentioned that when she was small her house had been robbed too. She was playing with her brothers in her living room when there was a knock on the door. When she opened it, three men with ski masks entered wielding baseball bats. The men locked Debbie and her two small brothers in a closet. They found her mother, forced her into a large sack, tied it shut, and proceeded to beat Debbie's mother with the baseball bats. My stomach wound in tight knots as Debbie sipped her Lancers and replayed the horrifying scene in excruciating detail. My brothers and sister peppered her excitedly with questions—they were titillated by the story, just as they'd been titillated by the graphic scenes from *Maniac* and *I Spit on Your Grave*, but I felt each detail as a series of piercing incisions. I was shaking uncontrollably. I tried to carry my usual desensitized air as I picked around my stuffed shells—I didn't want them to know I was childish and weak—but later that night I lay sleepless in bed, plagued by vicarious physical horrors, thoughts of men beating women with baseball bats. I tried to imagine Debbie's mother stepping into a sack, and what the men with masks looked like, and how it must have felt stepping into the dark burlap chasm of the sack. Why would people want to beat women in sacks with *baseball bats*? The perversity of it was unfathomable to

me—particularly when I imagined all this happening to Debbie's mother, who was like a wonderful, old, doddering woman in a screwball comedy. She was impossibly thin, and wore long, drapey rayon shirts and stirrup pants. She'd talk about cheesecake recipes and Pebble Beach and *Wheel of Fortune*. Debbie was horrified by almost everything that came out of her mother's mouth: "No one wants to hear about that, *Ma!*" she'd declaim, again and again.

For weeks after hearing the story about her mother I had fantasies of masked men carrying truncheons and bats. I would imagine being trapped in darkness, forced to listen to my own mother's helpless screams as she was beaten mercilessly by a bunch of sadistic thugs. Like a needle tracking the spinning groove of a record, the images and scenarios would play endlessly in my mind. I worked myself up deliberately; I made myself sicker and sicker. I had to master this anxiety and conquer it—but I kept snagging on the details: How was this sort of cruelty possible? Why would these men do something this awful? I knew there was cruelty in the world, I knew there was injustice. But couldn't the masked men have just as easily thrown Debbie's mother in the closet with her kids and robbed the house? I could understand moral evil when the cause and effect were clearer, but the cruelty in this case felt so out of measure, so senseless. And if I extrapolated from this act of senseless cruelty, what did it mean about the rest of life? How would I ever learn to cope with a reality so awful, so grotesque?

Compounded with all my other problems, the scope of potential awfulness that lay in wait for me sickened me to my very bones, and just prior to my tenth birthday I plummeted into depression. I became like my grandmother, sitting indoors for hours on end, gazing blankly out windows. Tears involuntarily leaked down my face as I ate lunch or read books. Crying was like breathing. The crying infuriated my mother, who took my

depression as a sort of indictment: if she didn't like life that was her private aberration, she resolved not to make it mine. But my mother had no persuasive tactics to coax people out of their moods. As she folded laundry or mopped the floors she'd bellow accusations in the form of questions: "What is *wrong* with you!?!?" "Don't you want to go *play?*" as if by bellowing things she could maybe rewire the circuits in my brain and make me happy. I tried to highlight the specialness of my emotions, to distinguish my grief from ordinary unhappiness, to make it feel more dramatic and worthwhile by accenting it in subtle nonverbal ways—but these attempts didn't faze her and often made her angrier. I resented my mother for her coldness, for I knew I wasn't being disciplined, I was scolded to calm her anxiety—but I also felt guilt for burdening her, for being so enervated and depressed when I should have been happy, the way people wanted me to be. And they were right to want it, but I couldn't manufacture the feelings I needed to have. Since I couldn't manufacture the feelings, I suffered consequences. I was socially isolated. And the bond with my mother—the one thing keeping me held to the social order, tethering me to life—was dissolving before my eyes.

One night, after watching some bank-heist movie on television, I went up to her bedroom and snuggled up next to her as she did her needlepoint. "If I robbed a bank would you still love me?" I asked. "No," replied my mother unblinkingly, "I would rip my clothes and mourn you as if you were dead."

This sudden, sharply critical matter-of-factness in response to a hypothetical and *extremely unlikely* infraction on my part was chilling to me, but I pretended she hadn't meant what she said. I tried falling asleep on her knee, following some rote notion I latched onto in the moment, one of mothers and gentleness.

After that night I was scared to show my mother I loved her.

I couldn't stop feeling love or needing my mother to love me, though I had ample evidence that love was damaging and made you weak. Every so often the love would erupt inside me like a volcano, and I would feel possessed by a need to hug my mother, but I learned to tamp these impulses. When I did hug her, I sensed her flinching discomfort. When she felt possessed with love for me, the expression wasn't soft or intimate; she'd tickle and poke at me with her finger. Her darts and messy lunges made me anxious and I started to dread her affection. The terror of closeness and the terror of complete isolation tugged and pulled at each other, leaving me in a permanently suspended state.

I made no friends at the yeshiva. Whatever strangeness I possessed innately was set in blunt relief against the straitlaced normalcy of the other students who debated hotly the kosherness of Funyuns and Snickers bars and got into heated arguments about mitzvahs. During recess I sat by myself and watched the girls jump rope, their long skirts billowing like parachutes. I watched boys run around with hot pink faces, yarmulkes flying aloft like saucers. I watched from the sidelines as children galloped in unscarred oblivion, kicking around flesh-pink rubber balls, insouciant and a little blank—but happily blank, the way children should be—or at least that was what I thought, for that was the kind of child I'd been encouraged to imitate. I was relieved not to have to socialize, but at the same time I felt eaten by loneliness. Seeing the happiness of these children opened up an insensate longing in me. I felt their happiness like a wound.

In response to the worried admonitions of my English teacher, my mother tried to force me to behave like a normal boy. She tried rousing me with pro forma sermons about socializing and fun; she rolled her eyes and made brusque comments; she asked rhetorical questions that battered me with my own strangeness.

Wasn't I *bored*? Did I want to just sit there and *rot*? But the tone of the comments quickly curdled from bemusement to rank impatience and hostility, until she was shouting things at me like, "WHAT'S YOUR *PROBLEM*?" and "DON'T YOU *WANT TO HAVE FUN*?" I didn't know how to explain to my mother that fun, as it was presented to me by the world, seemed a concrete oppression. That the kind of fun other people sought actively was a concept for which I had no referent. My mother's worry about my friendlessness curdled into an irrational antagonism: *Why* didn't I feel enjoyment? *Why* was I a vortex of ennui? Children loved to play! It wasn't mistaken of her to want me to play—it was *normal*!

To break me out of my funk she began dragging me around with her on weekends. She dragged me to the grocery store, the cleaners, the nail salon. She took me to card games hosted by any one of her loose confederation of friends from the old neighborhood, women with whom she might say she was "friendly" in an equivocal tone—they all bought one another crystal ashtrays at the Yellow Door on Avenue M and sent their kids to the same fat camp.

I tagged along to the standing lunch dates she had with her two sisters at a Greek diner named Caraville, a hot spot for SY ladies in those days. Everyone loved the owners, Jimmy and Perry, who flirted innocuously with them, and Beverly—the patrician, weirdly glamorous hostess whose voice dropped about six octaves from all the cigarettes she smoked. And Beverly and Jimmy and Perry were all inordinately patient with the sometimes oppressive whims and demands of the SYs who made exacting claims for preferential treatment, and refused to wait for a table, and insisted on making substitutions to everything on the menu or battered the waitstaff with weird idiosyncrasies— like my mother, who instead of the customary coffee refill demanded a "fresh cup" every twentyish minutes because she liked

it "steaming hot," and was remorseless about sending back food that was even slightly warm, and who would send back her shrimp salad because she insisted something was "a little off" (even though everyone else who tasted it had no idea what she was talking about). But the waiters gladly took it back, the people at Caraville gladly put up with my mother and these rococo exchanges in which she assumed quite naturally the mien of a deposed yet still royal Russian aristocrat. They were terribly patient with her. I was patient, too. My patience was conscripted as part of my role as a small boy who was to be seen and not heard. I'd pick at french fries as she and my two aunts drank coffee, chain-smoked, gabbed in rallentando overlaps. I felt my lungs blackening from all the cigarettes as they gossiped about their kids—how they were sneaks and pains in the ass, how they gained or lost weight.

One weekend, my mother drove us to Deal to visit Claudia Terzi, who unlike most SYs lived there year-round. Claudia was in the throes of a crisis: her daughter Betty was supposed to get married, but the fiancé broke off the engagement at the last minute—and Betty was already twenty-five, in the Syrian community that was verging on spinsterhood. Claudia was disconsolate. She was weeping and weeping in her kitchen, and later her sunken living room, the contents of which I took invidious inventory—the shiny baubles, the glass domes and cylinders, everything white and crystal and glass. My attention was forked between taking in all the glamour and listening to my mother's boilerplate consolations. She kept saying things like "Claudia, it's gonna be okay. Claudia, don't *worry*!" And Claudia kept responding with things like "What's going to *happen*? What's going to happen to *Betty*?" She showed us scallop-edged photographs of the then-happy-now-sundered couple, mourning the bitter brutal unfairness of life photograph by photograph, offering short epitaphs for each one as

though she were recounting the tragic death of a soldier killed preemptively in combat. *Why?* she repeated as tears sluiced down her damp cheeks now inked with mascara. *Why? Why?* She was perversely bent on putting herself through the stations of grief and making us watch her. I couldn't ferret the deep significance of Betty's breakup with her fiancé, but I understood, if not the circumstances of Claudia's unhappiness, the *fact* of it, the anguish of human existence. Seeing Claudia's pain, I felt my eyes well with tears. I felt the deep need to protect her—even though I knew there was no protection, which was why Sweeney Todd went crazy in the song "Epiphany" and sang about the world being a great black pit. I knew that I was powerless; I was invisible. Even as I sat in Claudia Terzi's house that afternoon looking at her scalloped photographs and watching the gray-black veins of melting mascara drip down her cheeks and chin, I was evaporating, fading inside all the sharp angles, the lapidary surfaces of white and glass.

For a short while, my mother and I arrived at a stalemate regarding my friendlessness. She maintained her posture of curdled irrational hostility, and I, despite my loneliness and slow suffocation, maintained I didn't want any friends or activities; I preferred to read a book, or lay supine in bed and stare at the peeling walls. But soon thereafter the stalemate dropped—my mother was far too compulsive to maintain things like stalemates. In one of her haphazard stabs at trying to make me cultured-slash-active she had the idea (good in theory) to enroll me in an acting class at Kingsborough Community College over in Sheepshead Bay that spring. The class met on Sundays. I was finally excited about something! I could be the next Quinn Cummings, the next Ricky Schroder! But when I got to the class we were instructed to make crowns from Reynolds Wrap. They marched us in circles and had us sing about castles. It was worse than never having gone to a class

because now I was certain there was no hope. I fabricated some excuse for why I could no longer take the acting class, but the initial problem (my detached loneliness and ennui and crushing boredom with life) resurfaced and I was back in my room, reading books, glued to the television set, so white from sunlight deprivation I looked almost bleached. When I looked in the giant mirror over my mother's dresser I seemed all out of proportion: my eyes were too big, my head equal parts shrunken and bloated.

One day after school I noticed a boy from my class, one I never spoke to even once, following me home. He walked directly behind me. When I stopped walking he stopped too; it was like that old Harpo Marx routine. I whirled around to confront him: "Where are you *going*?" I demanded, in a tone I'd learned from my mother.

"To your house," he said.

"*Why?*"

"To *play* with you," he said, rather annoyed.

When I got home my mother confirmed a playdate had been arranged without my consent. The stringency in her tone was infuriating; there was an undercurrent of perverse enjoyment in it too, a pleasure she seemed to take, as she puffed at her cigarette in her heels and tailored beige pants, in shoehorning me to fit her idea of what childhood should look like. As if interior lives could be retrofitted, molded for convenience. It seemed cruel of adults to repeatedly force me to perform my childhood, and I couldn't do it anymore. I burst into sobs of frustration. "I don't want to play!"

"I don't *care*!" said my mother, proudly sucking at her Kent 100.

"But I don't *like him*!" I shrieked, right in front of the boy.

"Too bad! Go play. *Now!*"

Her mulishness enraged me. My mother spoke to me as if

parents had a kind of spiritual purchase on children, as though children could be pried open like mollusks—that they could be made to yield happiness as a kind of dividend, a liquor to be extracted. From that day on playdates were sprung on me repeatedly, usually at the last minute. But I found that once the boys were in my home I could make them do what I wanted. I enjoyed controlling them, just as adults enjoyed controlling me. I taught my victims how to sit in half-lotus position—something I learned from a segment on the *Merv Griffin Show*; I made them do headstands for uncomfortably long periods of time. If they complained I told them they had to do what I said, that it was my house, that it was yoga, that it was good for them. "Too *bad*," I'd reply, in emulation of my mother.

I'd play the *Sweeney Todd* album for them—by this point I'd appropriated it as an origin story. With each listen, the screech of the factory whistle became less jarring, the snap of Judge Turpin's whip less sickening. And with those shocks buffered, once I could withstand the horror of it better by abstracting its terrible currents, I began to *enter into* the record—like there was a portal inside the music. Once I stepped through the portal I too could become Sweeney—I fused with him, just as I was able to fuse with Ricky Schroder. The music was an auxiliary power source I could hook into, like a city when the electrical grid goes black. The boundary between the record and myself melted and we became one. Over the course of the forced playdates I'd take my hostages through this narrative, point by point, as if leading them through the stations of a passion play. I'd swagger up and down the length of my bedroom as if it were a proscenium, railing against the scourge of human injustice; with each step I'd feel resuscitated with this new black plasma, revived by the grim prospect of vengeance. The boys would listen—fascinated, *horrified*—as I recounted the story of the barber who went mad, who slashed people's throats and cooked

them alive in hot ovens. If the world broke him, he would re-create himself in the frightening glimmer of its reflection; if its inhumanity shocked and terrified him he could viciously turn against it. I never felt so exhilarated as I did seeing the terrified faces of those boys in my room, the seal of their virginal Judaism broken forever. I felt as powerful conscripting their attention as Sweeney when he brandished his razor, treading the length of the lit proscenium, taunting us and swaggering, bleating and screaming so we felt it in our guts.

NOT WHILE I'M AROUND

IN THE FIFTH grade I made my first best friend, Ari Blume. Our friendship was the product of one of my mother's illicit brokerages. Though I hated giving her credit for anything, and despised her Machiavellian interference, I was, in this instance, grateful to her because I desperately needed a friend. The viscid gloom I now accepted as reality was too much to handle alone—and Ari was fun. And though I was, as a rule, suspicious of fun, the kind of fun we had was esoteric and strange enough that it actually *felt* fun. He didn't balk when I made him do yoga. We cooked custard pies, we discussed Charles Dickens. Ari was game for anything—he was a nerd. He was obsessed with IBM computers (he knew DOS, whatever that was, he talked about it all the time) and entomology and medieval history.

His eccentricity delighted me, but the rest of the Blumes were all straitlaced and conservative. I don't think they knew what to make of me—with my shirts perpetually untucked, my pants ineptly hemmed and permanently wrinkled, my hair overgrown into a mongrel shag. I was nervous and shy around adults, and I think my shyness made me come off as somehow untoward. Ari's father barely registered my existence, but his mother made no effort to conceal her distaste for me: surely the godless, oily-faced wastrel hanging around their living room was a bad influence on her son. When I was over, she'd clamber

around the mansion, clanking her keys, eyes sandbagged with weary contempt. She'd scold Ari in terms that felt violently intimate, as though I weren't there, and would find coded ways of getting rid of me: "We're having dinner *now*!" and "Time to get *moving*, Ari!" One afternoon we were playing in his yard when she came through the front gate with her clanking keys and her various briefcases, and, upon seeing me, shouted, "GET THAT GODDAM CHILD OUT OF MY HOUSE!" pointing her index finger like I was some ungainly spill on the carpet.

His mother's apparent distaste for me wasn't enough to doom our friendship—not in itself—but in the first week of sixth grade there was a shocking turn of events, for I made a new friend. I did so without any help or encouragement from my mother. I knew Howie Blum peripherally from the neighborhood, but like Ari, he wasn't someone I imagined myself speaking to, much less befriending. Even with my notably low status at school I felt I was above Howie, who was obese and sweated too much and was ungainly in every way. His hair was a worn-out Brillo pad. His face looked swollen with mumps. His mother dressed him in cheap-looking cotton shirts, ecru and plum. I used to see him on Ocean Parkway jumping rope with social pariahs like Judy Shamula and Tanya Applebaum and the spectacle of it repelled me: an obese boy playing jump rope alfresco with two miserable-seeming girls. But when he struck up a conversation with me (in gym class, on the sidelines; we were both refugees from dodgeball), we had an intense, instant connection. Within minutes of our meeting he launched spontaneously into incredible satiric impersonations of our teachers. His observations felt ripped from the inside of my own head; every secret thought I held he made explicit, right there in the middle of the gym. He laughed easily and copiously, and it was contagious. The laughter felt explosive and secret, a barely capped hysteria. I sensed the laughter belied more

primitive forces, that it opened into giant amphitheaters of rage and despair, but I was too swept up in the delirium to care.

Howie's family was German, and they'd recently emigrated from Munich. They lived in a two-family house on Ocean Parkway, just a few doors down from Ari Blume. I thought it was a boon to have two friends right on the same block—and we were all in the same Hebrew classes. But soon after meeting him Howie confessed to me that Ari was, to his mind, "sickening." He thought Ari looked funny, and behaved like an animal (he even came up with a portmanteau to this effect, *"Ari-mal"*). He repeatedly urged me to break off my friendship with Ari. He worked to instill in me the notion that Ari was *disgusting*. Though his mother seemed to despise me I still liked Ari—I liked his strangeness, there was nothing sickening or disgusting about him. I'd never been in a position to reject anyone, and felt it was unfair to have to choose between friends, but I did want to please Howie. I was impressed by his ardor, his determination to extract an exclusive loyalty from me. No one had ever wanted so eagerly to win my friendship, so I felt in debt to him for that. And with Howie's repeated insistences I felt less and less bound to Ari: maybe he really *was* disgusting, maybe I'd been lax and indiscriminate about my friends. Who needed Ari when there was this font of nonstop hilarity and charisma in the person of *Howie* who wanted me and only me? And yet Ari had done nothing wrong. I liked his friendship and didn't want to lose it.

My moral quandary plagued me for weeks. Howie continued to make aggressive bids for my friendship—and it was no ordinary friendship he wanted, it was something more symbiotic and intense. I'd never experienced anything like seduction, but that's what it was. I was being initiated into a new order, a new way of living. I was being groomed, courted—whatever it was, I was ripe for it. I was ripe for some form of escape.

In sixth grade, the yeshiva separated boys and girls during Hebrew classes so we could each learn the moral proscriptions of our gender. Boys had to study something called the Gemara, which involved the painstaking, exhaustive unknotting and regurgitation of lots of small thorny moral questions and debating them endlessly: Were you morally obliged to shut a window if someone in the room was cold? Must you give up your seat on the bus to an old woman? It was hard to take notes or pay sustained attention to all the various conundra about debts and mules and cows and crops, and I hated our teacher, Rabbi Lipnick.

Middle school seemed to occasion a new cruelty from the faculty. All the teachers were suddenly sarcastic and hateful, but he was the worst. Rabbi Lipnick hurled nonstop abuses at us. He smashed his fist against the desk so hard the blackboard shook. He threw erasers at us and called us morons and animals. He mashed gum in people's hair and threw cereal down our shirts. He weighed about three hundred pounds but despite his obesity he was quick, he had a lupine energy. He'd bound in swift strides, stalking the room and screaming at us with his parts pulling and whooshing in different directions like a giant water balloon. He sweated profusely even in winter: when he wrote on the blackboard, gouts of his sweat mingled with traces of chalk to form a thick mineral slush. He didn't have enough hair to clip on his yarmulke, and the sweat effected a lubricating slippage so it would keep falling off.

I despised Rabbi Lipnick but I'd had other terrible teachers and always found a way to pay some form of attention in class. Howie, however, spurred my dereliction. He didn't seem to care if he failed any tests or paid attention, so I didn't either. We began passing notes that lampooned what was happening in class. We dissected Rabbi Lipnick's every move, his odd animal growls and snarls. We broke down social dynamics of

different cliques in school, we gossiped about people we liked and didn't. The notes got longer and more elaborate. Howie got in the habit of starting them the night before, so they became more detailed and took on a formal epistolary quality. The notes were like manna to me. They made life feel new. The soul-killing repetitiveness and crushing routine that seemed a permanent feature of my existence up to then vanished. Each time I sat with his immaculate swooping cursive, its twisting bubbles and loops, I gained privileged access to his inner world: it was a kingdom and I'd been given the silver key. I was led into the interior of something, when up to then I'd only viewed surfaces and exteriors. I felt for the first time in my life like a human being—it was a feeling I never imagined for myself, a feeling that filled me up completely. I didn't know how starved for my own humanity I'd been up to then—for joy and pleasure and life. The belonging was so meaningful to me, so profound and unprecedented, I wanted Howie to know I didn't take it for granted. I wanted to give something back to him. But what would equal the impossible beauty of those notes, those dispatches that reached the elusive inner chambers of my own heart?

One day, on impulse, in the middle of class, I pulled out a sheet of loose-leaf paper and in my sloppy bad handwriting scrawled, "I hate Ari's guts!" It was one of those craven moments in life where one does the thing one least wants to do, but at the time it made a loose sense. Just as I was passing the note to Howie, a fat hand intercepted it. "What do we have here, *gentlemen*?" said Rabbi Lipnick. "It must be fascinating, *fascinating*!" As he unfolded the note and read it silently, sweating and dripping all over it, I felt my heart sink. He lifted his head. "*Ahhhhhri*," he announced in his thick Israeli drawl, "David Adjmi hates ya *guts*." He balled up the note and threw it in Ari's face. It bounced off his forehead and onto the floor.

The class erupted in laughter. Ari laughed too, but his face reddened and his eyes were flushed with sadness. I felt ashamed about what I'd written in the note. It was cruel and it wasn't even true, but I didn't know how to explain my actions to Ari—I couldn't explain them to myself. When I saw him at lunch, or in class or in the hallway, I never apologized or even acknowledged what I'd done; I'd learned from my family how to dodge unpleasantness.

Howie and I walked home from school together every day, we did homework together, we talked on the phone for hours. We were together every weekend. We wrote and recorded radio plays about people in our class. We went shopping and rented videos. I never had any money—my parents didn't give me an allowance—so Howie would pay for my bus fare. He bought me pizza, and soda, and tickets to movies. Almost right away we began to twin each other, though we looked nothing alike—it was a kind of spiritual twinning; we were two halves of a whole. People started to confuse us: they called me Howie and him David. It became a joke at my school, that we were interchangeable, but I felt our point-by-point isomorphism as a relief. The burden of selfhood had grown so oppressive, and now I had a supplemental self. And where we weren't alike I started to reshape myself to match him. I wanted our connection to be smooth, frictionless. I wanted no separation between us. Even though we were outsiders, together we built a world where other people were outsiders and we, cocooned together from the inside, could laugh at them. Popular students were caricatures of human beings. Adults were gorgons and monsters. Everyone was grotesque and ridden with warts and disease.

We satirized our teachers endlessly. Our science teacher, Mrs. Birman, was a favorite, with her absurdly perfect posture and gratingly precise diction. We loved her dumb, sarcastic quips— like when she asked her students if they would like a *zero in her*

book, as though it were some exotic special in a French restaurant. She had all sorts of catchphrases, and we turned them into musical numbers for imaginary Broadway musicals. We wrote a song detailing a wart on her face to the tune of Laura Branigan's "Gloria." We wrote plays and novellas in which she was assassinated, trounced in the jungle, thrown in an incinerator to ecstatic cheers. We thought it was absurd she could have power, but the world was an absurd place, and even buffoonish people like Mrs. Birman could have authority in it.

When my class brought a substitute teacher to tears one afternoon with our endless shouting and jostling, Mrs. Birman was dispatched to deliver a damning sermon and punishment assignment. Howie had put in a special effort to be on good behavior that day. He took offense at the blanket aspect of the punishment. "But what about the people who were good?" he asked.

"What *about* them?" said Mrs. Birman.

"I made a special effort to be good. Why should I be punished with the people who misbehaved?" he said. "It isn't fair."

Mrs. Birman's spine elongated with sudden gravitas. "*Fair?*" she echoed, a tiny facetious smirk curling at the sides of her mouth. "No one ever said that life was *fair, my friend.*" She punctuated each syllable with a kind of filigree, as if to brand Howie indelibly with the unfairness—as if to say that no, it *wasn't* fair, just like the tribulations of the *Jews* weren't fair, or the *Holocaust,* or all the pervasive sufferings and cumulative miseries and trials of human existence weren't fair but you still had to endure them, and once you endured them you were permitted to inflict their punishing embittering lessons on the next generation, and that it was Mrs. Birman's job to impress this very fact upon us: that we were helpless in the face of an absurd universe, that her salutary punishments were lessons in Judaic humility, that her authority was absolute whether it was war-

ranted or not. But this too became grist for our eviscerating satire. For months, Howie continued to hone his impression of her to my awestruck delight: "*No* one ever said that life was *fair, my friend.*" He sponged up every detail, every nuance of behavior, every twitch and incremental shift in her expression. He punctuated the routine with theatrical pauses—craning his neck, mimicking her every swivel and blank stare until I was breathless with laughter.

When I turned twelve years old that spring, I had to start seeing my father again. As inexplicably as he left, he was back, and I had to spend Saturday nights with him as part of some new improvisational custody arrangement between my parents. Howie was fascinated to be the friend of someone from a broken home. I thought he might judge me or reject me, but he openly pitied me—a response I found rather gratifying, as pity and love were interchangeable to me in those days. Richie, who was still my father's champion, came out with me and my father that first Saturday to the Genovese House—which, along with Fiorentino's of Avenue U, was one of two restaurants Dad liked. But my father didn't order food; he just watched us eat while he sat back like a reigning monarch. "Go ahead," he told us. "*Enjoy* yourselves, boys. Get whatever you want." I sat quietly in a constipated rage all night, picking at my Caesar salad, speaking in angry monosyllables. I resented, even then, with my poorly defined boundaries, having to spend my Saturday night with this strange man and his coarse tonsure of hair and his Stolichnaya on the rocks. He asked loud general questions and spoke in broad declarative statements. He never bothered to explain why he left or why he was back. He was a phony and, to my mind, despicable.

After dinner, my father dropped us off, and Richie, who maintained his tropism toward unquestioned piety and loyalty, railed against me for being a bad son: "How can you treat your

own father like that?" he cried. "Don't you have any *respect*?"
It didn't occur to me to respect my father, and it didn't occur to
me to defend my position. I didn't know I even had a position.
I just had feelings—and they weren't even feelings, just some
inchoate preverbal jam, like stem cells. Later that night, I called
Howie, who responded to my jeremiad with satisfyingly exag-
gerated expressions of pity and censure: "It's like *torture*," he
exclaimed hotly. "How can you *take* it? Your father sounds
disgusting!"

I relied on Howie to make me laugh, to show my life back to
me in the form of a satiric cartoon. In some respect, he took on
the job of raising me. He was more a parent to me than my own
father. The care and attention he lavished so freely put pressure
on me to give something back. I wasn't used to someone liking
me and didn't know how to keep his affection. The only cur-
rency I had was my sophistication, the worldliness I learned
from my mother. There was still lots Howie didn't know about
America, or Brooklyn, for that matter—his family was still
new to the country—so I started to operate as a sort of con-
cierge, a docent who could tour him through the civilized
world. When I took him to Caraville for the first time his eyes
lit up as if it were a fairyland. He'd never heard of cheesecake
or rice pudding—he'd never seen anyone like Beverly the host-
ess, never heard a voice so polluted by nicotine. I taught him
about Syrian foods, and SY slang, words he immediately
appropriated—but not just words, a whole *sensibility*. He ab-
sorbed it instantly, and was able to not only play it all back to
me but parody it *as* he was replaying it: he had the same bin-
ocular capacity I had. And with this binocular vision he was
able to see me: I was visible for the first time.

Howie had never seen a play, so during winter break I led
him to the TKTS booth one afternoon where we got tickets to
some Neil Simon thing. After that we went to see plays to-

gether all the time: culture was back! To fund my habit, I used money I saved up from birthdays and holidays, and when that ran out Howie would pay for me, or I'd filch tens and twenties from my mother's purse. Using her instruction as a guide, I exposed Howie to the dazzlement of cream tea in a little luxe parlor in the Trump Tower, salads at Le Train Bleu, apple pie à la mode in a dimly lit restaurant in a midtown Hilton. We went to the Met and the Guggenheim and Brentano's. We screwed up the nerve to enter into hallowed temples of fashion, places I'd never been because they'd seemed so forbidding, like Bergdorf's and Saks. The places seemed to dangle the promise of some initiatory bliss, a pleasure beyond ordinary familiar pleasure or beauty, almost a kind of spiritual ravishment. The subway rides back home were for debriefing and analyzing our findings, assessing what had indelibly happened to us. Our experiences were suspended in a vague cloud of art, culture— *something* exquisite, but we didn't have a name for it. We were pressing our fingertips against these alien surfaces and textures, and, in turn, every interface altered us, imprinted us permanently.

Once I had it I felt the obligation to maintain Howie's view of me as a precious font of culture and experience. I was ashamed to admit when I didn't know or understand or invent something. I wanted to appear magically self-contained, fully formed, *causa sui*. Whatever new foods he shared with me, movies he liked, I made a point to exaggerate my disinterest. I didn't want to concede he could enlighten me in any way, as such concessions were signs of weakness. Sometimes, though, I'd lose my footing. My insecurities and anxieties would emerge—the mask would slip. I was pathologically fearful of very ordinary things. I was scared to walk into record stores, scared to buy subway tokens. I was afraid to call 411 and speak to the operator—what made me worthy of a reply? What if she hung

up on me, sickened by my lack of personhood? Every social interaction addled me with panic. I felt shame in asking for things, terrified of asserting my existence.

But Howie was fearless—and he didn't judge me for my neurotic fear of life, he found it charming and endearing. He'd repeat his soothing mantras: that there was nothing they could do to us, that they couldn't have us arrested for buying subway tokens. "We're allowed to walk into *stores*!" he'd say with comic exaggeration, and I'd laugh with him, laugh at my own irrational fears, laugh at the way my siblings laughed watching Linda Blair's head spin in *The Exorcist*—for the horror wasn't reality, it was an illusion.

I didn't understand how the tenor of reality could change so drastically by seeing it through someone else's eyes: how could someone make you believe in something so emphatically? How was a boy of eleven who was fat and badly dressed so remarkably assured? I couldn't understand where he'd gotten the confidence, why he had it and I didn't; but I was able, for a time, to live on borrowed confidence. His confidence made me braver.

At his urging, I even mustered the courage to go to Charivari, an apogee of fashion in the mid-1980s. I always wanted to go inside but was afraid to sully the temple with my enfeebled presence. Howie went in first; I trailed obediently behind. I kept my composure and held my breath, studiously avoiding the gaze of any salesperson who might pock me with judgments. The space felt august like a Japanese temple. The salespeople were hieratic and very austere, shuffling up and down aisles like fish in a glittering koi pond. Howie and I clung to chrome balustrades, walked in terrified tandem up short staircases as Japanese music played. Everything was slick with white lacquer. Everything was teetering on the edge of everything else. Vitrines towered with luxuries. Charivari's glamour was different from that of an ordinary clothing store. It wasn't

tastefully elegant; it was modern and bizarre. Men's suits were monochromes in Yves Klein blue and fluorescent pink. There were weird puffy coats that looked like pieces of furniture. Everything was ripped or burnt or corrugated—the seams on a blazer were inside out, a sleeve was missing or mismatched. To what category of existence did these objects belong? Was this fashion? Was it culture? Was it even meant to be *clothing*? What was the ontology of an asymmetrical neon yellow blazer with cigarette burns? I didn't know. I just knew I was being exposed to something godly and lacked the aesthetic refinement to really experience it. As I was feeling bad about myself and ruing all my deficiencies, I stepped momentarily out of my body. I saw myself standing there in my lime-green sateen jacket and my overgrown shag of a non-haircut and the whole scenario struck me as ridiculous. Just as I felt the impulse to laugh, I heard a faint buckle of noise, and there was Howie: his face glowing bright red with suppressed laughter. It was like a transmitter linked our brains. He was pretending to look at some sweater but let out an involuntary snort, which made me start to break up. When we could endure it no longer we made a beeline for the exit, hurrying past the vitrines and glamour and out the front door, where we collapsed into fits of uncontrollable laughter. The laughter lifted me out of misery and into an otherworldly sphere. Howie loved me unreservedly, loved me in a way my own parents didn't love me—without conditions, with all my flaws and strangeness.

My mother didn't approve of our friendship. She didn't want me spending so much time with Howie. He, in turn, saw my mother as a camp icon. He performed endless vivisections on her: the way she spoke, the way she moved. As ever, he was able to zero in on details and tics no one else noticed, like her bizarre affinity for toothpicks. "*Daaaaave*," he'd trill in razor-sharp impersonation, "whehe's my *toothpick*?" He'd suck in

his cheeks and roll his tongue around in vaguely perturbed but still luxuriant swirls, picking out imaginary pieces of food as I fell to the floor laughing. My mother never caught us making fun of her, but she could sense some untowardness. She thought Howie was a sneak and a bad influence.

Our treks to Manhattan grew more frequent despite her staunchly irrational warnings that she didn't "want me" going to The City and she didn't "want me" going on the train. My mother didn't "want me" doing a lot of things back then—her maternal injunctions carried a poisoned strain, the taint of her own overcautiousness: Manhattan was terrifying, subways were terrifying. There was graffiti, there were muggers and squeegee men. Of course, she was right about all those things, but I objected on principle to my mother's response to imminent danger, which was to shrink the size of her world so danger wouldn't get at her.

Howie was baffled by my mother's endless worrying. His mother, after all, encouraged him to be intrepid. She thought my mother was insanely overprotective, and told me so in long-winded diatribes laced with her broken English: "Of *course* you can go on ze subvey, Day-veed! Zat is so *stupid* what your maza says—it's *crazy*!" Howie's mother had a lot of issues with my mother and had no problem openly voicing them: Why was she so enamored of Lean Cuisine and frozen foods? Why didn't she cook me dinner? Why did she string a house key over a soiled white shoelace and make me wear it around my neck? I defended my mother, or tried to, but had to eventually admit her demands *were* unreasonable, her anxieties infringing on my burgeoning manhood. So I resolved to defy her: I decided I *would* go to The City, I *would* take the subway. My defiance of my mother's wants began to give me a perverse satisfaction, a counterweight to the obsessive control she wielded.

Howie's mother was also controlling: she demanded a rever-

ence from her children that bordered at times on cultism, but she'd bonded with them sufficiently so that they accepted her intense alliance. His father was kind but passive; he survived the Holocaust and now couldn't really do anything but relax on the sofa with his sandals and his Hanes T-shirt tautly stretched over his giant spherical belly—but my friendship with Howie, with all its intensity and crazy exclusivity, was patterned on this other relationship.

He was somewhat obsessed with his mother: with her beauty (she was once a model) and her cute German accent and charcoal swirl of hair. To me, her Teutonic harshness was frightening but when she barked commands at him in German, Howie snorted with laughter. He found her spikiness entertaining. If she asked an invasive question or made a blunt remark he'd hug her theatrically like she was a life-sized doll, and laugh wildly, and say, "Oh, *Mommy*!" smothering her with kisses while she grimaced and displayed not a whit of reciprocal adoration—though it was patently obvious she adored him, and more than that: *needed* him. And her need felt most pronounced at precisely those moments when her efforts to contain it were made visible.

I didn't understand the calculus of her need. I knew she was depressed and alienated—that, like my mother, she had few friends and hated Brooklyn—and that she had an intense need for *drama*. She found the correlative to her need in trashy magazines like *Star* and the *National Enquirer* (both of which she read obsessively) and in prime-time soap operas.

Her favorite show was *Dallas* so it became Howie's favorite too—the whole family had a standing date as a family every Friday night to watch it. It was on Shabbos but they discreetly closed the blinds, no one would know. I'd never seen these shows. Howie wanted me to catch up on the plotlines so we could watch them together. He relayed the whole sordid history

of Jock Ewing and Digger Barnes and Ewing Oil. He spent hours and several cassette tapes recounting the entire season-by-season history of *Falcon Crest* as though it were a Homeric epic. Through the tapes (that I listened to repeatedly on my mother's Sanyo boom box: it soothed me to hear Howie's voice when I was without him, which I increasingly found impossible to bear) I learned about the evil Angela Channing, and how she usurped Chase and Maggie's winery, and how the actress who played Maggie would always sigh during her line readings in dismay of some awful new thing Angela had inflicted on them. And how Terri came to town with her yellow Ferrari convertible, and was a slut, and went horseback riding in silk blouses through vineyards with Angela's grandson Lance. And how Lance's mother Julia became a nun to escape her mother's evil turpitude, but one day disrupted a dinner party in her nun's habit and shot her mother in the face. The plotlines were magnificently preposterous but at the same time, Howie could sense the real, and even *tragic*, underpinnings of the stories; he was able to distill the crackpot elements so they felt elemental and genuinely upsetting. Just as I understood *Sweeney Todd* as a parable of the banished father gone insane with grief, he understood *Falcon Crest* as a parable of the mother as monster, the mother as supreme creator and supreme destroyer. This was how his own mother became magnified in his mind. Everything about her was heightened, she was bigger than life.

She was always in battle—with one of her siblings or a distant relative or her husband's relative or someone in the neighborhood. Her feuds would go for months, even years. She wouldn't speak to people, or hatched sulfurous plans against them, plots that matched the revenge plots on *Dallas* and *Falcon Crest*. Howie became her emissary, her accomplice. The two of them needed enemies the way great empires needed to wage wars: it edified them, it bonded them together.

Howie's mother taught him to be a vigilante. When in fourth grade his friend Alex Fogel turned against him, she showed Howie how to cultivate a rotten egg in a drawer of dirty socks, and instructed him to crack it over Alex's books as punishment. Together they canceled the airline tickets and restaurant reservations of various nemeses, they plotted to overthrow women in the Ladies Auxiliary, they threw rocks and eggs at the next-door neighbor's front window. As he detailed these exploits, Howie took great enjoyment from my scandalized responses. I felt like a square, but I'd never really known people in life to carry such vendettas, and certainly I'd never heard of parents colluding with their eleven-year-olds to carry out revenge plots on the neighbors.

Howie's mother harbored a special loathing for the next-door neighbor, Hildy Tasimowitz. The pattern was similar to all the other hatreds she cultivated. At first, they had a congenial friendship: Hildy was sympathetic to the plight of an immigrant woman from Germany with two kids and a depressed husband trying to make a new go with a nascent wristwatch business she operated out of a basement. But the friendship was quickly warped by vendettas and turned into a full-blown war, a war between two families, like the Ewings and the Barneses. Howie characterized Hildy Tasimowitz as a witch who walked with a limp and had gnarled fingers. He said her fingernails were grotesquely long and curled at the edges, and that she had a revolting degenerative disease on her arm—that the disease ate right into the bone and had to be regularly swabbed with a Kleenex to stanch all the revolting ooze. Hildy Tasimowitz was deep in Howie's unconscious, the Orthodox Jew cognate to Angela Channing—only Howie's mother was *also* Angela Channing, and so was Mrs. Birman and Little Chaya from the front office and a whole bunch of other women—and it was hard sometimes to know if Howie adored or despised these women,

the feelings seemed to spin in a confused exhilarated whorl in his mind. But he was so detailed and merciless in his characterization of Hildy Tasimowitz that I too became terrified of her; I too pledged to make her my enemy. I couldn't bear the thought of oozing, melting bone: she had to be evil.

One Friday afternoon, after school, we caught sight of Hildy Tasimowitz walking down Avenue J in her lavender sweatpants and smoking a Virginia Slim. I'd never seen her in person, I'd only heard the stories. Howie gripped the sleeve of my shirt so hard it wedged between his knuckles: "It's *Hildy!*" he said, thrumming with adrenaline. He spun around, pulling me with him, and together we ran back in a panic. We rounded a corner and kept running until we were safe from her terrifying contagion. "Did you see her *swabbing her disease*?" said Howie. "*Yes!*" I cried. "With the *Kleenex*?!" "Yes! *Yes!*" I screeched in overheated delirium, like one of the girls from *The Crucible* professing to have seen the devil—though I wasn't sure if I'd really seen the suppurating disease or just imagined it. I wanted to see what he wanted me to see. My loyalty tendered imaginative lapses in perception. I'd ally with Howie however he needed, even if I never quite knew what was real or what was in his mind. It didn't matter to me what was real, because my loneliness was alleviated. We lived in a bubble where true and false increasingly dropped their distinctions. It was the space of fantasy, and that space felt holy to me, just like the clothes at Charivari felt holy—clothes that were made for some fantasy body, a kind of personhood yet to be invented. The clothes opened the space for this person to spring into existence, just as Howie's stories opened the space for us to become characters in them. The stories bonded us together—for if you shared the same fictions you shared the same reality. Our friendship forced open the limits of reality, so I was somehow on equal footing with JR and Angela Channing. My mother was no longer my

mother, she was layered with all the impressions and camp em-
bellishments Howie gave her. I was no longer merely human, I
was a blend of fiction and reality.

This blurring of categories was intensely freeing to me, so
when I noticed Howie tipping the moral scales, pushing his
crazy fantasies and stories into the realm of outright falsehoods,
I didn't know how to react. But it was increasingly clear: Howie
was a liar.

His lies were often arbitrary, and usually revealed some bur-
ied wish or odd flamboyant fantasy. In Rabbi Lipnick's class,
Howie handed me a fifteen-page note written in his immacu-
late purple and light blue bubble script in which he described,
with a level of detail verging on the forensic, a party his mother
had supposedly taken him to at Ricky Schroder's Connecticut
mansion. He boasted of winning tickets to *Cats* in a radio
contest. He talked extensively about how his science teacher
brought a life-size Barbie doll head to class and taught all the
students how to shampoo her hair. He fed me ham and said it
was a kosher meat-like substitute made to taste like ham. For
Mrs. Birman's class, he made up a fake book he titled *Bamboo
and Nucama* (about an African boy and his best friend who
was an elephant) for which he got an A+.

Howie's mother corroborated all his lies (I hadn't yet learned
of the full extent of their collaboration) but after a lot of prod-
ding and interrogation I uncovered them, one by one. Each
time I felt a fresh sense of betrayal. But if my mother flat-out
said she would mourn me as if I were dead for my moral fail-
ings, I would love Howie unconditionally for his. And though I
cared about morality, whatever betrayal I felt being lied to was
trumped by the rapture Howie himself took in his own fabula-
tions. His delight fused with my own feelings and eventually
became indistinguishable from them: feelings and opinions un-
dulated between us like we were a single organism. I had the

same need for fantasy he did, the same flamboyant insistence on what reality must yield for it to be endurable.

By the end of the school year we were regularly creeping into rooms and offices we shouldn't be in, peeking at secret files and filching notes, coupons, slips of paper, anything we could get our hands on. The lure of the forbidden was too irresistible to him, the blanket of injunctions at the yeshiva too suffocating. Of course, he needed an accomplice for all this: he was raised by his mother to believe that vengeance required an amanuensis. The days when I flattered myself to be some kind of svengali were long gone: now I was Howie's underling.

One weekend, he convinced me to help him break into the nursery school at the yeshiva. It was a small building annexed to the main one. The doors were all unlocked, it was unmanned. We could just walk right in. Almost immediately he went on a sort of pogrom: ambiting quite confidently between classrooms, ransacking teachers' desks, stealing cassette tapes, rolls of unused tickets to some expired raffle. I didn't want to get caught and told him so. "Calm *down*," Howie said, like he was a safecracking expert. He seemed weirdly natural ransacking things, like he was unveiling some secret hidden expertise. I was ashamed of my prudishness. Maybe his minor criminal acts were interesting, even an adjunct of genius. I wasn't sure how to feel.

Shortly after our marauding of the nursery school, we raided his landlord Mrs. Schloff's storage unit—another woman with whom his mother had a long-standing enmity. He was laughing hysterically as he hurled her books and clothes to the floor. He found a small pump dispenser, uncapped it, and squeezed out translucent pink gel, some sort of lubricant for doors or metal joints. I watched as he pumped thick globs of it on Mrs. Schloff's clothes and books. He smeared gel on stray sofa sections, on the seat of a baby carriage. He laughed wildly at his own capac-

ity for evil. He didn't want to steal or plunder—he wanted to deface, to *desecrate*. The rage I could feel in those giant cascades of laughter when we first met was now uncapped. It scared me but it gripped me too—the rage inside him vibrated with some long-submerged part of myself. He became a conduit for all my buried feelings. Though I found his rages terrifying they bonded me to him even more closely.

By the end of the school year he was taking appetite suppressants and laxatives to lose weight. He was trying to become bulimic too, he said, but it was impossible for him to vomit, his gag reflex wouldn't work. He took NoDoz to stay up late and filched pain meds from his father's medicine cabinet to fall asleep. Each of these revelations was accompanied by a capriccio of wild laughter—he tried to pass it all off as one big joke. And though I laughed along with him (by now an unthinking reflex), I saw he was becoming more unhinged, only I kept pretending not to notice. I'd ceded my instincts to him by then. My grades started falling, but if Howie didn't care, I didn't either. He started cutting classes, so I cut class with him, just as I did everything with him. It wasn't even a question.

The door to the roof of the yeshiva was unlocked and it was easy to hide there between classes. He led me up there one afternoon. The roof was lined with tiny, heavy rocks. "Look," said Howie, picking up a rock the size of a golf ball. He casually lobbed it onto the sidewalk. "Don't do that!" I said. I looked down at the sidewalk, scanning the length of it with my eye. No one seemed to be hurt but that wasn't the point. People *used* that sidewalk—*actual pedestrians*—they walked up and down that very sidewalk every single day, and it was just his crazy luck that no one had been murdered. But when I looked over at Howie he seemed relaxed, like he'd just taken a nap. He picked up another rock and dropped it over the edge. "Now you do it."

"Someone could get *killed*," I said, in a pitched emotional voice.

He smiled an odd, wobbly smile. "Don't be so scared of everything, David."

It was an echo of pep talks he'd given when I was afraid to walk into department stores, but in this instance I noticed something taunting—even slightly sinister—in his tone.

Maybe he was right. Maybe to become a man I had to contravene my own instincts, and this was my initiation. I took a moment to rid myself of any final hesitations. I picked up a rock, dropped it down, then stood for a moment in an insensate daze. Was this freedom? Was it a new kind of morality? Would the morality empower me to survive life? Howie saw my expression and burst out laughing. I laughed, but there was no joy in it; the laughter was for him and him alone. For the first time since I'd known him, I felt myself performing for Howie. I'd sacrificed some part of myself and it felt wrong, but I couldn't bring myself to acknowledge the wrongness, because I couldn't be without my friend. I couldn't go back to the suffocating prison of loneliness. I needed to maintain our symbiosis. I needed to laugh—at anything. Our laughter was the golden laughter of salvation; it poked through and perforated the madness around and inside us. We were predisposed to laughing in restaurants, laughing at people on the subway—laughing in synagogues, in class, in school assemblies. The laughter was manic and unstoppable; it would come during dour ceremonies, and visits to the Holocaust museum on Avenue J. It would erupt during maudlin speeches about the PLO and Golda Meir, and in the middle of solemn prayers—as it did one day as Masha Bendikowski led the students in an a cappella end-of-meal prayer called *birkat hamazon*.

Masha was a math teacher but did this on the side, zigzagging between lunchroom benches with her wireless microphone

to rouse the students in prayer. Though her voice (off-key and grating and tinged with an unappealingly thick Long Island accent) was uniquely unsuited for a cappella singing, Masha Bendikowski made up for that with the almost military sense of pomp she brought to the proceedings. On this one particular day Howie and I had only just sat down to eat (we'd been corralled into doing a time-consuming errand for Little Chaya in the office) when, midconversation, we found ourselves peering quite suddenly into a magnification of frosted hair and burgundy lipstick. Masha was singing with a bizarre avidity; she was practically screaming. She was so close to my face that her microphone was jammed nearly up my nostrils. The spectacle of it was so preposterous, so wildly invasive that Howie burst out laughing in her face—and his laughter set off my laughter, we couldn't help it, just as we couldn't help it during school ceremonies and during discussions of the television miniseries *Holocaust*; it was beyond our still novitiate capacities as sixth graders. But that didn't stop Masha Bendikowski from seeking reprisal.

After school we found her approaching from the corner of East Eighth Street and Avenue I, walking toward us in slow deliberate steps like she was holstered for a duel. Her wrists sagged limply, her prairie skirt shifting in pleats with each step. Her hair was the epitome of 1980s Jewish hair, streaked with silver and black. Her fingernails were so long and glossy they seemed part machine. Each element felt so blown out and artificial that when one put them all together it was like a surrealist painting, like something from out of a dream. "If it isn't the Dynamic *Duo*," she said, in her Roslyn, Long Island, patois. She called us Disgusting Individuals, and castigated us for laughing "in the middle of a *prayah*" (her accent at times mysteriously veered toward something from *Gone with the Wind*), and asked us repeatedly how we dared, how we *dared*! Her

voice was pitched high up in the nostrils, and as she spoke she lifted and lowered her hands in languid, almost Kabuki movements, which only augmented the dreamlike surreality of the encounter. When she was done browbeating and shaming us, she spontaneously administered a punishment assignment right there on the corner of East Ninth Street: we were each to handwrite the entire *birkat hamazon*, she said, and to deliver it to her personally the following day at lunch.

Afterward, Howie and I ruminated on the unfairness of the punishment. He claimed it was arbitrary that we'd run into her at all, that laughing wasn't criminal or even against school rules. On these grounds we refused to do the assignment. He was certain she'd forget about the whole thing anyway, but the next day at lunch we found a pair of waggling wrists and hypertrophically long fingernails coming at us. "So," she began, before breaking out in a giant sarcastic smile, "may I have your punishment assignments, Disgusting Individuals?" We told her we didn't have it. Since we defied her, she said, we each had to write out the prayer *ten* times now. "Keep making things worse for yourself, gentlemen," she said. But Howie was dogged about not doing the punishment assignment. He'd become preoccupied with the lack of *fairness* of the punishment—and though I suspected the consequences would be grave, I agreed to stand with him. I admired him for his principles, and, in truth, I sort of liked the whole adventure of it. The intrigue with Masha was as titillating as it was unfair: our lives were beginning to deliciously abut the melodrama of soap operas and the intrigue with Hildy Tasimowitz.

Howie spent all his free time working himself up about how he *would never give in*. He appropriated the phrase "Disgusting Individuals" and used it whenever he could. Howie's mother was, as ever, thoroughly complicit with her son, plotting and scheming along with him. She agreed he shouldn't do the as-

signment, that he should fight Masha Bendikowski to the bitter end. I hadn't even bothered to apprise my mother, who was a conformist and morally very conventional; I had to defy injustice on my own. Which is not to say I was not frightened: Howie's lying and rock-throwing and thievery unnerved me, and I was not entirely convinced of the rightness of his actions (though he repeatedly and very confidently asserted that he *was* right, that he was standing up for a principle, for *fairness*) but I would go along with him, because I loved him, and because I wanted him to be right.

The following afternoon all hell broke loose. When accosted by Masha Bendikowski during lunch, Howie (who was by now perfectly comfortable speaking for me) told her point-blank that, as there were no school rules that forbade laughing, we were not going to do the punishment assignment, to which Masha replied that he was to go to the principal's office *immediately* (parsing that word out into multiple syllables to cement her authority), but Howie, now possessed by some uncanny, disquieting calm—the same calm he displayed hurling rocks and marauding nursery classrooms—said he wasn't *going* to the principal's office, and that he was *eating his lunch*. I could see Masha Bendikowski felt matched. He was only eleven but Howie was spookily self-possessed.

Sensing my intrinsic weakness, and in an attempt to cut her apparent losses (she had to enforce something, after all, she couldn't just shrug it off) she now demanded *I* go with her, but Howie intercepted even that demand: "No," he said assuredly, "*don't* go with her. She can't force you." And with that he sat back down with his plate of pizza, but Masha by this point had had *quite enough* of his rank insubordination. She grabbed Howie by his collar, yanked him up from the bench by it, and shouted, "YOU'RE COMING WITH ME, YOUNG MAN!" Howie's plate of pizza fell mid-yank, spattering his clothes with

tomato sauce, and for a moment it seemed that she knew it had gone too far—that she might pull back a little, help him clean the pizza, finesse it without losing face—but instead, Masha doubled down on bad instincts. She began yanking and twisting the collar of his shirt, which made Howie swat at her hand. He was battering at her with his small fist and shouting for her to GET THE HELL *OFF* A HIM! The spectacle of an obese eleven-year-old boy attacking a middle-aged woman attracted the horrified gaze of at least half the lunchroom but Masha had to address his insolence, she had to maintain her surety and sense of mission, so she proceeded to drag Howie by the flimsy yellow cotton of his shirt through the stadium length of the lunchroom as he shouted and wept crazily and repeatedly smacked her hand in his attempts to pry it from his collar.

Once they'd gotten up the stairs, he calmed down, and we walked in civil silence to Rabbi Bressler's office. Masha proceeded to explain the situation to him as she chewed her small pink rectangle of Dentyne in circumspect diagonals, and when she was finished with her précis made a whole bunch of rhetorical threats about school plays, and privileges, and holiday breaks.

"I don't know if these boys have earned the *privilege* of going on the Philadelphia trip, *Rabboy Bresslah,*" said Masha (referring to an overnight outing that was coming up) to which Howie rather violently rejoined, "If I wanted to go to Philadelphia my *mother* would drive me and we'd be there in *three hours!*"

After a tiny stunned silence (because he really was staggeringly brazen, and it was momentarily unclear whether his brazenness merited further punishment) Rabbi Bressler and Masha Bendikowski decided there was nothing either of them could really say to that; he was indifferent to their threats and strawman arguments—he had no intention of playacting the humili-

ation and sad penitence they seemed to want. My esteem for Howie went up at that moment, and I knew—despite his ransacking of basements, and smearing of gels, and jettisoning of rocks from roofs—I *knew* he was splendid.

After back-and-forth deliberation it was decided that because of our actions we'd be suspended, that the suspension would go on our permanent records—but I didn't care, because there was integrity in our actions. Howie was fighting for fairness. He was forging his own moral code in a society that was phony and empty and morally bankrupt. And I was fighting right along with him—even if my fighting was otiose and an inert bookmark for some noble battle I might someday fight in the future—*even so*, I was by his side. I was his abettor, his supporter. I didn't care about consequences. I didn't care about punishments. Standing alongside him, I could feel my own flame of integrity burn brighter and brighter.

SOMEBODY'S WATCHING ME

O N THE FIRST day of seventh grade, Howie, without fanfare or flourish, arrived in school wearing a new shirt. The shirt was in the vein of abstract expression: it was patterned with stochastically arranged pinwheels, multicolored frets and zigzags. It was collarless, somewhere between a sweatshirt and a sweater; I thought it was magnificent. He looked like a different person in the shirt. He'd lost a bit of weight, and with the combination of the shirt and his new slimmed-down figure, Howie looked, for the first time since I'd known him, almost *stylish*. I hadn't seen this coming. I knew his wardrobe by heart, his every ecru sweater, his assembly line of beige slacks, so I was—if not hurt, exactly—then somewhat stunned by this debut. He didn't share his new acquisition with me in advance, and I felt assaulted by the newness. Now that Howie had this pinwheel shirt I felt a small crevasse open up, ever so slightly separating us. When I ran into him in the hall just before class we made superficial conversation. I waited for him to call attention to his makeover but he didn't say a word about it. He didn't ask what I thought of the shirt. He didn't ask me to tender my approval. I tried to feel happy for him for being fashionable and losing weight, though I dared not introduce either as a topic of conversation—I would feel too vulnerable congratulating him when he seemed quite patently not to need my con-

gratulations. He blathered on about sugar-free brownies and Tofutti ice cream but I couldn't focus on what he was saying because of *the shirt*, because of the hidden registers of pain it tapped in me. I felt myself prowling for an advantage, some comparable treasure to flaunt in retaliation, but I owned nothing of value. I tried to hide my creeping envy. I tried slaloming around feelings that were invidious and unpleasant. I'd had a horrible summer, which was spent mainly without Howie, who'd been on vacation with his family—some dietetic spa in the Caribbean—while I'd been forced to go to a horrible Jewish day camp in Rockaway Beach. On weekends my mother toted me to Deal to visit with Claudia Terzi or my uncle Ralph with the expectation that these visits would "broaden my horizons" and expose me to new friends who might break my bizarre attachment to Howie. We spent our days at the Deal Casino, a club with a private beach where my uncle was a member. Syrian girls in gold bikinis and gold makeup strode languidly down the row of beach umbrellas with anodized expressions, their wrists garlanded with bangles, hair straightened to the point of lamination. I saw boys from school shooting one another with water pistols, swimming with their tans and Speedos, their bodies lacquered with Bain de Soleil. They were all developing muscle but I kept my shirt on, ashamed of my pale torso and flab.

Mainly I'd be ignored, but sometimes the boys would pepper me with rhetorical questions, things like "What are you *doing* here?" and "You *go* here?" and "*Why* are you here?" The questions implied that the Deal Casino was an inviolate sanctum, one I'd dirtied with my presence. Maybe everyone had some infrared capability, and there was some soiled, stained part of me I couldn't see. I tried to hide from the boys. I urged my uncle the following week to move to a different, less populated section of the beach, but the boys found me there too.

Something changed that summer: there was a new ruthless curation, a reordering of existing hierarchies. I felt spotlit under some new and very harsh criteria.

At school, Howie functioned as a buffer to social anxieties, but now I saw he could tire of my novelty. He could become fatigued by whatever abstract gifts I possessed. He could abandon me altogether. The pinwheel shirt seemed to herald something terrible. Would Howie become stylish? Would he *supersede me*? The fragile succession of these bleak thoughts led me to unspool in the middle of the hall.

"Why do you look like you're gonna cry?" said Howie.

"I didn't sleep good last night," I said, trying to keep it together. I then noticed that the balled-up Brillo pad of his hair had mysteriously unknotted itself into a sharply angled pillar of spikes. "Your hair looks different."

"My mother taught me how to burn my hair with a towel," he said. "And I put on mousse."

"What's *mousse*?"

"Hair mousse. You never heard of Studio mousse?"

"Maybe I heard of it," I said, but I hadn't. I felt so deficient. I hated the way he posed the question. Howie stood with his hand on his hip—his posture seemed different, straighter. He seemed to have it all together; it was driving me crazy. "Where did you get that *shirt*?" I blurted, my voice involuntarily dipping into a register of hard accusation.

"Lester's," he said, and again there was a slight glibness in his tone, like it was no big deal—even though he'd never before shopped at Lester's, even though his mother had only ever taken him clothes shopping at a discount outlet in Boro Park. Even though Lester's—like Caraville and Deal and the Casino—was essentially the exclusive property of Syrians, and Ashkenazi Jews like him had no real claim on it.

Lester's was in fact the height of Syrian glamour. Everyone

wanted the cachet that came with carrying their signature yellow-and-black plastic bag. The store existed in a particularly dilapidated and unsavory stretch of Coney Island Avenue, across the street from what was once a porn theatre and was now a McDonald's, but amid this gray wasteland Lester's grew into a mini empire, ultimately usurping an L-shaped piece of real estate that extended all the way around the block. It became a haven for SYs. The clothes were chic, and it was well known that Syrians didn't have to pay tax. But even with the tax break, Lester's was one of the places my mother couldn't afford—or if she could, I was asked to skim from the ugly piles of sale clothes from the Boys and Husky section, and she would try to convince me how great I looked in bad outfits. If I balked, she'd guilt me into liking things: "There's nothing wrong with that shirt!" If I vetoed a pair of pants she'd override me and ask practical questions, like, "Does it fit you in the *tushy*?" On every car ride home I'd feel sick, knowing I would be made to wear more unstylish clothes. I had no control over what I wore and how I looked. My clothes were shitty; my shoes were ugly. I was sent to school in wrinkled flannels and corduroys worn to nubs. I was roundly criticized by my classmates for my awful sense of style. I was asked why I dressed "like poverty" and condemned for not owning sweaters. I couldn't participate in the Izod-Polo wars (an internecine fashion battle that erupted in my homeroom class) and was exempted from all considerations of wealth and pomp.

My lack of control over my appearance and the reactions it garnered had become a near-constant source of anxiety. I couldn't hide and I didn't belong anywhere. And now *Howie* could shop at Lester's, and supersede me, and he wasn't even Syrian; it wasn't his heritage, it was *mine*—and though I wanted to reject it, once he embraced it I felt blindsided. I felt I was being robbed of something, like I'd been mugged.

The conversation with Howie was dislocating, but every-
thing in my life felt dislocated that fall. Everything was in flux.
Transformations were happening all around me in their car-
buncular oiliness and ugliness. People I'd known for years were
now strangers. Nechama Polin cut off her long braid and now
had a short bob and the faint hint of a mustache. Alisa Gold-
man had a mustache too. Joshua Fogel's face lengthened and
thinned incomprehensibly—he looked like he'd contracted some
weird illness that somehow made him more handsome. Ugly
people became suddenly beautiful. People who were beautiful
morphed into troglodytes. It was unpredictable, a kind of cor-
poreal roulette. Bodies began to leak unwanted oils and secre-
tions. They produced rotting smells. There were bumps and
pustules and protrusions. My own face had broken out in hid-
eous welts of cystic acne, and I'd recently sprouted hair from
my nipples—a harbinger itself preceded by the appearance of
two tiny lozenges under the aureoles that I thought were tumors.

I spotted them in the bathroom following my shower and,
sobbing in terror, sprinted downstairs to my mother. "I have
cancer!" I screamed. The following morning she took me to see
my pediatrician. I sat on a sheet of rustling paper loosely placed
and crinkling loudly on the examination table as Dr. Deutsch
felt the tumorlike masses. He then gazed at me over the crescent-
like downturn of his giant nose. "That's not cancer," he cack-
led, "you're just in *puberty*."

The instant he uttered the word I felt sick. There was some-
thing proprietary in his tone, some perverse ownership over my
body he was asserting with his terrible cackles and grimaces. I
felt stripped of my humanity, like I'd been called a whore, and
Dr. Deutsch was a sadist administering the puberty—*inciting* it
as part of some secret unethical experiment. When he saw my
reaction, he patted me on my naked shoulder and laughed even
harder. I looked up and could see the gray hairs jutting out

from the ovoids of his laughter-distended nostrils. My mother sat on a tiny black stool and lit a cigarette while I put my shirt back on. In the clinical office, with its puke-green walls and jars of tongue depressors, I could feel the ghosts of all the other children told of their puberty like they were specimens, mealy worms spawning uncontrollably in a glass cage littered with pencil shavings. We were on a relentless treadmill of human evolution; this was the ugly and dehumanizing overture to some terrible opera to come.

After that day, puberty and its stirring perils were my sole concern. Spidery black hairs began to cover my milk-white legs. I noticed a milky substance in my ejaculate that hadn't been there before. Life was a nightmare and I couldn't make the nightmare stop. My depression worsened. My scoliosis matured significantly. I walked with my hunched shoulders and with my coat on, always. I wore it like a carapace indoors and out, in warm and cold weather—it was my protective armor. I kept my gaze fixed downward, avoided eye contact. I was becoming a man, and manhood was destroying me.

My bar mitzvah was that spring, and the ceremony was at the Ahi Ezer synagogue on Avenue S. I remember sitting in the pews as a quorum of Jewish men wearing microscopic expressions hovered over me: my father, some uncle I barely knew. I looked like a boiled egg: my skin was impossibly white. My eyes beamed terror and discomfort. One of the men rolled up my shirt sleeve to reveal a naked white forearm with its sheath of incongruous tiny hairs. Then he and the others took turns wrapping my arm in a black leather strap connected to a black cube positioned near my shoulder. The cube, I assumed, contained one of those wrapped scrolls with biblical passages inscribed in miniature, and of course I would have to kiss it—I had to kiss everything—but the kissing was bereft of any

affection. There was something uncaring in the ritual that reminded me of the strange hushed violence of my doctor's exam, the frigid chill of a stethoscope pressed against warm skin. One by one, the men took a turn of the strap, wrapping the leather tighter and tighter as the pain scaled my left arm. I looked to my father for some sign of warmth or recognition but he barely noticed me, he was a faceless stranger; he'd fused with the cabal of men, any hint of individuation would break their grim unison.

When they were done the rabbi said something and the men chanted in response. He said something else and then a chorus of women (who'd been totally silent up to then, I'd forgotten they were there) thundered with surprising violence, forcing my eyes upward to the mezzanine. I looked for my mother but she was hidden in the tumble of raked hats. I imagined her up there, somber in her motherliness, watching mutely as I was taken from one column to another, from the world of epicene boys to the world of men, a border invisibly separating us forever.

I was led to a dais where I stood—legs shaking, my poor arm battered and violated—and dutifully wailed my haftarah portion, in my thin tiny voice. After the ceremony, as people congratulated my parents and my relatives all caught up and dispensed barbed endearments, I sneaked away to the basement where the DJ was setting up. The party room had a darkly lustrous feel, it was strangely pagan. There were fluted pilasters, a disco ball. Dim long walls were lined with panels of smoked mirror, each snaked with veins of pale gold. I stood before one in the Italian suit my father bought from some discount outlet in Long Island. My reflection intersected with beams from overhead light—monobrow and pimples on full display, the gap in my teeth a chasm that split my face in half. I hated the boy-man chimera I'd become. I felt humiliated by the

ceremony, which wasn't really for me. It wasn't even for my parents. It was for some judiciary force that claimed our lives, a force I couldn't see, only feel. I didn't think it was God, it was something else. It was dark and ruthless and unforgiving.

When the party was in full swing, I hid at a table anchoring bouquets of red and silver Mylar balloons that matched the color scheme of the invitations. Richie and Stevie were smoking cigars with Morris Shalom. Debbie was vaunting about her calligraphy for the invitations. Arlene smoked Camel Lights and fended off compliments about her red dress she'd bought for ten dollars at Joyce Leslie because she had no money. She was very vocal about hating her dress. She said she felt low class. She didn't even want to come to the party.

My sister was in a bad way. She was forced to move back home that winter because it turned out Charlie, in addition to being an alcoholic, was addicted to heroin, and on one occasion while inebriated (either drunk or on drugs or some combination) had an argument with Arlene, and in the heat of it nearly dropped their newborn daughter, Lauren, and for my sister this was the last straw. The penultimate straw came a few months prior, when she walked in on Charlie having sex with a prostitute. She wanted a divorce then, but a bunch of rabbis and men from both sides of the family persuaded her to try mediation so she didn't turn out a fallen woman like my mother and Aunt Nina. Arlene decided, in the end, that she couldn't live with a druggie, she couldn't subject her daughter to that. I was thrilled she was back; it relieved the claustrophobia of living with my mother, but my sister was lost. She had no money, and no plan for her life. "You look stunning in that dress," said Debbie, who was bouncing her daughter to the beat of "Vamos a la Playa." "This dress is a piece of shit," said Arlene.

The DJ from 92 WKTU was in full swing now, the dance floor was getting crowded. "Oooh, it's my song!" cried Debbie

when he played "Somebody's Watching Me." "Stevie, dance with me!"

Stevie wore a brown suit and he'd grown a thin mustache. His shirt was unbuttoned to the solar plexus, his neck cross-hatched with gold chains. "Dance with yourself," he said, puffing on his cigar.

She turned to me. "Dave, you wanna dance?"

I'd vowed to never dance publicly, though I knew how by watching Arlene practice disco at home. The idea of people watching and judging me, even if the judgment was positive and encouraging, filled me with dread.

Debbie's body began to jerk and spasm and convulse with dance.

"Let's *boogie*, Dave!"

She handed the baby to Stevie.

"*Uch*, no. I don't want to," I said, but it didn't matter what I wanted or didn't want, Debbie dragged me onto the dance floor. Everyone started clapping. The DJ made some comment over the speakers, my mother was saying *Hillu, hillu*. They could see my pimples. They could see the single undisrupted horizon of my eyebrows, like someone drew a thick line across my forehead in black marker.

There was no way to shield myself from the draconian judgments. I searched for some nuanced way of complying without making a spectacle of myself. I swayed neutrally. I made tiny unnatural movements with my arms and legs.

Debbie was shockingly uninhibited. She was windmilling her arms, whipping her head around at unpredictable angles to "Hey Mickey" and shaking her fists like they were pom-poms. Even post-pregnancy she had enormous reserves of energy. She was dancing slightly faster than the beat of the song, as if the song would catch up to her. Quantities of jewelry swung from her neck and banged in loud zirconium claps.

Debbie's bravery made me slightly braver. I started to loosen up. The dance floor was getting fuller. Arlene was doing salsa moves in her ten-dollar Joyce Leslie dress—she was dancing with Howie, who was spinning and swinging his arms and wiping pips of sweat from his forehead. My mother and my father were dancing together. Ari Blume was dancing with my cousin Grace, who wore a lavender off-the-sleeve taffeta dress. The boys from my yeshiva were practicing their spins and pop 'n' locks and various arthropodal break-dancing poses. Nechama Polin was dancing with Danielle Sibener, who wore a long prairie skirt, and was jumping in rigid vertical bounces and repositioning her clunky glasses every few seconds. I didn't think people would show up, but everyone came. It didn't matter that no one was really close, or got along with one another, or liked their outfits, or had enough money. There was something democratizing about the dance floor. Somehow, we became the purest truest versions of ourselves. When "Billie Jean" came on, the feeling changed in the room. It was a song everyone wanted to dance to. Though I couldn't understand the narrative of "Billie Jean," I felt the force of its urgency—there was something in the music that gripped the entire room like a fist. The song felt serious in a way that mocked the liturgy of the ceremony we'd just come from. The pressures encircling me lifted. I lost the feeling of being watched and became one with the music. I felt light as air; my skin melted away like dead weight. The dance floor was crowded with strange silhouettes, soaked bodies. Partners slid from one to another, whorls of refracted light showered the room like spinning bits of glitter. My hair was standing on end. My heart beat so hard I thought my chest would explode. I was out of shape, I thought I might collapse but I pushed my body to its limits. I became one with Michael Jackson. I became one with the gold chains, the slithering bodies and damp swaths of Armani. We were a single corpus, a

single undulant body. We were bacchants, worshipping at the altar of disco. As I got more and more lost in the music I felt myself reaching for something—not physically, but inside myself. I was reaching for something I couldn't name. A deep yearning broke open inside me like a dam.

The triumph of the bar mitzvah party lingered for weeks, as small triumphs do when one has been plunged in despair. Howie and I debriefed about the party constantly. He had brand-new material for his impersonations. He parodied Arlene being self-lacerating about her Joyce Leslie dress. He did impressions of Debbie and my mother's friend Sonia. The powers that be at the yeshiva forbade him to wear the pinwheel shirt—which, being collarless, violated school rules—so we were again on equal footing.

A few weeks before the end of the school year, we descended a staircase leading to the recess yard just as two popular Syrian girls were on their way up. As they were about to pass, the girls screamed in sudden revulsion, and, in perfect tandem, flung themselves against the wall: two bugs smashed by a flying windshield. I moved out of their way, trying to proceed along the lines of some etiquette I devised on the spot—but when I saw their revulsion yield to hysterical laughter it became apparent: this was a plan to inflict humiliation on us, to brand us with the inferiority of our caste. The girls locked eyes, they were delighted with themselves—they were laughing so hard they couldn't speak. Then, one of them unpeeled herself from the wall. I could see her face now. She had strawberry-blond hair and freckles. She wore an expensive-looking suede jacket. The girl was looking right at me—laughing in my face, glaring at me with a brazenness I'd never seen in another person. Her gaze was like a fishhook. For a moment, I thought she was laughing *with* me, to show it was all in good fun—but her crisp

smile and erect posture showed me that the laughter was *not* good-natured, that it was part of her punishment. The punishment wasn't arbitrary, it was directed specifically *at me*. My presence in the stairwell was an offense, an infraction that demanded reprisal.

People were asking what was so funny and giggling in small clusters. Eventually the congestion in the stairwell dissolved. The girl was gone. "Come on," said Howie. We sat at our familiar stoop in the recess yard. I felt too humiliated to address what happened in the stairwell, so we talked about other things. For a few minutes I couldn't feel anything. The hurt was invisible, like a paper cut, until it materialized very suddenly and I was *miserable*. Howie tried consoling me. I wanted to take in his consolations, but was too steeped in my own pain. It was all so inexplicable—I didn't even *know* this girl. I'd never spoken to her. I didn't know why she should hate me so intensely.

Howie told me her name was Audrey Levy and she was in his English homeroom. He told me he'd secretly given Audrey Levy the nickname Rust because of her freckle-mottled complexion— a vast network of them spanned her face and neck. Her hair was rust-colored too. He tried making jokes about Rust to get me to lighten up. Howie was able to let it go, but he wasn't victimized like I'd been. He wasn't on the receiving end of her violence, that terrifying look in her eyes that made me feel like I was being stabbed in the face with an ice pick. I couldn't concentrate during my classes that day, and later that night I couldn't sleep. Audrey Levy's face was burned onto my retina. I was tormented by the scene in the stairwell.

The following day I thought my pain and anger might dissipate, but the feelings began instead to grow and ferment. I tried focusing in class but couldn't stop replaying the event in my mind. I couldn't stop seeing that look in her eyes—the look

that proved what I'd always suspected: that I was grotesque and subhuman and deserved to die. My heart pounded with despair as I shuffled from class to class, winter coat wrapped around me like a wet blanket. I sat on the sidelines during gym, chin bowed to chest, eyes glued to the floor. I'd consented to being an object of ridicule. I allowed some stranger to question my basic right to exist, my right to take up space—to use *stairwells*! As I sat sweating on the floor of the gym in my winter coat, a streak of insolence flared up in me. I suddenly had a focal point for my lifelong despair, someone to blame. And though my nature wasn't vengeful, I had to get revenge: it was the only way to retain any self-worth. I had to cultivate new qualities, qualities advantageous to my survival—and people could do this. People could adapt, they could become who they needed to be to survive life: like my siblings, who spoke in Southern accents and said things like "y'all" until the SYs ridiculed them for it, and made a concerted effort to become Syrianized. They began speaking with thick Brooklyn accents and learned SY slang. If they could transform themselves, so could I. I wasn't strong, but I could force strength. I could crowbar my strength into existence.

In my newly bedeviled state, using narratives watered down from soap opera plots and *Sweeney Todd* and Howie's mother, I hatched a plan against Rust and embarked on my first truly evil scheme. That afternoon after school, I sneaked into my mother's closet and located her cofferdam of Stayfree Maxi Pads. I pulled one out, unwrapped it from its plastic sheathing, and on it—with the two-toned marker Debbie used to address my bar mitzvah invitations—wrote in big block letters:

PROPERTY OF AUDREY LEVY

CLASS 306

My plan was to leave the Maxi Pad out in the hallway during lunch. Someone would find it and make a spectacle of returning it to Rust. She would be humiliated, reminded of the indignity of menstrual blood—an indignity that I, a boy, would be spared.

There was something undeniably powerful in unkindness, but I couldn't exactly muster the feelings of true meanness. It wasn't in my character. I could prop the feelings up with proximal behaviors—the stealing of the Maxi Pad, the diabolical choosing of the offending Magic Marker—but I was just going through the motions of vengeance. As the night wore on I began to doubt myself. I called Howie during a commercial break from *Knots Landing* and told him my plan. "Holy *crap*," he said. "That's such a good idea!" His confidence restored my sense of mission. We plotted out details, just as he and his mother plotted to destroy Hildy Tasimowitz.

The following afternoon during lunch, Howie and I sneaked up to the fourth floor. We found the perfect spot in the hall—not too salient, but just enough—positioned the implement of vengeance, then quickly sought refuge in a darkened classroom, where we hid behind a row of cubbies. For a long time it was silent; then the hallway began to fill. I could hear people chatting, grabbing books from their lockers. They were so innocent of what was about to happen: their ignorance was my ambrosia.

Eventually, I heard a voice: "Audrey, did you lose something?" There was a slight pause followed by a small chorus of laughter. The chorus built in volume, more and more people joining in, until the entire floor was *exploding* with laughter. I was shaking, terrified. There was a jagged clatter—more students raced into the hallway to see what the fuss was about. Howie and I emerged from our hiding spot and followed them.

The hall was crowded—I could only vaguely make out the scene. As I strained to get a view, I heard a sudden crashing sound like a thunderclap, and another. The laughter died down, then came another crash. I tried to make out the source of the terrible sound. Then I saw it was Audrey herself. She was ramming her head repeatedly against the metal door of the locker and making an ugly guttural sound—a raw terrible cry that came from some odd foreign place inside of her. A couple of Audrey's friends went to console her. A teacher came and intervened. Students reluctantly began to scatter. Audrey was sobbing uncontrollably, her fists mashed against her soaked face. I felt slightly sickened by what I'd done. It was true I hated Audrey and wanted her to suffer, but I saw in the rawness of her anguish a mirror of my own. I knew it was monstrous to make another person feel that.

Then I remembered the scene in the hallway. Was *Audrey* drowning in guilt and self-reproach over *that*? Did *she* feel sickened with opprobrium and guilt? I was sure it was just the opposite—that she thought fondly of my humiliation, that the memory of degrading me in front of all those people made her heart jump a little. This was why I *had* to get revenge—it was a matter of self-respect! I had to congratulate myself for the ingeniousness of my plan. I tried forcing myself to enjoy my victory.

My Damoclean happiness was cut short by a witch hunt set into surprisingly immediate motion by Rabbi Bressler, who made a special announcement on the school loudspeaker the next day demanding the offending party give himself up *immediately* or risk suspension. During recess, Howie told me two people from his class—Alisa Forgash and Ness Finkle—had been called to Bressler's office for interrogation; I felt a pang of guilt. I didn't want someone innocent to be punished. At the same time I didn't have the courage to turn myself in.

And anyway, life wasn't fair—innocent people were punished all the time, that was how the world worked.

Just as I'd come to some kind of temporary resolve, I saw Poopa Menashe, the girl who found the Maxi Pad in the first place, bounding toward me from across the recess yard in giant denunciatory steps. She pointed her finger at me, arm extended like a war musket. "YOAH GUILTΛΛY!" she shouted in piti-less evangelical furor, "WE KNOW IT WAS *YAOUU!*" My slipup was the two-toned marker—which she linked easily to my bar mitzvah invitations. At the very mention of the marker, I began shaking like a leaf. I couldn't bear to refute even the weakest shred of evidence. Howie stood and coolly began to remonstrate on my behalf. "What are you *tawwwking* about?" he said in a hard-boiled voice. He shook his head and laughed robustly but injected the laughter with a malign undercurrent like Angela Channing on *Falcon Crest*. "You're acting like a *fool*," he continued. "Oh *pleasssssse!*" spat back Poopa with bilious contempt. "You know he's guilty, *Howway*, just *admit it*." The two of them went on like this as I made intermittent protests from my cowed little sideline, things like *Shut up!* and *Mind your own business!* Once she was gone, Howie devoted the remainder of recess to convincing me nothing bad would happen to me, but even with the balm of his assurances I felt uneasy.

The following day, in the middle of science class, I was called to Joe Dreyfuss's office (an order from a third-grade emissary punctuated with the dreaded *and bring your books* postscript that usually meant you were in real trouble). Joe Dreyfuss was a new hire, the head of general studies. He was clean-shaven and wore wire-rimmed spectacles, sweater vests, and Florsheim wing tips. I skulked into the office wearing my winter coat— even though it was now June—and sat uncomfortably hunched across from him. "Do you know why you're here?"

"No," I lied.

"I spoke to your friend, Howie," he began—and as soon as he uttered the words, I knew I was doomed. The pretense of my evil collapsed like the façade of a burning building. Every emotion I'd capped to convince myself of the rightness of what I'd done came flooding out: shame, guilt. Surely, I would be made a pariah when it all came out. I could be beaten, humiliated. I could be made the subject of long parabolic speeches in synagogues describing the scum of humanity, and how to wash me and my ilk from the face of the earth. Tears streamed down my face as Joe Dreyfuss spoke softly to me. He wasn't like Rabbi Bressler; he was sensitive. And it was clear from the gentleness in his eyes, the tone of his voice, that he understood how the flowering, protosexual feelings in young boys (because this was how he'd mistakenly interpreted the situation) were complicated, and, like the delicate involutions in origami, one false crease or fold could forever mar the shape of the thing. So he proceeded with a combination of avuncular understanding and neutrality, careful to sidestep areas about which he had neither clinical knowledge nor experience. He leaned forward and spoke in a gentle, sobering tone. He explained in his soft, eerily dulcet male voice that he would need to call my parents—to which I reflexively wailed "NO" in between sobs, as now that I was no longer evil I'd morphed into an insane person.

I got down on my hands and knees. I began, literally, to *beg*, saying things like *"Please! I beg you!"* as Joe Dreyfuss stared, aghast—for what could he possibly say? A thirteen-year-old boy was sobbing and pleading at his feet. I'd gone somewhat crazy and knew it. I tipped over the edge of civilized behavior. I'd never entreated anyone like this, never outright begged anyone for anything, but I couldn't let my parents discover that I knew about sex—tampons and Maxi Pads—and, more critically, that I had unlocked the primal connection between sex

and humiliation. My family would see me as a type of pornographer, a pervert, the lowest of human scum. I had to make Joe Dreyfuss see the magnitude of this situation, the urgency of my plight, but after several failed remonstrations it was clear my pleas fell on deaf ears. "I absolutely have to call your parents," he said. "I'm sorry about that."

When he picked up the phone—on instinct, and as a sort of coup de grâce—I reached for the phone cord and, in a single jerk, yanked it out of the socket. Joe Dreyfuss sighed deeply: "David, what are you doing?" Since I'd taken it that far, I kept going, and jerked the cord so the body of the phone flew toward me. Dr. Dreyfuss maintained his impressive patience.

"Give me the phone," he said.

"*No!* I *won't*!" I sat cross-legged on the floor of his office, cradling the receiver to my chest like it was a newborn baby. I was hiccupping and gasping and choking on tears. I was exhausted, worn out by days of plotting and humiliation and worry. Maybe he would feel sorry for me, I silently opined, as I shook and heaved. Maybe my little juddering lachrymal form would evince enough pity for him to release me with a tiny slap on the wrist.

Joe Dreyfuss stood—he was gigantic, he seemed to be seven feet tall—and then slowly, cautiously, like he was about to defuse a bomb, walked around his desk and kneeled by me. "I know this is not a good situation for you," he said, "but this is temporary. You won't feel this way forever. Right now, though, you must deal with the consequences of your actions."

Something about the warmth of his delivery calmed me. I conceded the phone and its cradle. I watched him dial, heard the familiar tones of my phone number. I heard my mother pick up, cringed as he relayed the sordid details. He used awful euphemisms like "feminine napkin." I heard my mother shrilly voice her disgust and disapproval on the other end, and when

he hung up, he relayed her message that I come *right home* after school (for I was meant to run some errands). But instead of going right home I skulked to the school basement, desolate by then. It was the end of the day, I was sure word had gotten out, and I didn't want anyone to see me. I couldn't begin to process Howie's betrayal—and was eager to deny it, for my world was crumbling. I found an empty kindergarten classroom and waited there among the colored building blocks, dollhouses with their shapely cornices and vaults. On the radiator were a row of dolls lying supine, their eyes lusterless and dead. Through tiny rectangular windows near the ceiling I was able to track the bottoms of people's legs, the departures of school buses. I felt like a sewer rat, hiding in a basement, biting my fingernails.

Once the traffic dissolved and I felt it was safe I exited through a side door and ran back home as fast as my legs could take me. I quietly crept into the house using the latchkey I kept on the soiled shoelace around my neck, hoping my mother would be gone or forget, or that her frenzy would have abated in the intervening hours. I tiptoed into the den. When I entered, there on the sofa sat my mother, smoking a cigarette that had burnt to a single pale gray ash. "You think you can hide *from me*?" Her tone was absolutely gelid.

"I'm sorry."

"You *shamed* me. Don't tell me you're sorry—you shamed your entire *family*!"

"I know."

"How am I supposed to show my face? Why would you *do this*? I'm ashamed to have you as a son." I stood before my mother in mute hopelessness as she shouted and strafed and dipped me repeatedly in her vat of endless shame. The irony was I had wanted to see myself in this new way, as a villain. Now my mother saw me as precisely that—but it wasn't even *me*, and she had no idea, and I had no way of telling her. I never

felt more alone than I did that afternoon, listening to her lecture me about morals, branding me with her various permutations of shame. I was worn out from the awfulness of the day, and I longed for softness and quiet and calm. In all my emotional exhaustion I felt tears pool in my lower lids, but my sadness, as usual, enraged her. "I don't care if you cry!" she said. "Your tears mean nothing to me."* I remember thinking she looked beautiful as she screamed at me, but her beauty was like a porcelain mask, smooth and distant.

My mother warned that my father was going to "have a talk" with me—leaving me suspended in terror for days. I'd never been punished by my father. I'd never been subjected to any discipline whatsoever—the happy upside of neglect. It terrified me to think what punishment could be like. Whatever it was, I knew I was too sensitive to endure it. My brothers spoke about getting the belt when they were kids—I knew I couldn't endure physical abuse. But when I saw him, my father gave me his winking approval. He thought it was all a kind of charming adolescent flirting. There was a short preamble, some hackneyed advice about girls and humanity, and that was it. It didn't occur to him to ask why I'd done what I did, just as it hadn't occurred to my mother. Like Joe Dreyfuss, and my siblings (and eventually my mother) he assumed I had a crush on Audrey Levy, and I didn't bother to correct him. I never explained how she humiliated me in the stairwell. I didn't want to have to tell my father about the shame I felt. Somehow having to articulate the shame would only redouble it—and anyway my motives weren't relevant. It didn't matter that Audrey Levy had calculatedly humiliated me that day in the stairwell. It didn't

* A line that became one of Howie's signature phrases when he fell into doing impersonations of my mother—he loved the archness of her cruelty.

matter that the nastiness of my actions was at war with my own feelings. People would fill in the motives with a story that suited their imaginings. My inner life was not relevant. All that was important was what was visible. And all that was visible to the adults conducting this human autopsy were my actions. I was buried inside these surface behaviors—crushed, as if by avalanche.

Howie called to explain that Joe Dreyfuss forced it out of him, that his mother impelled him to give me up; that they'd have found me out regardless, and why should he be punished as well? I listened, half in sympathy with him. I didn't really buy what he was saying but pretended to, if only to make my life easier. Deep down, though, I resented him. I couldn't put my finger on why, but I blamed him for everything.

Once my suspension ended, I had to wait in the lobby for Audrey Levy at the end of the school day so I could apologize— it was part of my punishment. I saw her walking toward me, her small body sandbagged by a heavy knapsack. Her hair was pulled back in a frayed ponytail, her freckled face frozen in a smirk. "I'm sorry for what I did," I said flatly. It was a fake rapprochement but I was too broken and defeated to lard my words with contempt, to show her I wasn't beaten, because it wasn't true. Audrey stood there smirking with her sallow, sickly complexion. She said nothing—she didn't have to say anything. I was no threat to her. I wasn't part of The Community. I was nothing. Justice had been served. The cancer had been excised and destroyed. The stain removed.

IT'S A SIN

M Y FATHER WAS one of those men who, once their fathers died, became suddenly very religious. Later in life, I came to see this sort of libidinal transfer wasn't uncommon, but at the time, somewhere around the middle of eighth grade, I didn't know what to make of it. He started hanging out with rabbis, and was increasingly modeling himself on them. He started wearing a yarmulke all the time, usually under a beige fedora hat garnished at the brim with an unfortunate, rigidly flexed, and speckled feather. He kept saying things about *hashem*—that was his new word.* If he ate a piece of bread he thanked *hashem*. When he saw a tree on the sidewalk he thanked *hashem* for its arboreal splendor. His piety struck me as performative and fake, and I didn't know if I even believed in *hashem*. My skepticism, which never really left me since those first stirrings in the second grade, troubled me, because I found no support for it at school or anywhere else.

I once confessed my ambivalence to Howie, who watched *Dallas* on Shabbos and ate *traif*—he even pressured me to eat shrimp cocktail at some business luncheon his mother took us to in the World Trade Center—but he'd already cultivated an

* Hebrew word for God.

amazing ability to move between contradictory points of view with untraceable swiftness. When I made my admission, he looked at me as though I'd shat on his most sacrosanct beliefs. "What exactly are you *telling* me?" he said. "I can't believe what you're saying!" After that, I went into a kind of latency about the matter. I tried to declare a moratorium on skepticism, to force belief because it was so much easier. And the truth was I *wanted* to believe. I wanted a moral foundation for my life. I wanted to make an investment in something bigger than myself. I wanted to be *good*—whatever that meant to other people, since based on the horrified responses I yielded I could tell I had no innate understanding of goodness. The moral code I tried to build for myself was impotent and insufficient, and only brought me trouble.

I started going to shul every Friday with my father. We went to his favored synagogue on Avenue P. It felt manly: a boy and his father, a chorus of men beseeching God on a Friday night. I tried to enforce the piety demanded of me, tried to not only *speak* the words of prayer and ape all the ritual behaviors but to *feel* the supposedly concomitant feelings that went with them. Submitting to religion gave me a feeling of safety. I felt sheltered by imposed boundaries; I felt potentially holy. Maybe there really *was* some rapture accorded to people who said and did these things. Maybe there was some gnomic element that, were I to open myself to the possibility—*really* open myself— I'd sense, and then my life would change, and I'd be transformed by my devotional acts. I kissed the little black cube with the leather strap. I squeezed my eyes shut and rocked on the balls of my feet. I sang incantatory songs in the melismatic Arabic stylings I learned watching old men as they wailed— practically *sobbed*—with devotion. They loved *hashem* so much they seemed like they might combust into flames. Religion suddenly seemed like a gateway to a new whole life, a life

of moral rectitude. I wanted to change. I wanted to grow up! I made a radical decision to embrace the status quo in every conceivable formulation: I'd get married, buy a house in Deal. I'd get a job in an electronics store and work my way up to being a Ray-Ban-wearing business magnate with a Jaguar and Tenax-slicked hair. Somehow these all fell, along with my new religious devotion, under the loose rubric of "morality." I had to become sexy and religious, and I had to narrow these attributes into a single delta of concentrated ambition.

I spent the summer plotting my transformation. My father, newly obliged by my passage into manhood, set aside a budget for my expenditures—he had his own linens business now and was making pretty good money, so he could afford to indulge me. My bathroom cabinet was arrayed with all manner of ointments and unguents: creams to dispel acne, gels and mousses for my now Bumble and Bumble–coiffed hair. Dossiers were kept about what kind of outfits I needed: how many shirts and sweaters, and what brands, and what shoes. I had it all graphed in elaborate flowcharts on pieces of unreinforced loose-leaf paper I kept stacked pell-mell in my top desk drawer. I would return to it night after night, crossing out "shoes" and replacing it with "pants," crossing out "pants" and replacing that with "shirt." It was obsessive, but I'd *become* obsessive. I was determined to give an illusion of social competence. My insistence on becoming Syrianized was all I ever talked about—and I cajoled Howie into wanting the same thing. There were other Ashkenazi Jews taken in by the Syrian Community: he could become one of them!

At my urging, he went on a diet where he only ate salad and FrozFruit. He started doing the Jane Fonda tape and quickly dropped his excess avoirdupois. His face lengthened and thinned out, but this, to my mind, revealed new deficiencies—particularly with his chin, which, I was quick to point out, was

now too egg-shaped. I suggested (because if I couldn't tell him these things who could?) he get it surgically shaved down. In an act of tender largesse I bought him a value-pack of Seba-Nil cleansing pads so he could rid himself of the acne that, like his ovoid chin and too-protuberant forehead ridge, was ruining his otherwise good looks and chances at popularity. I had to be brutally honest, as I wanted for him the same gleaming perfection I sought for myself.

Together, we took the bus to Lester's twice a week. We were like starving animals, greedily devouring new arrivals from the fall lines, rushing to the dressing room with our heavy armloads of WilliWear and Ton Sur Ton. Shopping made us anxious, it was work. The manager, Perry, would breezily reassure us that new shipments would be coming soon while the saleswoman— the rather butch, corkscrew-permed Hope—popped her gum, sputtering and confused by our endless obsessive shopping. There were limited selections at Lester's, and we both wanted the same outfits, so we'd get into scabrous fights about who could buy what. Ultimately neither of us would forgo a flattering outfit to give psychic individuation to the other so we ended up with nearly identical wardrobes, but I didn't care. By the time classes began I had all my outfits coordinated by days of the week. I felt almost a kind of military preparation.

On the very first day of school, after lunch, a Syrian girl struck up a conversation with me near the candy machines. "So, you're an Adjmi," she said. "Very *interesting*."

She gazed contemplatively at her bangles, playing with the circumference of one until it lined up with the bones in her wrist.

"What's so interesting about it?"

"It's just interesting. That's a good family, Adjmi."

"What's so good about it?"

"The Adjmis are a good family, everyone knows that." She unwrapped a pack of chocolate Velamints and popped one in

her mouth. "I like Adjmis," she said, a contextless smirk plastered on her face. "Very shahrp." She loudly clicked the mint around in her mouth.

The girl was very appealing. She had that marble-mouthed drone so prized among Syrians—nasal and cloying, but to me it was heaven. She was squat, somewhat chinless, but striking. She wore a white leather cowboy jacket with matching white cowboy boots and an acid denim skirt that came down to her calves. Her frizzed hair was blown out into the requisite pin-straight helmet, fringed with long bangs that covered her wide (probably acne-scarred) forehead, and her lipstick had a bleachy, pearlescent whiteness to it—it seemed like a kind of sunscreen. We sat at one of the carpeted banquettes in the lounge and chatted some more. I learned her name was Yvette Sutton, and that she lived on East Third Street—a stone's throw from the Avenue P synagogue, and just around the corner from a kosher deli my brothers liked. "Sa who ya releeted to?" she continued. "You know *Donna* Adjmi?"

"She's my second cousin."

"I love hah! Who else? I want *info*!"

The lines in her forehead compressed as she mentally mapped out my family lineage. The SY community was insular, but there was something comforting about everyone knowing everyone else—situating a person inside a matrix of blood relations was like finding a word in a search-a-word puzzle. I rattled off my list of blood relatives to her ecstatic cries of recognition. Then, out of nowhere, she took a sharp sudden inhale, like the building had erupted in conflagration: "Ya sweata is *stunning*."

The sweater was an oversize fluorescent orange Ton Sur Ton featuring a pixilated, faceless worker in overalls climbing a ladder to nowhere. I got the last one on a spur-of-the-moment shopping trip. "I bought it at Lester's," I said, trying not to communicate my overwhelming sartorial pride.

"I *love* Lester's," cried Yvette.

I could feel her admiration for me building in quantum leaps and bounds. She became more voluble, telling me about her summer in Deal, and some ride she and her cousin went on at Great Adventure that broke and left her *gushing blood*, and how her cousin got blue food coloring all over the cat. I admired her sudden prefaceless glides between topics, how her every remark was topped off with the omnipresent smirk—which I took as an index of flirtation. Was my makeover working? Was this *love*? Would Yvette share with me the marble-floored mansion in Deal I'd one day own? Would she have *cusa b'jibin* and *kibbeh* waiting when I got home from a long day at the electronics store?

As she continued her rambling monologue I studied her strangled cadences, I practiced making my own speech more nasal so I could sound like her. I tried pronouncing words like my jaw had been dislocated. I blew out my vowels so that I sounded practically inhuman—but the inhumanity felt grandiose, almost galactic. When the bell rang we left for our separate classes. I felt I'd matured in some unspecific yet profound way. It felt like a giant leap—almost too giant, like I'd taken a huge gulp of oxygen.

After school, Howie and I met up at a kosher pizza place under the elevated Q train. "So," he said, picking his teeth with an imaginary toothpick in spontaneous imitation of my mother, "are you gonna ask Yvette out on a date, *Daaave*?"

"What if she doesn't like me?"

"You said she did."

"I said *maybe* she liked me, I'm not positive of anything."

Howie told me he'd heard that Yvette, in seventh and part of eighth grade, dated and endured a violently emotional breakup with Harry Beyda—a popular, pageboy-hairstyled Syrian boy

who was also a terrible bully and one of my main tormentors in grade school. The stakes felt impossibly high now. Yvette wasn't some shoddy, garden-variety SY; she'd dated high-ranking boys In The Community, and my status could be raised by affiliation.

That week I arranged, vis-à-vis Yvette's cousin Shelly, in a series of twisty back-and-forth conversations (many of which involved Shelly, and Yvette's best friend Sharona Goldkrantz— who wore the same bleachy-looking lipstick as Yvette and had the same boots and white cowboy jacket) for Yvette to be in the lounge that Thursday after lunch so I could ask her out. I was terrified (despite the cousin's repeated insistence that Yvette liked me and wanted me to ask her out) that she would reject me—that, even though the Adjmis were a Good Family, ours was a bad branch, and she would find out, or she would hear about my hideous reputation from grade school, that I was a weirdo and a loser. My mind raced with catastrophic outcomes as I waited in the lounge for her on one of several carpeted rotundas. I was dizzy and sweating; my heart beat violently. I could feel my recently reapplied Clearasil liquefying over my face into a filmy medicinal sheen. Eventually Yvette appeared at the entrance of the lounge. She walked toward me with her mischievous cockeyed smile, the fringe of her cowboy jacket flapping with each step. When she arrived at my rotunda she stood looking down at me, the low-angle perspective accenting her chinless physiognomy. She seemed to want me to stand but I nervously made an impulsive unshakable decision to continue sitting, thinking it would make me seem assured.

"How a you?"

"Good," I replied. "What's new with you?"

"Mrs. Fleischman gave me a demerit," she said, still standing. The height discrepancy was starting to become awkward.

"How come?" I asked.

"Cause she's such a disgusting *wachshe*!"* she exclaimed quite suddenly. "I hate playing kickbawl."

"Me too. I hate gym," I said, bristling inwardly at my own ineptitude for small talk. With my last comment, I had inadvertently segued our less than thrilling conversation into a hideous, awful silence. Yvette shook her bangles around, then pulled her frayed hair back into a ponytail. "*So*," she said, pointedly, "you wanted to *ask* me something?"

With considerable effort, because I still believed I would be ridiculed, I stammered something in my clammy sweat about going to a movie. She scrawled her number on a slip of paper in purple ink. "Cawl me," she said, and, loose-leaf binder in tow, exited the lounge. My heart rocketed through my chest, so profound was my joy at having been found desirable by *anyone*, much less a girl who represented a totemic form of Syrian femininity.

For our first date we saw *Against All Odds* at the Kingsway, and afterward went for salads at the new Greek diner on East Seventh Street where, over the theme song from *Against All Odds* (which she played on repeat at the tiny jukebox in our booth to keep the pathos from the movie alive) Yvette rhapsodized about the movie—how romantic and tragic it was, how stunning Rachel Ward looked, how *mysterious* the character was, how she loved when people in movies had *mystery* like the Amish people in *Witness*. I was hardly listening to her; I was fixated instead on exaggerating my vowel sounds, thinking about my cologne and hair, wondering if I used enough styling mousse. My self-involvement—meant as a safeguard, a way to ensure my presentability—had the contrasting effect of making me more null and blank. I wanted her to believe in my worth,

* An overweight person.

the worth that attracted her the previous year to Harry Beyda, but since I had none, I had to produce an illusion of worth in inferences—like the "mystery" she inferred from the Rachel Ward character in *Against All Odds*. I was removing my personality feature by feature until I developed an eerie but genial emptiness, like a house stripped of furniture.

At the end of the night I walked her home and we stood together in awkward silence on her front step. I knew I was supposed to initiate a kiss or hug, but I had no impulse to do it—and anyway kissing seemed improvident and somehow blasphemous: we were subjected to a lot of mixed messages at the yeshiva. We were meant to prepare ourselves for marriage, but sex was also dirty, and girls couldn't wear skirts that showed any knee—and human contact, even platonic pats on the shoulder, made people squeamish. The line between religious etiquette and natural sexual curiosity felt unclear. Maybe kissing was like being "on drugs" or eating shellfish or an unkosher Snickers bar and it made you revolting and subhuman. I'd heard rumors that some girls were "sluts"—Corky Laniado for instance—but what did that really mean? Did they have actual sex with people? Florence Goldbaum supposedly gave Ralph Haddad a hand job at the UA Sheepshead Bay cinema during a screening of *Mad Max beyond Thunderdome*, but when the rumor came back to her Florence screamed, "It's not true, it's not *true*!" and she covered her eyes and burst in hysterical sobs right in the middle of the lounge. After that day she seemed tainted to me. I'd sneak glimpses of Florence in class as we studied Rashi or Zionism and imagine some sexually transmitted infection lurking subcutaneously. Sex seemed ugly, almost criminal; it was so humiliating for girls to be subjected to it. At the same time I was envious of Florence, because I myself wanted to give Ralph Haddad a hand job—or something in the family of hand jobs, I wasn't sure what. After hearing the story

about Florence I fantasized about Ralph during class and hated myself for my fantasies. I'd been trying to ignite libidinous feelings for girls since I was nine, when I found that ripped-up copy of *Club* magazine under Stevie's mattress, but the giant breasts couldn't get me going the way Lee Majors did with his tracksuit. Of course I would never do anything about my attraction to boys, it wasn't even a remote possibility—and even if I had the chance, which I never would, I could "get AIDS and die" (a refrain heard frequently in those days). If homosexuals died of AIDS I didn't want to know about it, just as I didn't want to hear the sodomy jokes Mrs. Wasserstein made in law class when discussing *Bower v. Hardwick*—though I laughed with the rest of the class when she told them. And if there were homoerotic undercurrents to my friendship with Howie, these were safely bedded in a dark continent of denial: a denial we fortified for each other because it was a form of survival. When we rented porn tapes from Avenue J Video we feigned boredom at all the huge cocks. And in seventh grade Howie blindly shoplifted a copy of a porn magazine from the twenty-four-hour store, which turned out to be a copy of all-gay *Honcho*. When Ari Blume caught him with the *Honcho* in his locker he gave Howie the nickname "Honcho Villa," but the nickname only lasted for a week and then people forgot about the *Honcho*— and so did I. It didn't mean anything, because homosexual people weren't real, or if they were, they existed as part of some other untoward pervert reality that would never intersect with my own. I was the boy in the plastic bubble. If anything pierced the bubble, pierced the germless world I inhabited, I might die. And though I didn't like life particularly, I still wanted to survive it. I wanted to be good, and moral.

I kept asking Yvette out on dates, even though I had no idea how to be on a date, or whether dates were even supposed to be any fun. I saw them as a sort of prestigious job I'd gotten by

accident. I started to see that the concept of a girlfriend was far more appealing than its concrete realization. Having a girlfriend felt moral, like prayer and religion, like swabbing the dirt off your face with cleansing pads, but that was it. After a few weeks the novelty of Yvette's boots and pin-straight hair wore off—even that nasal voice whose cadences I held so dear started to grate. Maybe I was too fixated on protocol to get to know her beyond her love of Phil Collins and Wham! and her loosely defined aspirations to become a fashion designer (or model, she hadn't yet decided) but our dates were *boring*. Yvette subconsciously picked up my weird gambit of making myself blank; after a while neither of us wanted to make a gaffe or stain anything with too much personality—what if we said something abnormal, or *strange*? When we slow danced at her birthday party to "Careless Whisper" (at the strenuous urging of Sharona Goldkrantz—I experienced a sudden temporary resurgence of shyness about dancing publicly) we bobbed rhythmlessly like two wobbling helium balloons whose strings were tangled. I looked up and saw Sharona staring at us from the sidelines with her oversized sweater and huge lips, slathered in bleachy makeup and sipping her Diet Sprite. Her eyes gleamed with invidious desire: when would she experience a love like *that*?

After the birthday party I stopped calling Yvette. When we saw each other in the lounge at our separate rotundas we just smiled and looked away. There was no acrimony, only the tacit agreement that we'd made a boring couple. And when the dust cleared from my relationship, I saw it proved advantageous in ways that were lasting. Popular students still avoided me but I managed to move up a rank, from the most ignominious of pariahs to a middling, neither-here-nor-there stratum.

Howie, on the other hand, had become somewhat popular fairly quickly. He began dating a junior and it was a succès de scandale. Brenda was Syrian, but not quite In The Community.

She lived in a part of Queens called Belle Harbor—an isthmus near the Belt Parkway populated mainly by Italians and J-Dubs. She wasn't beautiful, but she was wealthy (her father owned a successful jeans brand) and that gave her cachet. She was slightly overweight, with gigantic breasts and short brown hair and a skinny upturned nose—the product of an impeccably wrought (maybe two, it was bruited) nose job. She and Howie were soldered together almost instantly. They twinned each other, just like Howie and I used to twin each other, but in this case they actually looked sort of alike: her face, like his, was oval shaped and wide; the stark domed prominence of her forehead matched his own. And they were together constantly. They made out in public on the front lawn (something of a scandal), they did homework together every night. Their weekends were crammed with activities: disco parties at the Beth Torah, Trivial Pursuit games. Howie spent time with Brenda's family; they took him to dinner, gave him free jeans, tutored him in their likes and dislikes. He wanted to incorporate me into their relationship in some way but I was holding out for the infatuation to end, not simply because I felt myself being supplanted (though that was a very real and distressing factor) but because I *could not stand* Brenda. She was obnoxious and aloof, and given to florid expressions of disgust or disinterest: the very embodiment of a Jewish princess. But Howie seemed to like spoiled girls; he seemed to find their insolence refreshing. It was fun watching them vamp, listening to their histrionic complaints. He had that binocular ability to be at once distanced and intimate with people; their foibles could make him laugh without him feeling implicated. Maybe in some way Brenda echoed the captious theatrical intensity of his mother: her crabbiness, her endless grinding dissatisfaction.

His relationship with Brenda gave Howie a new platform. He started garnering the attention of SY boys like Nathan

Kraiem and Isaac Sitt. He was the rare J-Dub invited to Seymour Dayan's Saturday poker game—they even invited him to join a Syrian bowling league. He was quickly becoming a dazzling star in the homogeneous firmament of the Syrian Community. He was at sorties and Chinese auctions, fashion shows at the Sephardic Community Center, parties in Deal. He was invited to mansions, to Acapulco and Bermuda with people's families.

As a way of staking my claim on him, I trumpeted my dislike of Brenda more and more, but for the first time since I'd known him, Howie was indifferent to my claims. He seemed to have quietly unshackled himself from my claustral opinions, my criticisms about his ridged brow and egg-shaped chin, my judgments about what he should do and who he should be. He *loved Brenda*. And it became bracingly clear he wasn't going to honor the pact of hermetic, exclusive intimacy we established in the sixth grade (a pact he cajoled me to make, however wordless and implicit) because he was forging a *new* pact now, one with the larger social world. If I came along to his parties it was often to his annoyance. Despite my efforts to create a good impression, I remained visibly awkward in social situations. I was studied and wooden. I made constant faux pas. I required moment-to-moment approval for nearly everything I said and did, and I viewed every interaction as a gauge of my success or failure as a person. I was always stricken by some mysterious sorrow, some ugly inchoate new misery. And where I used to be able to count on Howie to comfort me in my states of fear and withdrawal, he was now turning against me in small, visible increments. He'd begun to interpret my bad moods as a form of hostile takeover, so he became hostile in turn, and the anger that used to be covered over with laughter was now full-blown rage. At first the rages shocked me. I'd seen him act out, but it was with other people—and even then, it was always under a

patina of humor. Now he was just *angry*. And the angrier he got, the sadder and more saturnine and more low energy I became, which only served to stoke more rages from him, more chilly invective. In response, I'd wriggle between needy bids for approbation and long gambits of punishing silence—I had no other tactics at my disposal—but these only made things worse.

One night, during some social outing I'd become sullen and dramatically introspective as a way of trying to filch some measure of attention or ardor I felt had been displaced from me, and in the car service on the way home he lashed out. "What is your *problem*?" he said. "Why do you just sit there? Why don't you speak or do anything? You're like a *brick*. Why do you have to be so fucking annoying?" The more I tried to resuscitate our friendship, the more disinterested Howie became. I was over at his house all the time but he'd ignore me. He'd talk on the phone to Brenda or one of his other friends, and I'd sit in the living room while his parents spoke German and watched *Night of 100 Stars*. I felt unloved; I felt it the way a wound throbs. I'd been trying to flash signals from that dark and lonely place inside myself, but the signals didn't transmit. The conditions for love were so opaque—I had to do something, but *what*?

My sister and mother's relationship hit a new apex of violence that year and I was desperate to avoid my *actual* home. Once she moved back in, Arlene became the de facto housekeeper. My mother gave her a whole bunch of household duties, and if Arlene didn't do something to my mother's satisfaction, my mother would lose her temper. Arlene would try harder to please her, but my mother would nitpick and nitpick (because she couldn't stand all the *mess*, why couldn't Arlene understand that?) and eventually my sister, who only knew one-upmanship since no one practiced or taught her diplomacy, would scream

hysterically at my mother, and doors would slam, and threats would be issued. Over the course of a year, the threats got more and more desperate, until one day during a melee over a vacuum hose, when Arlene had been pushed to her breaking point, she said, "Maybe I *should* just commit suicide!" to which my mother heatedly replied, "You want to kill yourself? Go ahead!" to which Arlene rejoined "I WILL!" at the top of her lungs. She grabbed her purse, marched across the living room, slammed the door to the house, and took off in her little broken-down silver car with the maroon interior. I was terrified for my sister's life. A few weeks earlier, in the heat of some other violent affray, Arlene even told my mother to SHUT *UP* (which *no one* ever said to my mother, it was the one forbidden utterance); she was crossing pernicious thresholds, which made me think that she in fact really *would* try to kill herself—she could buy a gun, she could slam her car into a tree or drive to Brighton Beach and drown herself in the ocean like James Mason in *A Star Is Born,* which I'd just seen on the Million Dollar Movie.

The vacuum-hose fight pushed Arlene to find a job. She started working part-time for Eddie Antar (who owned the Crazy Eddie chain of stores, he was our second cousin) and quickly saved enough money to move to her own apartment—a cockroach-infested one-bedroom near Avenue V, but at least it was hers.

When she and Lauren left, I became the sole and unwilling reservoir for all my mother's overflowing sorrows. Her need for cleanliness had gotten more obsessive in the intervening years, her cleaning more and more an act of aggression. She was driven toward a standard of cleanliness that eluded me: it verged on a hospital-grade, germless asepsis. A single plate in the sink constituted a mess, and messes infuriated her. She'd recite apothegms to me about cleanliness and godliness. If I neglected to shower, she'd bunch up her face in an expression

of revulsion: "You *stink*!" she'd bleat, loudly and unapologetically, so everyone could hear. "That shirt is disgusting!" she'd decry—usually in front of her friends, to show them she hadn't raised me to wear ugly shirts. She had no patience with my adolescence, which she took as an affront. Any salvos of independence on my part were deemed acts of treachery. If I were moody or sad she'd barrage me with harsh retaliatory insults. The margin for error was impossibly slim—she wasn't going to let me get away with *that bullshit!* She raided my room, read comprehensively through my diaries. She went through my wardrobe and threw out clothes she didn't like. I'd regularly hunt down a lost pair of pants or shoes only to find she disposed of them in the trash. I retrieved clothes and shoes from garbage cans to her withering putdowns. "I don't care!" she'd snap defiantly. "That outfit is *disgusting*." She grew fond of chiding me in the form of abstract threats, she had all sorts of little sayings at her disposal: "Don't mistake my kindness for weakness," "You better get your act together!" She meant to chasten me but I only got more detached. I hid in my room but she'd stalk me like a predator. There was a lock, but the door was never fixed from when my father broke it off the hinges, so she could bang it open without turning the knob—which she did, frequently. I'd look up and there she'd be, attacking me with the impetus of a crescendo. If I raised my voice she'd raise hers louder. If I slammed my door she'd shout on the other side that I was a piece of shit. My mother was unflaggable, but we were at a deadlock because I would never consent to her supremacy.

I began to spend more time with my father. My breakup with Yvette coincided with the end of my short stint as a religious person, so I stopped going to synagogue on Friday nights, but we shared secular entertainments, mainly dinners at the Genovese House. He resumed calling me silly nicknames like he did when I was a kid, and speaking in the weird baby voice,

but he was also drunk much of the time. In his liquored-up haze he'd make halitotic confessions about my mother and how mean she was to him and how shitty his life was overall. Or, worse, he'd outline his achievements and good qualities for me. I'd bristle at his catechisms, which would come without warning:

Who takes care of you?
You do, Dad.
And who loves you?
You.
And who do you love the most?
You.
Who takes you for the best dinner?
You take me for the best dinner.

His rodomontade was sad and cheerless, but he'd beam with gratitude at my every rote affirmation. My father's loneliness and despair mirrored everything I was running from in myself. It depressed me to be with him. He continued to harbor the desperate fantasy that my mother would get back together with him, and continued his decade-long pursuit of her—even with her thorniness, her moods, her pickiness about culture and luxury. He'd make unpredictable visits to the house. He'd show up drunk, caress her shoulder. He'd play with her hair while my mother fake-smiled and flinchingly endured it.

With my family mired in various states of rage and depression, and Howie increasingly consumed by Brenda, I lowered my standards and tried befriending *anyone I could*. While Howie was promoted to the high honors track at school, I'd been demoted to what was rather bluntly known as the "Dumb Class"—the sixth and lowest track—but my reversion from Genius to Dummy only slightly fazed me; I accepted the whiplash changes in labels and designations by then. And I began to see the Dumb Class as an advantage: there was less pressure to

do well, and I found acceptance among my fellow dummies. The stigma bonded us together. Everyone in the Dumb Class knew they were in it—other students would say things like "Aren't you in the Dumb Class?" right to your face. Teachers knew it and made little effort to hide their contempt for us. Something had been inflicted on us against our will, but once the initial humiliation wore off we started to embrace it. Since we were dumb, we'd start to act dumb on purpose—it felt subversive and punk. We'd say rude stupid things. We'd laugh at our teachers, mock them openly. We felt a new wayward freedom. We had nothing to lose and nothing could be taken from us. We'd erupt spontaneously in whorls of crazy kinesis in the middle of class. During algebra, Sophie Sasson drew freckles on her cheeks with a Magic Marker and did a shimmy on top of her desk. Inspired by a scene in a Bret Easton Ellis book, I jumped from a windowsill during a chemistry quiz as part of a feigned coke high. I got punished with suspension. I didn't care. Caring was beneath me, beneath all of us, because we were *dumb*. Our teachers would futilely try to leverage their power to grade, to condemn, but we could not be curbed. Our immanent evil and dumbness had become a force. Our power was our anomie. Once in a while, a student would become spontaneously reformed: "*Stop* it," they'd declaim in an outburst of spontaneous piety and compunction, "I'm trying to *learn*!" But these poor souls were pulling against the current of an unstoppable tide. Soon, like tiny seashells plucked from the shoreline, they were swept back into the current of prevailing dumbness.

The Dumb Class freed me to question orthodoxies. Since I was Dumb, I had the freedom to think anything. I became more confrontational with teachers. I learned how to rip down façades. I punctured all the flagrant contradictions in my Jewish Philosophy class until Rabbi Warhaftig kicked me out. When

Lonny Braverman produced a pickled fetus in a jar during biology to make us pro-life, I told him it was propaganda. When he replied that fetuses had souls, I debated the existence of the soul until I was suspended from class.

Lonny had a sort of cult following among certain students, but for someone who held himself up as an example of moral rectitude, I found him sort of repulsive. He wore a yarmulke that had "Hell's Bells" crocheted into it—a reference to the AC/DC song (which felt mildly satanic* though no one seemed to really care), and as the school disciplinarian he put himself in charge of conducting random skirt checks for girls; he was always touching their skirts, and staring at their legs. He was a creep—but he was also obsessed with rules.

He punished me constantly. I was suspended for eating non-kosher pizza, and for wearing the wrong color shirt on some Jewish holiday. I was suspended for gyrating too wildly in the school production of *Joseph and the Amazing Technicolor Dreamcoat* (I played a character modeled on Elvis). There were so many rules they became nearly impossible to not violate. The rules seemed designed to trap me, to make punishment inevitable. And Lonny was only happy to administer punishments from his high plinth of Jewishness and moral authority.

I don't remember the final straw, but somewhere in the thick of all these suspensions and arguments about fetuses I decided to become an atheist. And it wasn't just God I stopped believing in—I stopped believing in anything. If I didn't believe in God or religion, I couldn't believe in souls. If there was no soul, there was no self. If there was no self, what was I doing *on the planet*?

* A sample of the lyrics: "I'll give you black sensations up and down your spine / If you're into evil / you're a friend of mine . . ."

The difficulties a life of atheism presented felt insurmountable, so I waffled constantly. I was desperate for a foundation for my life but now a godless chasm of existence yawned before me and I hated it. And I didn't know a single other atheist: I had no community, no one to turn to. When I could, I ignored the subject of God, but I was confronted with religion and God on a daily basis. For a brief moment, I panicked and started going to the synagogue again, but my native skepticism resurfaced. My doubt kept plaguing me. I was in constant war with myself. A pressure was building uncomfortably inside me and it found no release—until one afternoon, in the middle of a car-service ride with Sophie Sasson, on our way to shop for records, I blurted my evil truth: "I don't think I believe in God," I said.

I don't know what made me say it; I hadn't planned to bring it up.

Sophie turned to look at me, squinting exaggeratedly as though threading an impossibly tiny needle—it was a look Syrian girls had when they meant to refute or diminish you. "What are you *tawking* about?"

"I don't know," I said, backtracking lightly. "Don't you ever wonder if this stuff is made up?"

Sophie's jaw hung open. I could see the fluorescent wad of gum, the saliva pooling around her tongue. "Whaddayou mean you don't believe in *God*? Like, what are you *saying* ta me?"

The plastered expression on her face mirrored back to me the radicalism of my confession. "Fagedit," I said, now chewing on a fingernail.

"So basically your life is a lie. Is that what you're saying? Your whole life is a *lie*?"

"Just *fagedit*, okay?"

"Well that's what you're saying to me!"

"Well I'm *SORRY!*" I shouted. "I don't believe in the *BIBLE!* I CAN'T *HELP* IT!"

My intimate revelations were marred by my shouting, and I hadn't meant to shout—I knew we didn't have a foundation of closeness that warranted violent emotion—but it was a reflex, a defensive measure I'd taken unthinkingly.

"Fine," she said, staring through the stitched headrest of the driver's seat.

We sat for a while, buried in a thick, awful silence. I imagined at any moment she might fling open the door and rush into traffic to escape the mephitic evil I spontaneously came to embody in the back of the car service. *Was this the end of our friendship?* We'd never had a deep conversation, certainly we'd never said anything controversial to each other, and now we were in uncharted waters. Would she tell everyone in the Dumb Class about me? Maybe they'd all turn against me, and my one remaining source of companionship would be lost.

I feared making things even worse, but I felt desperate, so after the lengthy silence I should have already accepted as her answer, I repeated my question: "*Do* you?"

"Do I what? Believe in *the Bible?*"

Sophie scanned my expression, then looked down at her watch momentarily. When she bowed her head I thought I heard a small "no" escape her lips. "What was that?" I said. Her expression relaxed for a moment. Then very suddenly she erupted in spontaneous laughter. Sophie reached out and squeezed my arm, and, still squeezing it, doubled over in the back seat of the car with laughter. "Religion is totally made up!" she said, now laughing so hard she was gasping. "I just *pretend!*" For a brief moment, I thought she was putting me on. When it became clear that she wasn't, I started laughing too. It was a relief to laugh, a relief to have found someone who saw what I saw, who

didn't think I was crazy or awful for seeing it. Someone who built a life from pretending, just as I'd done. With her admission, Sophie became very chatty; she talked a mile a minute—the kind of garrulousness that comes from sharing a long-buried secret. "How stupid do you hafta be to think Moses parting the sea is literal?"

"I know!" I said, more relieved and thrilled by the second.

"It's *literatcha*. How is it different from Greek mythology?"

"Exactly!"

"It's the same thing! It's like Zeus hurling his *thundahbolts*! It's the exact. Same. *Ing-thay!*"

At the record store, Sophie and I talked excitedly about hypocrisy and morality and religion and life. We made a pact to never tell anyone what we discussed in the car service—we had to resume our impersonation of devout Jews—but I'd spoken the words aloud to another human being, and it was as though a spell had been broken.

I knew the spell was broken because now I was furious *all the time*. My fury could not be abated. I was furious to be wasting my life, and studying a fake history, and learning a language I never intended to use. I was sick of Bibles and Rashi and mandated weekend attendance at Zionist parades down Fifth Avenue. I was sick of all those endlessly detailed stories about the tribulations of Jews in various stages of exile and persecution and crisis. I'd been made into a human calculus of disposable data; I was bloated and tired and disgusted with everything. The pressure of living a double life had become unbearable. People kept assuming my beliefs, and I felt myself falling again and again into the gutter of their assumptions. Now I needed to make a violent break with those assumptions.

At the start of tenth grade, when it was Yom Kippur and everyone else was fasting, I exhorted myself to go to an Italian restaurant on Coney Island Avenue. I'd never broken a fast

before and this was the highest of holy days, it was the most profane you could get. Maybe once I desacralized it, the vestigial grip religion had on me would be broken.

The waiter seated me at a table with a little carnation, a tiny wick floating in liquid paraffin. I ordered a baked ziti. When it came to the table I forced it, hand trembling, shivering with terror, forkful by blasphemous forkful into my mouth. I chewed, I swallowed. I wasn't hungry, but I cleaned the plate and felt sick immediately. I paid the bill (also a sin, you weren't supposed to carry money) and walked to the subway station on East Sixteenth Street, the undigested brick of ziti weighing me down like an anchor. I took the train (also a sin) to the Benetton near Astor Place, where in my altered state I settled quickly on some sweater (I didn't even try it on, I was too anxious and had a stomachache), paid for it, hopped back on the Q train to Brooklyn, and—to make a very deliberate point of my apostasy— walked the streets of Midwood with my Benetton bag. I loped in arrogant strides down East Eighth Street waiting for someone, *anyone,* to confront me about my Benetton sweater: I couldn't wait to tell them their lives were all *bullshit*! But in a harrowingly immediate fulfillment—like a phantasm or wraith I'd summoned—there, walking toward me from the opposite end of East Eighth Street, were Richie and my mother dressed in their High Holy finest.

My mother wore her grape blouse with the sash at the neck, Richie was in his Armani tweed. Instantly, I regretted my bravado. I was able to make out quite clearly the shift in my brother's expression once he eyed my bag. And now I had to walk the interminable length of the sidewalk to reach them—it was like walking to my death. Once we were face-to-face, Richie bore a hole in me with his gaze, his eyes small and black like a hermit crab's.

"You went to *Benetton*?"

"Yes," I replied, with shaky defiance.

"You went to *Benetton* on *Yom Kippur*? Don't you believe in *God*?"

My brother's temper intimidated me. He'd punched that hole in the kitchen wall—he once tracked down and threatened to beat the crap out of a delivery guy for getting his order wrong. He might physically attack me right in the middle of East Eighth Street. But I had to talk back to him: for I knew in that moment that freedom wasn't merely a choice, it was a commitment, something you fought to have.

"No," I said, my heart now pounding in my ears, "I don't believe in God."

"You're disgusting," said my brother. He repeated the word "disgusting" for emphasis. And then, once he'd given me the requisite glare to punctuate unambiguously his utter disgust with me and my inexpiable failure as a person and Jew he made a volte-face, while my mother, who often just accepted whatever violence real or intimated men wrought, made some boiler-plate condemnation of me and my "lifestyle" and walked off to soothe Richie's hurt feelings.

I was determined to follow through with the actions I'd penciled in for the day, so I resumed my symbolic walk through the streets of Midwood. With every step, I felt a new surge of contempt for my brother's pat moralism. He wasn't even really religious. He just wanted to tick off the boxes of Moral Goodness. He was like my father, conformist and unthinking. I didn't care if I shamed him, or the family, or my mother—with her fickle pantheism, her secret cache of *Daily Words** in the drawer of her end table. They were all hypocrites. Hypocrisy was all around

* *Daily Word* was a Christian periodical that came delivered to our house, a small pamphlet with parables about Christ and Christian love. When I asked my mother why she read it, she said, "All paths lead to God."

me. It was an ether, a poison. It was something I had to actively fight or I'd be lulled into its seductive slumber.

But I didn't know what I was fighting for.

I finally found the strength to reject things, but I couldn't find anything to fill the vacuum left by their absence. I didn't have a belief system.

I found a bench on Ocean Parkway and took my sweater out of the bag. It looked and felt cheap. I knew I'd never wear it. There were some old men nearby idly shuffling decks of cards. I sat and watched them. I contemplated my fate until the sun started to go down. I watched the sun bathe the tall brick buildings in its waning light until we were all caught in its clambering shadow.

LOT SIX

SOME TIME PRIOR to my conversion to atheism, near the start of my freshman year of high school, Howie and I got the idea to pool our bar mitzvah money and use it as the seed investment on a retail business. Our intention was to rival Lester's: we'd start small and grow eventually into a behemoth of women's retail. We'd use the basement of his parents' new house on East Twenty-Ninth Street as a showroom—with the low overhead we could sell the clothes at a huge discount. Together we carried big yellow legal pads to midtown showrooms and pretended to take detailed notes on the collections as the sales reps (who were all pretty confounded, we were only fifteen at the time) went through their presentations. The shipments of clothes were delivered to Howie's house: bright red stirrup pants, oversized shirts with too many colors and loud slogans, pseudo-nautical motifs, cutesy pastiches of 1950s iconography. We had no way to advertise (we were pretending to operate out of a storefront, it wasn't exactly legal) so we'd solicit appointments from girls in school or relatives. We couldn't afford shelving, so Howie enlisted his twelve-year-old sister, Helga, and her bucktoothed friend Mindy to be our models, and we devised theatrical presentations with dances inspired by *Solid Gold*. My mother brought my two aunts and their friend Stella to our inaugural showing. Mindy and Howie's sis-

ter came out and danced in the outfits to Nu Shooz and Mr. Mister. While they changed into some other outfit in an adjacent room, Howie and I floated by in stiffly choreographed cross formation from opposite ends of the room with permutations of pants and shirts to show how everything we sold could go with pretty much everything else. Then Mindy burst out from the dressing area spinning and modeling to "Dancing on the Ceiling" or some Gloria Estefan song. When the presentation ended, everyone bought a stirrup pant and maybe a rayon shirt—but aside from them we couldn't find a clientele. No one wanted to be squadroned into a basement and held hostage to twirling twelve-year-olds modeling stirrup pants. The business was failing, our bar mitzvah savings siphoned away. And there were graver impediments: Perry from Lester's found out about us. He registered his offense to the different wholesalers, who then called to question our legitimacy. Howie used his charismatic ability to lie and convince, and he calmed them all down, but then, in the middle of school one day, we were summoned to Mr. Winkler's office. He'd had gotten a call from Lester's too, and he threatened us with expulsion if we didn't cease operations immediately. Both of us ended up consequently broke. We lost our entire investment. I ended up getting a weekend job at a clothing store in Sheepshead Bay called Jazz (the owner was a friend of my brother's), but Howie couldn't find a job, and Brenda was bankrupting him. He had to take her on dates and pay for spendy dinners at I Tre Merli and Canastel's.

"I'm sick of being poor," he said, picking at a plate of spareribs with his fingers. We were at a kosher Chinese restaurant on Avenue J eating off styrofoam plates. "My mother said I could work for her but she only wants to pay five dollars an hour."

"I make eight an hour at Jazz, and I get commission."

"So get me a job there!"

"I can't. Lee just finished hiring a whole bunch of new people."

"*Ert!*" He dramatically threw down a half-eaten rib and pushed his plate away. "These spareribs are making me *nauseous!*" His lips were curled in an exaggerated snarl, a tic he probably picked up from Brenda. He sucked sparerib sauce off his fingers, making deliberately loud sucking noises to drive me nuts.

"Could you not do that, please?"

"But what am I supposta do, *Daaaave*," he said, doing his camp imitation of my mother. Our conversations had by this point become whirligig pastiches, bursting at the seams with catchphrases from television shows and SY slang and flashes of things our mothers said. He pulled a napkin from the dispenser and wiped his hands clean. "How much do you think I could make at Bloomingdale's? I could be one of those people who sprays perfume samples."

I had no idea how one got a job at Bloomingdale's, but it sounded daunting. "Aren't those, like, really hard jobs to get?"

"What are you talking about? Any *dibeh** can spray perfume!"

"Yeah, but they're not gonna hire a teenage boy."

"I could lie about my age," he said. "I could type up a fake résumé—my mother could be a reference."

"Howie, you're fifteen. You look fifteen."

"What if I dressed as a woman? I could make myself look older that way."

"You want to dress as a woman to get a job spraying perfume samples?"

His eyes lit up suddenly, as if he were struck by lightning. "I

* SY slang for "idiot."

know they would hire me," he said. "I could do it part-time. I'd be so good at it, and you make a ton of money in the city!"

"Howie!" I said, now breaking up with laughter. "Just get a job at a record store!"

"I know Bloomingdale's would hire me, David!"

By the time we were done eating, Howie had convinced himself that the *only* part-time job he could ever get was spraying perfume samples at Bloomingdale's dressed as a woman. The inanity of the premise began to stoke my enthusiasm and I pledged to help him. After all, I'd seen this scenario play out with varying degrees of success in movies and television shows, things like *Tootsie* and *Bosom Buddies*. And, like that, we were back in our shared bubble of reality.

When my mother was safely out of the house the following week, I sneaked Howie up to her room, where he unpacked the contents of a small backpack. He produced a pair of white stirrup pants, an oversized powder-pink sweater, and a bra—all of which he'd filched from his mother's closet—and quickly dressed. The sweater hung past his thighs and was augmented with huge, severe shoulder pads. He looked a little like a linebacker. He sat at my mother's makeup mirror and started applying makeup. Immediately, it became clear, as I watched him, that he'd done this before—probably more than once. He knew about mascara. He knew about liquid foundation. He knew about contouring sponges (Claudia Terzi's *raison*) and eyelash-curling implements. He knew tricks to create the illusion of angled cheekbones. I watched closely as he applied eyeliner and lipstick with painted-egg precision. I had never seen him so focused, so serious. Watching him, I felt myself recess slightly, a deferential instinct. I sensed this wasn't merely a means to an end for him, that the procession in itself had a great deal of meaning. When he was done we rifled through my mother's jewelry box. He cadged a bracelet, a pair of meretricious clip-on

earrings. He unpacked the Lee Press-On Nails he brought with him and pasted them on. I lent him my mother's wig from the sixties, the one she kept in her closet on a tiny styrofoam stand. It was brown with little mod ringlets. As I saw his look begin to come together, it was hard not to compare him to *his* mother—after all, he was made up as her, sort of. They were both lantern-jawed and angular. But her femininity stood out in hard relief in comparison with his strong aquiline nose and bulging brow and fleshy lineaments. When he was done he examined himself in the full-length mirror on the inside of my mother's closet. He stood stiffly, but I could see the rippling emotion in his eyes.

"What do you think?" he said, his voice trembling with fragile expectation.

"You look good," I said, which wasn't exactly a lie. He was transformed, even if everything seemed slightly off. All the pink and white layers gave him a patina of virgin provinciality, but the long red nails seemed louche and mismatched. His breasts, shaped from molded toilet paper, were oddly pointy, like funnels. Mounds of eyeshadow gave him a kabuki garishness. All the lashings of gloss and color formed a kind of thick crust over him, like a shell you could crack. Inside that shell was a fifteen-year-old boy, liquid and oozing like the white of an egg.

On our way to the subway station I was worried someone might attack or kill us. Howie's coniferous breasts were too big and bounced lifelessly as he walked—their absence of fleshy suppleness a dead giveaway. Once we got on the train, though, we seemed to blend in. This provisional success made me perk up. On instinct, I began to operate as a sort of drag triage: if his makeup got smudged I'd tell him and he could fix it, or he could straighten one of his false eyelashes or reposition his wig. Though I silently determined his outfit wasn't really appropri-

ate for a job interview at Bloomingdale's, I discovered a new part of myself that afternoon, a part that was loving and generous. I traded my punishing obsessive perfectionism for kindness. I sensed my role was to embolden and cheer him. "You can do this!" I told him. I could see he felt buoyed by my help, and by his victory on the F train. I could see him counting in his mind the thickly packed wads of cash he'd doubtlessly earn as a perfume sample person. His mood lifted. When we hit midtown, instead of transferring to the green line, we took a detour at Forty-Seventh Street and taxied over to the Palace Theatre, where *La Cage aux Folles* was playing. It was Brenda's birthday that night—he'd already made dinner plans for them at the Marriott Marquis (some restaurant that revolved while you ate) but now Howie impulsively decided he had to take Brenda to see *La Cage* that night. We'd seen it together back in seventh grade, and since then Howie had been to see it twice more—he even bought the soundtrack at the Sam Goody in Kings Plaza. When his parents were out, he practiced dancing like a Cagelle in his room. He put on shows for me, gliding and posing and bouncing off his bed to my ecstatic enjoyment. Now he wanted to share his love for that play with Brenda.

With his giant shoulder pads and perfectly positioned wig, Howie approached the man at the ticket counter to query for availability, only slightly torqueing his voice to make it sound womanlier. To his delight, there was a cancellation: two prime seats in the center of the orchestra. It was as if the providential, the celestial courses of heaven were guiding him to this very moment in time—so uncanny, so *perfect* was this confluence of omens. We exited the theatre and crossed Broadway, weaving through the crowd of tourists toward the N, which would deposit us on Fifty-Ninth Street at the very lip of Bloomingdale's, that Valhalla of perfume samples and makeup and prospective employment.

As we gabbed about how great his seats were I noticed, in the pinging traffic of Times Square, about thirty feet in the distance, a woman with blunt Semitic features and short frizzy hair, frozen in place on the sidewalk, *glaring* at us. Her glare was unremitting—eyes stabbing us, practically—her expression an unsettling combination of horror, disbelief, and disgust. I assumed she was simply a very observant woman who could see what was plain, that a teenage boy was walking around wearing women's clothing in the middle of Times Square. But something about this woman felt distressingly familiar, and though Jewish women of her ilk all had an archetypal aesthetic sameness, I felt I knew her. And then, in a nightmarishly swift escalation over the course of the next twentyish seconds, I realized who it was: Ellen *Kaplowitz*—a girl from the yeshiva, a junior; she was in Brenda's homeroom. I tried to warn Howie, who was painfully, woefully oblivious to subtle cues. Even as I dug my fingers into the sleeve of his mother's cotton sweater—so tightly the threads of it practically disintegrated in my grasp—and whispered *Ellen Kaplowitz!* again and again, he just bounced along in his stirrup pants, loudly replying HUH? and WHAT?

As we drew nearer, Ellen Kaplowitz's fiery outrage, the murderous expression on her face, came more and more alive and I felt time slow down. I heard a sharp cry escape her lips; it was like the squeal of a braking car moments before a fatal crash. Her voice dropped to a brittle scrape, the morphology of her mouth twisted—its shapes conforming to loose syllables spaced at impossibly long intervals—until the agglomeration of sounds and scrapes and high-pitched noises condensed into a single word, the way individual notes of music develop into a chord, and that word was *his name*. She said it not as a form of salutation but as an indictment. She said his name again and again. HOWIE. HOWIE. As if the repeated utterance was itself a

form of punishment—as if his very name would annihilate him, would shame and destroy him. She was attracting the attention of pedestrians but Howie remained oblivious until, when we were just inches from her face, so close you could count the pores in her nose, Ellen said her final and most damning HOWIE!, stopping him dead in his tracks. Once she was certain he'd heard her, and they were face-to-face, she shook her head slowly, as if to say *Shame, shame.* The emotion drained instantly from his face, the joy from his eyes. His makeup suddenly looked like it weighed fifty pounds, he looked tired and old. He stood for a moment framed by the flimsy vinyl banners of the TKTS booth—and then, as if remembering some forgotten errand or appointment, clutched his mother's purse with its patchwork of sparkling fabrics, and marched resolutely past Ellen Kaplowitz and into the oncoming traffic of Forty-Seventh Street.

We never made it to Bloomingdale's. The train back to Brooklyn was choked with passengers. I tried to laugh off the encounter but Howie was panicked: what if Ellen Kaplowitz told Brenda? What if she went to the principal? She could lodge a complaint, they'd tell our parents. I'd have to admit to lending him my mother's wig; he'd have the more onerous task of copping to wearing his mother's stirrup pants—her *bra*! This anxiety, coupled with the overall emotional expenditure of the day, caused him to unravel somewhat in the subway car. His makeup needed refreshing, his face was clammy with anxiety, and you could see the scuff of his beard. His wig was tilted at an infelicitous angle; some of his nails dropped off or were loose and he had to keep pressing them back on. He seemed defoliated, like a dying houseplant. He was collapsed against the window of the subway car, a human emblem of defeat.

We'd fooled them earlier, but now people shot nasty looks or shook their heads in disgust. The farther into Brooklyn we got,

the more vicious the stares and mute gestures. I tried to make him laugh at the absurdity of the situation, but by then he'd lost all sense of fun. It was horrible to witness his humiliation. I'd never seen him so defeated. Seeing him this way, I felt a surge of intense loyalty, an unbreakable solidarity with my friend. If they stared him down, I would bear with him the hate in those stares. I would diffuse the hate somehow by sharing it with him. But as I sat alongside him, warding off the hate, I myself felt blasted with it. A creeping terror began to surge inside of me, a terror I hadn't felt since I was small, when my brothers imitated those Flip Wilson skits and I made the compact with myself to never become the Lot Six. I would never allow my brothers to see me—the way Ellen Kaplowitz saw Howie when she shook her head at him, when she spat his name like it was a repulsive curse word. She saw *into* him, like an X-ray; she saw right into his very insides. But what did that really mean? Was Howie a woman inside? Was *he* a Lot Six?

The whole *La Cage* scenario seemed a bellwether of something, but I wasn't sure what. Maybe it was a phase,* and he'd eventually tire of wearing his mother's outfits, and stealing issues of *Honcho*, and dancing flamboyantly to the Pet Shop Boys' 12-inch remix of "It's a Sin." Maybe he just liked being in touch with his female side, or he believed (as Dustin Hoffman's character in *Tootsie* learns) that a man could become *more manly* by becoming a woman.

* And sexuality was a *continuum*. I knew that from reading my sister's copy of the *Hite Report on Male Sexuality* (I found it in the drawer near her bed when I was ten years old and became obsessed with it), which regaled me with stories of pubescent boys in the Midwest playing games called "milk the cow" and stories of married men who masturbated wearing their wives' underwear. The men stayed married, the midwestern boys went on to later identify as fully heterosexual. Reading this book gave me the impression that sexuality was fluid and changeable.

Or maybe he felt that by dressing as a woman you could be who you were *inside*, as the George Hearn character declaims in the "I Am What I Am" number in *La Cage*, when he strips off his wig and makes a passionate case for being accepted as himself. But even that was confusing, because if he was "who he was," why did George Hearn have to dress as someone else to be that? If you changed clothes and pretended to be someone else, was your *identity* changed? Did a new self actually emerge?

How far could a fantasy about one's life be pushed to make it reality?

My friendship with Howie had always been a gateway to fantasy. Through him I came to believe that fiction and reality could blend harmoniously, that reality could be heightened and ecstatic. But that day was a turning point. Howie's defeat made clear to me that even if you were a charismatic, brilliant person there were rules, and if you broke the rules you would be punished. His failed experiment showed me there was only so far one could take a fantasy; that afternoon I had a terrible premonition reality would one day crush me.

By the end of sophomore year my grades dropped precipitously. I failed all my Hebrew classes and got straight Ds in English. My self-esteem was nonexistent. I was in a near-suicidal depression. The fury that burned so brightly when I marched through Midwood with the Benetton sweater had dwindled to a burnt wick, and now just getting through a single day was a drudging effort. Because of my dismal grades I was put on probation at the yeshiva. As a condition of my readmittance, and against my wishes, I had to see a psychotherapist.

I'd never been to a therapist, but Howie was forced to see one back in eighth grade—his grades were abysmal, he was cutting school all the time. By the third or fourth session, he began to suspect that the therapist was leaking private details

from their sessions to people at the yeshiva—there were things he'd told the therapist that no one else knew, *no one,* and those things had gotten back to him. When I heard that, I decided psychotherapy was simply a way to extract information to be used against you. Howie told me he overheard his parents talking about us. He heard them say the principals at the yeshiva were convinced we were homosexual lovers—that that was the *real* reason he was forced to see a therapist, not his bad grades. At the end of eighth grade, Rabbi Bressler actually forbade Howie and me from having any contact—ostensibly a punishment for cutting school together. We had to remain a minimum of fifty feet away from each other, even outside school hours. School faculty were deputized to enforce our separation. Teachers stood in forbidding syndicates at the end of hallways during breaks, and when I passed them I'd catch the incremental nudge and giggle, the slight eye roll. Because of this prior history, I felt, when the school mandated it, that my being made to see a therapist was not about grades. The therapist would force an admission from me. Once it was secured, they'd kick me out of the Syrian Community and the yeshiva and Judaism and I'd be left with nothing.

In light of these unsavory possibilities I decided I would lie to the therapist. I'd dodge his questions and probings so he'd have nothing of substance to offer the people at school. If I refused to confess, he'd be powerless to hurt me.

Dr. Weinberger's office was off on a side entrance of a large, impressive Victorian mansion in Ditmas Park. The entrance led to a small wooden flight of stairs that opened into a basement office. It felt like a sealed-off tank; it was airless and well appointed. I thought it was terrible to have an encounter with a stranger in a windowless basement. Even with my disregard for protocol and boundaries I was uncomfortable and felt the grat-

ing unnaturalness of the situation. Upon sitting, he said absolutely nothing. Apparently, he was waiting for me to voice some concern, as though I hadn't been forced to see him, or had some concrete understanding of what psychotherapy could offer me.

Eventually, he made an opening gambit: "So why do you think you're here?"

"I don't know," I said, determined to bring zero valence to my every utterance.

"Well," he said, "there's some concern about your grades."

I said nothing.

"What do you think it was that prompted the slip in your grades?"

I shrugged. I shifted in the armchair. I replied "I don't know" to nearly everything he said, or merely shrugged or looked away. It seemed presumptuous of him to expect me to start telling him intimate things—you didn't just walk into a room with some stranger and spill your guts. His entitlement rankled me. I didn't know much about therapists but I wasn't impressed— and he didn't look like much. He had a thick reddish mustache and wore large, ugly spectacles. His hair was too curly and balding at the temples, and he wore a lot of brown.

Therapy, said Dr. Weinberger, was predicated on my openness and trust, neither of which I was prepared to offer up, so I resigned myself to clocking in and out, like it was some grunt job. After a few sessions, though, something changed and I felt a shift in my attitude. I began to look forward to going to therapy. I liked his grand home in Ditmas Park. I liked being asked to talk about myself. I came to see how rare a thing in life this was, for someone to devote himself entirely to you, to your problems, your thoughts and concerns. And though I still didn't trust Weinberger and saw him as an emissary of the yeshiva,

the project of analysis became interesting to me. It was an opportunity, the kind of opportunity that hadn't ever presented itself to me before, and I wanted to avail myself of it.

Over the course of several weeks, my silence in the therapy gave way to long winding soliloquies that sometimes took bizarre turns, leading me in directions that pointed to terrain that was utterly foreign: the terra incognita of the self. I found that I didn't exactly know what I thought or felt about things, and, moreover, that I was *curious* about these aspects of myself. Who was this person speaking through me? I didn't recognize him. The unconscious began to fascinate me—it took the place of what I formerly believed was a soul.

I started to trust Weinberger. I realized I liked him. He was the first adult I'd ever known who didn't seem damaged or enraged or disturbed, who spoke to me in measured tones, and didn't shout back if I said something deliberately inflammatory, or baited him with some dumb remark that smacked of arrogance or insult or mawkish exhibitionism. He could deal with me because he was a *grown-up*—he didn't feint at some notion of being a grown-up; he didn't require my obedience to feel strong. He was the first person I knew whom I could maybe even respect—whose love, should I garner it, would mean something. Because unlike my parents or teachers, this man seemed to know something about life. He knew about literature and art and esoteric films. He had access to echelons of culture that eluded me—and now I *wanted* culture again. I needed something to take the place of religion, the heritage I'd rejected.

Weinberger was part of that generation for whom going to art films represented something about who you were, who felt an anthropologic duty, practically, to watch Japanese films and Godard and to read Pauline Kael and Andrew Sarris. Art films were art because they were outside the mainstream current;

they were deeper and more mysterious—just like Weinberger was deeper than the people from my school or in my family.

He was particularly obsessed with a film called *Woman in the Dunes*. When I told him I never heard of it, he faked stupefaction: "You never *heard* of *Woman in the Dunes*? It's one of the *great films*!" I went to Avenue J Video to rent *Woman in the Dunes*, but they had no idea what it was. The rarity and specialness of it made the film seem like manna from heaven.

Little by little, our relationship began to satisfyingly deepen. I felt myself becoming Weinberger's protégé. I became infatuated with how he spoke, how he thought and acted. I got attached to his tics and quirks of behavior the way one does with a lover. His expressions never ceased to be of interest to me: sometimes he was lost in a rhapsody of tender contemplation, other times his features cinched in a sort of scientific inquiry. When he got excited about something his face widened as if it were a piece of Silly Putty. He'd taunt me with his knowledge, speak in discursive registers. He wanted to impress upon me the fact that a world existed outside of the tiny bubble of the yeshiva, and that that world was compelling and interesting. Weinberger was pressing me ever forward, pushing me to apply to colleges, to plan for my *future*. I never believed I could have a future. Previously, when I looked ahead I only saw a gaping featureless void, but now I started to make concrete plans. I decided to reject the path laid out by my father. I didn't want to be a businessman or own a house in Deal—I didn't want to be In The Community, *period*. I wanted a life of meaning.

I thought I might go to NYU to study film, but Weinberger kept pushing for UCLA or USC. "The film industry is *in* Los Angeles," he insisted. I was annoyed that he was coercing me to actualize a fantasy; maybe I didn't fully believe I could make the fantasy real. And there was the issue of my execrable school

record: I failed nearly all my classes for two semesters in a row. But Weinberger gave me incentive to succeed.

"Get your grades up," he said, "so you can get the fuck out of here."

The following semester I got straight As. I didn't have to work hard to do it, I just memorized things they said to memorize and regurgitated those things on tests. The Dumb Class was still a stain on my academic life, though. I'd never have the same status as Howie—who'd been asked to join Mrs. Foxman's Masterpiece Theatre program, in which a select group of students were invited to see Broadway plays for free. He did end up taking Brenda to see *La Cage* for her birthday that night, and she loved it, just as he imagined. She never found out about our abortive trip to Bloomingdale's. Ellen Kaplowitz must've consulted a halachic text and found some arcane, mitzvah-bearing support for keeping her mouth shut. We never again discussed that afternoon, but my anxieties from the subway ride home lingered.

Then one day, Weinberger, in the middle of a session, started asking me about sex.

"Do you have particular fantasies?" he said.

I felt the blood drain from the top half of my body.

"No," I replied. "I do *not*."

I'd so enjoyed the minutiae of psychotherapy that I'd forgotten all about the guard I meant to maintain. Now his agenda was surfacing. He'd just been patient, like a spider planning its predation—like the Theresa Russell character in the movie *Black Widow* who plans a whole elaborate seduction of Debra Winger as a prelude to killing her. But, in truth, I didn't think Weinberger was trying to harm me. I believed, despite Howie's situation with his crappy therapist, that Weinberger was trying to help me. I hadn't ever trusted anyone enough to let them help me; it seemed impossible. I'd only known congenial diversions,

pleasant escapes, but help—real, actual, tangible *help*—seemed so far beyond my grasp that it wasn't ever a consideration. Weinberger was offering that help. I felt tempted to accept it, but I knew that despite my temptation, despite my need to trust another human being and Weinberger's good intentions, I would never confess. If I spoke the words aloud, I'd be undoing the pact I made with myself when I was eight, when I swore to never become a Lot Six.

I later learned the origin for that term from my brothers. It came from SY businesses. Lot numbers were the numbers affixed with little stickers to the backs of cameras and Walkmans—they gave salesmen a coded system, a quick way to negotiate prices with customers. Lot numbers were double the wholesale price, so Lot Six was code for three, an odd number—*odd*, as in *queer*. It wasn't just an epithet for a gay person—it was a price tag, a declaration of value. And a Lot Six had no value. The identity, if I ever claimed it, would render me worthless. A confession to Weinberger would be an act of hideous violence against myself, like ripping open my stomach with my fingers and pulling out my own entrails.

But he was determined to force my confession. He sat patiently, month by month, session after interminable session while I evaded his questions. I could be very skillful; I knew how to divert him, how to make him laugh. At times it seemed I'd gotten him to forget, the way everyone in my family seemed to forget when I was small. But Weinberger was nothing like the people in my family, and he had no intention of forgetting. The momentary lapses were a tactic: he wasn't going to budge. He was going to make me say the thing that was so unbearable, the thing that would sully our enlightening conversations about foreign films and great books.

I grew more and more silent. The more he wanted me to talk about sex, the less I wanted to talk about anything. Near the

end of one unusually fruitless session, Weinberger produced a hand puppet. He asked if I would have the *puppet* talk to him, if perhaps it wouldn't be easier to speak through a puppet than as myself. It wasn't a terribly thrilling prospect but I wanted to please him. I crouched behind an armchair and managed, in my puppet voice, to eke out that I was attracted to men— because that was all I really knew or understood about my condition. I spoke the words he required of me and then it was done. Weinberger said he was proud of me, that it was hard to admit what I admitted and not to worry, it would all be okay.

"*How?*" I asked him. Because I didn't see how it would ever be okay. I would be ostracized from society. I would be alone for the rest of my life.

"Well," said Weinberger, "there are ways, that, with therapy, you can be made into a functioning bisexual. You'll still feel your attraction for men, that won't go away. But you'll be able to get married."

"I will?"

"Yes," he said with a gentle smile. "You can have a family and you'll be able to live a normal life." His smile showed me that my anguish about being a homosexual was almost charming—because of *course* it would be okay. It was his smile that tendered just a little bit of the relief I craved, and I didn't know how intensely I craved it until that moment. I'd resolved to live in darkness but now there was a little sliver of light: I could be a *functioning bisexual*! It sounded so elevated. And the way he spoke about it, there were multitudes of us, not just me. People could transform themselves, and it *wasn't* a fantasy, and I wouldn't have to hide or skulk or lie.

At the beginning of junior year I was sparklingly restored, the prize student of the Dumb Class. Now that I was rehabilitated my teachers all loved me. I had a near-perfect GPA. I sent away for applications to film schools. It was all going swim-

mingly when, in the middle of chemistry class one afternoon, there was a knock on the door. Lonny peeked his head in. "David Adjmi?" he said. "Come out to the hallway, please."

I was genuinely surprised it was me he wanted.

"And bring your books," he added, stoically ambiguous.

I packed my stuff and toted my backpack out into the hallway where Lonny was waiting for me. His shirt sleeves were carefully rolled up; his arms and skin had a depilated-seeming softness. His hair was longer than I remembered, it fanned out at the edges like a lion's mane. "What's going on?" I asked, in the same honeyed tone I used asking police officers for directions—for I always half expected to be arrested because of some arcane statute. I hadn't done anything wrong but I was shaking.

"You have a whole bunch of unexcused absences for swimming," he said. "Do you have notes for these?"

"I have an excused absence for the semester," I told him. It was the truth. I had some medical excuse that got me out of swimming—fake, but at least I'd taken the trouble to procure it.

"Yes," he said, his shivering upper lip curling slightly, "but you still need to be *on* the bleachers."

"I have a doctor's note."

"That exempts you from having to swim, but you still need to be at every class."

"But the smell of chlorine makes me sick."

"I don't *care*," he shot back.

I felt blindsided. No one ever said anything to me about sitting in the bleachers. For a brief moment I considered arguing my case, but within seconds I could feel myself relax into the familiar dynamic. I was punished so frequently in those days, and for such trivial offenses, that my recidivism was practically mandatory—how else could I receive the new punishment? For my truancy, he said, I would receive a two-week in-house

suspension. I didn't know how this was meant to punish me. I had thirteen classes to keep up with, I'd just turned a roster of failing grades into a 4.0 GPA—was this really the time to unearth my wanton neglect of *swimming*? Was there *no* fungible alternative? I asked if I couldn't be punished in some other way but Lonny wouldn't hear of it. The suspension was to take place *effective immediately*.

The school library, where I was to spend the next two weeks, was an airless tomb decorated with Republican-leaning periodicals and Zionist manifestos and some books. The librarian was an Israeli woman named Mrs. Wyzkowski who was a sort of jack-of-all-trades at the yeshiva. She was a substitute teacher, she organized Zionist campaigns, and did a little bit of everything. I had her as a substitute for a month when our math teacher had a baby, and found her extremely high-strung, even for the yeshiva. I thought it was odd she'd been made a librarian, as she was extremely loud. As a substitute teacher she bellowed instructions to us in her broken English as though she were at a naval base; every syllable was so exaggerated and guttural and fraught with earsplitting shrillness that, after a while, the words themselves dissolved into an abstract jumble of sounds or chords. In her role as librarian, though, Mrs. Wyzkowski assumed a surprising air of relaxed quietude. She kept busy organizing catalogues and listening to Country 97 at soft volume on her transistor radio. She sipped coffee from a Touro College mug, flipping through pages of *Ladies' Home Journal*, clipping articles that held her interest and humming softly to Kenny Rogers. I found her fascinating to watch. When she walked to the card catalogue or to refill her coffee mug her hips seemed to land up near her shoulders, so their amplitude affected her movement—she didn't walk so much as swivel, like John Wayne at high noon. The creaky torsion of her movement made her seem weirdly slow and out of synch with the

world. I imagined her living on a frontier or as the heroine of a Western, making coffee, swiveling her tall hips, cranking her machine parts.

The idea of a bewigged Israeli woman living out a frontier life appealed to me, but the appeal was not inexhaustible, and by the second day of the suspension I was feeling antsy. The school days were nearly eleven hours—a long time to be stuck in a room—and the anxiety I felt at missing my classes made my boredom all the more excruciating. I had to keep up my GPA if I wanted to get into a decent college, and though the Dumb Class wasn't that challenging, it would still be a feat to make up two weeks' worth of school.

Lunchtime came but I wasn't, as per the dictates of my punishment, allowed to leave the library, so I picked at a tuna sandwich I packed that morning. People from the Dumb Class showed up with doleful expressions and kind words about how they missed me in class. Lunch ended, and I sat in my chair and looked around at the Zionist books. Quite suddenly, the idiocy of my predicament filled me with rage. My punishment was insufferably stupid. The people running the school were stupid. They were sabotaging me, sabotaging my academic progress— my *future*—and for *what*? Sitting there in the tomblike library with its deathly shadows, as I watched Mrs. Wyzkowski and her matted ash-blond wig, I felt some ugliness in me start to get roiled up. I felt a nihilistic urge to destroy my life—it was blurred with my healthy urge to transform my life, to make it better, but now I wanted both at the same time. I wasn't feeling logical. I was coming out of my skin. I threw my half-eaten tuna fish sandwich in the trash, and marched into my English class down the hall. They were discussing *The Scarlet Letter* (which, upon reading, I instantly appropriated as a cri de coeur and symbol of my own martyrdom). I knew Lonny would come for me, but I surrendered to the moment. Mrs. Mandel read

passages from the book aloud and I luxuriated in the sublime prose. I laughed along with my classmates as we parsed the heresy and sprightliness of Hester Prynne's bizarre daughter Pearl.

Not twenty minutes into the class, Lonny was at the door with his rolled-up shirt sleeves and pinched face—but it was more pinched than usual. "*Get your books!*" he said, scowling, but before I could get my bearings, his hand was on the collar of my shirt and I was being half dragged toward the stairwell. "You've really *screwed* it up for yourself, Mr. Adjmi."

Lonny tugged me by the collar all the way down the stairs. I could feel his knuckles banging against my clavicle. It felt like a personal hatred. When we got to the bottom of the stairwell, I screwed up the nerve to ask him why he hated me so intensely, but it came out an ugly recreant cry: "*Why are you doing this to me!?*"

"*Because,*" replied Lonny, his mouth puckered in an awful, sour-lemon expression, "you don't follow *the rules.*"

My mother was there within the half hour to meet with Mr. Winkler in his office while Lonny stood nearby, his collar-tugging bravado from the stairwell now covered over with a sexless administrative judiciousness. He made his fingers into a steeple to project provident concern. Winkler dug up my school record, everything from kindergarten on, and commenced the prosecution, serially recounting the long history of all my torrential failings, my many and varied infractions from the age of six.

The stereoscopic breadth of their inquiry was impressive: I cut school, I didn't pray enough. I ate unkosher, hated sports, had bad grades. I was a delinquent—I was *anathema*. Winkler had the deportment of a barrister with a powdered wig or some Puritan bemoaning the iniquity of Hester Prynne. His long litany was tinged with a kind of regret, a spurious mix of sancti-

mony, rue, and caring—as if to say that *yes*, principals had
moral obligations to care about students, and it was unfortu-
nate that I was too besotted with Evil to be helped and cared
for. His tone was so familiar; I recognized in it the passionless
biblical instruction from my classes. Morality was something
to be executed, like a gymnast sticking a landing. As Winkler
inveighed, Lonny stood by him in his curled vulpine stance,
head bowed, fingers still mated, nodding with his eyes squeezed
shut like he was participating in an exorcism. I could feel him
silently averring *yes, yes* to each one of Winkler's towering as-
sertions about my bad character. They could see I was worth-
less and wanted to be rid of me. They could see into my future,
and the crystal ball was black and empty.

I'd anticipated my mother getting all worked up by their vit-
riol, saying that they were right, that I was shameful and
hideous—but to my shock she *fought back*. She began to peti-
tion them. "Why are you holding all of these things from the
past against him?" she said. "What about the good he's done?
Why aren't you bringing any of *that* up?" I hadn't ever seen my
mother stand up for me like this. And she wasn't even annoying—
she was sensible, persuasive! "*No*," she went on, rimless glasses
plastered to her nose, "you're just *condemning* him!" Her face
was glowing, almost burning. There was a new vitality in her
limbs, her carriage, as if any minute she'd jump up from her
seat and they'd need to restrain her. This was *my mother*! It
was as if the woman I'd known all these years withdrew and
vanished, then suddenly reappeared in this new strange form.
As though I'd been drowning, and like Neptune or some crea-
ture from mythology she dove in and pulled me up from the
bottom of the sea.

And remarkably, her entreaties worked.

Winkler reversed course. I was allowed another chance.

"Do you have anything you want to say, Mr. Adjmi?"

"No," I replied, staring through him. I felt stony with self-possession. My spine became erect. My little chair became a throne. I saw a tiny snarl of incomprehension in his face, for I wasn't sobbing or hysterical. It was one of the rare moments I didn't have to act or affect a sense of my own worth. I didn't feel victimized or wounded, I was *indignant*. And with my indignation I began to feel inklings of other things: sovereignty, pride. Feelings so new to me, so alien, I felt them the way a pregnant woman feels a baby kicking. It was almost violent, like a bomb had exploded right there in the room: the very instant I stopped caring what happened to me, my life came jarringly into focus. I'd been dreaming all my life, and now I was certain it was all a dream. In the dream I was powerless. In the dream people were cold and cruel and I had to submit to their rules to feel safe, but I'd never *been* safe. These two men standing before me with their tweed and worn expressions and bemusement had no purchase on me, and on some deep level I believed they had. My reality seemed so colorless and bleak— but it *wasn't* reality. They'd devised a reality for me to step into but I could just as easily step out of it. I could build a new reality. I could make it anything I wanted. Once I knew that, and not just knew it but *felt* it, saw it with bracing clarity— once that happened I could feel some invisible perimeter, some unspecific captivity I lived with and accepted all my life start to melt, and dissolve. And like the desert-trawling Jews in the Bible, my exile was transmuted into freedom.

BOOK II

A NEW PAST

EUROTRASH

WHEN MY EXPULSION was rescinded I exited the office, and asked my mother to wait in the lobby. I marched down a bunch of empty corridors, took the stairs to a mezzanine, found my locker, grabbed the books I wanted (*The Scarlet Letter*, some poetry anthology, a bunch of useless but pricey textbooks I felt obliged to keep) and lugged them in huge theatrical armload out the building. As I nudged the door open with my shoulder, there stood my mother at the foot of the steps wearing her little beret and puffing on a Kent 100. "Honey," she said, "what *now*? What are all those *books?*"

"Where'd you park the car?" I wobbled down the small flight of granite steps, balancing the wall of books with my chin.

"Put those back in your locker."

"Nope. I quit."

"Put those books back in your locker *right now*," she said. In my peripheral vision she looked like one of those tiny French dolls they sold in flea markets. I could feel my arms starting to give out so I picked a direction arbitrarily and started walking. My mother trailed alongside me. "You're being very immature."

I spotted her Chevy parked near the corner and stepped up my rhythm.

"*Daavve*," she trilled in a plummy voice, "you're not quitting school."

"Then I'll transfer to public school."

"Your father's not gonna go for that."

"Then I quit!" I said. "I don't give a fuck!" It was the first time I said "fuck" to my mother, but it felt important to estrange her from any familiar understanding she had of me. I was like a cartographer drawing new lines on a map and expanding its territory.

She unlocked the trunk, and I shoved the books in.

"You're not quitting school," she repeated, but this time I could detect the slightest note of resignation in her voice, and it was the slight note of resignation that gave me hope—from it I inferred my little gambit might go unchallenged.

Later that night she invited my father over for dinner, where we broke the news. And she was right: he didn't go for it. My father said in no uncertain terms he wouldn't hear of my going to some heathenish dirty public school. He said I'd be surrounded by crucifix-wearing gentiles, and get diseases, and have filthy congress with people who did drugs. He tried rationalizing away my predicament. "The rabbis wouldn't answer your questions," he said. "We have to find you a school where the rabbis are more open-minded."

"But that's not the problem," I told him.

"Your teachers didn't answer your questions."

"But I don't *have* questions."

"You were frustrated because you wanted to understand the religion," he said. "They wouldn't answer your questions."

This narrative that I was a Jew full of questions ossified immediately in his mind. Dad was stubborn in this way. He was constantly situating his kids in stories about our lives that had nothing to do with us, but somehow we ended up as characters in those stories. Richie was going to work in electronics (which he did), Stevie was going to be religious and live in New Jersey (and then he did). My greatest terror was that, like them, I

would become a character in his story—that I was nothing more than a moving piece on a chessboard my father could situate and resituate at will, because I had no will of my own.

At our weekly dinners at the Genovese House he endlessly narrated my inner life to me, telling me all things I wished for and felt and believed. I found a strange comfort in being molded and fabricated in the moment by him, the way one can enjoy a slightly painful massage. I felt a compulsion to be something for my father, even though I didn't really care for him as a person. When he insisted on my being a mansion-owning businessman I couldn't say anything about my intention to be a filmmaker, because I wanted to please him. I wanted him to love me, even if his love confused my sense of self. When he smiled at me I felt reconstituted through his aura. I had to keep unpeeling myself from those dreamy smiles. I had to unglue myself, like he was flypaper and kept getting stuck to my fingers.

As he blathered on about rabbis, my mother sat in her robe, hair pulled back in a terrycloth headband. She was flicking her lit cigarette constantly into an amber ashtray. Her patience astonished me, but years of marriage inured her, I gathered, to his long, repetitive speeches. When he was done she put down her cigarette. "He doesn't have questions for the rabbis," she said, plainly. "He wants to go to public school."

"HE'S NOT GOIN TO NO PUBLIC SCHOOL," my father thundered back.

I didn't like the way he shouted at my mother.

"I don't believe in God," I snapped. "I'm sick of pretending to believe in something because *you* want me to believe in it! I'm not doing what you want *anymore*!"

My father looked at me like he'd been shot point-blank. It was the first time I ever asserted myself with him, and I didn't know any nuanced way of doing it so it came out blunter and colder than I'd intended. Dad nervously tugged at his gold pinky

ring. The muscles in his face began to strain and contort, like he was blowing air into a trumpet. His eyes pooled with tears. Then he pushed his chair back and stood up from the table. "EVERYTHING YOU HAVE IS BECAUSE OF *HASHEM*!" he cried suddenly, raising and lowering his arms expressively. "MY HEART IS HURTING!"

My mother cut him a slice of pecan Danish. With her pantheistic tendencies—her subscription to the *Daily Word* and secret cache of Jesuitical icons—she was sympathetic to my rejection of the Jewish faith, but Dad was crushed. My disavowal of religion was a break with *him*, with his vision of spiritual reality. When he was done with his tears and quavering raptures and deeply felt evangelism re: *hashem* he slumped to his car and drove away.

We spent weeks in a détente. My newly admitted atheism forestalled any decision about school. My mother tried to play the ombudsman, she'd relay messages back and forth, but the messages were mainly to relay that neither of us would change his position.

In the meantime, I was elated not to be at the yeshiva. I stopped following their idiotic sumptuary code. I wore ripped jeans and started growing out my hair. I shaved my sideburns in ways that flouted Talmudic prescription. I vowed to erase the Hebrew language from my mind, to erase Rashi and biblical commentary. I felt brave and macho, for I'd stood up to my father, and did so even with the forfeiture of his good opinion. Weinberger told me it was progress and a sign of my increasing health as a person. For the very first time, I felt ownership over my life.

Late one night, I was in bed half-asleep, when the phone rang on my private line.

"Adj! Are you awake?"

It was a woman's voice. "Who is this?" I said.

"V."

"*Who?*"

"David, it's Vivian *Goldberg*. Am I cawling too late?"

I sat up in bed and turned on my bedside lamp.

"No," I said, "it's really good to hear from you!"

Vivian was an alumna of the Dumb Class who'd been kicked out of the yeshiva in the middle of freshman year. I forgot all about her quirk of calling people by their first initial—meant to be a cool trend, but it never took hold.

"G. told me you dropped out," she said.

"Yeah, last month."

"Lonny's gonna drag you by your *collah*, that piece a *shit*?" I could hear the metal grill of her braces thickening all her consonants. "He's a freakin *psychopath*."

Vivian and I weren't great friends, but we liked each other, and I felt grateful for peer support and for the opportunity to say volatile things about Lonny. Even Howie hadn't called to ask how I was holding up; our friendship was all but gone by then. He found a new best friend named Andy and that was that. I was heartbroken, but in some sense it made things easier. I wanted to have a clean break with the past.

"I'm trying to convince my father to let me go to public school."

"Don't go to public school," said Vivian. "Come to *my* school!"

"Where?"

"York Prep."

"Would I like it?"

"Adj," she cried, "you will *love it*."

"Really?"

"We don't have a principal, we have a 'head *mastah*,' and he's *British*." The instant she mentioned him, the image of a British man running a high school materialized like a mirage,

it slaked a thirst I never knew I had. "His wife is a famous college guidance counselor," she continued. "She can get you in *anywheh*."

Vivian drew a mental picture of the life we'd have: lunching together, going to movies and art galleries. She described the other students—French expatriates, people who lived in sharp prewar apartments with doormen to buzz you up. As soon as I hung up the phone, I knew York Prep was the nonpareil of schools, and made the impulsive decision that this would be my new life. When I brought up the idea with my father, I made private school seem a compromise—less sullying and degrading than public school—and, after a lot of persuading, and once it became unambiguously clear I was willing to be a high school dropout and destroy my life if it came to that, he gave in. My mother drove me into The City for my placement test; two weeks later I had my first day.

I wore my best Lester's ensemble—an oversized Williwear cardigan and satiny houndstooth baggy pants I considered au courant—and waited in my mother's living room, checking through the huge protruding grid of windows for my father. It was a long subway trip to the Upper East Side, so Dad (who worked in midtown now) committed to driving me in the mornings. I spotted a pair of low beams enter the darkened driveway and went out to meet him.

I could tell my father was excited by our new ritual; he kept fussing over me. *You comfortable, honey? You need more heat?* My father was, for the first time, committed to me in some semiregular way—not just as a signer of checks or inveigher against bad morals. I felt like a prince in his Lincoln Town Car, with its heated seats and automatic lumbar adjustment. And it felt majestic going to school in The City. When we crossed the Prospect Expressway I gazed across the river at the skyline and traced the beams of light animating the towering glass build-

ings, beam to beam. The light was so perfect at six in the morning, like a cup of barely steeped tea.

To cope with my atheism my father told himself it was "a phase" and if I had the right instruction, I would gravitate naturally back to Judaism the way a plant gravitates to sunlight for nourishment. He pushed his new narrative about me: that I was more religious than lots of people he knew, that I was very spiritual, and very *pure*—that I was a good person and he didn't care what anyone said, or even what *I* said, because he knew me better than I knew myself. And because he was compulsive and couldn't help it (but also because the overlap of our interests was extremely limited, and we'd otherwise have nothing to talk about) he forced one of his catechisms on me: "You didn't think I'd *let* you go to Yohk Prep, didja, Dave?"

"No."

"But who takes care of his boy?"

"You."

"You were *shocked* that I let you go."

"Yeah."

"But I'm more open-minded than you thought."

"Much."

He'd already begun revising history, manufacturing a new narrative that cast him as the hero of my life story, but I didn't care—and in some sense, it wasn't untrue. He'd opened a door for me, for my life to change, and I was grateful for it.

My father dropped me off at the corner of Lexington and Eighty-Fifth Street, in front of a crappy-looking restaurant called Chirpin' Chicken. I stepped over piles of chicken bones stacked on the sidewalk like kindling for a bonfire, and walked toward the school, a beige sliver wedged between townhouses. Outside, students milled about in freezing weather bumming cigarettes. No one shivered or seemed cold. The boys and girls were very touchy with each other in a way I was unused to. They were

giving each other massages. They were hugging and sitting on each other's laps and blowing smoke rings. The boys had preppy haircuts; they wore Top-Siders and bland, ugly pants. The girls wore baggy sweaters with vintage-looking motorcycle jackets and cowboy boots. They weren't primped like the yeshiva girls—they were less delicate, and had an unwashed, oily-hair aesthetic that seemed to represent some kind of chic authenticity. It was a currency unfamiliar to me but I accepted it immediately. Whatever this was, I wanted to be a part of it.

When I entered the building I spotted Vivian at the end of the main hallway. She pumped her fist and did a cute little victory dance over to me: "*Adj!* You're *here*!" She wore an oversized Mickey Mouse sweater and fluorescent green corduroys and looked about eleven years old. She hadn't changed a bit. Her smile was the same wide flash of metal, her hair was cut in the same elfin bangs she'd worn since the fifth grade. It was a sentimental reunion, the fragile sweetness of it only slightly marred by the hard-to-ignore reality that we'd never actually been close friends in the first place. But whatever affection we did share seemed distilled now, its potency strengthened by our bond from the Dumb Class and our extradition into this new strange world.

Vivian toured me around the building, furtively pointing out various characters she'd mentioned over the phone: the straight-edge skinhead who lived in Murray Hill, the girl with curly hair who stole everyone's boyfriend. "This is my cousin, David," she inexplicably remarked while introducing me to one of them. Why was she telling people I was her cousin? Later, we had lunch at some pizza place she liked on Lexington Avenue and I asked why she invented the pretense. "Aduknow," she replied, blotting the excess oil from her pizza with a paper napkin. "I thought it would be shahp."

I contented myself with Vivian's nonexplanation. On some

level it made sense that she'd be eager to form a protective non-sexual alliance with another Jew. At the yeshiva we'd been repeatedly warned of the dangers of assimilation: now *we* were the dirty assimilants we'd been warned about. What if we assimilated parts of life that were dangerous? What if we unwittingly assimilated things that would kill or harm us irreparably? With all its rules the yeshiva kept us safe from unsavory gentile reality, and now we were imperiled. All that day I felt a deep, inexplicable longing for the yeshiva and my old life; yes, it was unbearable and stifling but it was all I knew of home. The City was surprisingly uninhabitable and unfriendly. I felt intensely lonely, and I hated having to start all over again.

Though the social scene was more balkanized than at the yeshiva, there was a small popular clique at York Prep. The de facto leader was Harper Goldfarb. She was in my English class. She wasn't pretty or well dressed, but I could feel her penetrating jurisdiction when we met, some aristocracy of blood she seemed to possess. "You're new," she said, less a question than a label she was affixing to me. "Where are you from?"

"Brooklyn."

"Oh," she replied, openly disappointed. "Well, I'm Harper."

When I repeated her name back, to make sure I'd gotten it right, her eyes contracted into little brown discs. "Not 'Hah-pah,'" she said, "Ha*r*per."

"I *said* Hahpah."

"*No!*" she said joltingly. "Not 'Hah-pah'! HAR-PER!"

"Hah-pah," I said, enunciating as best as I could. Harper bore into me with a tiny, vituperative sneer, then shook her head. "Forget it," she said, and she walked over to a group of girls wearing expensive-looking stirrup pants.

I felt like I'd been whipped, and the lash was sudden and inexplicable. Afterward, I locked myself in a stall in the bathroom and quietly sobbed in self-pity and frustration. I knew

Harper Goldfarb was right, and civilized people had a right to have their names properly pronounced—and I'd been *trying*. In the weeks leading up to my first day I practiced saying words in ways that sounded weird to me: "cahfee" instead of "cawfee," "sahlt" instead of "sawlt." I was desperate to shed my hideous, nasal Brooklyn accent—the very one I'd worked so hard to perfect just a couple of years earlier—but I hadn't been rigorous enough.

That night I spent hours taping myself saying words with hard Rs: "car" and "star" and "part." And I continued work on my vowels: "coffee" and "small" and "call." When I recorded myself speaking into the mic it didn't sound so bad, but when I played the tape back I sounded like a cretin: "CAWFEE. STAHH. HAHPAH." I erased it and started over. I kept trying, but every word I spoke felt alien. It hurt my mouth to talk. I'd already come to hate my body—its lurching postures and slumping scoliotic slants—and now I hated the sounds it emitted, sounds I couldn't control. I had to produce the sounds, it was the only way I had of reaching out to the world, but they came out of some broken, ugly, unfixable place in me. The sounds were echoes referring to some inner core of hideousness I had to either fix or kill. I had to reshape myself from the outside in, like Eliza Doolittle in *My Fair Lady*. I had to mentor myself—I had to do it out of the shapeless void of my inexperience.

I made an impulsive, breathless vow to myself to put things on my walls—a kind of stand I felt compelled to take against my own formlessness as a person. I bought a bunch of magazines, found models who looked interesting, zealously cut out pictures of them with scissors, and taped the pictures up on my bedroom walls in a makeshift collage. The models in the photographs weren't just people—they existed outside time, unchained to the past. They floated like planets in a magnificent constellation, sidereal and empty and omnipresent.

There was a series in *Rolling Stone*'s spring fashion issue, with Keanu Reeves wearing an ascot. I positioned that directly over my bed the way people kept icons of the Virgin Mary. There were two photo sets as well: the first was a series with Stephanie Seymour on a plain somewhere—probably Africa— alone and wearing a bra. Her hair was wet and blowing in a sirocco, eyes ringed in weary confusion. Another set had Linda Evangelista and Cindy Crawford wearing identical pixie hair- cuts with severe bangs that came to the very tips of their eye- brows. Cindy was more down-to-earth (which I already knew from seeing her interview on *David Letterman*, in which she talked about studying engineering at Northwestern) and Linda was deliberately artificial. Her poses were appealingly stagey, her eyes tinted a gemlike violet. She emanated splendor. I wanted that splendor for myself, but didn't know how to ac- quire it. I didn't know how to bring the objects I so desired close to me. I stared at the images for hours. They hung on my walls like emblems, symbols of an unimpeachable beauty I wanted to extract, absorb by the osmosis of simply looking.

The encounter with Harper Goldfarb traumatized me, and for those first weeks of school I worried that a black cloud of cal- umny had somehow followed me from the yeshiva, but it wasn't true. The initial excitement about me among the student body died down fairly rapidly but I was well liked. I avoided making any faux pas, and I was thriving academically.

I loved the secular curriculum at York. For my arts elective— they offered such things at non-Jewish schools—I took a drama class. The teacher was a woman named Barbara, who was an actress; she reminded me a little of the actress who played JR's secretary on *Dallas*. She had straw-blond hair and wore pearl earrings and ruffled blouses buttoned to the neck. The first play she had us read was *A Streetcar Named Desire*, which I'd read

once before in seventh grade. Then, it seemed like one of those etiolated classics, but this time around I felt the opposite: it was *too* alive, almost painful to read.

Blanche DuBois reminded me a little of people in my family: high-strung, neurotic. She's unbearably fragile. When she's exposed to a naked lightbulb she screams like her flesh is being incinerated. At the same time she thinks of herself as *cultured*; she refers to herself as a "cultivated woman" and "a woman of intelligence and breeding." Her brother-in-law, Stanley, thinks Blanche is a phony and a snob. He wants to expose her as a liar—but I didn't see her as a liar. Yes, she was dramatic and slightly annoying, but she was also like me, sensitive and poetic and desperate to re-create herself.

Blanche has an idea that she will marry a wealthy man named Shep Huntleigh, and wear furs, and live the good life, the life she wanted—but not *just* wanted, the life that was in some way most logically and appropriately *hers*. But that future never materializes. Shep Huntleigh never arrives to save Blanche. Instead, she falls in love with a bland man named Mitch whom she believes is a respite from sickening *reality*, "a cleft in the rock of the world to hide in." But Mitch finds out about Blanche's past: that her husband (who was, from what I could gather, a Lot Six) killed himself and Blanche became what the SYs called a *meshnooneh** and moved to a sleazy hotel called the Flamingo Arms and began sleeping with lots of strange men. Mitch says she isn't "clean" enough to introduce to his mother and breaks off their relationship. Then Stanley rapes Blanche, and the pile-on of traumas causes her to lose her grip on reality, and she is sent to a mental institution. I sobbed when the doctor from the institution arrives and Stella screams *"My baby sister!"* (which

* A crazy person.

made me think about my own sister and how she too was frag-
ile like Blanche, and how much I worried about her, that she
might kill herself one day or lose her mind), and when Stella's
friend Eunice consoles Stella by saying *"Don't look!"* as if by
denying Blanche's existence the whole experience would cease
to be real. In a way, that was what Blanche was doing too—
and what everyone I knew was doing. We were all trying to
collage together a reality we could stand to inhabit.

When Mitch calls Blanche a liar, Blanche replies that she
never lied to him, never "in my heart." I teared up reading that
line. The real world was phony, but the world in Blanche's heart
was *real*. I felt myself claim Blanche as almost a spiritual totem:
she was like me, an outsider, a sensitive person crushed by
reality—just as her husband was crushed by it, the husband
who killed himself for being a Lot Six. But the play brought out
my anxieties. Would I shoot myself like Blanche's husband?
Would I die or go insane? What made some realities stick, and
others not? I had no idea.

The days at York Prep were extremely short in comparison
with the relentless, all-day double curriculum at the yeshiva,
and since our classes ended relatively early, Vivian and I would
sometimes take off in the metallic-blue BMW her parents bought
her. We'd go cruising around the city, speeding up and down
highways, listening to the Cocteau Twins and the Sugarcubes
and singing along at the top of our lungs. If I could hear myself
sliding into my Brooklyn accent when we sang along to "Lips
Like Sugar" it was too much fun to care.

My love of art was revived around this time. I felt an excite-
ment about culture that took me back to my childhood, and the
trips with my mother. Together, Vivian and I retraced the old
haunts: we went to the Met and to MoMA, and to the Gug-
genheim, with its spiral interior that seemed to portend some-
thing holy and transcendent.

Soho still had an arty cachet back in the late eighties; the galleries were all there. We'd saunter in and out of them, then go shopping and look at clothes we couldn't afford. There was a store on West Broadway we liked called If, and a shoe store called Tootsi Plohound. Barneys was still in Chelsea; we'd trek up on foot, make our ritual stops on the different floors, then have lunch afterward in the chic downstairs atrium where we'd conduct bull sessions about our classmates. We'd laugh about "Harperrr" and her Rs so round they were practically compass drawn. We'd discuss our affection for the brooding Michael Veltin, and Michael's on-again-off-again girlfriend Deb, a straight-edge skinhead who wore Doc Martens and listened constantly to Salt-N-Pepa on her Walkman, and Deb's best friend, Allison, an aspiring model who'd just come out of rehab. Everyone got drunk on weekends and talked about their pot dealers. There was a ragtag, somewhat lurid feel to the student body—which consisted mainly of wealthy Army brats or people kicked out of better schools like Trinity or Horace Mann for disciplinary problems, taking drugs. One recent graduate strangled his girlfriend[*] and went to prison and it was on the front pages of all the newspapers. And a few weeks into the semester a congenial blond boy went to Phoenix House[†] and we never saw him again. A couple of months after *that*, a teacher was fired for having sex with one of his students on a class trip. I had no idea if any of this was normal. I just assumed secular schools were thronging with privileged attractive teenagers going to jail, having sex with their teachers, taking drugs. I decided I would acclimate to whatever set of norms presented themselves. Vivian, however, maintained a

[*] Robert Chambers, the infamous "Preppy Killer."
[†] A Manhattan rehab clinic that was popular in the prep school circuit.

cautious distance from the other students. Their predilection for drugs and drinking and sex intrigued her, but she viewed the whole experience as a kind of tourism or noncommittal moon-lighting. Vivian couldn't relinquish her Syrian friends from the yeshiva—they felt native and familiar, and she wanted to strad-dle both worlds.

Though I dreaded their inclusion, her friends sometimes joined us on our downtown rovings: carpetbaggers like Lou Cohen and Gladys Abadi. Lou was a grade younger than me, and I knew Gladys from the Dumb Class. Though we'd seen movies together and shared car service rides to disco parties, she now emblemized everything I hated about Syrians. She was needy and crass and wildly temperamental. Her reductio ad absurdum arguments obviated any possibility of having a nor-mal conversation. On our jaunts through Soho she dragged herself gracelessly from one shop to another, making small scraping sounds when she walked like her shoes were tacked with sandpaper. She spoke in long soliloquies about losing five pounds and how her contact lenses were hurting. She drove me absolutely nuts.

One afternoon, Vivian brought up her plans for college when, out of nowhere, Gladys violently stomped her foot against the sidewalk and shrieked YA MAKING ME NERVOUS! and then burst into tears. She sobbed hysterically as pedestrians squeezed by us, but I did nothing to comfort Gladys. I stared coldly at her pinched pink face as she wept and shivered. Vivian was more patient. She made circular movements on Gladys's back with her hand the way you did to newborn babies. She said "Are you okay?" again and again in a soft voice, and later plied Gladys with frozen yogurt and sugarless gum. Vivian ful-filled some maternal function for Gladys, and Gladys gave Vivian some sense of familial closeness, of family—but this closeness is precisely what repelled me. Gladys *was* me, she was

a version of how my life could play out. And the version wasn't remote and distant, it was standing right in front of me in an oversized Donna Karan sweater. I knew Gladys cried because she was trapped. I knew she would spend her life eating carrot sticks until her hands turned orange. I knew she would marry some guy she didn't like because her mother pressured her, and live in a two-family home near Kings Highway and shout at her kids and shout at the maid. She had no choices, it was all chosen for her, but I felt no sympathy for her. I *hated* Gladys. I hated how easy it was to be with her. I hated how naturally I was able to contour myself to her crazy tantrums and neuroses, how desperately I wanted to sit across from her in a diner and eat endless plates of disco fries. It would be so easy for me to slip back into that life: as simple as toggling a little mental switch in my head. The ease of it terrified me. There was a sick part of me that wanted to be stuck in the past, because the past was the repository of my so-called heritage and tradition and family, things that felt familiar. My intense aversion to Gladys was really an attraction, but I had to resist that attraction. I knew my desires were all contaminated, that my yearning for the past was a form of weakness in me I had to kill.

In the late eighties New York nightlife was still happening; there was a sense of a secret underworld that, if one were resourceful and hip enough, one could penetrate. Vivian scoured Stephen Saban's columns in *Details*, she read *Paper*. She did recon on what clubs were hot, and would take me to them—usually small off-the-beaten-path places with cheeky names like Jackie 60 or Million Dollar Bar (that one was on a boat) or Lift Up Your Skirt and Fly. Vivian and I wanted to immerse ourselves in this glamour as if in the waters of a baptism. We were stepping into a world where no one knew us and we could be anyone. We had passing encounters with semifamous club kids like

the It Twins. We saw drag queens (completely new to me out-
side of *La Cage*) lip-synching to old disco songs. There were
Eurotrash types everywhere, chic people who wore a lot of
black and were habitués of restaurants like Indochine and Ca-
nal Bar. Usually the Eurotrash were maître d's in restaurants or
models manning the phones. They were kind of moribund and
sexy at the same time, like Venus flytraps. They represented a
kind of glamour that seemed utterly unattainable. I was fasci-
nated by them, just as I'd been fascinated with the images of
fashion models I'd collaged onto my bedroom walls. With their
clothes and hairstyles, the Eurotrash were able to project a
story about life—a story of glamour and restaurants and par-
ties. I wanted that life, and fashion could help me acquire it.
Fashion created a narrative, and fashion made you a character
in that narrative. Fashion accomplished what the images in
those cubist paintings at MoMA did. It changed reality by
showing the world a version of reality that couldn't be refuted:
seeing was believing.

My wardrobe reeked of Lester's and Z Cavaricci. I threw
that stuff out. I bought a bunch of black clothes—monochromes
felt European. At Vivian's urging, I bought a velour harlequin
shirt at If, a pair of bright red wool crepe Yohji Yamamoto
pants, a black cotton shirt with a looped ascot at the neck. I
bought Stephane Kélian shoes that emblazoned a silk screen of
a cowboy on a horse—those cost four hundred dollars, but
everything was ruinously expensive, I wasn't going to be *cheap*:
I wasn't going to scrimp the way my mother did at Lester's,
with her "fit you in the tushy" criterion for buying me pants. I
wanted *the best of everything*. I blew whatever savings I had.
My mother hated my taste and wasn't afraid to tell me how bad
I looked. She said I looked impoverished, I looked horrible. I
studded a denim jacket with safety pins like the one I saw in a
Stephen Sprouse layout in *Interview*. She threw that in the

trash. Then I tore rips in my jeans—rips were just starting to become a thing—and she threw *those* in the trash. I bought Dirk Bikkemberg shoes that had thick horizontal metal strips banding the toes. My mother told me they looked like polio shoes. "You think that's *fashion?*" she said. "You think that looks *good?!*" Every time I walked down the stairs in some new outfit she'd say "What *now?!*" and subject me to her eye rolls and enervated sighs. But all this made me terribly happy: I'd banished myself from the Syrian Community, now I needed to inject myself with a dye that would change me forever.

I was enamored of Michael Hutchence so I bought a Fiorucci cropped denim jacket like he had in one of his videos, and started to grow my hair—it was curly, like his—down to my shoulders. But my British headmaster, Mr. Stewart, chided me one morning for it. I tried explaining that long hair wasn't merely a whim, it was a way of ingraining my new deep beliefs about being human. I tried to make Mr. Stewart see that my fashion statement was a matter of personal ethos and moral urgency—but there was *nothing he could do*, he said. *Rules were rules*. I started to weep right in front of Mr. Stewart. I didn't want to, but my response was cumulative: I was tired of being forced, I was sick of rules. In my lugubrious state I went to see Randi, my hairdresser at Bumble and Bumble. "Don't worry," said Randi, "I have an idea." She started cutting, forming my head into a kind of cantilever. She kept the front long but styled it so that it blew upward, as if by electric shock. To balance it, she let the back jut out a little and tapered it at the neck. She left the sideburns long, almost down to my chin. When she was done Randi handed me a shiny plastic canister. "This is *wax*," she instructed. "You take a *tiny bit* in your palm and you rub it back and forth like this." She illustrated by squeezing her palms together. "And you dress the hair like this," she said. She brushed back my hair with her hands. The

wax was viscid and heavy like glue or cement: it made my hair shiny and kind of goopy. The curls matted in frozen gleaming clumps, each ringlet sculpted as if by hand—my head looked like an edifice, like those steel-rimmed glass buildings that fringed the Manhattan skyline. I was able to stay in Mr. Stewart's rigid framework avant la lettre but the spirit was subversive.

I was transforming in leaps and giant bounds. My siblings were furious I'd abandoned my Brooklyn accent, they kept shouting at me to *tawk normal!*, but I saw them as victims of a sad atavism, a noose I'd sneaked out of before it could snap my neck. I started going to foreign films at Lincoln Plaza and the Angelika, European movies with subtitles: *Camille Claudel* and *Law of Desire*. Vivian and I loved the bleak and funny *The Cook, the Thief, His Wife & Her Lover*. After watching it, I read up on Jean Paul Gaultier, who did the costumes. I learned about other French designers, and French filmmakers and artists, and in all this effluvia of Europe and France I started to become more enamored of the French contingent at York—especially Paul Hamilton, a charming, attractive boy in my homeroom class. Even though I repressed all my feelings, I was slightly in love with Paul, and I think Vivian was too. He wasn't that handsome, but he was striking with his putty face and big guileless puppy-dog eyes. Paul's father was a diplomat and he lived in a giant penthouse on Park Avenue—but Paul was unpretentious. He was always bopping along to house music on his yellow Walkman, and every so often bleated a stupid phrase out of nowhere like invisible lined music in a cartoon: "HOUSE MUSIC ALL NIGHT LONG *SAY WHAAA??*" His French accent made everything sound poetic and elevated. I viewed the accent as a possible acquisition, like an expensive watch or rare book. I began to consciously affect Paul's accent outside of school. I'd buy my coffee in the morning with a French accent.

I purchased subway tokens with a French accent. I was desperate to be something new—why not *French*? Of course, it didn't occur to me to actually learn French, just to affect the accent—which I did by augmenting my ordinary speech with a lot of groggy "ehhh"s and "uhh"s, and giving myself a sensuous and vaguely psychological air. I thought if I continued to speak in a French accent it might take root in me in some unexpected permanent way, like seeds that blindly scatter into lush growths. I quit my job at Jazz and I applied for a job at Emilio Cavallini, a high-end retail shop on Madison Avenue. I used my fake French accent at the interview and it won me the job.

The manager was a diminutive, humorless Persian woman called Ziba who took fashion too seriously, even for me. Ziba looked a little like those women in Erté lithographs: she had a severe, cropped asymmetrical haircut and lustrous pallid skin—so pale it was almost blue. She was the kind of manager who liked to have lots of private, severe talks with her employees about their failings—these happened every couple of weeks. You'd be called into her office and she'd explain how disappointed she was. She didn't want you to speak or explain anything, she just wanted you to feel the impress of her disappointment. Sometimes while repositioning skirts on hangers I'd feel the weight of a disapproving gaze and there she was: wraithlike and blinking at me with her gooey black eyelashes. I felt a compulsion to please Ziba. I viewed Emilio Cavallini as a sort of laboratory where I could produce myself day after day in this new European format.

The clothes we sold didn't have a terribly pervasive appeal on the stodgy Upper East Side—the silhouettes were too avant garde, the palette of monochromes a little bit forced—but I was actually good at retail. My selling strategy—one I perfected at Jazz—was to tell the customers that they looked terrible in the first thing they tried on, then say they looked great in whatever

they tried on next. Since I seemed so honest about them look-
ing terrible in the first thing, they nearly always bought the
second thing. Retail was like that; there was a lot of manipula-
tion. It was tedious and crude. There was a lot of folding and
stocking and unstocking and restocking. There were long, bor-
ing stretches where you had to be accountable for your time—
you were on the clock, after all, bosses wanted to get the most
from their money, so you had to look busy (Ziba would actu-
ally say this to my face, "Look busy!") and refold sweaters even
though they were perfectly folded the first time. You had to
walk back and forth from the storeroom like you were actively
searching for something, when in truth you were just walking
in circles as people tried to extract some inexact demand for
work. But my job was to perfect an appearance—and it wasn't
just a job, it was a way for me to perform myself. The job was
theatre, and I was giving a stellar performance. I made more on
commission than even some of the full-time people. I felt good
about myself. I felt my life had value. It had value because other
people valued me: they believed in me, they felt I belonged, and
in the collective mirage of their belief I *did belong*. All that was
required was their belief.

I maintained my French accent with varying degrees of suc-
cess for the duration of my employment at Emilio Cavallini. No
one bothered to ask where in France I was from—a relief, as I
hadn't developed my lie that far—but I definitely made an im-
pression on my coworkers. The first couple of weeks everyone
was curt and professional, but then they began to open up.
When it was slow we'd all hide upstairs or in the stockroom
and dish about Ziba and make one another laugh. Frankie was
from Vietnam, she was trying to become a photographer. Ian
was tall and gracious and sort of august. He had every new
outfit; he was on the cutting edge of fashion all the time. He
slavishly spent his meager salary on expensive suits he got at

sample sales. To me, Ian seemed perfect, and I wondered how he achieved this perfection.

One afternoon he asked if I wanted to grab lunch, and we walked over to the Burger Heaven on Fifty-Third Street. I worried it might be awkward—we'd never spent time together outside the shop—but we talked easily. He talked about secret sample sales and models, new clubs, people in magazines. I listened in rapt anticipation and responded in my usual laconic suite of "ehhh"s and "uhhh"s. Ian told me he used to work at a high-end couture clothing store on the Upper West Side but hated it so much he had to quit. He talked a little about the woman who owned it who was so *notorious* for abusing her employees, he said, that they retaliated by starting a smuggling operation. They'd hide Matsuda and Claude Montana and Thierry Mugler in black trash bags, and at night, just before closing, carry them inconspicuously out with the rest of the trash, leaving them on a nearby corner with a newsstand owner to whom they paid a monthly sum. Once the manager was gone and the shop was closed, someone would pick the bags up from the newsstand owner. Then the salespeople would go off to nightclubs and convene with salespeople from Bergdorf's and Saks and Barneys and strike up bargains and trades. Evidently this became a pandemic, everyone in high-end couture shops was stealing clothes from their bosses, *but*, Ian said, it wasn't right, he wasn't morally okay with any of it, and the environment at the store was generally toxic and abusive, and all of this led him to eventually quit. As we sat and talked I found I'd stopped listening to Ian. I was interested in what he was saying but was more interested in *him*, in the sort of person he was. He had a gentle girlish face, pale and joyless. He sipped his soda and picked at his french fries with perfectly manicured hands, his fingernails brushed faintly with gloss. When I first met him I found him intimidating but, sitting with him, I saw

Ian was harmless; there was even something a little sad about him. He seemed like he was worried about something but had to fake insouciance—like he was a hostage, or had a bomb strapped to his chest. He looked straitjacketed in his fitted black Comme des Garçons suit—one I desperately coveted, but it was too expensive. The buttonholes in the jacket were each meticulously sewn with differently colored threads. Every stitch was perfect, every line in the fabric. But Ian looked mashed in the jacket, like a pressed flower. I could see the sadness in his eyes. It wasn't that puzzled ambient sadness Stephanie Seymour had in the photo set on my wall, it was grimmer. I wondered if I too had that sadness, if people could read it in my eyes the way I could read it in his.

Whatever misgivings I had about the project of my self-creation, I was able to steamroll past them, because it was working: my past really was fading away. In our senior year, Vivian's braces came off, and she started to mature into a very peculiar kind of beauty. That autumn she got a job at the same store where Ian had worked (she confirmed for me the existence of a couture black market) and her style became more rarefied. Her outfits got bolder and wilder and more European. She bought deconstructed suits by Gaultier that had slits near the breasts. She bought an Azzedine Alaïa taffeta pouf dress: it poufed at the sleeves and poufed around the neck; it was one big pouf. She even bought a dress from me at Emilio Cavallini. The dress was stretchy and bright red and flared into a hoop skirt ringed with an almost condom-like flexible wiring. The circumference of the hoop was about as wide as a Hula-Hoop; it was heavy and bounced up and down when she walked in it. I could tell it was supposed to be whimsical but it lacked the spirit of whimsy. I thought Vivian looked insane in it—but she wanted it, and in truth I was happy to get the commission. She wore the hoop dress one night to MK, but the club was so

crowded, she had trouble moving around. When she danced people mashed up against it, causing her to wobble unattractively. The skirt was mashed into various concave shapes: tilted like a satellite dish, banged into a hard right angle. The dress was a kind of violence, a hatchet she took to the dance floor, but I could see her delighting in this—just as she delighted in cursing out people who cut her off when she was driving, or (as she did one afternoon) issuing a vivid threat to murder the entire family of some lady who took her parking spot. With her red dress she was in the process of inventing a character, like a character in a play—a woman who was odd and beautiful and powerful, who'd never been to Avenue J or tried the lunch special at Kosher Delight. I caught glimpses of people staring at Vivian on the dance floor, as though she'd always been this woman with a red dress, as though she'd never been anyone else.

Gaultier was doing a whole cowboy theme that season— they were selling a bunch of his luxe cowboy hats at Charivari. For two hundred dollars I decided on the one Keanu Reeves wore in that photo set from *Rolling Stone*, a simple black hat with black snaps on either side. I'd never worn a hat before, and I hated cowboy hats, but filtered through Gaultier's optic it seemed European, and therefore more significant than American cowboy hats. I wore the cowboy hat to the Mary Boone Gallery and to Canastel's and to Soho and Tribeca. I wore it to clubs, to Nell's and MK and Mars. My body was no longer a vulnerable piece of flesh; it was a blank slate capable of taking on adornments and decorations, capable of being reshaped and carrying disguises and masks. Now that I had the cowboy hat I started fake-smoking Marlboros to get myself more in character. On the way to some club one night, I lit a cigarette in the subway station, and a policeman stopped me. "New York isn't like Texas," he said. "You can't smoke in the subway station."

"Sorry 'bout that, office-ah," I told him in my extempore

Southern vernacular, like I was the Outlaw Josey Wales. As the words came out, I had no idea who was speaking them—my own voice shocked me. The police officer smiled and nodded as I put out my cigarette, and I walked up the stairs to Fourteenth Street. I knew that when I replied to the police officer something was working through me, like the Holy Ghost—but it was a secular power, a power galvanized through Jean Paul Gaultier and Kenzo and Dries Van Noten. With my new hat, I spoke and moved differently, I became a different person—the way models in magazines apparently became different people with different essences when they changed outfits. Maybe fashion didn't just change how you were seen, maybe it could actually change who you *were*. The self was an endless burden, like a giant piece of luggage you were forced to haul around. But what if there was a way to remove the burden? What if you could just erase the self you had, as though it were a drawing in pencil, and start over?

In my senior year, some of the cliquey students at school began to accept me. They'd begun to invite me after school to Mama's Pizza, a daily ritual. I got invitations to weekend parties in the Hamptons, and hangouts at Nell's and Dorrian's Red Hand. Harper Goldfarb invited me to her birthday party at Mezzaluna, and I tried gnocchi for the first time and drank a peach Bellini. I felt sophisticated. I was in my element. My grades were good. I was in the process of applying to colleges. I thought, as per Weinberger, that I should go to USC and make movies, but Mrs. Stewart (the college guidance counselor) gently nudged me to apply to a place called Sarah Lawrence. It was a place for people "who are a little . . . *different*," she said, with the hushed and rueful circumspection of a nurse ministering over a terminally ill patient. I didn't like her tone. And what sort of name for a school was "Sarah Lawrence"? It sounded unaccredited.

I blew off the guidance counselor and finished up my applications to USC and my safety schools, but the weekend before the application was due *Vivian* urged me to apply to Sarah Lawrence. Mrs. Stewart said she was "a little different" too, and Vivian looked into it and got excited. She insisted it was the right school for me. It was highly ranked in the *Fiske Guide to Colleges*; it was artsy and modish and all the things I wanted to be.

It wasn't until a drive down to Soho to meet Gladys Abadi one afternoon that she finally convinced me to apply—but the deadline was in three days. Vivian said if we hurried we could drive up to Bronxville to snag an application before the office closed for the weekend.

"Do you feel like driving all the way up there?" I asked.

"Let's just do it, Adj!" said Vivian.

Gladys's face wound into a tiny compressed knot. "But we're going *shopping*-UH!"

"It won't take long," I said.

"It *will* take lawng!"

"We just gotta drive over really quick."

"WHAAYY!?"

"Because," I said coldly, "the application is due on Monday."

Gladys's expression ignited as if by solar flares.

"WHO *CAAAHES* ABOUT YA APPLICATION?!"

"Gladys," said Vivian, in a semimaternal intervention, "this is about David's future."

"SO MY FRIDAY IS *RUINED* BECAUSE OF HIS *FUTCHAA*?!"

Gladys was appalled by the notion of a future. Futures were things to be avoided until they happened—and even then, even when they became the present, you had to push *that* away; everything was intolerable unless it could be sublimated into little digestible bytes of distraction. Vivian didn't try to soothe

or mollify Gladys, she just kept driving. I could feel almost a literal break or split between the two of them, as if over the course of the drive they'd broken into separate continents and were now floating in opposite directions.

We made it to Bronxville, and I was able to get my application. But as I got back in the car, Gladys began waving her arms as if signaling for help. Her mouth hung in a sudden oval, her pudding face melting into teary blobs and spatters. "It's not *faih*," she cried. "*IT'S NOT FAIH!*" A minute or so later her loud sobs decelerated to low sputtering noises. I could hear her take small wavering breaths, but didn't dare turn around or speak. I didn't make a move. I could tell from Vivian's silence that Gladys had effectively depleted whatever reservoir of goodwill she'd managed to accrue up to then. We glided in silence down the Saw Mill and toward the Henry Hudson Parkway. After a few minutes, I sneaked a glance at Gladys through the side rearview mirror. She was a phantasm, a terrifying reflection of who I could have become. She stared out her window at the flux of cars and trees. Her forehead was beaded with droplets of sweat. Her mouth hung slightly open, baring the tips of her yellowed teeth. She didn't appear to be contemplating anything, not even her pathless future. Her expression was blank and slightly electrified; a kitten licking itself clean.

FRAMES WITHIN FRAMES

BOLT WAS FROM Camarillo and wanted to party and get hammered. That first week at USC he joined a second-rate fraternity and was drunk and doing beer-bong hits all the time. His fraternity brothers were always over getting wasted and playing poker. Their roistering kept James and me up—we shared one of the two double rooms in the suite in the Century Apartments with Bolt and someone whose name we never learned, whom everyone called Fish-Eater because of his predilection for cooking fish in a toaster oven. James and I would toss around in our beds moaning and cursing Bolt and his fraternity brothers under our breath at one, two, sometimes three in the morning. I could hear James's mattress creaking unhappily under his thin and slightly pubescent body, the rising and dipping notes of his voice cascading in quiet torment as he whimpered exhaustedly for them to "shut uuppp." I once mustered the courage to go out into the kitchen in the middle of the night to ask the fraternity people to quiet down. They were drinking from a beer bong and playing poker and throwing darts at a poster of a woman in a bikini. "Hey, guys," I said, rubbing my tired eyes for emphasis, "it's kind of loud." When they saw me, the fraternity people all traded smirks. "Uh . . . yeah," said Bolt, rushing me out of the room. "Okay, man, take care now."

Those first weeks of school I found myself comparing myself to Bolt endlessly, just as I compared myself to everyone, for I only understood myself in relation to my surroundings. He represented an aspect of California that felt slightly unreal to me, and a kind of manliness I'd never encountered. He looked a little like Tom Cruise, but a degraded inferior copy. The resemblance actually hurt him; it made him slightly grotesque. He had a big square face and huge white teeth and wore a retainer. His hair was glued in place with Dippity-do. His biceps were compactly formed like golf balls. He'd gaze at himself in the bathroom mirror for what seemed like hours at a time, mesmerized by his reflection as he inspected his acne, fixed his hair, checked to see if his muscles were getting any bigger. He was one of those men whose vanity was functional, instrumental— like barbell squats and dead lifts. He didn't seem at all bothered when one of us had to brush our teeth while he flexed and posed and gazed.

Bolt was striving toward a kind of masculinity, but the effort and attention he gave the masculinity felt feminine. Wasn't the whole point of masculinity that it just sort of fell off you, like sweat? At the same time, I knew these attempts to gild his masculinity were premised on real desires. He really *did* harbor lust for the bikini-clad girl in the poster that was covered with phallic darts. He really *did* want to take out his aggression on other men wrestling and roughhousing. Men wanted things, and that was part of masculinity. The authenticity of one's needs, if they were the right needs, if they were manly and rugged enough, could situate one in the world. The correct urges tendered status. My urges were the wrong ones—I didn't want a girl in a bikini, or to drink from a keg—but I was in the process of reforming myself. This was why I turned down my acceptance to Sarah Lawrence: it seemed too female. I wanted to become macho somehow.

When high school ended I came to feel the haircut Randi gave me was too desexing and fussy and decided to have it matted into dreadlocks. I found a place on Nostrand Avenue in Lefferts and got my hair braided. The braids were so tight they turned my scalp pink for a week. I stopped washing my hair so the oils would make the braids mat up. They were loose and malformed, but it was good enough to be a look—slovenly in just the right way. I had no real affinity for Rastafarian culture, but did not see this as an impediment to my fashion statement. The hairstyle was, more than anything, a way to project male power. But, studying Bolt, I realized if I genuinely wanted to acquire this power I had to change my *insides*, my core desires. Desiring things men were meant to desire was work; it would take effort, like posture. But eventually the effort would vanish, and it would become second nature.

My first afternoon at the Century dorm, there was an RA meeting in the lobby downstairs where we were admonished about drugs and STDs by a girl from a place called Montecito. The girl had a kind of optimism that felt unearthly, almost unhealthy. She had terrible cystic acne and plasticky sun-bleached hair and wore a "Go Trojans" sun visor. I came to the meeting wearing sunglasses and a tam knit in the colors of the Jamaican flag. I was trying to project sexuality and noblesse oblige—and it seemed to be working. During the meeting I noticed people sneaking intrigued glances my way. After the meeting adjourned the RA passed around a basket of condoms, and a small group clustered around me. I disbursed chocolate-covered espresso beans from a tiny linen sachet—I'd gotten them at McNulty's in the West Village the week before, thinking I could use them as a lure. The girl from Montecito swung her hair around: "*Yummy*," she said, "I love coffee *anything*!" When people asked where I was from, I replied "New York" with a perfectly rounded R. I conveniently elided my yeshiva back-

ground and made up some lie that I was a model and had done a bunch of runway shows. When people asked my name, I said it was "Dread." I'd changed it the week before. Some Rastafarian guy biking down Bleecker Street shouted it to me as a salute, which I promptly took as a sign. I could tell the Californians hadn't ever met a person called Dread. I could tell they'd never tried anything so gourmet and esoteric as chocolate-covered espresso beans. The whole thing went off without a hitch. I beamed inwardly with success.

Later that night Chris and Julian (they lived across the hall) made drinks called Purple Nurples, and James and Bolt and Fish-Eater and I all got wasted and went to a "big blowout party" at a room down the hall. At the big blowout party I chatted up a girl from Arizona named Eve Hammer. Her father invented cleaning products, she said. He invented a scrubbing brush that dispensed liquid soap when you squeezed the handle, and he got rich from the scrubbing brush, and the family moved into a mansion. As she spoke about the mansion, I felt myself entering it, as if I'd managed to break in with my imagination. I felt myself jumping forward in time to a deep intimacy I felt with this woman, an intimacy I'd never known. The liquor bolstered my bravery and in the middle of her conversation about cleaning products I leaned in to kiss her. *My first kiss!*

I took Eve back to my dorm room and brought some vodka with me. We were tippling and kissing and groping on the bed. My dreadlocks kept falling in her face and I kept pushing them away. To give to illusion of spontaneous desire, I climbed on top of her very suddenly, then lashed myself to her body like it was a mast. Her body was not compact, it was like a mountainous slab—too big to caress but I scaled its slopes and curves as best as I could. When I got to her face I could smell her hair, the tropic salvo of papaya. The dorm mattress made sharp

squeaking noises beneath us: hard evidence of the male prowess I was trying to make legible. At some point, Eve looked up at me through the miasma of liquor. There was a brief flicker of lucidity in her eyes: clearly, I had no idea what I was doing. I was trying to build a simulacrum of desire that would be perfect and complete, but the shape of the thing I was trying to build eluded me. I hoped some of my functional bisexuality would kick in—after Weinberger introduced it as a possibility, we never again discussed it; I was too shy to ask him about the particulars, and before I knew it the therapy was over, but I still clung to it as an ideal. I was hoping if I acted the part, new desires would spontaneously arise, so I tried doing masculine things. I shook Eve's shoulder and squeezed the skin on her neck. I squeezed her hands like they were the mitts of a lobster, then slammed them on the mattress so that the coils in it fleetingly fit my knuckles. "Do you have a condom?" she asked (my self-esteem skyrocketed; I was someone of whom such a question could be asked) and as it turned out I *did*—I'd taken it from the basket the girl from Montecito passed around that afternoon. As I drunkenly unwrapped it, a broad shaft of light enveloped us on the bed. When I looked up, there was poor James standing half in the doorway and half outside the room frozen in terrified *contrapasso,* his virgin insufficiency echoed and magnified by my display of manly prowess with Eve Hammer. James had broken a protocol; this was college and there were conventions around sexual activity, he should have known. "Sorry, Dread," he mumbled in shamefaced apology. He offered to leave but Eve said no, that it was alright, that she was drunk and had to go back home. James stood there for a long time apologizing gratuitously while Eve Hammer groggily buttoned up her shirt.

I felt intense relief. I didn't know if I could've gone through with it. And then immediately I began to spin a mythology about

Eve Hammer. I could feel the outlines of a story forming, the story of a man who desired nice heterosexual sex, a spurned lothario—but *sensitive*—who was desperately in love with an elusive woman. I could feel myself stoking new desires, insisting upon them the way my father insisted upon my endless unanswered Jewish questions. Eve became my idée fixe, an abstraction to which I attached free-floating urgency. If I kept the urgency alive, I could keep the power I'd been drawing to me those first few days of school.

I talked about Eve Hammer to James (who continued to frown naively and beat himself up over his bad timing and ruined protocol); I pined openly about her to Chris, the cute blond guy across the hall after whom I secretly intermittently lusted; I prated and boasted about her to Paul Bachant, my new architect-major friend who chain-smoked and was always cutting shapes out of foam core. I ambled through my suite of goosed-up regrets and fake-horny feelings for Eve to anyone who would listen. People were receptive to my plight—which was building momentum; it felt like the beginnings of a movement.

We started to refer to Eve Hammer as The Hammer, which sounded like something Fonzie on *Happy Days* might call one of his girlfriends. This pleased me. Straight men objectified women—I wanted to be one of them. It was male bonding, it felt like progress. I knew the progress was based on a lie, but I was holding fast to Weinberger's assurances (however vague) that sexual orientation was like a garment, and like any garment it could be taken off and reassembled at will. If that was true then I *wasn't* lying—or even if I was, I was lying to *myself*, which made it a kind of ethical stance, a way of repealing the lie.

A couple of days after the big blowout party, I got a call from The Hammer herself. She wanted to talk, she said, and

her voice had a gelid impersonal air. I took her tone as a kind of seduction. "I'll be right over," I said. I changed into my tam and Sex Pistols T-shirt and ripped jeans and walked to her apartment at the other end of the hall. But when Eve opened the door she wore a grim, uninviting expression. Her hair was in a matronly bun. She wore desexualizing sweatpants to make clear the platonic character of our meeting. She sat me down in the living room—a public space—and hastily proceeded to take inventory of my failings as a lover. She had not been impressed with my lovemaking technique, she said, and hadn't found my groping and neck and hand squeezing arousing but, on the contrary, boring and off-putting. I felt rejected and hurt but was determined to act bored and masculine (I think I even said something like "Whatever, Hammer," when she encouraged me to take classes in feminism).

If there was an advantage to The Hammer's rejection, it was that I now had permission to be crestfallen. I began drinking to excess every night to ward off the despair of my loveless solitude. I thought it would be compelling to be publicly drunk a lot, that it could signify lovelorn isolation, horny male drives, things that would make me sympathetic—but it was difficult to tease out validation from my roommates. James was nice but passive, Fish-Eater was lonely and strange—and I defied Bolt's basic precepts about what it meant to be a person, and he'd come to hate me for it.* I had to look elsewhere for social approbation.

I spent more and more time at Rona and Pam's down the

* Once I used his towel to dry off after a shower. I didn't know anything about living on my own and harbored the stupid assumption that college roommates were supposed to share towels, and he chastised me in his sleepy surfer drawl: *Dude. That's not cool.* This moment led to many unpleasant confrontations, and soon after my disruption of his beer-bong party and uncivilized use of his towel, Bolt and I were not on speaking terms.

hall. They consoled me chirpily about Eve Hammer and told me I was "going to find someone" and not to worry. Rona and Pam were a little déclassé but I liked all the attention they gave me. Their apartment was bursting with tennis trophies and pennants and Champion sweatshirts and purple eyeliner and protein bars. They sipped water from identical pink and purple water bottles emblazoned with school insignias: *Go Trojans*. They frightened me in the way Bolt frightened me, but at the same time they appealed to my appetite for normalcy. Their friend Cathy was over at their place a lot of the time—she too was approving, and consoling, and strangely in awe of me for reasons I never bothered to question. Eventually a clique began to form between the three girls and me, Paul Bachant, and Paul's two roommates—a blond, tall man everyone called Big Brother, and a sullen but intermittently sweet guy named Wulf. Together we'd shuffle in a pack to California Pizza Kitchen and to Westwood to see *Edward Scissorhands* at the Avco. We'd go to Tijuana and get wasted *off our asses*. We'd go to Marie Callender's for pie, to Souplantation for all-you-can-eat soup, on day trips to Manhattan Beach where Rona was from. I forgot about Eve Hammer, and forgot I was even trying to win people over with my performative kvetching and lovelessness. At times, though, I had no real idea what I was doing with these blond people who went to chain restaurants. Who were they, these chirpy happy people with helium voices and Champion sweatshirts?

Cathy was different. She seemed like the others—she drank smoothies and took aerobics classes—but was sensitive in a way they were not. Like me, she had an artistic bent. She wanted to be an actress, and had interned the previous summer at a place called Williamstown, where she met Rebecca De Mornay and the guy who played Norm on *Cheers*, and was Christopher Reeve's dresser for some play he was in. At Williamstown she

learned about an absurdist writer named Eugene Ionesco, and she got me to read his plays, which I loved. The comedy in them was dark and bold and utterly insane. "I find him very inspiring," she said. Everything inspired and impressed and interested Cathy. Everything felt so private and secret with her. When we were with the others I'd catch her laughing slyly at me, looking askance as though we were always in some secret communion—which, as it turns out, we were. She wasn't urbane or fashion conscious, she had a gauche perm and spoke with a midwestern accent, but I still liked her. When we were with our clique we walked a few feet behind, speaking in hushed tones in some new idiolect we invented on the spot. "Cathy and Dread!" they'd complain in tandem while making the requisite eye rolls and sighs. One night we ended up at the cafeteria, Café Eighty-Fuck (Café Eighty-Four but we thought it was clever to give everything a dirty name), and had one of those defining three-in-the-morning conversations about life, and how full of shit people were, and how sad it all was. I expressed my frustration with the superficiality of people—even as I strove for a kind of heightened superficiality in my own life. Everything I said back then was shot through with hypocrisy, but I didn't see it as hypocrisy; my thoughts and emotions weren't organized around a single center. I wanted to be too many things at once. I wanted integrity, but at the same time I didn't give a shit about integrity. I was a giant maw. I just wanted to consume everything, and I wanted to be more than the sum of my own parts.

USC was a large university; the different parts of it were like small microclimates in which I could experiment with different possibilities for the kind of life I might have. Suddenly people— all sorts of people—wanted to know me. I was a gadfly, the most social of social butterflies. And in this crazy fluxion of social

activity I found my way into a new and very prestigious all-male clique.

The guys in it were cut from the disaffected cloth of Bret Easton Ellis novels. Dominic was from Hong Kong and took a lot of acid. There was a British guy named Sebastian, and a goth called John who had Peter Murphy's threadlike slimness and dyed his hair bright pink. There was a deadhead named Chris from New Jersey who wore tie-dye shirts and had perfectly bronzed skin and big muscles. It wasn't a very cohesive group but we had a loose affinity for one another. We bonded in our common distaste for Trojans and football and the cheesy California stuff my other clique liked.

Together, we'd maunder in a pack and brood in sluggish silence. It wasn't the silence of rumination, it wasn't laden with hidden meaning or emotion, it was empty and masculine. I'd tag along in my usual phony equability whenever they went to a concert, or to Venice Beach to buy tie-dye shirts or drug paraphernalia. *I am becoming a man now*, I'd think as I essayed a diffuse manly enjoyment of our quiet aimlessness. I started to affect monosyllables and deliver them in a deep-voiced grunt: "Cool." "Rad." It felt strained but I inferred my discomfort was healthy. Dominic made me mixtapes of ska music, and got me a bootleg of a Bad Brains concert (because I'd pretended to like them), so I forced myself to listen to these at home even though I detested all of it. It was my castor oil, my homeopathy, a bit of poison to cure me.

With all my drinking and clique hopping I didn't give an enormous amount of thought to my classes. I didn't like college all that much. I was always at the bursar's office talking to some woman behind a plexiglass window. I hated all the pro forma course requirements and how students were herded like farm animals from place to place. I hated the broad boring

lectures in giant corporate amphitheaters, how professors as-
signed survey textbooks and took notes on large projection
screens. The one class I loved was Introduction to Film, taught
by a man named Drew Casper. Drew was very theatrical. Every
week he made his big entrance in his leather bomber jacket and
aviator sunglasses, and spoke over a tiny microphone clipped to
his shirt. He had spiky white hair, and his face looked pulled
back like he'd had a face-lift or two. Drew had an encyclope-
dic understanding of movies and film theory. His voice was
drenched with dreamy infatuation whenever he talked about
mise-en-scène or sound editing. If one of the TAs hadn't seen
some esoteric thing like *The Passion of Anna* ("one of the great
films of all time . . . by a *master*") he took it as a personal insult
and would reprove them in front of the class. He also loved
Doris Day. He would regularly sing the praises of *Lover Come
Back* and *Pillow Talk*, movies that sounded really shitty to me,
but to him Bergman and Doris Day weren't mutually exclusive.
I hadn't realized you could admit love for something lowbrow
and still be interesting. It occurred to me for the first time that
that could be a kind of sophistication.

We watched movies in that class that blew my mind: *Touch
of Evil, Caligari,* and *Wild Strawberries*. My favorite was *Rear
Window*. Jimmy Stewart plays a photojournalist hobbled in a
big cast and wheelchair who spends his days watching people
outside his window through binoculars. He has a girlfriend,
sort of (Grace Kelly), but he doesn't want to be subsumed into
her feminine domestic softness, with her mint-green dresses
and socialite luncheons and sybaritic lobster Newburg takeout
orders from the 21 Club. He wants his *masculinity*—something
he has to protect, just as Bolt had to protect his by inspecting
the little squares in his abdomen every morning in the mirror.
Grace Kelly is really into Jimmy; she wants a commitment. She
keeps appearing in swirling cocktail dresses and diaphanous

negligees, hair perfect, lips laminated with red gloss, but Jimmy prefers to stare through his telephoto lens, past the glass parti- tion of the window. "Can't we keep things status quo?" he asks, before dispersing himself in the flurry of images across the courtyard.

Jimmy seemed to desire Grace Kelly but he was ambivalent about that desire; maybe that desire would suffocate him and lead him to choices that would ruin his life. I connected to that problem. Drew told us the people in the building across the way were manifestations of Jimmy's fears and desires, and the prospects were sometimes grim. Miss Lonelyhearts tried to kill herself because men were so horrible to her. Mrs. Thorwald's husband chopped her into pieces and stuffed her in a trunk. The life you picked had monumental consequences. If you chose badly you could be destroyed. But if you *speculated* about other lives, you were safe. I understood this intuitively. I knew to cultivate distance in my relationships, and to compartmen- talize my life so that no one got close to me.

Sebastian and Chris's dorm room quickly became a social hub; it was where everyone went to get drunk or high. I spent more and more time there with the deliberate aim of studying manliness. I was speculative and remote, like Jimmy Stewart in the movie. I watched people more than I was with them, like watching the world from inside a cyclorama. Sebastian's side of the room was tidy, his walls festooned with tapestries and Me- tallica posters. Chris's was a debauched nest of beer cans and pot and ragged, unelasticized pairs of Fruit of the Looms. He was often drunk or stoned, and would customarily swagger around with a Budweiser bare-chested, or in a tight-fitting Hanes T-shirt so that the taut mass of his pecs bulged through the fabric. People I'd never met were always in and out, playing hacky sack or watching the same porn tape over and over. Boys with large, dark eyes played poker with their girlfriends draped

over them. Our masculine quietude was every so often punctuated with slight head raises to indicate hello, or high fives. Every so often someone would break out in a groovy dance to a Jerry Garcia guitar solo. I could never tell when it was appropriate to talk, so I trained myself to be quiet and genial. I didn't possess needs or opinions. I ceded my wants and desires to everyone around me so I could be part of life. I was scared to give offense, scared to reveal anything of myself, scared I didn't have a self to reveal.

Sebastian owned a bong and I admired him for it. The purchase of drug paraphernalia impressed me; it felt a sign of connoisseurship. The implementation of one's interests and curiosity into manifest plans, ideas into things, the formation of hobbies—none of this occurred to me yet; I was still too scattershot in my aims. I watched him prepare a hit one time. He pulled the clump of weed out of a small plastic bag he kept in his JanSport, then carefully parsed the clump for seeds, which he said made the smoke taste rancid. As I watched him, I began to feel that the agricultural aspect of pot smoking made it degrading. People culling flowers and plants to sniff and smoke, it seemed grubby—all that sad rummaging for pleasure, like they were starving orphans in a bombed-out shelter licking their hems for crumbs. At the same time, the desire to be stoned felt irrepressibly male. There was something so cavalier and dangerous about deliberately drugging oneself—it had to be a sign of manhood. The other guys would constantly push me to get stoned with them, but I still had my yeshiva-instilled ideas about even soft drugs; I associated smoking pot with AIDS and filth and pork sausages. I kept saying no to them, but my resistance only increased their determination.

Then one day Vivian called long distance to tell me *she* had smoked pot—and not only that, she'd snorted cocaine and shot heroin! She'd done all this with her new boyfriend, Carlos, a DJ

at the Sound Factory; they'd been dating since the fall. I found all this patently shocking. Vivian had been terrified of drugs and non-Jewish people, she was much more prudish and provincial than even I. But she sounded exhilarated—happier than I'd ever heard her. Though the shooting of heroin sounded extreme, I took it as a step in her evolution: I marveled at her bravery and daring. I also felt a tiny spike of competition with her.

I was over at the hub one night when Chris was being especially pushy. "C'mon, *Dread*," he beseeched, his voice inflected with that delinquent New Jersey drawl. His smile was half-cocked, gray eyes drooping and wide. And this time, I felt something in me yield. "Just one hit," I said. Sebastian clapped his hands and rubbed them together. "Dread's getting *baked*!" Chris took the first hit, then Sebastian—who, when he was done, oversaw my inhale. I sucked in the smoke as per his instructions. Seconds later, I felt something flip, like an air pressure change in my brain. I must've made a funny expression because Sebastian and Chris were laughing at me. The laughter was infectious, and eventually I was laughing so hard I fell off my chair. The room spun all around me. I was under the table, laughing and laughing. But even as I felt relaxed and happy there was a part of me that felt *too* relaxed, *too* at ease. My unmodulated display of enjoyment suddenly made me anxious. I felt scared they'd seen something in me I hadn't wanted them to see. My insides felt suddenly exposed, like a steel beam or scaffolding. I worried any unconsidered joy I felt would be used against me. The idea of having blind spots—that I would be viewed by another person in a way I hadn't predetermined, that some feminine need or longing could reveal itself—was unbearable to me. I lifted myself to an unsteady squat and grabbed onto the edge of the table to pull myself upright.

"Don't leave now, Dread," John said, "You're too baked."

"I'm okay," I said, wobbling out of the dorm room, but I

could barely walk. I was falling all over myself, high as a kite. When I finally managed to get to my apartment, James was at his desk, so I locked myself in the bathroom. I sank to the tiled floor, steadying myself against the toilet. My senses were all harrowingly alive, the surfaces cold and hard against my skin. The air was permeated with the peppermint stench of Bolt's mouthwash commingled with a vague halitosis. The seat of the toilet was up, the porcelain rim lightly stained with a urine glaze oxidized to a burnt orange. I imagined my entire existence swallowed up by that septic ugliness—and I'd been so careful: *so careful.* Up to that night I approached my life as if I were growing a culture in a petri dish or tightly sealed mason jar: it was a controlled experiment with isolated variables. Now I'd destroyed that work.

When Drew Casper screened *Rear Window*, it was for a class on modernism. Drew told us the bordered windows inside Jimmy's binoculars, which in themselves were frames, was Hitchcock calling attention to *another* frame: the frame of the movie screen. He said that in calling attention repeatedly to the frame, Hitchcock made *himself* the subject of the film. I thought that was clever. I remembered Drew traversing the aisles with his clip-on microphone and bomber jacket. "Frames within frames," he intoned again and again in his dreamy voice—like he was summoning some dead ghost, like he was trying to hypnotize us into appreciating cinema. "Frames within frames." Hitchcock's watermark was everywhere in *Rear Window* but he was also invisible, like God. I wanted that godlike power. I wanted to be unassailable, untouchable.

I'd kept my different worlds as separate as I could, but that wasn't enough. I couldn't continue to be a socially active gadfly and remain safe. It was too dangerous. I would be found out.

I made the choice to drop my cliques and abandon my social world. I stopped returning people's calls and going to parties.

In the spring I got my driver's license, and with the credit card Dad gave me I rented a cheap car for a few weeks. I spent my days exploring Los Angeles alone. I drove across town to West-wood and saw films at the old haunted movie palaces near UCLA where premieres were held: the Fox, the Bruin. I went window-shopping at Maxfield and the tacky thrift stores that lined Melrose Avenue.

I had a new look: I wore a blazer over a T-shirt and ripped jeans. I used Alberto VO5 Hot Oil Treatment to unmat my dreadlocks, and my hair fell in taut ringlets down to my shoulders. I tied a dark paisley-print scarf around my head like a pirate. I looked macho and distant; no uncurated feminine weakness could leak out. I was holding an idea of myself in my mind and I had to protect the idea, wrap it in a mental prophylaxis. I wanted to cultivate what Yvette Sutton used to call "mystery." I wanted to give myself an allure, and it was working. I'd walk down the street and people would nudge their friends and whisper and point semidiscreetly in my direction. I felt powerful. I felt I had tremendous currency. It was all very delusional, but there was something about being in Hollywood that lent to this kind of inventive distortion.

West Hollywood was teeming with gay sex. There were rent boys cruising Santa Monica Boulevard. Teenage boys with dicks protruding obscenely from pastel spandex who walked the streets, loitered at gas stations. There were porn shops lining Melrose—they weren't like New York porn stores in Times Square; these were almost elegant. I used to walk by one, faking noninterest, but each time I passed I felt more intrepid, until one day I went in. I'd gotten porn before: a few weeks after Howie impulsively shoplifted the *Honcho* in eighth grade, I bought a copy of a magazine from a newsstand on Coney Island Avenue, a niche-type thing in which all the men and women wore leather hoods with zippers. I was turned on by the

severity and brutality; it felt like life. I kept it hidden in a drawer near my bed, but my mother found it on one of her cleaning pogroms and off it went into the trash. Richie kept his *Playboys* and *Hustlers* in his drawer when he was that age, but those fell I guess into the realm of acceptable pornography, soft-core and benign, fantasies my mother could remotely comprehend a man having.

When I entered the porn shop, I told myself I would just quickly survey the contents and hurry out, but once I was inside it was like I had amnesia, and had no recollection of how I'd gotten there. I simply found myself in this place, this sensorium, with my desires and appetites spilling out into the open. As much as I was scared of those appetites, I felt the irresistible compulsion to sate them. I told myself this was a break from my actual life; sex was just one tiny compartment, a room in a series of unlinked suites.

The shop was well lit and incongruently cheery, and there were several men standing around thumbing through magazines. There were peach and teal shelves stocked with brightly colored sex toys, and pastel-hued lube. I went immediately to the straight section (in case I was being watched), picked up something like *Hustler*, and thumbed through it. I was much too frightened to move or look to see if anyone was evaluating my choice of magazine. After a few minutes I noticed a young guy inching toward me with a copy of *Inches*.

"Hi there," he said.

I was astonished at his action. I hadn't expected an actual human encounter, just a quick opprobrious visit to a porn shop. He directed my gaze to a few stills from his magazine. Two naked men were doing aerobics and lifting weights and performing fellatio on each other. "What do you think of that?" he asked. When I looked up, he winked. He was handsome, trim with auburn hair and blue eyes. I didn't know how to

answer his question. Finally I said, "It's good," with the notion that it was better to be concise than long-winded. "You wanna do this with me?" he said, now winking more inscrutably—the wink having dropped down into his voice somehow. My heart was pounding. I felt a tiny frenzy of energy in the pit of my stomach. "Okay," I said, feigning disinterest. I didn't want him to know he'd made any impression. I didn't want to bungle it with my bad self-esteem and nervous prattling.

We left the shop in silence and walked to my car. He was older than me but not old, maybe twenty-five or twenty-six. He looked like a completely different person in the sunlight. He was still handsome. I wasn't unattracted to him—I didn't know what I felt, I just vibrated incoherently with impulses. I felt the force of sexual desire without knowing how to peg it to the fuzzy coordinates of my own psychic life.

As I drove to his apartment, Inches touched my leg and sort of caressed it. I looked over at him and he was smiling a mischievous smile. I felt manly behind the wheel of my Rent-a-Wreck with this auburn-haired man beside me. He started to unbutton my jeans. He bent down and his head was in my lap. The unfamiliar scent of his hair conditioner rose up from my crotch. My car was swerving. "I'll get into an accident," I said, and seconds later we almost hit a passing car. My foot groped for the brake in a panic but Inches was undeterred, not caring particularly if we died or if we didn't. His bravery made me brave. My every consideration about life and death faded completely. My fears about AIDS and diseases vanished. I hated my desires overall but, in that moment, I embraced them totally.

When we got to his apartment, Inches removed his clothes and stood naked in his bedroom. It wasn't a nice apartment; the carpet was littered with unvacuumed debris, it seemed underfurnished. He wasn't well muscled but essayed various beefcake poses, borrowing unself-consciously from the debauched

vernacular of porn magazines like the ones at the store. I wasn't sure if I should touch him. I had no instinct to be sensuous. I took off my clothes, but didn't really want to be seen naked. Inches tried touching me but I flinched. I wasn't used to being touched, the nerves in my skin felt too alive. His lips stretched an involuntary shy smile. I worried I'd insulted him. "No, no—it's okay," I said. He tried touching me again but I flinched again. It was no use, I couldn't be touched. I thought he might be upset with me, but he smiled broadly, to show he was easygoing. He lay on the bed, legs bent in a diamond shape like an insect, and his pelvis rose slowly. This mimicked one of the poses from the magazine—the one with the aerobics. I could tell it was tongue-in-cheek but for some reason I took it very seriously. I could feel myself openly staring at him. I became an anthropologist, watching him gyrate and writhe, noticing the tiny hairs on his chest, the lines in his neck. I'd never seen a man gyrate for another man and I wasn't sure how to take it. It didn't seem masculine to me.

With his yellow knuckles he began to masturbate himself. I masturbated next to him for a while, mainly out of politeness. I lost the spontaneous feeling that overtook me in the car. He sucked me off. I touched him and played with his dick a little bit. When it was done we waved goodbye, like we'd been at sleepaway camp. He stood by the door and watched me leave, eyes twinkling, a faint smile spreading across his thin, pink lips.

In the car I felt myself shrink into my familiar snug carapace, my desires now capped. I felt a pleasant sense of order and calm. Driving toward the freeway, I passed the swath of gay bars on Santa Monica Boulevard with their pink neon signage, their Dolph Lundgren–looking muscle men spilling over onto the sidewalks with scooped pectorals and lantern jaws and dark tans and rainbow tank tops. The men all had that strange California physiognomy: those odd square faces that

reminded me of Bolt. Their hair was intimidatingly blond and either spiked or down to the shoulders. They seemed angry and horny and on drugs. Their bodies were hard, like armor. The men funneled in and out, place to place, their faces scrawled with sneers that passed for lust. The lust felt distempered with annoyance, like someone was late to meet them and now they had to wait around. Was that masculinity? Was it life? I had a quick impulse to park and go into one of the bars, but when I thought of myself circulating among these men I began to panic. I wouldn't know what to say. I wouldn't know who to be. I stared at the men for a while through the partition of a glass windshield.

Then the light turned green, and I drove away.

THE LONG CON

I WAS NOT LOOKING particularly forward to my brother's visit. As part of the larger project to erase my past I'd deliberately cut him out of my life—we hadn't seen each other or spoken in over a year—but now (for reasons that were, to my mind, incredibly stupid) his visit had become unavoidable. I'd moved into a new complex at the juncture of the 110 and the 101, not really within walking distance of anything, so my dad agreed to get me a car. I'd have been happy with some used piece of shit, but for some reason he'd become incredibly cosseting and over the top and told me he wanted ONLY THE BEST FOR HIS SON and I would have BRAND-NEW EVERYTHING and AUTOMATIC EVERYTHING. But rather than get the "brand-new everything" car in California, he got it, for reasons I couldn't ascertain, in New Jersey—in retrospect I'm sure it was hot, the product of some informal peculation or threat or handshake, something to make it worth his while to have it shipped across coasts. Except he scrimped on the shipping— and despite his grandiloquent speeches about "the best, the best" used some two-bit towing company, and my Honda was held hostage on a tow truck in Arizona for two months. "Don't worry about nuthin," said my father, who quickly conscripted Richie to take a bus to Arizona, confront and haggle with the towing company people, and then drive the Honda to Los An-

geles, whereupon he would crash with me and Leslie and Mike and make a little vacation of it.

Leslie and Mike were a couple I'd met in my film history class. They'd found the apartment and needed someone to rent the spare room. We clicked as roommates right away—and we weren't just roommates, it was deeper than that; we'd become a family. We cooked for one another and went to movies and drank wine and had long talks. I was scared of showing Leslie and Mike that I had a vulgar and spiritually ill brother. Not that I'd necessarily lied to them about who I was (I'd given up trying to pass myself off as an erstwhile model for Paul Smith and Gucci) but I'd faked, certainly, in small indefinable ways, a past, one that gleamed in the luminous shadow of my vague descriptors and ambiguous phrasing.

Mike didn't give a shit about status: he came from a bluntly lower-middle-class family in Camarillo, infamous, he said, for its disproportionately high concentration of mental hospitals. Leslie, on the other hand, was from tony Brentwood, and was the adopted daughter of a famous television producer. I found her slightly intimidating. She was from Los Angeles but seemed like a New Yorker. She wore a lot of black and looked like she'd be good at hailing cabs. She wasn't tanned or blond—she was whey-faced, with red hair and freckles, and she spoke with a slight lisp. The parts in isolation were pitiable but the gestalt gave her an impression of glamour. Throughout her childhood, her schoolmates tortured her about being adopted. She didn't belong to her family, to all that wealth and glamour—and that fact was impressed on her, just as the fact of her exceptionalism was impressed upon her. Even if Leslie repeatedly stated that she did not *feel* glamorous. So, like me, she hovered in between selves, a traveler caught between time zones. Maybe she sensed this root similarity between us and it was what prompted her to take a sort of pedagogical initiative with me.

Leslie seemed to know everyone and everything. Her parents were cineastes. She knew every movie. She referred to Woody Allen's longtime producer as "Charlie"—he was an old friend of the family. She understood screenplay structure and explained to me why mine (because I'd started writing one the previous year, I'd patterned it on Lina Wertmüller movies, and it was awful and made me question whether I had any talent) wasn't working. I was plagued with doubt, but Leslie soothed my fragile ego and said this was normal, that it was important to learn from your failures and move on. Her advice was so sensible! Why hadn't anyone said this to me before? Why did I have the misfortune of being raised by people who believed my every ambition was doomed?

And rather than lord her knowledge and cosmopolitanism over me, Leslie wanted to share it. She pushed me to register for summer classes with her at Santa Monica College—an inexpensive way to fulfill credit requirements for USC. She took me to her parents' house in Brentwood and showed me her father's Emmys. She explained how the star of a television show her father produced was difficult and was potentially bipolar. She toured me past restaurants she liked, and discussed politics that offended her. She spoke at long disquisitive length about a lot of things—it was like she held a constant salon. She wasn't confident, but I think my own insecurities loosened her up. She took me to a famous cheese shop she used to work at and explained how cheese was made. She said, "Cheese is the corpse of milk, Dread," and added that it was a quote from Nabokov. I was impressed with her ability to quote people like Nabokov; I was impressed with her encyclopedic knowledge of film and literature. I wanted her mastery, her capacious understanding of how life worked.

One afternoon she took me to see a double bill of Preston Sturges movies. I'd never heard of him but was instantly won

over by all the *prestissimo* dialogue and dry wit. For weeks we quoted Barbara Stanwyck's delicious one-liners from *The Lady Eve,* a movie that had particular resonance for me, because it belonged to that odd subgenre of parent-child con-artist movies I loved, like *Paper Moon* and *The Grifters*—films that stirred unresolved (probably unconscious) feelings about my own father, who himself was a low-level con artist (or at least that was how my mother used to talk about him, though she was typically oblique and light on details).*

In *The Lady Eve,* Barbara Stanwyck's character is conscripted by her father into a life of crime. He teaches her that crime is an art, that the criminal is a kind of demiurge who stands outside pedestrian moral economies, that "sucker-sapiens" *deserve* to be conned—offering as proof of their deservedness the ease with which he cons them. The father is genial and pleasant, we're not meant to despise him, but I did. He was more like a pimp than a father. He calls Barbara Stanwyck his "minx." He openly exploits her beauty as a lure, bait for the traps he laid to cozen the "sucker-sapiens."

Jean goes along with her father, just as my brothers went along with mine—but I rebelled. I told my father I wasn't going to study business. I outed myself as an atheist. I looked down upon my father. I believed I was morally superior to him and to everyone in my family—money was crude, business was crude. I was attracted to higher things. I had *great artistic ambitions.* I wanted to know about Nabokov and cinema

* The most blatant offense I witnessed was during senior year of high school, when I needed Dad to fill out financial aid forms. He had me come to his office, where I watched him use white-out to erase figures on his tax forms. He then typed in fake numbers on the electric typewriter, smiling and whistling some Gershwin tune. His casual perfidy seemed to go hand in hand with his religious beliefs and love of *hashem*—there was some logic in his head that tied it all together.

and goat cheese from the Pyrenees. I resented and judged my brothers—who, it was true, were simply following the rules laid out by my father—but he'd laid out those same rules for me and I found a way around them. I saw their obedience as contemptible weakness. They in turn saw me as snobbish and delusional.

Before I left for school, Richie, in particular, maligned me endlessly for my new elocutionary speech, and my stupidly expensive outfits. He was like Stanley Kowalski badgering Blanche: he thought I was vain and phony, he caviled nonstop behind my back (though someone, usually my sister, always spilled the beans about it) that I was "spoiled" and "thought I was *all it*" and better than everyone.

Now I worried he would intercept my still-unformed self-creation. I didn't want my new roommates to hear Richie's Brooklyn accent. I didn't want them to see his wardrobe that consisted almost exclusively of parachute pants and Hard Rock Cafe T-shirts—it would be like some vulgar part of *me* leaking out; it would thwart the impression I was trying to make.

Mike and Leslie couldn't have been more oblivious to my anxieties. They were like two small children waiting for Santa Claus: "Is Richie coming soon?" "We can't wait to meet *Richie*, Dread." I found their enthusiasm slightly bizarre. I didn't know what prompted their excitement to meet my brother and didn't know how to prepare them for their inevitable disappointment, so I said nothing and smiled, thinking they'd figure it out for themselves soon enough.

The day of his arrival I waited outside my building and Richie pulled up in the Honda. It was a silvery metallic color. I touched the glittering hull, which was burning hot. He lowered the window and poked his head out. "Nice car, brother Dave!" He was smiling broadly.

"How was the drive?"

"My back is killing me. Hop in!"

I opened the gate with the remote and got in on the passenger's side. "I thought the interior was supposed to be leathah," I said, slipping involuntarily into my Brooklyn accent like it was a worn glove. "You don't need leathah," he said, lightly castigating. "Be grateful you have a car."

Richie showed me some of the car's features (automatic seatbelts!) and once we parked it in the lot I gave him a quick tour of the complex. Now that he was ambulatory he began to perk up—he seemed to bounce when he walked. "So, ya workin hard or hardly workin?"

"I start summer school in two weeks."

"You look *mahvelous*," he said, referencing some skit from television.

"Thanks."

"You took that shit outta ya hair." He was talking about the dreadlocks I'd managed to reverse. He peeked over the guardrail, down to the atrium on the first floor. "Wow, you got a *pool*? Very arp-shay, brother Dave!"

I cringed at his Syrian use of pig latin. I hoped to God he wouldn't speak it in front of Leslie and Mike, who were waiting for us up in the apartment. To celebrate his arrival, Mike cooked Richie some kind of creole gumbo thing he found in a recipe book, and Richie regaled them with stories from his trip—the crazy lady from the Greyhound bus, the tow truck driver who wanted to break his face. I cringed every time he spoke—"Tawk," "cawl"—but his Brooklyn accent didn't repel Mike or Leslie. They seemed utterly taken with him, even with his unfurling hyperactivity and pent-up energy from the long drive. They didn't mind that he ate his food too quickly and spoke with his mouth full. They didn't mind his frenetic assemblage of vignettes from *Saturday Night Live* or that he peppered every other sentence with some Rodney Dangerfield

quote. We finished off a bottle of Chianti and Richie went to take a shower. "Dread," beamed Leslie, "we *love* Richie!"

"You do?"

"I wish Richie lived with us," chimed Mike.

"I wish Richie were *my* brother."

"Yeah, he's so giving and unselfish."

"Dread, he took *two weeks* out of his life to get you your car. *That's* a great brother."

Mike and Leslie were evaluating Richie along the lines of some criteria that remained invisible to me, but now the scales were falling from my eyes. Why didn't I see all the great things about Richie these two strangers could see? Why didn't I appreciate him? He *was* a great brother. He *did* ride all the way across the country on that shitty bus to get my car. Why was I so snobbish and status-mongering? Why did I feel the need to distance myself from him?

Los Angeles agreed with my brother. I'd never seen him so relaxed, so open. He seemed to love bunking with me in my downtown digs. I got him a little blow-up mattress and we stayed up late, talking and laughing. In the mornings he hung out by the pool. He went surfing with Mike. We all played volleyball at Venice Beach, then drove out to Malibu and watched the sun set. I felt a new intimacy with my brother. For most of my life I'd known him as someone very depressed and angry, but now he was almost childlike. He was so wide-eyed and in love with everything, like the world was brand-new. I realized I'd never taken the initiative to know him.

I'd never thought about Richie as a person, not in a deep way; he was just my moody angry brother. When I was little he barricaded himself in his room for hours practicing chord progressions in Led Zeppelin and "Smoke on the Water," cathecting the prison of his room with his own black magic. The wallpaper was diagrammed with maddening squares and

diagonals, brown and black and white—their oppressive recurrence lent the room a perspectival chaos; it made your head hurt. If my sister's room was florid and hysterical with its curlicued oranges and yellows, its overripe fruits and flora melting and grading unstoppably, Richie's was marked by a masculine linearity and lucidity; the lucidity was its own oppression tipped too far, metastasizing into notes that spilled out of his Cerwin-Vega speakers, vibrating in waves throughout the house. I could feel the treble pulsing through my heart, my own biorhythms substituted with this other alien pulse as I lay night after night in sleepless agitation. I could only know my brother through the remote din of that music. I didn't know how to get close to him. He was so angry. He hated his job; he hadn't had a real relationship. Anytime he showed interest in some girl, my father would insist she was trashy and unworthy and a "whooah" until Richie's confidence in his own taste was sufficiently shaken and he eventually stopped dating altogether. The resultant loneliness made him more sulky and tense than ever. He developed a distasteful brooding air that made people avoid and reject him, and the repeated rejections caused him to retreat from humanity. He bought a goldfish and became a vegetarian. He resigned himself to a monastic, joyless existence. When I started high school he bought a condo in Sheepshead Bay just up the street from Randazzo's Clam Bar, and the El Greco Diner, and the erstwhile Lundy's that was turned into an ill-attended, depressing weekend flea market where they sold clown paintings and scented candles and sweatshirts with phrases written in thick bubble script like *Life Sucks and Then You Die!* and *Where's the Beef?* He bought new accoutrements for his fish tank, glowing fronds and colored pebbles. He curdled into the acceptance that life was to be hated, that it was loathsome. When I'd come to visit him in the condo, the force of his negativity was so overwhelming it left me sacked for days.

But in Los Angeles I saw another side to my brother—and though every so often I'd find myself battered by his weirdly sudden chastisements (usually about my bad driving and inability to parallel-park), in general I was surprised by how pleasurable it was being with him. He could live vicariously through me, and if some of the vicariousness was fringed with slight resentment he could swallow those feelings for the time being and enjoy days at the beach and dinners in West Hollywood. He could marvel at the hills and canyons and sumptuous panoramas of Los Angeles. He was having fun. And it was fun *being* with him. And before I knew it I could feel myself sliding into the familiarity of the past—but not the ugly parts, the parts I liked; when I believed (because I did, at times) that there was a place for me in the world.

I toured him around the USC campus one afternoon—which had mostly emptied out, but summer classes were in session. "The G's here are *unreal*," he said, as we passed two blond sorority girls sipping smoothies and wearing short shorts. He had a big silly smile plastered across his face. I showed him the Century dorm, and the film school, and the building Steven Spielberg donated that from an aerial height reputedly looked like a grand piano. As I toured him through esplanades and manicured gardens, Romanesque buildings spilling with ivy and bougainvillea, I could feel my brother sinking into an Eden of repressed wishes. His excitement wound down. He got noticeably quiet. He seemed bombarded, crushed by all the beauty and possibility. He seemed sort of shrunken and lost, the way I used to feel when my mother took me to The City as a child. I could feel him pining for all the blond sorority girls he would never sleep with, the books he'd never read, the treasures life contained that would never be his. "You're so *lucky*," he said, his voice barely a whisper, his words filtered through a haze of unregistered disappointments and losses. He didn't seem

jealous, just sad, like his life was dissolving in front of his very eyes. "I never should have dropped out of school. That was so stupid."

"What school?" I asked—probably a little too bluntly, so that I broke the strange trance he'd fallen into.

"*David*," he said, "I went to Brooklyn College for a *semester*."

"I didn't know."

He cocked his head, and his jaw slackened slightly.

"Oh," he said. "Well, you were just a little kid then."

He said that in the middle of his first semester my father convinced him he didn't need an education. My father told him colleges were like finishing schools and made you effeminate and that he needed to get a real job. Through his connections, Dad found Richie a job at a typical SY tourist trap: that once ubiquitous but now semi-obsolete camera joint that flanked the streets of midtown Manhattan. The salesmen worked grueling hours; there was no minimum wage; everyone worked on commission and got paid under the table. The salesmen were adjured like foot soldiers not to let customers leave the store until they were "milked for every penny." Richie told me his boss trained him to con and scam. He'd never been so frank with me about his job, but everything about our relationship was suddenly different; he was being open with me—and not in an angry or sad way, he was just telling me the facts, like a journalist or anthropologist. He broke down for me the outlandish scams and rackets the SYs taught him—and not just the garden-variety sort like bait and switch, but other scams with little nicknames like "koshering a sale" and "building a sale." Richie did everything he was told to do, for it was obedience that was demanded of him repeatedly. The obedience his boss demanded was a diamond-hard reflection of the obedience my father demanded; everything in his life was spindled around that core subservience. The obedience and the demand for it came with

the tacit promise for love—but the promise never materialized, it hung suspended like a single quivering droplet.

I felt sorry for my brother, but mainly I prided myself on being able to outsmart my father. After swearing up and down for years that he was sending me to college, he had a sudden change of heart when I got my acceptance letter. He said college was too expensive, he didn't have the money for it. "You'll figure something out," he told me, but there was nothing to figure out: my financial aid was dependent on his income.

My mother was, as ever, a bellwether for Dad's shifting perspectives and opinions. She knew this was coming. She warned me to steel myself against his endless promises, but I wouldn't listen.

One night she sat me down in the kitchen. "I want to have a talk with you," she said, pulling a cigarette from the case. My mother wasn't particularly communicative—she never taught me life lessons, we never had family talks or meetings, so I found it odd she wanted to have one now.

"About what?"

"Your father has money." She held the cigarette so it was flush with her mouth; gray smoke wafted in sharply vibrating diagonals. The smoke gave her the air of necromancy. "He can pay for your school."

"He said he doesn't have it."

"He's lying."

"How do you know?"

"Just call him."

"And tell him what?"

"That he needs to *pay for your school.*"

Her expression was lacquered and cold, and the directness of her gaze unnerved me. The idea of commanding my father to do something for me, as she suggested, was an utterly foreign one. I had no sense of my own worth, and no sense of what

role, if any, my father should play in my life. "It's not his prob-
lem," I told her.

"*Bullshit*. A father is supposed to educate his children. That's
his job." As she took a sharp drag off her cigarette, I noticed her
hand shaking.

"But what if he doesn't have the money?"

"He *has* it," she said with defiant certainty. "He doesn't want
you to know what he has because he's a *con artist*." Her lips
curled into an embittered smile. "Don't you know that? Do you
have any idea what I've been through with this man?"

My mother liked to impress upon me the suffering she en-
dured over the course of her life, but I never knew when she
was being accurate or drawing impressionistically from a well
of her own deep hurt. I knew the hurt could stain everything,
warp the facts; sometimes I found her cynicism overdone.
"Can't *you* talk to him?" I asked.

"He won't listen to me. You have to do it yourself." Her eyes
gleamed with a tense, aggrieved worry. "You have to be selfish,
honey," she said. "Use him! Manipulate him!" Her voice was
stern and coarse, like a steely naval commander, but she had to
be that way, had to take the emotion out of it, bark orders—
and she was *giving* an order, she was doing it for my own good;
this was a lesson, a horrible lesson but one she nevertheless
needed to teach, a lesson in vice.* "Be *selfish*," she hectored again

* My mother was accustomed to vice. It was so common in the SY commu-
nity. In 1987 the SEC discovered that her cousin Eddie Antar was skimming
tens of millions of dollars in income from his Crazy Eddie electronics stores.
He evaded taxes, lodged tons of false insurance claims. He was hiding un-
reported income in offshore bank accounts, in the ceilings of houses, in
mattresses, in closets. He boarded airplanes with wads of cash strapped to
his body, deposited the money in an Israeli bank, had it wired to Panama,
and then laundered it *back* to New York—a scheme he called the "Panama

and again, though I knew she herself couldn't really be selfish—
it was more like she harbored a wish to become selfish, as if
selfishness was a kind of justice she could mechanically enact,
a very stubborn crank she could wind. She was just like those
characters Barbara Stanwyck played in movies I devoured after
watching *The Lady Eve*—women who were tough and hard-
boiled, because the world was brutal, and they had to fight
tooth and nail just to survive.* But under the tough veneers and
iron determination the women were in extraordinary pain.
"Don't be stupid the way *I* was stupid," said my mother, and
for a moment all her coldness melted away. Her lips pursed, her
eyes got glassy and red. "Don't let him ruin *your* life," she said,
in a voice that was soft and thin like tissue. I knew in that mo-
ment she wasn't just fighting for me, she was fighting for

Pump." There were all sorts of elaborate cons with all sorts of names. In
1984, Eddie brought the company public, overstating income to help insid-
ers dump stock at inflated prices. Once the SEC got wind of what was going
on, Eddie's father—who'd been estranged from his son and erstwhile part-
ner in crime—paid off witnesses in an attempt to frame his son and evade
culpability. His cousin Sam testified against Eddie, and Sam's testimony sent
him to prison. Eddie Antar became infamous as a symbol for white-collar
crime in America. Years later, when he was released from prison, an embit-
tered Sam confronted his cousin in a television interview. "You brought us
up to be *crooks*," Sam cried. "Everything I became I learned from *you*."

"No," Eddie replied, "we both learned the *culture*."

* Stanwyck achieves the ne plus ultra of hard-boiled glamour in *Baby Face*,
where she plays a barmaid in a sleazy joint adjured by a customer (reading
from, of all things, Nietzsche's *Will to Power*) to "use men . . . not let them
use you! You must be a master, not a *slave*!" Inspired by the customer, Stan-
wyck proceeds, via a series of elaborate chess moves, to pimp herself to the
top. She manipulates men. She procures for herself every material comfort a
girl could want. When, at the end of the film, her rich husband goes broke,
he asks her to make a sacrifice to help him, but she can't. "I have to think of
myself," she tells him, "I've gone through a lot to get those things. My life
has been bitter and hard. I'm not like other women. All the gentleness and
kindness in me has been killed. All I've got are those things. . . . Without
them I'd be nothing." This was the credo my mother instilled in me too.

herself, fighting for all the failed battles that came before me. Her demand was so intense I felt myself meld with it, I felt my boundaries involuntarily relax. I wanted her to know I identified with her, that I could protect her from my father's mendacity by seeing him the way she saw him.

The night I called him I used the phone in my mother's room, while she waited in the kitchen downstairs. I was terrified but I thought to use my terror to my advantage. I dialed, and when he answered I eked out in my shuddering voice a barely audible "Daddy?" as though I'd emerged from the smoke-dredged aftermath of an air strike. I made myself sound physically tiny, small and cowed. I exaggerated all my feelings of terror and anxiety and supercharged them, in improvisatory fits and starts, with a kind of derangement I suspected I always had in me but was now ripening into a kind of genius.

The conversation involved, on my end, a great deal of heaving, and crepitations of spit against the insides of my cheek, and choking endlessly on a slurry of tears and snot. It wasn't altogether a performance: I *was* the broken, hysterical man-child I was pretending to be. But I was able to use my despair for a strategic transactional purpose: I traded in my psychic pain for college tuition money.

As I spoke and cried and pleaded and choked—exploiting my father's idea that I was *pure* and therefore incapable of deceit—I imagined my mother listening in on the telephone line in the kitchen: I could see her in my mind's eye smoking and worrying, her worrying eyes lit like braziers as I worked the tat* from the master bedroom, absorbing her lesson, my education. She symbolically stood over me, head crowned with cigarette smoke that sputtered in irregular ovals. She was there in the

* Another way of describing a so-called short con, or one-time scam.

room with me, even if only in my mind's eye as a pleading, soundless omnipresence in her pink cotton robe and slippers. As I continued my weeping, extracting and extruding whatever weakness and pitiable feelings I could for my performance, I sensed there was something in my father that enjoyed the spectacle of my intense anguish. Maybe I exposed some broken part of himself he couldn't access but through me. Maybe I made suffering seem rarefied and beautiful—the pain consecrated by the vividness of its rendering, like those paintings of Saint Sebastian pierced with arrows. I was *pure* because I was a tormented emotional wreck. If I was sick and broken enough, he would rescue me—if I could heighten things to the level of tragedy, my father would sweep in as the deus ex machina. And then he did. He made a sudden volte-face. "Okay, honey," he said obligingly. "Don't worry about nuthin. Daddy'll take of everything."

"Thank you, *Daddy*," I said, in my saddest, tiniest, most regressed voice.

"Who does everything for you?"

"You do," I said, equal parts gratitude and opprobrium.

"Who takes care of you?"

"*You* take care of me," I pledged. I hung up the phone, thrilled by my own mendacity and brilliance. With no real expertise to draw on and only vague instruction from my mother, I managed to con my own father. Now I knew I could make my way in the world. I was building a ladder to live a more refined and artistic life; my father was a rung in that ladder. I used him to escape him, to climb up and out of my life so I would never have to see him again. As far as I was concerned my logic expiated me. I never again had to think about the matter.

But now I *was* thinking about it, and my thoughts left me with a queasy feeling. And there, in the quad, under the Tommy Trojan statue, in the shadow of his unsheathed sword, in a

sudden flash of banal clarity, *I could see the truth*: I was not
expiated. I was not a refined or moral human being. One
couldn't simply make a series of moral compromises, as I'd
done, and then be clean again—I'd signed a devil's contract
with my father; I'd fused my helplessness and his need for con-
trol into a single indissoluble molecule, and now I was more
bound to him *than ever*. He *owned* me: my car and school and
luxury apartment: those were his ghosts, they carried his pres-
ence. Not only did I *not* escape him, he was everywhere now,
like a pair of traveling eyes. I wasn't morally superior to my
brother: I was more my father's son than he would ever be. I
was *built* for scamming and conning—I was *moral slime*!

My thoughts pinballed from one grim association to the
next for what seemed like hours, until I ended up in a parking
lot staring at a bunch of SUVs. I was exhausted. My calves
ached. Richie was standing alongside me, hand cocked on his
hip. "*I'm starvin' like Marvin*," he said. His mouth was curled
into the tiniest of smiles, but he seemed slightly dazed or dehy-
drated, like he'd been wandering around in a desert. "Wanna
eat something, brother Dave?"

I took him to Senor Sushi, a Mexican Japanese fusion res-
taurant in University Village. I felt my thoughts spilling com-
pulsively over lunch and I couldn't seem to collect them, like I
was stanching a dam with my fingers and toes. When we were
finished, I paid the bill with my credit card, the one my father
gave me, but the credit card felt dirty. I felt dirty driving back
home in my shiny new Honda. I felt assaulted by its gray metal-
lic nothingness. Everything I said and did felt like spitting in
the face of my brother. All that night I was drowning in guilt
and self-loathing, but at the same time I could feel myself psy-
chically clutching onto whatever possessions and entitlements
I had. I wouldn't let go of my ill-gained possessions, not for
something so abstract as a moral principle. Not once did it

occur to me to ask my father to stop paying my bills. I needed that money; I wasn't strong enough to build a life without it. I'd always despised Dad for being a salesman, I thought he was vulgar. But I had to sell myself too, just like he did—just like everyone. It was how you survived.

On his last night, Leslie and Mike had to attend Mike's parents' anniversary in Camarillo, so it was just the two of us. I took Richie to El Coyote in West Hollywood. We had dinner outside on the patio overlooking Beverly Boulevard. The sun was going down. My brother's eyes were drenched with sunlight. His face was pink and shiny. His skin had an almost floral delicacy. "I don't want to go back," Richie said, smiling that same goofy smile he had scrawled across his face all week. "I want to stay here forever."

I took a sip of my Jarritos and grabbed a handful of chips. "You should stay a little longer."

"Nah, I gotta get back to work."

"How's work going?" I asked, thinking I was making bland conversation—but apparently I'd come across an unexploded land mine. The instant I uttered the question his eyes became glassy and distant. The warmth of his smile mineralized into stone.

"How's *work*?" he said, echoing my question with a cold shred of a laugh. "Work *sucks*. That's how *work* is."

I could sense it was a mistake to keep probing, but it felt impolite to simply drop the subject altogether. "Well . . . what's the matter?" I said. "Is the store losing money?"

"What store? We shut it down."

"You did?"

"David, what *planet* are you on?"

"No one said anything to me!"

"We shouldn't have to chase after you," he said. He downed the rest of his margarita and set the empty glass on the table,

the salt rim eerily intact like some kind of deathly exoskeleton. He then launched into a lurid story about my family: about how Stevie had ruined *everything*—how in the beginning it was alright and they were getting along, but he increasingly felt that Stevie (who hadn't invested a cent in the business, Richie made him a partner to be brotherly and bury the hatchet between them) wasn't pulling his weight. The store was hemorrhaging money, and Richie was forced to shut down. He was flat broke, having invested his entire life savings, so he went to my father (who, for reasons that remained unclear to me, owed Richie tens of thousands of dollars) and asked if Dad could pay some of that money back. Dad claimed he was broke—but then turned around and gave *Stevie* thirty thousand dollars to start some new business—only Stevie never ended up opening his store, and Richie was forced to get a new horrible job in Jersey, and now *everyone* was screwed over and fucked up and broke and miserable!

When the food came, Richie ate quietly, taking giant mouthfuls—as if eating would force out the bitterness he felt toward Stevie and my father. It was dark outside now, and the waiters brought out little candles. Outside in the air, my fears began to condense. As I sipped my Jarritos and picked at my guacamole, I began to feel sick with worry for Richie. He told me how shitty his apartment was, and how all his appliances were breaking. He told me about his horrible job, and how the commute was awful, and he was working for some SY everyone hated who docked him for snow days, and forced him to work weekends and holidays, and he was in total hell, but no one gave a shit, because *life sucks and then you die*!

As Richie went on about his life and how rotten it all was, his face grew more pinched and angry, his misery more reverberant, his stories increasingly bleak until I was six years old again, lying in bed and drained by those same invisible psychic

transfusions. But now his misery fanned my compulsion to save him. Maybe I could pull out the sick ideas implanted in him by my father and replace them with new healthy ones. Something loosened in him over the past week—we'd become *close*—maybe he'd be susceptible to my influence! I started making suggestions: what if he moved to the West Coast and started over? Maybe he could go back to school for music. He still had his equipment from the Musique Magnifique days—maybe he could be an engineer or a producer!

He rolled his eyes. "You know how hard it is to get that kinda job?"

"It doesn't have to be music," I said, maintaining my cheery tone, "You could go to Kingsborough. You could get your degree."

He scraped a lone fingernail against the edge of the table. "Daddy wants to start a new business," he said. "He wants to make me a partner."

"You think that's a good idea?"

"It's better than the shit job I got now."

"What if you went back to school?"

"I'm not going back to school."

"Why not?"

"Because it's not realistic. That's why." He dipped a bunch of tortilla chips in a grayish-green paste.

"You could take night classes."

"*David*," he said, "I'm thirty years old."

"Lots of people change careers."

"What am I gonna do, study for tests when I'm fuckin thirty-five?"

"Thirty is not *old*."

"And how am I supposed to support myself?"

"You can go part-time!"

"You think my shit boss is gonna let me work *part-time*?"

We went on like this, with me lobbing idea after idea, and him swatting off each one like it was some nettlesome insect, but I felt a sense of mission. I wasn't going to let him leave the restaurant until my brother saw what I did: that he could be free, that his life could be good. The more I suggested options, though, the more frustrated and clipped and turgid Richie got, as if my relentless optimism was a kind of violence, as if by chipping away at his ideas about life I was smashing him to pieces. He attacked me with one battering assertion after another until I couldn't stand it: "*Richie*," I cried. "You don't have to be so *goddamn miserable!*" I was so loud, people at adjacent tables turned their heads.

My brother glared coldly at me. "You have no right to talk to me this way," he said. "You have someone paying your bills. I don't have that."

"But you don't have to do a job you hate."

"Oh *really*? You think you know about how life works?"

"Yes," I said, now feeling cornered into giving reductive answers.

"So how does it work? You tell me, big shot!" My brother's face was aimed at me like a bullet. "You think you're a big shot now? With your car and your fancy college and your freakin condo? So then tell me! What am I supposed to *do*?!"

"Leave that shitty job! You can get something better!"

"That's not *reality*. It's not so easy like you think."

"I know it's not easy but—"

"No, you don't know *shit*! You don't know shit!" He gnashed his teeth at me like a small frightened dog, a small wounded thing whose every encounter was nerve-fraying and paralyzing. He couldn't try a new thing: a new thing was a bad thing. The present was intolerable but any movement would only make it worse.

Richie left for New York the next day and I was pulled into

that awful black hole of childhood. I slept a lot. I barely left the apartment. His repeated insistence that certain things were not "realistic"—a refrain heard frequently all through my childhood—wedged itself inside my head like some infernal piece of music, and I couldn't get it out. I used to dismiss him as provincial and limited, but maybe Richie was right: maybe I didn't know shit. Maybe I didn't understand reality. He had actual experience of life; he *didn't* have someone paying his bills. I'd been holding on to the idea that if I worked hard in time my molecules would be replaced and I could be completely new—but what if this belief was delusional? What if Leslie was wrong, and I *couldn't* learn from my failures and just move on? What if with all my running from the past I was like one of those protagonists from a Greek tragedy—like Oedipus, whose fate was unavoidable, who only got more trapped the more he tried to wrest himself from it? What if, like these tragic figures from literature, and like Richie, *I too* was programmed to self-destruct?

Mike dragged me to Gorky's late one night in an attempt to pull me out of my slump. I got a bowl of kasha and mushroom barley soup—it was the kind of food Howie's mother used to cook for us on Friday nights. The kasha had a ferrous taste I liked. "You know what I think, Dread?" said Mike. "I think you miss your brother." I nodded, but felt a strange feeling in my throat, like I might break out crying. I stayed quiet for much of the meal. That night I went to sleep and had a dream Richie was hanging from a cliff; when I reached out to save him, he refused to take my hand and plunged to his death.

I knew I had to cut myself off from my brother. I needed to cut the love I felt for him out of me, because it was hurting me. I couldn't force him to save himself. He didn't want to be saved, and that was his choice—and I believed then that you could choose to be saved. You could choose to be successful and happy, you could *choose* the kind of life you wanted. I knew I

needed to exert my will and every last ounce of strength to forge my own success, but it could happen—it was *already* happening. I was building a stable and healthy foundation for my life with Mike and Leslie. I was creating the basis for some future happiness my family could never give me.

Santa Monica College was awash in anodyne pastels, pinks and seafoams—strangely out of joint with the rest of California, which had moved on from pastel. The warmth felt slightly creepy to me, though. The school reminded me of images of state fairs from the encyclopedia, places whose surface warmth belied their essential municipal coldness. Since our summer class schedules were compatible, Leslie and I would carpool from downtown. The car rides made the tedium of gridlock bearable. We'd have long, involved conversations in which we plumbed unsoundable depths—deep, important subjects to twenty-year-olds. Leslie would unwind in expansive leisure around me. The ashtray in her Volvo brimmed with cigarette butts glossed with red lipstick. I was driving on a freeway to Santa Monica with a chain-smoker; it felt desultory and glamorous.

A few weeks into the summer semester, Leslie confessed that she and Mike were having problems. Mike was jealous of me, she said. He worried Leslie and I were having some kind of affair—why else would we be spending so much time together? How else could he account for our easy banter, our volubility, the deep conversations of which she'd apprised him?

I was secretly thrilled that Mike could suspect *me* capable of sex with Leslie but put on a good act of dismay and regret. "How could he accuse us of that?" I said. "It's crazy."

"Dread," she replied, "I love Mike, but sometimes he can be impossible."

Days later, Leslie conceded to Mike's demand, which was that we each take separate cars to school—which was absurd,

as we had practically identical schedules and left and arrived home at exactly the same times. I reluctantly agreed to his condition but never actually spoke about it with him, and when we were in the apartment watching television or cooking dinner Mike would act like everything was fine. But there was an undercurrent of tension. Casual conversation felt forced and inelegant. Leslie and Mike started to make displays of their cuddling in public areas in the apartment. The cuddling in itself was not offensive to me, it was more the inveteracy and frequency of it. *No one* cuddled that much. They were always in a pietà: on the sofa, the floor. When she chopped lettuce he massaged her shoulders. When she folded clothes he hugged her.

I felt less and less flattered by Mike's imagined rivalry. To forestall more awkward moments and give them space for cynosural cuddling, I would retreat to my room and study my astronomy and anthropology. It was awkward, but Leslie wanted to save her relationship. I could understand that. Then, just prior to the beginning of the fall semester, Leslie sat me down. Again, she'd been delegated to administer bad news: a one-bedroom was going to become available in the complex and she and Mike wanted to take it. This wouldn't be for months, she hastened to add, there was still time, but she wanted me to know. I made a visible pretense of being upset but I was relieved. Things had gotten too weird living with them, and I wanted to preserve our friendship.

I'd never rented an apartment on my own, so the following morning I called a bunch of real estate agents to get started and learn the ropes. That night, I found a bunch of moving boxes littering the living room. "*So*, Dread," said Leslie, her lisp edged with bitterness, "since you've decided to start looking for apartments *right away*, we've decided to move *tonight*." One of the agents, it seemed, left a voice mail on our answering machine and Mike and Leslie upon hearing it assumed that I'd planned

to bail on them. She talked to the landlord, signed a new contract, and now we all had to be out by midnight—including me. I wanted to explain that I was merely learning about renting an apartment, that I'd never rented one on my own and didn't know how to do it, but it was too late. Mike was packing avidly. He and Leslie were now mutually fortified by a new and enhanced dyadic closeness—a closeness obtained in large part by excluding me and making me the enemy. They had that certainty and unflappable energy in their box-packing couples get when they feel reciprocally galvanized in an assumption: I was a threat to their survival, I would sunder their relationship. I would threaten their shelter, their most primal needs.

I had no idea where I was going to go—or even sleep for the night. Mike was still mired in his preemptive, useless jealousy, but Leslie was capable of reason. I thought I might try to speak to her. I went to their bedroom, knocked lightly on the open door, and, when no one answered, peeked in. The room had been completely emptied out. The bed was gone, the cherrywood dresser. It was just carpet and louvered metal vents. The breeze from the ceiling fan made the vertical blinds clatter against the window. I saw Leslie inside the bathroom packing up toiletries and I knocked on the open door. "Hi," I said. "I just wanted to have a chance to explain things."

"Please don't."

"Leslie," I entreated gently, "this is so last-minute, and I don't have anywhere to go."

"Well," she said, zippering Neutrogena products into a tiny vinyl case, "if you need a place to stay, you can sleep on the floor of our new apartment." Leslie's tiny armored smile horrified me, the frigid chill of her indifference. I knew instantly there was nothing to be done, that whatever bond we had was permanently severed.

I nearly broke out sobbing, right there, right in front of

Leslie and all her toiletries, but I restrained myself. I left the room, packed my books and clothes as quickly as I could and shoved everything into the trunk of my Honda.

Leslie and Mike made a makeshift bed for me in their hall closet from a sheet and sack-like pillow. The new prefab apartment bore a superficial, eerie resemblance to the apartment we'd just left. It was like a wormhole in the universe, an upside-down mirror existence. Leslie blow-dried her hair. She and Mike laughed and canoodled, now with unforced enjoyment of each other—not a spectacle to ward me off; it was for themselves. They stayed up late talking and hugging as I lay on the floor, my head in the closet, fetal and unwanted. The carpet brushed against my cheek, its artificial poly fibers tickling my nostrils.

I thought families could be easily re-created, that I could pick the people I wanted in my life just as I picked my outfits for the day, and bonds would automatically form. I thought I was building a foundation for my life, but the foundation was quicksand. My heart was broken. I'd never experienced a breakup before, but I imagined it felt a little like this.

When Barbara Stanwyck's heart breaks in *The Lady Eve*, she experiences it as a death. Henry Fonda finds out she's a grifter and breaks off their relationship. She's never made herself vulnerable to another person, she's never exposed herself to love, and the rejection obliterates her.* She rushes to her cabin and falls apart completely. Sturges's camera holds on Stanwyck's sobbing over an agonizingly slow fade. The next time we see

* Earlier in their courtship, Stanwyck's father tries to warn her against love. He tells her to keep her distance, to use people like Henry Fonda for what she could extract from him, because love, *actual* love, was dangerous. "I don't mean for us," he tells her, "I mean for your *heart*." Watching the movie, I remember it being shocking hearing the father talk about any heart not on the face of a playing card. He was so venal, but—ironically—warning his daughter against love felt like the purest act of love in the film.

her, the cruise ship is about to dock; the warm flow of tears has congealed into a stiff wounded fury. Jean is wearing a funeral veil. She's been destroyed and killed, but has no time for grief. Stanwyck is reviving her *noir* persona here: she's a black-veiled statue of icy ressentiment. She's back at her father's side, back to hating humanity. "When I think we let that sucker off scot-free," she says, scowling, "it makes my *blood boil.*" If she's been a victim, now she will become a predator.

In the moment, I felt that same black veneration. I understood that rage. I was *trembling* with rage as Leslie's laughter echoed inside the cavelike hollow of my closet. I trusted people and I'd been screwed over, just like Stevie screwed Richie, and my father screwed over my mother. That was *reality.* It was how the world worked. I knew I had to embrace my own moral ugliness—because it enabled me to survive.

As I lay at the foot of the closet I could feel a power buoying me, a strength I always knew I had, but it was activated in a new way. I could feel my mother symbolically presiding over me, wreathed in endless sputtering ovals of cigarette smoke, her face burning with vengeance, lit as if by the flaming sword of an archangel.

SAVE US, SUPERMAN!

IT WAS THE second week of the semester, I was on my way to the Sarah Lawrence library when I noticed a woman crossing a small trellised path bisecting the Westlands Lawn. The woman had on a very elaborate, couture-seeming taffeta dress tiered with sashes and culminating at the neck in an almost Elizabethan ruff. But it was the hair—long and thin, crowned with the signature elfin bangs—that gave her away. Though our conversations had gotten more elliptic and distant, I still counted Vivian among my closest friends. But when she caught sight of me she seemed dismayed. "Oh, you're here," she said, as if describing a square of linoleum. She stood very erect, and there was a crisp glare in her eyes. The puckishness and humor were gone. She was unhealthily thin. Her cheeks were sunken in like those models in the Calvin Klein ads, eyes lined with dark circles—but she looked beautiful, more beautiful than I'd ever seen her. I got a good look at her dress, which was impeccably made: it was iridescent green and grape; the color changed when the fabric shifted in the light. I was wearing shitty Army pants and a cheap T-shirt I got for five bucks at the Antique Boutique—but that was how I wanted it now, the sartorial equivalent of a buzz cut, clean and nondescript.

"When did you get here?" she said.

"Last week."

"It's a cool place. The people are interesting."

"It seems that way," I said, manufacturing a weird grammatical politeness on the spot. I found her tone slightly unnerving—a tense alloy of forced and relaxed—and I lost the ability to make spontaneous conversation. "You look really well. Do you live on campus?"

Vivian produced a pack of blue Dunhills—Harper Goldfarb's brand—and lit a cigarette.

"No," she said, "I have a place in Manhattan with my boyfriend." She stared expressionlessly as she spoke and held her regal posture, her neck stiffly caged like those women in gilt-framed portraits. I noticed she'd lost her Brooklyn accent entirely—in fact I could see no trace of her former self, no winking acknowledgment that there was some other history to refer to. That history was gone now, and I marveled at the erasure.

We exchanged a few pleasantries, but eventually the duress of strained humor wore us both down. "You should give me a call sometime," she said in a valedictory tone, then blew a single smoke ring. Vivian had become a character in *Slaves of New York* or Stephen Saban's column in *Paper*. She was a new person, and the new person had contempt for me. The new person occupied some rarefied station in life, and I was just some ugly vestige from her past. Though it hurt me, I understood—and anyway, now I had greater ambitions.

In the first semester of my sophomore year at USC, Cathy made a grand announcement outside Café Eighty-Fuck. "I've decided to become an intellectual," she said. She told me she felt burdened by the superficies of Southern California, that she was applying to transfer to some other school, one that was more serious. I found myself oddly threatened by her announcement. *Should I become an intellectual too?* Chastened by her abrupt change in direction, I felt I had to match it. Within days I re-applied to Sarah Lawrence as a transfer student.

Even in that first week it was a relief to be back on the East Coast—away from stupid football games and vapid Californians with their tinted sun visors. At Sarah Lawrence there were no giant lecture halls, but intimate seminars in Tudor houses with little fireplaces. There were no grades because grades were vulgar; no tests because multiple-choice questions weren't a metric of actual knowledge. To me, it was heaven.

I made my initial pilgrimage to the library, which was newish—no carved alcoves, no intaglios of dark lacquered wood, no rooms with rare folios. Instead, there was a Norwegian-feeling sunken floor area filled with oversized floor pillows. The room was encased with glass walls like an aquarium and shrouded in silence. If anyone dared whisper a single syllable the whole room would turn against them with an enfilade of SHHHs and dirty looks. With all my sensitivity to noises and movements, I was in ecstasy.

I picked a pillow and sat with my copy of *Beyond Good and Evil*. It was like sitting with a boxful of jewels. There were no courses that semester on Nietzsche, so I'd devised an independent study. I knew nothing of him except for quotes like "God is dead" and the Barbara Stanwyck movie where she turned into an ice-veined harridan after reading him, but Nietzsche seemed the most serious of philosophers, and I wanted to become a *serious person*.

I gazed for a moment at the cover, which had an image of a beady-eyed man with a gigantic mustache. He wasn't handsome but I wanted to caress his hideous face, I wanted to stroke his mustache that desperately needed grooming. I knew at that shining moment, lounging on my huge pillow, white Westchester light streaming through the tall glass walls, that my life was about to change. I could sense this wasn't just a book, it was a passageway between realms. I closed my eyes and made myself empty inside, a receptacle for knowledge and nothing more.

The first few pages were exhilarating—though Nietzsche activated my bad self-esteem. Reading him, at times I could feel myself adopting a fake posture, like I was at a dinner party and didn't want to betray my own stupidity; I'd never read philosophy before, except for Plato's *Republic* and a couple of Ralph Waldo Emerson essays. Nietzsche was nothing like Emerson. He was provocative and sort of intense—and at first, I liked the provocations. But the further I got into the book, the more I felt my joy and anticipatory excitement turn to horror.

The truth was that Nietzsche seemed kind of crazy. His writing was extremely overheated. He seemed to be shouting at you constantly. There was a lot of talk of hammers and an overuse of exclamation points. He hated women. He was demeaning to other philosophers. He compared people to apes and worms (and at one point he used the phrase "pygmy animal," which sounded racist). He talked about things like pulling yourself up from a "swamp of nothingness* by the roots of your hair." I tried to picture myself ripping out my hair and pulling myself out of a swamp—a swamp *of nothingness*, no less—and felt sick to my stomach. It kept going like this, page after page: Nietzsche seemed deranged, but at the same time the derangement in the writing seemed urgent and potentially important. He was cruel, but there was something bracing and lucid in all the cruelty. "Almost everything we call higher culture," he wrote, "is based on the spiritualization and intensification of cruelty." Could cruelty be spiritual and beautiful? Could cruelty, if you just intensified it, be a portal into *culture*?

* He wasn't actually advocating for people to pull themselves out of swamps of nothingness—in fact, he was mocking the idea, but I'd misread him. It was easy to misread Nietzsche, but I misread all sorts of important texts in college, and the misreadings led me down a whole bunch of blind alleys in life.

A few pages in, he wrote that "charity is a malady" and I thought of Richie, my charitable, obedient brother whom Nietzsche would have hated. I thought of my mother's screeds about selfishness, and how much I'd been helped by them. Though much of what Nietzsche wrote felt wrong, maybe there was something right in all the wrongness.

In the aura of these mingled feelings, I grasped my yellow highlighter like a weapon, marking anything that seemed provocative or obscure so that my book glowed with haunted citric light. I read on, my stomach in knots: underlining passages, cradling his abuses to my little masochistic bosom. I was terrified of Nietzsche, and I fought him in my mind, echoing his cruel tenor with my notes in the margins: "*Total* contradiction!" "*Smacks of DOGMA?!*" "*What does that EVEN MEAN?!!*" I was fighting, *fighting*, but then I would feel myself being pulled by the seductive violence in the writing: the convulsing shocks and stabs, the polemical overuse of exclamation points. I wanted to hide from the klieg lights of Nietzsche's horrible merciless scrutiny—but I wanted to be *exposed*, too, and he could see me. He was calling to me with adjurations and warnings from the dead.

By the time I left the library there was so much exhortation and shouting and exclamation points that I felt slightly traumatized. I walked to my dorm room in a state of electrified horror. The Westlands Lawn was dark and desolate, like a graveyard. I was trembling with exhaustion. I felt the way I imagined prisoners in movies did when guards stripped them naked and sprayed them with some harsh cleansing acid: unhealthily cleaned, scoured to the point of illness.

I lived in a Tudor-style dorm called Gilbert. It was idyllic, the shining opposite of USC's styrofoam-and-caulk monoliths. My room smelled of thyme and moldering wood. Outside my window were tapering vistas. In winter the roofs shone with

snow-capped domes and gables. In the daytime bald white patches of sunlight peeked through branches of trees. I shared a single room with Kaspar, a transfer student from Antioch. He mainly ignored me that first week. When I entered I saw him at his desk, facing the window. He was wearing only Fruit of the Loom underwear, and reading a book. His body was small—almost a child's body—and his fingers were long and thin like insect antennae.

I tiptoed to my bed, so as not to disturb him.

Kaspar swiveled his chair around to face me. "Mmm, De-ved . . ." he said, "did you have a, errrr, productive evening?"

"Sorry, I hope I wasn't loud."

"No, no," he said, and he put down his book.

"I checked out the library."

Kaspar was the oddest-looking person I'd ever seen. His eyes were tiny and black and bulged like a beetle's. His cheeks were sunken in and set in relief against two protruding lips. The sides of his head were shaved, and the top flopped downward, draping his head like a black shroud. "And mmmm did you get . . . work done?"

"Yeah, it was productive."

"And *mmmm*, what are you reading, pray tell—errrrrr?"

"*Beyond Good and Evil*," I replied.

His eyes seemed to dilate. "Ah, *Nietzsche* . . ." he said, and his face widened with an initially multivalent spreading of fea-tures and flesh that resolved into a kind of smile. "Who is un-thinkable without Schopenhauer, yes?"

"Yes," I said, not knowing who Schopenhauer was or what he was talking about.

Kaspar's speaking voice was bizarrely deep for someone so physically tiny. He sporadically switched octaves midsentence as if tuning an instrument, punctuating his words with bi-zarre "mmm" noises. He'd gesticulate by holding his index and

middle fingers together, and canting his head right then left. His speech and movement seemed alien, almost mechanized, and seemed to point to some deeply alien spiritual referent.

"And what are you reading there?" I asked him. He lifted the book. It was one of those Penguin titles with the black border, something called *Gargantua and Pantagruel*. It sounded horrible to me, but exactly the kind of book I imagined him liking. "What class is it for?"

"It's not for *mmmm* class. It's, *errrr*, for a literary journal I edit."

Clearly Kaspar was formidable. He was an intellectual—but the other students thought he was creepy. He was always marching up and down paths in solitary ennui, with his flopping hair and bulging features, his tiny insect body swimming in the bulk of his trench coat.

I defended him to people. I was drawn to Kaspar the way one might be drawn to a lost animal. I wanted to believe his ugliness betokened some quarried, gemlike beauty. Sharing a single room lent a proximal intimacy to our relationship: I could hear the tiny bones in his bare feet crack when he walked around; I could hear him singing Elvis Costello and "Some Girls Are Bigger Than Others" in his off-key baritone while showering. He was so vulnerable and weird. His oddness and smallness and physical ugliness made me want to care for him—and at the same time I was magnetized by his brilliance.

Starved as I was for instruction, an informal tutelage began between us. Kaspar became my teacher, and I threw myself into my education. I purchased something called a Barron's *Vocabulary Builder* and a pack of index cards. I made hundreds of flash cards with words I got from combing through the book. I taped the cards in a grid on the wall near my bed. Every morning upon waking I'd memorize definitions. I read Heidegger, Kafka, Derrida. I read essays with titles like "What Is

the Thingness of a Thing?" Each day I worked myself to the point of exhaustion as a point of pride. I didn't need sleep, I didn't need food. My own pleasure or well-being was not a consideration—it *should* feel grueling, I thought. I saw myself as a rare stone that needed polishing and cutting. I was a brilliant gleaming diamond that only looked lumpen and black because I was untended.

Cathy transferred to Barnard that January, and I invited her to visit me in Bronxville just before New Year's. We hadn't seen each other in nearly a year, I was still in the pupa of my self-creation, but I wondered if she'd be able to see my still-forming spiritual greatness: would it be visible to the naked eye? I was polishing my spiritual beauty like it was a genie lamp, burnishing it for her delectation. When I picked her up from the Metro North station Cathy looked like a different person: gone were the fluorescent water bottles and fanny packs. She stopped bleaching and perming her hair; now it was flat and mousy brown. She wore a denim jacket, crappy shoes, jeans with rips and holes. She'd begun listening to Joni Mitchell. She purchased the new Indigo Girls and Ani DiFranco. It was a holiday weekend and the campus was emptying out, but I took her on a tour of it. I explained how the Oxford system worked, how much I liked the small classes, and the little Tudor buildings, and the fireplaces in classrooms. I explained how the other students were arty and troubled but that the trouble rippled with interesting details. I was *cultured*, not the rube she met last year who devoured all-you-can-eat focaccia at the Souplantation. I read aloud to her from *Thus Spake Zarathustra*. I spoke about cubism. I gave myself a psychological air. Was my greatness visible *now*? *Now*?

That afternoon I wanted to screen Bergman's *Persona* for her in one of the AV rooms in the library. "I don't really want to watch a movie," she demurred. "You've *got* to!" I said hotly.

"I'm locking you in!" Then I locked her in the AV room and watched the whole thing with her. I had to share this secret, this film that represented a part of me, a part I'd only hinted at. The movie was about fracturing identities, loneliness, desperation— things that pointed to a kind of profundity I wanted her to see in me. When it was over she was so shaken by the film, she couldn't speak.

Cathy was the first person I knew who understood pain in the way I felt it. Her mother died of cancer when she was very young, and that death affected her in ways she hadn't yet come to understand. She hadn't been to therapy, she couldn't speak openly of it. And we were just twenty years old, when anguish and its expression are still secrets to be buried. But the secrets gleamed in our eyes. And like the silver film crusting the surface of a lotto ticket, we couldn't help but scratch at them. Now that we were on the East Coast it was like some metaphysical filter was lifted and we began to reveal more of ourselves; the biographical details magnified into folios of wrenching sadness. The sadness became so constant, it *had* to be a mark of authenticity: it was the most stable thing either of us knew—it felt like a kind of bedrock. We began to take full ownership of this new, composite grief. We held grief almost in a kind of copyright. Every apparent satisfaction was merely a prelude to some new distress. The line between pleasure and distress was blurred. Sad things felt fulfilling and we confused the fulfillment for happiness.

That spring we were inseparable. I'd drive down to Morningside Heights and we'd walk to the Hungarian Pastry Shop and read together. We devoured culture with an ardor bordering on hysteria. Cathy was doing a whole class on Pascal and Montaigne. I was reading Kafka and Foucault. We had a relay race of personal development; we were doing research for characters we would eventually play in life. We both wanted to

be intellectuals, but there were different subcategories of intellectuals. There were warm intellectuals. There were nasty intellectuals, humorous ones. I was leaning toward becoming a dour, exacting intellectual like my English professor Danny Kaiser, with his jackal laugh and his shocked responses to students not having read important books like *Absalom, Absalom!* Cathy's intellectual was more stolid and a little depressive. We were equally drawn to stories of disintegrating and splintering psyches and felt it was glamorous to see this depicted in art—like running into a movie star at your favorite restaurant. Our cold-eyed apprehension of life thrilled us, it felt very grown-up. But where my tastes could sometimes get very lowbrow (I could enjoy bland pablum and stupid sitcom folderol) Cathy hated that mainstream *garbage*—she was too serious for that. "Ugh," she'd pule at the merest suggestion we see a dumb lowbrow movie, "it's so *sickening*!" She hated stupid action movies. She hated *Pretty Woman* and Julia Roberts. The ideological content of that movie in particular repulsed her: that a prostitute could be redeemed and "saved" *by a man*! I'd come to accept vis-à-vis Drew Casper's vocal love for Doris Day that lowbrow things had value. I could partition my mind and maintain a space in it where I could enjoy movies like *Pretty Woman*, but Cathy could not. Like me, she was getting priggish about her certainties, only more so. She only wanted to go to foreign movies at the Lincoln Plaza: *Un Coeur en Hiver* and *La Belle Noiseuse* and the Kieślowski films. She fell under the influence of writers like Marguerite Duras and Sylvia Plath. She liked the languid, doomed women in *nouveaux romans*, women who were unhappy and wanted to be annihilated by doomed sexual encounters.

The women were the antithesis of Julia Roberts in *Pretty Woman*; they were grim and unsmiling and somewhat dissociated. They were in the grip of dark forces from which they could

not be rescued; if anything, men would destroy them—desire *itself* would destroy them. This idea seemed very highbrow to her. The highbrow visions of female abjection in those books gave her grief something to fasten itself to. The grief was literary now, it was part of a tradition. The women in the *nouveaux romans* elevated her despair into something mythic. They were not just characters in books, they were her avatars. Through them, she fused with some archetypal feminine misery that filtered itself through the atmosphere, that was part of everything, part of history and life. The abjection in the stories correlated with her own abjection, and with horrible traumatic memories, like when she walked in on her mother holding a prosthetic breast and saw the scar from her mother's mastectomy and thought her mother's body (and *all* bodies) came in detachable parts—a horrible buried thought that had been disinterred in the archeological dig that was her English major. The past was a big black smudge on her life, and at the center of the smudge was the death of her mother. She never spoke about her mother's death with her siblings or her father. They tried to ignore it and move on, but Cathy could not. Now the kernel was erupting under the heat of her liberal arts education, the horror of childhood suffering pigmenting everything in the present moment.

She made regular, audible refrains about her wish to be mothered. She had become infatuated with Mary Gordon—the professor of the class about the depressed women—whom she wanted as a mother, and her obsession started to drive me insane. "I wish she could be my mother," she'd say again and again, "I wish I *had* a mother." I cringed at how openly she would admit such shameful wants and needs—why couldn't she want and need *nothing*, the way I'd taught myself! Her desiderata were open wounds, it was so ugly. Why did she need her mother so much? Why was she so stuck in the past?

We were at an Indian restaurant on Amsterdam when I confronted her about her unhealthy fixation. "You need to get into therapy," I said. Cathy stared down at her plate of uneaten chana saag. She was on some crazy diet that prohibited her from eating oil, and worried the waiter ignored her food restriction. "It's glistening on top," she said. "That's oil."

"Don't you think you're being a little extreme?"

Cathy laughed. "Oh, *I'm* extreme?" Her thick brown hair fell to one side and she pushed it back.

"What's that supposed to mean," I said.

"Maybe you should be the one in therapy."

"I was in therapy for years. I've been in therapy since I was fourteen."

"Okay, good for you."

"There's nothing wrong with therapy."

"Did I say there was?"

She was staring at the table. She dug her fork through her food, making a little furrow through the plate's diameter.

"I'm not the one who keeps bringing up my mother constantly," I said.

"Don't be so reductive. *God.*"

"It's not reductive to say someone needs therapy when they do actually need it."

Cathy was glaring at me now.

"You know *what*, Dread? You don't know what it's like to deal with losing your mother, and you're being a complete *asshole* to me right now!"

Was I being an asshole or was she being defensive and unreasonable? It was hard to know. We were fighting more and more around this time; small peccadilloes quickly blew up into huge arguments, and we were getting stingier and nastier with each other. I hated seeing the ungainly machinery of her thoughts, her failed attempts at sophistication. I'd erupt into

huge peacocking tantrums, and Cathy would respond in the vein of whatever Marguerite Duras novel she happened to be reading. We parried endlessly in this specular revulsion of each other. Even though our fights were utterly stupid, we staked everything on them. We were so eager to fight every fight, as if each idea was a limb or an organ, and if we lost the argument we'd have to surrender a part of ourselves we'd never get back.

Cathy's morbid incursions into the past made me more determined to propel myself into the future. I was up every night in the library with my trusty highlighter reading Balzac and Ralph Ellison and Hélène Cixous, transcribing polysyllabic words onto index cards, unknotting Proust's winding clauses and the strange marginalia in Derrida's *Glas*. I worked until my body shook with fatigue; it was like I was training for an Olympic event. But I was getting smarter. I felt the ideas from different books and writers connecting and interleaving, building into a reticulate order inside me like arteries or veins. I was no longer frightened of Nietzsche; now I drenched myself in his ideas. I read *The Birth of Tragedy* and *The Will to Power*. I read Heidegger's multivolume biography and Stefan Zweig's. I read about Nietzsche's hideous sister, Elisabeth, who co-opted his work and tried to refashion it for Nazi propaganda. I read his "Madness Letters" from 1889, how he signed them *Dionysus, Jesus, Napoleon*—fusing his own life with myth and history, the way Cathy did with the depressed women in Mary Gordon's class, the way I soldered my own self to Nietzsche.

For Nietzsche there was no self. The "self" was, in his words, "an audacious forgery."* There were no facts except the facts you

* He contradicted this idea elsewhere, as in *The Birth of Tragedy*, which contains the famous aphorism "become what you are"—suggesting an essentialist humanist notion of the self, with the "true self" locked inside the

invented. Reality wasn't objective or solid, it was a perspective—and the perspective could shift. Reality was just another kind of artifice. If that was right—if artifice was simply another kind of truth—what did it matter if you were truthful or not? If there was no truth, there was no self. I didn't need a new past. I didn't need a *past*, period! I could create myself from sheer will, moment to moment.

It's impossible to overestimate how seriously I took these ideas. There was nothing speculative about my reading of Nietzsche: as far as I was concerned, he was offering me a practical guide for how to live. I was drawn to him the way I was later drawn to bad romantic relationships. In some sense, my infatuation with him *was* romantic infatuation—it was Freudian. Nietzsche was the family I was running from, the insanity I wanted to escape to become sane and cured. But if my father suffocated me with his narratives, Nietzsche offered me a narrative of limitless freedom. God was dead, and it was up to the *Übermensch* the Superman—to imbue the world with meaning. The Superman establishes his own values in the vacuum of a godless world. He embraces all of life. He does not turn away from pain or suffering, for he is the embodiment of human *greatness*. To be great meant you had to overcome your own self—and I took this as a personal mandate. Maybe greatness would compensate me for all the indignities I'd been forced to suffer in life. "Man," wrote Nietzsche, "is a rope tied between beast and Superman. A rope over an abyss." The task was to

person like a piece of unsculpted marble. And in other writings he suggested that the past can never be eradicated, that we must accept and even *will* the "eternal return" of it—i.e., live out said past again and again like in *Groundhog Day*. There were lots of contradictions like this inside of Nietzsche. He had a Rorschach quality—he could be whatever you needed him to be. And I needed more than I could ever admit at that time. I conveniently (and shamelessly) read him against the scrim of my own prejudices.

cross the parapet, to walk the tightrope from slouching beast to *Übermensch.*

Kaspar oversaw my progress as though he were monitoring a child's science project. He'd look over at whatever I was doing and make a patronizing little fist and salute: "Keep *going!*" He tendered flinty little compliments that had the result of making me feel small and useless—but at the same time I felt flattered, *seen.* I gave him short stories I'd written and he'd make purplish, equivocal comments: "You're not *un*talented. You have a certain felicity of phrasing . . . a *word sense* . . ." The swollen narrowness of his face exaggerated his every movement and gesture; he was odd and possibly malign but it didn't matter—I wrapped myself around his approbations like ribbons around a maypole.

I began to write down and memorize clever things I read or thought—then I would regurgitate them for an audience and make the thoughts appear spontaneous, as though they emanated naturally from me as a kind of glittering residue. I collated new traits and mannerisms: an empty series of gestures I could unpack at will, the way a child unpacks toys from a chest. Smugness seemed like a virtue so I faked it. I swaggered around campus in self-mythologizing postures. I wore my arrogance like an insignia. In the back of my mind I could hear Nietzsche barking at me: "Clench your teeth! Keep your eyes open! Keep a firm hand on the helm!" I began to walk upright and puff up my chest. I shot words from the Barron's *Vocabulary Builder* like lead balls from a cannon. If there was ever an opportunity for me to say "prestidigitation" I seized it! Nietzsche cautioned against sympathy and the warm heart so I made my heart freezing cold. I had to be as vicious and sophistic as I could. I began to develop a reputation among teachers and students of being formidable and brilliant. I battered other students with counterintuitive ideas that were hard to argue. I tormented my

classmates with crazy, baroque attacks in class—but I *had* to be cruel. Charity was a malady, cruelty was my portal to higher culture, and I had to be *cultured*. I had to become the Superman. I had to be severe and unforgiving of people's failings, the way Harper Goldfarb had been with me when I couldn't round my Rs, the way Nietzsche had hurt me with his name-calling and sickening images of hair-pulling and swamps. Pain was astringent and clarifying. Pain would burn away the mediocrity until all that was left in the world was a bright shining nucleus, a single electrified atom of human greatness. I wouldn't be like my brothers, or my sister, or anyone in my family. I wasn't *part* of a family—I wasn't part of *anything*. I was living on the flickering border of life and death, real and imaginary. I was like Atlas, supporting an entire universe with the strength of my own mind, my *will*.

One crisp afternoon, as I basked in the lambent glow of my academic success, and waited on line for a grilled cheese at The Pub, a girl from my nineteenth-century literature class accosted me. Sarah Lawrence wasn't a haven for preppies but this girl was a rare exception. She was intelligent, but had an unsavory primness. She wore Izod sweaters and had a shoulder-length haircut with short, precise bangs. As she approached me, I saw right away she looked dazed, and a little worried. "I was upset by your comments in class," she said, referring to a cynical defense I'd made of one of the utilitarian characters in a Balzac novel. The Izod Girl was a humanist. She wanted to scold me for my corrupt and jaded morals. On the surface it was not a scolding, just a friendly colloquy, but there was a touch of crusty lecturing in her tone. That made me angry. And so, marshaling the unseen forces of flash cards and painstakingly memorized quotes, I began to dismantle her flimsy premises. Piece by piece, I broke her down. She argued back but I argued harder. My arguments were like shards of glass cutting and

slashing at her. "But that's moral *relativism*," she cried, when she could take it no longer. "Because *I am* a moral relativist," I replied, brushing off her silly philistinism like a cobweb. The girl looked me right in the eye, and I looked right back. I stared with such chilly defiance it made her face redden in splotches. I enjoyed the spectacle of her defeat. I enjoyed watching her slump away with her soggy sandwich of sprouts and cucumbers. At the same time I couldn't shake the feeling that there was something depressing about this person I'd become. I was like a house made of all bricks with no rooms, fortified and empty. I had no friends, not really, and I was still in the closet. I'd started having semiregular sex—a bunch of one-night stands with boys I met at school or on chatlines—but was still deeply in denial, and couldn't begin to envision being in a relationship or falling in love.

And yet, I felt, for the first time in my life, *powerful*.

I didn't want to relinquish that power.

Cathy began emulating my snide aristocratic airs—maybe they were part of some readerly effluvia from her Marguerite Duras books, I wasn't sure, but our friendship, which I'd begun to rely on as a salve and reassurance, had suddenly become very punishing. Her disgust toward me had become intense, and would break out every so often like a blistering rash in the form of nonstop insults: How could I fail to see what was so *gobsmackingly* apparent? How could I be so stupid and retrograde and useless? We'd eat dinners together in drawn-out, aggrieved silence. We'd suffer long, quiet drives in my Honda as we stewed in our private frustrations and animus. When she wasn't shouting at me, she'd be hunched in a sweatshirt, a dark silhouette in my passenger seat, hair in her eyes and clutching a copy of *The Bell Jar*.

Over time, Cathy became increasingly tiny and locked; she had to completely cut herself off from me or risk being infected

by my cretinous thoughts and utterances. The more discon-
nected she got, the more I'd fight to make her see my position,
which would only make her more disgusted, more locked. She'd
make little quiet ripostes only half meant for me, so quiet I
could barely hear her. Her voice was soft and gravelly, like
she'd had a long screaming tantrum and was now hoarse and
tired. Her psychic shutdowns put me in a momentary state of
terrified distress. I couldn't bear to be ejected from the bubble,
the privileged communion we shared. And then, just as I'd
think the friendship was done forever, her outlines would sud-
denly sharpen, her eyes would beam with adrenaline and in-
tense need, and she'd make a new bid for my affection.

Back in those days, I was predisposed to magical thinking. I
had the naive idea that I'd crossed over to some idyll of intel-
lectual perfection, and that once you became an intellectual
nothing bad happened to you. So when things took the turn
they did in the spring, I was shocked. It was barely light outside
when the phone rang. I fumbled for the receiver—wedged, I
remembered in my half-asleep state, between the mattress and
the wall, where I dropped it after some three-in-the-morning
conversation I had the night before.

"*Dread?*" said the tiny, frail voice I recognized as Cathy's.

"I asked you to please stop calling me that." I felt a terrible
pain behind my eyes, like I hadn't slept in weeks. "Can I call
you later? I'm still asleep."

"I uh . . . I'm in the hospital."

I sat up in bed.

"What happened?"

"I'm in the psych ward," she said. "I had myself committed
last week."

After a stunned silence I asked if she was okay.

"Not really," she said.

Her tone was affectless, and there were odd silences after all my questions. She sounded so tiny and far off, like she was calling from overseas.

"Did they give you drugs or something?" I said. "You sound a little weird."

"Yeah, I'm taking something."

"How long are you staying there?"

"I'm not sure. I talked to my dad, he's coming with my stepmother."

"Did you sign something? Are they allowed to keep you there?"

"I think so," she said. "I don't know."

I'd never known someone to go insane before. Other than what I'd seen in *One Flew Over the Cuckoo's Nest*, I knew nothing about mental institutions, but the idea of Cathy pumped with Thorazine and abused by nurses made me sick with worry.

Then I wondered if this wasn't some calculated move. Even if she hadn't consciously planned for it, Cathy was clearly determined to be put in a mental ward. Now she could follow in the footsteps of Sylvia Plath and Camille Claudel and all the other women who were destroyed by sex and grief and life. Now she could be destroyed too! She could talk about her mother endlessly to doctors who subjected her to their nonstop clinical dissection—it was what she'd always wanted!

I told myself that if Cathy had herself committed it was her *choice*—that she was part of what Nietzsche called an inferior herd, and this was what happened to people like her. I rationalized my worry away by telling myself worry was a useless emotion. And if I ever doubted the "reductive" (to use her favorite word) things I told myself, or related too deeply to Cathy and feared that maybe *I too* would end up in an institution, I could bury those feelings. I was *able* to bury feelings now. I was like Eunice at the end of *Streetcar* shouting *"Don't look!"* to Stella

when the doctors come for Blanche. I was able to block things out. I sensed this new ability signaled a tragedy, the tragedy of my fading into adulthood. I hadn't been taught coping mechanisms but somehow they mysteriously erected themselves inside of me. Only now I couldn't see through or past them: it was like I was staring through a thick pane of fog-condensed glass.

A week or so after Cathy had herself committed, the phone rang and it was, of all people, Gladys Abadi. "*David?*" she said—and right away I could tell she was sobbing. She was making a high-pitched noise, a sort of yelping sound. She kept saying, "Oh my God, oh my *God*" and her voice was cracking and abrading over the phone receiver. I hadn't spoken to Gladys since the day we drove up to Bronxville, but it was like no time had passed—like she was living out one long, extended nervous breakdown over three years—and I felt a sadistic wish to punish her. I wanted to impress upon her in the most unambiguous fashion that her phone calls were unwelcome, that despite our stupid common heritage she was a stranger to me. "*How* did you get my number?" I asked in a deliberately arch inflection, but she just kept sobbing. I took this as her indulgence. "Gladys," I said in my most condescending voice, as though she were a puling infant, "why are you calling me?"

"Vivian *died*," said Gladys. "She's dead. She's *dead*, David!"

Gladys was crying so intensely I couldn't make out much of what she said after that: something about Vivian's parents, how they were all liars, how there was a funeral but it was done in secret, and none of Vivian's friends were told about it and nobody even knew where she was buried.

I hung up the phone in a daze and called Vivian's house. Her mother, Faye, answered the phone. I asked if it was true: if Vivian was really dead, if there really had been a secret funeral. Faye had taut answers that had nothing to do with my questions—they were almost non sequiturs. She kept saying Vivian was a

good person, she was a nice girl. She spoke about her like Vivian was some remote acquaintance, not her daughter who'd just died.

I kept pressing for answers: How did she die? Why wasn't there a funeral?

"She was a good girl," replied Faye. "She was pretty."

Then she hung up the phone.

I wanted to visit Vivian's grave but I didn't know where she'd been buried. I kept calling her parents but they stopped answering their phone. Soon after, they had it disconnected. Their official story was that Vivian died in a car accident, that she'd totaled the BMW. But Gladys told me she heard Vivian took heroin with her DJ boyfriend and overdosed— which was why her parents didn't invite people to the funeral. I remembered the dark circles under Vivian's eyes when I ran into her that day on the Westlands Lawn. I remembered how thin she looked—how at the time I saw all that as a kind of European glamour, a character she invented who was perfect and deracinated. Now I wondered if Vivian's sophistication wasn't just a mask for something dark and unresolved inside her. Maybe, like Cathy, she was driven in some infernal, terrible way to wreck her own life, even as she strove to make it better.

I didn't know how to grieve Vivian's death—which wasn't a death, it was more a disappearance. I felt numb, but maybe that was a good thing. What was the point of getting lost in a huge welter of unmanageable feelings when there were things I *could* manage? What were feelings, after all, but stupid versions of thoughts?

I began to read with savage, almost murderous intensity, like I was chewing and clawing at the books with my mind. I couldn't sit in the pillow room anymore; all the sensuous pleasure interfered with my new spartan regimen. I found an un-

comfortable desk and chair near the periodicals section and sat
there for hours on end.

For one of my classes that spring, we read *Crime and Punishment*. The main character of the novel, Raskolnikov, comes
up with a scheme to murder and rob a pawnbroker. He believes
the murder will benefit the world, that he can use the money to
do great things for humanity. Raskolnikov thinks this murder
will be the test of his *will*—like Nietzsche's Superman—that
this act of cruelty will be proof of his ultimate greatness.

Early in the book Raskolnikov has a dream. In it he is a
small child. He is on his way with his father to visit the graveyard where his baby brother and grandmother are buried. As
they cross the town square, drunken townspeople outside a
tavern are hectoring a horse's owner to murder his old and useless horse. The townspeople are laughing wildly, urging the
owner of the horse to "whip her in the eyes" and "beat her to
death." Several seize whips to beat the horse, joining its owner
who is battering it in the face with a crowbar. Raskolnikov,
upon witnessing all this, becomes hysterical. He rushes through
the crowd to the horse, then "put his arms round her bleeding
dead head and kissed it, kissed the eyes and kissed the lips."
His father pulls him up, and carries his son back home. But
Raskolnikov is overwhelmed by grief:

> "Father, why did they . . . kill . . . the poor horse!" he
> sobbed, but his voice broke and the words came in shrieks
> from his panting chest.
>
> "They are drunk. . . . They are brutal . . . it's not our
> business!" said his father. He put his arms round his father but he felt choked, choked.

I saw the scene vividly, as though it were playing out before
me. I heard the lashings of the whip, the whinnying screams of

the dying horse, its twisting flank and bloodshot eyes. Most harrowing, though, was the image of the boy choking and sobbing in the arms of his emotionally vacant father—who's as numb as the men in the tavern. The boy is shocked by the brutality of the men, he needs warmth or comfort, but the father's lame response, "It's not our business," only makes things worse. The boy's voice breaks, cracks, rendering him incapable of speech. He is, literally, choked.

Confronted with this spiritual deadness, Raskolnikov wraps his arms around the void where his father should be, just as he wrapped his arms around the dead horse. I understood that terror and desperation: the horror of being left to fend for oneself in a world so brutal it reduces one to choked sobs. I knew what it was like to feel so full of love, and have that love choked out of you because there was no outlet for it in the world.

Raskolnikov's dream bore a remarkable similarity to the circumstances around Nietzsche's breakdown—I'd read about it in one of the biographies.

Nietzsche, crossing a piazza in Italy, saw a man viciously beating his horse—and he *too* rushed to the horse and threw his arms around it in a protective embrace. After that he became catatonic and was placed in a clinic in Basel and never recovered.

I thought this was kind of weird. What was Nietzsche's breakdown doing in *Crime and Punishment*? Did Dostoevsky base his book on *Nietzsche*?

I did a search in the library and learned that actually, no, the reverse was true: Nietzsche's breakdown came long after Dostoevsky finished *Crime and Punishment*; in fact, Nietzsche was known to have been influenced *by Dostoevsky*—he'd read and admired this very book. So what was going on here? Was Nietzsche just waiting to find some man beating his horse in a public square so he could play out the scene? And *why*? Was he just

drawn to the book the way Cathy was drawn to Sylvia Plath and Marguerite Duras?

I'd known about Nietzsche's breakdown, but I thought it was part of some brilliance or spiritual genius embedded in his philosophy, that he was a bright, burning asteroid streaking through black skies before flaring into burnout. But, there in the library, I started to see the breakdown as something else. I decided Nietzsche had become obsessed with the story from Dostoevsky, that this story of a small, helpless child choking at the human condition resonated intensely with who Nietzsche *really* was—not some ideal mythic supernatural being, but who he was *inside*: the fixed unchanging part of him, the wounded, broken child whose father died when he was four, abandoning him to a heartless world. Raskolnikov's dream touched some Freudian wound in him, some unhealed scar he tried covering over with intemperate writing and exclamation points and stories about jumping into frozen lakes naked—some mythology he wanted to make his own but *couldn't*, no matter how vehement and violent he made the writing, just as I couldn't make myself into *him*.

The Superman was *bullshit*.

The Superman was a fantasy. The fantasy couldn't just be made into reality by exertion of will. We couldn't simply *choose* who we wanted to be. If that were true, Nietzsche would have married Lou Salomé; she wouldn't have rejected him and broken his heart. He would have had a nice little life lecturing at universities—which he couldn't, because no university would hire him. He couldn't even sell three hundred copies of *Beyond Good and Evil*, which was what he needed to recoup the publication fees, because he was forced to publish it himself with his last dollars, because it had been rejected *by everyone*! He did not live the life of a Superman: it was a sad, *horrible* life—just like mine, and Cathy's, and Vivian's, and Richie's, and

everyone I knew. You couldn't change your past. You could make yourself into a character, sure, but hiding inside you, lodged deep—like a molar, or the ringed interior of some ancient redwood—was the damaged, sick part of you that could never be healed. And that sickness, that horror from your past, would dominate you, trail you forever like some atavistic latch, because that was destiny. That was life.

That was *reality.*

And there in the library, I felt something break inside me. It was like that moment near the end of *Persona* where the filmstrip snaps and burns: the very material of my life disintegrated. I felt like I'd been pushed out of a building—my stomach dropped, my body started to buckle and shake. The world seemed to come to a grinding halt. Colors began to parch and dissolve. I could barely breathe, barely stand or make my way to the car.

I drove to the pharmacy where I purchased about twenty boxes of sleeping pills. I must've seemed suicidal—with my tremoring hands and my dozens of sleeping pills that I charged to my father's Discover card—but the man at the register didn't seem to find any of this notable. His indifference slightly annoyed me, but I didn't want a scene, I just wanted to die. When I returned to the car it was dark out. The tremoring subsided. I'd been so worn out from all my psychic torment. Now I felt a strange peace wash over me, a serene preamble to death. The darkness was a sumptuous deep black; I felt cradled and held by it like it was a huge dark womb. On my drive home the darkness erased all the details, and all I could see were lines and angles and disembodied glimmers.

Goodbye world, goodbye life.

I returned to my apartment and locked the door to my room. I sat at my desk. One by one, I popped the blue oval pills from their aluminum casing. I piled them up on my desk in compul-

sive fervor. They were sloped to an apex like a mountain, like the mountain in *Close Encounters of the Third Kind*, the one people in that movie kept compulsively painting and drawing. There was something ecclesiastic, even beautiful, in the vertical arrangement of the pills. I didn't want to disturb their fragile composition, but I knew I had to die. As I prepared to scoop a few into my mouth, though, I felt drawn to some force, some holiness in the pastel blue pyramid. I didn't want to feel the holiness, I didn't believe in holy things, but none of that mattered. I couldn't move. I felt pulled back as if by ropes. A strange thought entered my mind: that life was beautiful and sacred. The thought sickened me, because I knew life was a nightmare, but the feeling it evoked showed me I was wrong. It was just a feeling, yes, but the feeling was somehow more real than any thought I previously held—about *anything*. The feeling etched itself into my entire being with the precision of a laser. And that was it.

In the vague attempt to end my life I was connected back to some part of myself I thought was gone, a part that linked me to something eternal and unknowable, that hearkened back to my childhood, when I believed in spirits and angels and even God.

I took an incomplete for the semester and a brief leave of absence from school. I was exhausted. I felt sore all over, like I'd been in an accident. I rented dumb movies. I baked brownies from a recipe that was supposedly Katharine Hepburn's.

One night, my brother Stevie drove to see me. I was surprised by his visit. We hadn't spoken in a few years. He said, "I've been where you are. I've been to the bottom. I lost everything, but I got up and kept fighting, and you can do that, too." There was nothing revelatory in what he said, but it struck me as a revelation. It was so rare for anyone in my family to open up to me. It was an act of pure love.

I bought a ticket one afternoon at the TKTS booth for a play

called *Six Degrees of Separation*—there were posters for it everywhere: a black man and some austere-looking white woman drawn in pastels. I liked the look of it. I hadn't been to the theatre for at least a decade, and I missed it. I wanted to restore some lost part of my life that once gave me pleasure.

The play was about the impossibility of ever being anyone but yourself, and also the pain of never fully becoming yourself. Paul is a gay man who trains himself to speak and act a certain way so he can function inside the hermetic envelope of bourgeois privilege. He stabs himself, lies about having been mugged, then passes himself off as the son of Sidney Poitier to Flan and Ouisa Kittredge—a wealthy art dealer couple who live in a glamorous penthouse on Central Park West.

Paul is a con artist, but he doesn't want Flan and Ouisa's money. He wants beauty and art. He wants love and eternal friendship. He wants a tribe, something he can belong to, a cleft in the rock of the world to hide in.

Like Blanche, Paul's story ends badly. The suggestion in the play is that he hangs himself with a pink shirt Ouisa and Flan gave him to replace the one he bloodied stabbing himself. "He wanted to be us," Ouisa says. "He stabbed himself to get into our lives." I was choking on my tears during her monologue. I saw myself in Paul. I saw my own story play out right on that stage—and I didn't know I even had a story. I thought that, like Paul, I only existed in my attempts to become someone else.

All around me people were wiping away tears. Somehow the story belonged to everyone in that audience. We were knit together by the fiction of this play, which harbored something more real about life than the lives we might return to when the lights went up. In the darkness, we weren't burdened with those lives. In the darkness, everything solid became amorphous, and we were one organism. We belonged to one another: to life and all the beauty and tragedy and pain that went with it.

When the play ended, I sat in my seat for a while, wiping my eyes as people stepped over me to exit the theatre. I didn't know if my heartbreak was about the play or Vivian or Cathy or my own life—probably all of it. When the theatre emptied, an usher tapped me on the shoulder. I collected the sobbing mess of my self like a rumpled heap of laundry and walked to Broadway. I didn't feel like going home just yet, I needed to shake off the dream of the play, so I arbitrarily chose a direction and started walking.

I walked past skyscrapers and midtown plazas of dimpled pink marble, past men in navy-blue suits wolfing down stacked plates of halal meats. As I walked, I felt I wasn't just shaking off the play, but some dead part of my life, like I was molting. Eventually I ended up in Times Square. I hadn't been there in years, but now I felt a deep pang of nostalgia. I walked down Shubert Alley, past some memorabilia shop where Howie and I had one of our crazy laughing fits. I walked past marquees of theatres that advertised plays I'd never heard about, but now I wanted to see all of them. Some fuse inside me was relit.

As I watched *Six Degrees of Separation*, my life story unfolded in a sort of dream. The dream was dreamt up by a playwright named John Guare, whom I had never met and who didn't know me—but he understood me, he *knew* me. The play was his message in a bottle, a transmission between remote shores.

Late in the play, Paul appears to Ouisa in a dream and delivers a message. He tells her the imagination shows you "the exit from your nightmare," and a way to "transform your nightmare into dreams." The theatre could do that, too, I thought. The theatre could transform nightmares into dreams—and that felt to me like a kind of power. It was a power I desperately lacked, and suddenly craved more than anything in the world.

It was getting late, I didn't want to miss my train back to Westchester, but before I left for Grand Central Station I took

one last look around me. It was twilight, one of those nights where everything is lit up with color. Strips of pink light were reflected on the sides of buildings—which became living murals all of a sudden. The city became a giant reflective mirror, like the reflectors my sister used when she gave herself those terrible sunburns. The vertical glass walls became screens that revealed my entire history, as if a kind of ancient scrollwork. I thought of the trips my mother and I took to The City when I was a little boy, how I would stare at my own reflection in tinted surfaces and see nothing reflected back. How I felt like nothing back then. How I lived with the constant terror my life would never amount to anything, that I would never belong to anything.

The deepening twilight turned the city for a moment a shade of burnt orange. The buildings were bathed in orange light intersected by darkening shadows, black and orange, like plastic jack-o'-lanterns. Every so often, light from digital displays hit in startling flashes. I looked around me, looked up at the floating signs and black barriers. I stood for a moment in the jangle of voices and noise, and I felt a sense of enormous calm wash over me. It was where I belonged.

BOOK III

AT SEA

L'HOMMELETTE

MY FATHER STILL held a torch for my mother, he never really got over her, but he was very fond of his new girl-friend, Cookie. She was the first and only person he dated in the twenty years since he and my mother separated. They were introduced by his younger sister the summer I graduated from college. Unlike my mother, who was diabolically infatuated with the things he could buy her, Cookie was simple, humble. She taught my father about macrobiotic diets and eating healthy. She taught him about hijiki and green shakes. My father ditched his tan suits and started wearing sporty tracksuits and baseball hats. He started going to Turnberry, where Cookie had a condo from her first marriage. A tiny quorum of Syrians had houses there; they were chummy, smoked good cigars, went fishing and gambling. Dad had everything he wanted: the girl, the house in Florida, beatific exchanges with rabbis, soul-nourishing exegeses of Talmudic paradoxes. For the first time in a very long time he was happy.

Then, late one night, he called me, hammered on Prune Juice. He was slurring and speaking in teary incoherent circles. "She don't want me no moah," he said, again and again.

"Did you and Cookie get into a fight?"

"Who needs *her*!"

"Dad, you sound really drunk."

"She don't want me no moah."

"Did she break up with you? Or—"

"Good *riddance*!" I heard him sniffling on the other end. Then, after a long silence, he mumbled, "I'm blue, Dave . . . I'm very blue."

I'd never seen my father in this lovelorn condition before. Though he was liquored up beyond comprehension, I was able to make out the basic facts of their estrangement. Cookie felt Dad was too stubborn and controlling: he wanted to dictate what restaurants they went to, and how religious she should be, and what she could and could not wear. And while Cookie was constitutionally averse to, and even terrified of, conflict, she felt she had to stand up for herself. She'd already dealt with a controlling husband in her first marriage; she was tired of having to sacrifice autonomy for companionship.

I could only imagine how difficult it was to be in a relationship with my father, because God knows he was controlling and monomaniacal, but I felt sorry for him. He was lonely and in his sixties. He'd been single for so many years, and finally found someone to love, and though my father's idea of love was bluntly transactional, and I was sure their love was attenuated— the love of people who groped blindly at the world, striving vainly for some vague ideal of happiness that would always elude them because they lacked a basic self-concept—I still wanted him to have *something*. I suggested he apologize. "Let *her* apologize to *me*!" he thundered back. I gently explained that he *was* a little bit controlling, an allegation that horrified him: "How am *I* controlling?" he remonstrated. "If she don't want me that's *her* problem. Who needs *her*! I'm through with women!" His romantic notions were trapped in the amber of 1940s Hollywood comedies: grumpy, loitering bachelors and their inveterate vows to swear off women who snared and collected men like toys.

A few days after the drunken phone call Dad called again, this time sober and cheerful. He sucked it up to apologize to Cookie, he said, and they were reconciled. My father credited me with saving their relationship, so now I was triangulated in it. He wanted me to meet Cookie. He invited me out to Jersey for a weekend to see the new house. He'd remodeled an old two-car garage that was "very high-line" and "very sharp" and "very much your type, Dave." We could all have dinner together, he said, and in the morning he'd take me to get pancakes, some secret joint he knew about.

I'd never spent a weekend with my father. I'd never slept over at his house. It was exhausting having to perform for him even in small amounts—I couldn't imagine how I would do it for an uninterrupted weekend. But maybe he'd changed. He apologized to Cookie at my urging. He'd never done anything like that before. Maybe he was beginning to soften. Maybe there was still a relationship we could cultivate, and some kind of healing could take place.

Healing had always seemed lowbrow to me, even lurid, but I needed a new approach to life. The first few months after graduation, things were shaky. I moved back home and temped intermittently. It was a rotten time. I thought becoming an intellectual would serve as a preparation for life, but as it turned out: no one gave a shit. At my temp jobs, I'd try to strike up conversations about Lacan's *Ecrits*, but the other temps would just stare at me with deadened expressions. I was pretentious and it turned people off. Without a stage for my intellectual posturing, and the reassuringly measurable gradients of progress academia gave me, I became depressed and underconfident. I was presentable, mainly, but something was off. I was like a cake that looked sort of appetizing, but when you cut into it oozed uncooked vanilla gunk.

During my senior year of college I officially decided to

become a playwright (after watching *Six Degrees* I started see-
ing plays all the time, it was a fait accompli) but when I tried
writing my own plays they turned out wooden and impersonal.
The plays mirrored back to me how fake and stunted I was.
That was my impetus to change. I wanted to be a good writer,
it was suddenly all I cared about—and I knew there was some
buried part of me I had to confront.

I started seeing Boris Fischer, a psychoanalyst one of my
professors recommended to me, which helped. In one of our
earliest sessions I explained that when I was fourteen, my then-
analyst said he could make me a functioning bisexual, that I
could marry a woman and live a quote-unquote normal life.
"Oh *did* he say that?" said Boris Fischer, not very cordial.
"What was the name of the analyst?" At the very mention of
Weinberger's name I saw a slight twist in his expression. "*Yes,*"
he replied, with sudden surgical coldness, "I know Dr. Wein-
berger. I'm familiar with his methods." From the way he said
methods I sensed some antipathy between them. I asked if he
knew Weinberger personally. Fischer sighed languidly. "We co-
chair a school of psychoanalytic training together," he said. I
couldn't imagine Boris Fischer and Weinberger in the same city,
much less chairing a program together. They were so different.
It was clear, for instance, that Boris Fischer believed gay men
should *not* be made functioning bisexuals and that attempting
this would only damage and warp them. Boris was progressive
and humane—possibly a gay man himself.

Because of my therapy with him, I was able to heal, and
because of the healing I was more open to having a boyfriend.
I started dating someone named Kurt in the fall, and it quickly
became serious.

The courtship was a blur. I went to a bar, got drunk, saw
Kurt slumped by a wall, and made out with him. Back then, I
had no criteria for relationships; I didn't know who to like or

reject. I experienced the whole bar scene as a kind of ambient mobile flux, and slept with mostly everyone—not because I wanted to, but out of some combination of pity and politeness and bad self-esteem. Many of these men seemed desperate (in a way that made me feel relatively adjusted, though I found only minimal compensation in that), but Kurt was able to project sanity, even in a rough outline. This made him stand out.

That night, he took me back to his apartment, a small one-bedroom on Avenue A he shared with a small, very officious dog named Rudy, and the following morning we went to a café across the street and ate croissants and played board games. By the end of Yahtzee there was the tacit understanding that we were already in a relationship. It was a little accelerated, but I didn't know any better—and in my state of famished loneliness (because I *was* at the time) I believed it was what I needed.

Kurt was in his early thirties, recently out of the closet, and in the process of a very amicable divorce from a woman who lived in a place called the Thousand Islands up near Canada. He was over six feet, lantern-jawed with symmetrical features. His outfits were all variations of one outfit: a fitted T-shirt, jeans, black Chelsea boots, and a bandanna (de rigueur for a period in the nineties, like goatees, and he sported one of those too). He was blandly stylish—which is not to say he was a schlub; he worked in fashion. He was an art director for a high-end clothing label; he directed commercials for them—I'd even seen a couple. They played before coming attractions at the movies: people in beachcombers drinking wine coolers; people laughing and wearing linen. I thought it was so impressive to know someone who made commercials. It felt important.

We started going out with a bunch of his friends from work a few times a week. I rarely went on one-on-one dates with him, which I initially found odd, but eventually determined was probably fine—that most gay men of a certain social status

and economic bracket probably did that. We rented cars and drove to parties in Queens, in Long Island—parties in people's basements, parties in suburban houses, parties we were far too old to attend, where models hung around and ate nachos, where there were beer bongs and table tennis. *Who are these people*, I wondered. *Why are we driving to Queens?* But I dared not ask, and frankly I was just grateful to be part of a couple. To feel I belonged, even in some nominal way, to something.

At the parties Kurt ignored me—which, again, seemed normal. He'd go off and talk to male models who were famous at the time and I'd wait patiently for him, usually somewhere close to the door where it would be easy for him to find me. I was eager to prove my worth as a boyfriend, be supportive, not someone who would hamstring his social needs. After the parties, Kurt would compliment me in the car while the friends cooed and giggled and mocked us playfully from the back seat. He'd say things like *You were so great!* I never knew what I'd done that was so great but I was ecstatic to be complimented. Maybe he saw my stillness and quiet as a sort of profound homage. Once, after complimenting me, he put his hand on my knee and gave it a squeeze. *Now the bonds that unite us are sanctified*, I thought, and I felt a deep warm joy spreading through my insides, a feeling of completeness I had never known.

With my new boyfriend and new prestigious analyst and my new playwriting ambitions I felt suddenly ascended into some new stratum, now part of the world instead of jutting against it with my usual hard perpendicular angle. I'd moved through successive vessels for growth and self-expansion.

I started to think the trip to see my father would be a natural extension of all that—like going to a healing spring, or soaking in a mineral bath and absorbing some elemental nourishment from the very pit of the earth. I didn't have to erase my

family to become myself—in fact, I'd likely done some sort of violence to myself in the attempts to block them from my life. I wanted to be a writer, so I had to confront the truth about my life—a truth I couldn't extract from plays or films or books. I had to go to the source of my problems. If the past had a hidden structure, I was ready to unearth that structure, to bring what was hidden to light.

I drove out to Cookie's condo in Long Branch on a Saturday evening. Cookie was jittery, she was clearly nervous to meet me. She kept apologizing and flittering, preempting my judgments with her own burbling self-reprovals: her house wasn't nice enough, she looked terrible, she hated her outfit. She wrung her hands together anxiously, smiling precariously as though she were falling off a cliff and didn't want to trouble anyone by screaming for help. She kept offering me tea and food as her eyes darted all over the place. My father chuckled with amusement at Cookie's routine. He seemed to interpret her bird-fluttering hysteria as a watermark of some kind of female genuineness—apparently it was entertaining for him to see grown women perched on a ledge of psychic terror for no real reason. Maybe he enjoyed the expansive ease he felt being a protector when the stakes were low to nonexistent.

He spoke about her in the third person: *Cookie is excellent at sudoku. Cookie likes all that stuff you like, Dave.* Cookie seemed relieved not to have to come up with topics on her own. When my father switched subjects to nutrition she pivoted with free-floating ease. "I only eat healthy," she vaunted. "I try to get your father to take spirulina. It's very good for you, spirulina." As she went on about herbs and macronutrients and detoxifying properties, she relaxed a little bit. The sun-scorched lines in her face softened. She started speaking openly about

my father's controlling personality. In an attempt to chart new territory with him, I made a couple of jokes about my dad—who smiled slightly, to show his openness and good humor. I spoke in long paragraphs about humility and compromise, and became a sort of impromptu marriage counselor, which gave me a sense of purpose: I was the parent and they were kids needing advice.

That night we ate dinner at my father's favorite kosher Italian restaurant. He was only eating kosher now—somehow it went with the tracksuits and baseball cap. Cookie hated kosher food but she brought her spirulina supplements. My father wolfed his two doughy lobes of manicotti teeming with kosher cheese, and downed that with cupfuls of kosher wine. Cookie fluttered and shook and said endearing things. There were spontaneous ruptures of confidence and ease (my father kept asking if I had a girlfriend, even though I'd come out to him four or five times* by that point and had *no* intention of introducing him to Kurt), but then they faded and we laughed again. There was a spirit of goodwill. We had the sort of good-natured camaraderie strangers have with one another.

After dinner we dropped Cookie off, and my father drove us to the carriage house. Once she was gone, he seemed switched off. I was used to his loud exertions, his strained efforts and whipped-up blandishments, but once we crossed the threshold

* The process of my coming out—to both my parents—was complicated, and happened over the course of several half-forgotten conversations in my twenties, and even early thirties. The first time my father brought it up, it was because my mother outed me. "Your mother tells me you have tendencies toward men," he said, using that weird clinical language from the 1960s, "but I wanted to say that I love you anyway." I was still so self-loathing that even this grudging acceptance moved me deeply, but the acceptance was premised on the notion that my "tendencies" were no big thing, and I would eventually marry some SY girl and give him grandkids.

of the carriage house, it was like I ceased to exist. He didn't show me the house. He didn't say where the bathroom was. Maybe in his aggravated state of manliness he assumed I would trounce around, pee wherever, sleep on a rumpled pile of laundry. I was hurt. It was late, yes, but he wasn't merely sleepy, it was a kind of arrogance. And I didn't see what was so "highline" and fantastic about this redecorated house of his. It felt strangely bare and shrunken; the furniture was tacky and ugly. He'd put in new wood floors, but the wood seemed splintered in parts and unevenly graded, and the glaze over it was thick and goopy. I changed into a pair of sweatpants and sat for a bit in the kitchen, thinking my father might come back and say good night to me. When he didn't, I went up the small spiral staircase. I found him in a darkened room, lying in bed and watching *The Tonight Show*.

From a distance, he looked imperious, with his head resting on a stack of white pillows, his bathrobe gigantic and flowing like a judicial robe. But when I got a better look at him, my father seemed ragged and old. He seemed drugged watching television. His baseball hat was off and I could see the outline of his skull. I could see the shadow in his open mouth. The remote drooped in his hand. His expression was slack and empty. His feet were relaxed into a default V shape, the big toes jutting with bunions.

I sat on the edge of the bed and pretended to watch television with him. I wanted to feel the filial comfort and ease sons have with fathers, but I hadn't sat in a bed with my father since I was six years old. I felt like a stranger, and he was treating me like one—but then, out of nowhere, I felt suddenly determined to have an intimate relationship with him.

"So I'm in analysis," I told him, as if continuing something I'd said earlier.

"Huh?"

"I'm in *analysis*," I repeated—even though he was the one paying for it.

"How's that goin, honey?"

"Well," I said, my voice trembling, "I'm having some issues with abandonment."

I felt myself slipping off the bed slightly as if it were an inclined plane. My father didn't move a muscle—he didn't look at me, didn't flinch. I felt an impulse to leave the room, but I knew I would never again have this opportunity to confront him, that I would never find the courage. Exerting my every last ounce of trembling will, I began to prod and push him— *gently,* so as not to frighten him—to make him explain his actions to me, actions for which he'd never been asked to account, for which I deserved an explanation: *Why* did he leave without telling me, forcing me to guess at his whereabouts? *Why* did he cut off contact for *five years* before insisting on those awkward punishing dinners at the Genovese House where I was forced to sit like a ventriloquist's dummy and pick at caprese salads while he got drunk?

As I disgorged the contents of my tortured history with him, Dad didn't interrupt or try to answer; he just stared straight ahead with his same blank expression. Shadows from the television flickered over his face in the darkness, so it appeared to change shape. "She wanted me out of the house," he muttered eventually.

"But you didn't speak to me for five years."

"I told you," he wheezed, "your mother wouldn't *let* me."

"What do you mean 'wouldn't let you'?"

"She wanted me out of the house. I didn't want to go—she pushed me out."

"But she would have let you speak to me."

"You don't understand—"

"You were legally *entitled* to see me. You could have told me

you were leaving—you could have written me letters, you could have made a phone call—"

"I couldn't," he eked out.

"What does that *mean*?"

He said *I couldn't* again, still holding his parallel gaze. My father was completely ill equipped for this conversation. I was violating some wordless contract we'd made, some story about life we tacitly agreed upon, one that made him blameless, a savior. I was asking for a substantial rewrite to the script of our relationship and he wasn't interested in the revision.

"Honey, I'm very tired," he said, as if to settle the matter.

I bade my father good night, then crept down the spiral staircase. I tried to get comfortable on the leather sofa. There was a sheet, a thin quilt with blue diamonds, and a single pillow. It was not a great sleeping situation. The small of my back kept collapsing in the wide depressions between sofa cushions. No matter which way I turned, my shoulder was up near my chin and it was making my neck hurt. I lay there for a while, sleepless. The ground floor was laid out like a studio apartment, and from the sofa I had a view of the kitchen and the front door. The house had an eerie depopulated emptiness. The darkened room was overcast with shadows, the spiny outlines of trees. I berated myself for visiting him. I felt conned into it—yes, I'd gone of my own volition but I felt I'd been tricked. I'd always said no to him, and I was right to say no all those times, and now I felt I'd broken some kind of chastity. I foolishly thought I could undo the black spell—the way I had that one time when I was fourteen, after one of our dinners at the Genovese House, when I tried (as I did from time to time) to rescue my father from his own spiritual deadness.

Back then I was able, if he was sufficiently loosened up from the Prune Juice, to open a little spiritual aperture and connect with him. It was tricky, like threading a fine needle, but

sometimes I could do it. And on that one night, between the liquor and deep conversation, my father had gotten particularly raw and sad. I could see he felt some relief sharing this sadness, this secret part of himself, with another person, someone who could empathize, who wouldn't reject him for his weakness. After dinner he drove me home. He pulled his car into the driveway and we sat for a moment in the parked car. It was raining, and I could hear the squeak of the wipers as they washed thick cataracts of rain from the windshield. I turned to look at him and his eyes were watery. Each lid was rimmed with a shimmering wet tear that gleamed like the droplets of rain banging down on the windshield. "See that?" he said. He pointed to the wipers. "That's what I do every day of my life. I don't know how else to live." I was intensely moved by my father's admission—not exactly a revelation, I knew how he lived—but it was still the deepest, truest thing he'd ever said to me. In that moment he was sad but he was alive, and his aliveness resuscitated something in me. My mother was so calcified by cynicism, she never believed he could change, but I *could see* the change in him. The black spell was finally broken.

But when I saw him days later my father seemed more deadened, more false than ever. He came to pick up some bill or mortgage papers, and loped around the house with his hunched shoulders, pillaging the refrigerator for Entenmann's cake. I kept waiting and hoping for some signal from him, some secret acknowledgment that his life had undergone a giant shift in the car that night, the way mine had, but he barely noticed me. When he finally did, there was a blank look in his eyes. The blankness felt deliberate, like he was marking a boundary in chalk, like he was saying *Don't go near me, don't even think it*. It was another broken promise—and not even a promise he made to me, but a promise that we would be there for each other, which was all I wanted.

. . .

I got to sleep eventually that night. Early the next morning I awoke to the sound of a click, followed by the infinitesimal turn of a tiny metal gear. When I opened my eyes there he was, hunched in his baseball cap and sporty cotton jacket, carefully opening the front door. His feet were planted unsteadily and he had a sickly, persecuted expression on his face.

"What time is it?" I asked, my voice still phlegmy with sleep.

"I didn't want to wake you up," he said.

I sat up and my upper back throbbed with pain. "Where are you going?"

"I have to go in to work. Cookie'll come get you. I was gonna call you later."

"You're working on Sunday?"

"We're very busy, honey."

"I thought we were getting breakfast."

"Cookie'll come get you," he said. "We're very busy."

He left and shut the door behind him. I tried getting back to sleep. I tossed around, climbing out and around the depressions and large leather folds in the sofa, but each time I felt myself drifting off I compulsively replayed the scene in my mind. When did he get this supposed phone call to be at work—at *dawn*? And why would Cookie need to *get me*? I could walk in and out of houses! I was *ambulatory*, for God's sake! My father was speaking nonsense to me. He was obviously lying to me. And though I generally excused his lies, this one revived the outrage I'd been trying to bury from the previous night: I was suddenly completely *hell-bent* on holding him accountable for something, *anything*. Maybe I could confront him before he drove off, I thought. I hobbled exhaustedly to the door, my back rippling with knots. I fumbled for the knob but there *wasn't* a knob, just a keyhole. One could ostensibly turn a key in the keyhole to open the door that way, but there wasn't a key.

I tried pushing the door open but it was locked from the out-side. I banged on the door and screamed to be let out. I thought of jumping out a window, but there were just grids of glass built into the wall. I looked for another way out, but there was just the one knobless door. Who lived like this—with doors that trapped people from the *inside*?!

Cookie's number was scrawled on a pad near the kitchen. When I called she sounded like a totally different person, curt and very cranky. I wondered if I'd called too early. "No," she said, "I'm up. I'm always up." My father hadn't mentioned any-thing to her about getting me but it was "no problem" and she didn't find it an unreasonable imposition, she said, though she undercut this apparent sangfroid by repeating "I have a *million* things to do" and "I'm *sorry*" over and over in a tone that in-dicated not apology but resentment, because she was *very busy*, and had a *lot of errands*, and couldn't get me right away. Cookie seemed unhealthily intent on setting a boundary with me for judging her (which I wasn't) for not being prompt or maternal or available enough, and I felt suddenly caught in a whole mis-erable skein of neuroses and transferences. To calm her, I said reassuring things like "take your time" and "I totally under-stand" even though I did not understand and couldn't bear an-other second in the carriage house. I felt claustrophobic and panicked but didn't want to say or do anything to agitate Cookie for fear she'd become too nervous and angry to free me from the house. Though I didn't know her terribly well, I had to assume she was like my father, crazy and labile and inconsis-tent, and that I was hanging by a thread. I hung up the phone and made myself a cup of acrid instant coffee. I poured in two percent kosher milk that pooled up to the surface of the mug in stale-looking cirruses. I showered using my father's scented bar soap, which by that point had deliquesced somewhat eerily into a kind of thick emerald cream that somehow kept its bar shape.

The water pressure felt good on my aching muscles. I was exhausted from lack of sleep. I was furious with my father. I didn't know how I would get his silly, vacant look out of my head—the stain of dereliction in his eyes. Usually he could block out upsetting conversations, but maybe this was the beginning of some period of reckoning. Maybe once you got older your capacity for denial was leached from you the way minerals were leached from bones, making everything porous and breakable. He was riddled with *guilt*—a guilt for which I was a living symptom, like the anamorphic skull and bones in that famous Holbein painting. I was a buried secret coming to light and it horrified him.

When I finished showering I got dressed in my father's bedroom. I hadn't seen it in daylight. There was the same drab furniture he had in his last apartment, dropped in as if by construction crane; the same fungible bedspread, the kitsch figurines. On the credenza were the tiny vulgar enameled sculptures of elephants I knew from childhood, tiny geishas hiding their faces behind imbricate ivory fans. On the dresser near his bed were school photos of children I didn't know poised against a backdrop of fluffy white clouds. The children, like the figurines, were decorations, evidence he belonged to something. There were no pictures of my siblings or of me. We were from some other life, some past that had faded and vanished. He was creating a new past, one that exonerated him. Maybe it was a fundamental human desire, to erase the parts of life that threw it out of balance or made a person feel weak or guilty or inept. As I slipped on my socks and pants I noticed a queasy feeling in my stomach, from the coffee probably, but it seemed a symptom of distress—like the distress I experienced as a small child when I'd lay in bed late at night, unable to sleep, fending off my many nameless terrors. I remember looking around at my darkened room and feeling it was haunted, like I'd broken into some

other child's life. I felt that same dislocated emptiness now in my father's house as I slipped on my socks, washed myself with his green bar of soap, drank his acrid coffee, sat where he sat. My father was to me what those children in the school photos were to him: a prop, a set decoration. He was someone I looked to when I needed a father, but he wasn't mine.

Across from my father's end table was a long, flat oak dresser. On top of it were two rolls of quarters propped up vertically, like twin towers. I took one. My father wouldn't notice. I didn't care if he noticed. It was another transaction, one of many that comprised our sick relationship. I didn't save the roll of coins. I used the money on tolls for the drive home. When it was spent, I disposed of the sun-faded pink wrapper in the trash.

GALAXY

MY MOTHER'S PRIMARY aim in life was to become relaxed. She often spoke about being relaxed, when she might be relaxed, whether you were or weren't relaxed. She wasn't a hedonist, she wasn't a pleasure seeker; pleasure was too full, she was after the skeleton characteristic: pleasure without content, beyond calm, divorced from any stimulus.

When she was in the process of achieving said relaxation my mother would narrate in running commentary its various phases, registering like a Geiger counter any shifts in her arousal: "I feel less nervous now," she'd say, or "I'm *nervous*!" or "I'm feeling *more relaxed*." At times she seemed almost surprised that it was even possible to get to the place of calm she'd arrived at. To reinforce her sense of certainty she liked to repeat how relaxed she was, and ask rhetorically of others "Isn't this relaxing?" and "Aren't you relaxed?" with the hope of generating a sort of feedback loop of homeostasis.

The flip side to my mother's obsession with relaxation was her encumbering nervousness, and only cigarettes could subdue it. When I was little I viewed her addiction as a steely resolve: an unrepentant individualism that cared nothing for social trends or ghastly images on posters of tar-rotted lungs. In truth, she was just addicted to cigarettes. She tried to quit smoking when it became fashionable in the late eighties—the

first of several crusades—but at the slightest skirmish, the slightest hint of a problem, she was back off the wagon. My siblings and I staged interventions, we threw out the cartons of Benson & Hedges Ultra-Light 100s she hid in her drawer, but she'd just get new cartons and find new hiding spots. We made vociferous complaints, we warned her she'd get cancer, but nothing worked.

Then, just before she turned sixty, she was diagnosed with something called an acoustic neuroma, a tumor lodged between her brain and acoustic nerve. The tumor was benign but still potentially life-threatening, and she needed to get an operation. The doctors insisted she quit smoking prior to the surgery, and we were all shocked when she was able to do it—particularly in light of how nervous she was about having brain surgery. After her recovery she tried to make it stick, but there was a problem, which was that when she was nervous all she knew how to do (if she denied herself a cigarette) was torment herself with nervous anxiety.

To worsen matters, my father was suing her for divorce—he made the despicable moral error of serving her with divorce papers *the day before* her operation. He had the temerity to show up at the hospital the day of the operation—he even brought a rabbi with him to give her an extempore blessing. My mother snubbed them both as she was wheeled away on the gurney—she didn't need some shit blessing from his shit rabbi. When she was recuperating, Dad started in with his inveigling, urging her to sell the house, explaining how she didn't need to live in that big house anymore, it was *too big* for her. The money would be a nice chunk of change for my father, but it wouldn't get Mom a decent apartment, not in New York. How was she going to live? She had no collateral, no savings. And she desperately wanted to retire. She was pushing sixty, she couldn't work at her receptionist job forever.

In the skein of these unpleasant thoughts—and as an intermediary respite from the horrors she conjured in her overactive mind—my mother decided to book a luxury cruise to the Caribbean with my sister. There were only two beds in the cabin, but for a couple hundred bucks, she said, I could join them—there was some kind of pull-out sofa or trundle bed.

It wasn't the most appealing offer, but at the time I felt rootless and a bit lost. I was about to leave home for three years. I'd gotten into a graduate program for playwriting in Iowa. I'd written a one-act play and used it as a sample, and they accepted me. It was very prestigious—I was thrilled—but I'd be leaving a trail of broken relationships in my wake. I was no longer on speaking terms with my father. And in the spring, Kurt broke up with me. It was my first relationship, and my first breakup, and I was crushed—even if I knew deep down that the whole thing had been a disaster.

For one thing, Kurt was constantly driving up to visit his wife (they were meant to get a divorce, but never did) at that house they shared in the Thousand Islands, because the dog allegedly missed her, and because it was just *so tonic and lovely*, he said, in the Thousand Islands. He was driving up every weekend, and since he worked late during the week we almost never got to see each other. If I balked, he dismissed me; if I asked to drive up with him, he drew a line in the sand. But the wife thing was symptomatic of bigger problems: a rotten sex life, the sickening cocktail of my garbagey self-esteem, and his oppressive need for control. It was a bad match, but I took that failure as an indication of my failure as a person.

I worried I was too damaged to have loving relationships—and I was *desperate* to be loved. My life seemed like a catalogue of rejections. After the breakup, I was in desperate need of comfort and care—and I'm sure I harbored some liminal, dimly conscious wish that my mother could be a person who

might tender such things if we were trapped in a confined space for ten days. And after that terrible experience with my dad, I wanted to prove I could meet at least one of my parents at some vague horizon of adult communication.

I flew into San Juan, where I met up with Mom and Arlene. The ship was nice, but the cabin was significantly tinier than I imagined—it barely fit the three of us. Arlene already seemed to be anticipating the bad time we'd all have in the small cabin, but my mother was in a "roughing it" mode: we'd hardly be in the cabin with all our activities and sunning and dining and relaxing. While the surgery was deemed a success, the healing process was going to take a bit, and my mother was almost entirely deaf in her right ear. The deafness caused her to shout at everyone, but she didn't think she was shouting because she couldn't hear herself. As we unpacked, she loudly lectured me about sunscreens and warned me about the dangers of the Caribbean sun, explaining that it was "NOT LIKE THE SUN YOU THINK YOU KNOW" and that it could "BURN YOU ALIVE." The other residual effect of the surgery was that it left her with a constant sensation of imbalance. Every so often she'd lean cautiously, her fingertips grazing a wall or a piece of furniture to steady herself. Or she'd become oddly still, then slowly hold out her hands with her palms facing out as though she might do a pirouette. She'd look over to one of us, and inquire "ARE WE MOVING?" in a loud monotone. Her eyes were sweetly uncomprehending; her feet planted unsteadily like a child just learning to walk.

I thought it was cute but Arlene was visibly annoyed, and she huffed and marched around the cabin. The two of them went on vacations all the time, and things generally went badly. Arlene was essentially a nervous person, and her nervousness often triggered my mother, who would in turn criticize her (not

deliberately, she was trying to be helpful) and their conversations would become threaded arbitrarily with these small warnings and minor correctives from my mother. Arlene would try to work around Mom's obsessive critiques (*Did she want to be alone for the rest of her life? Didn't she want to read the great books and be spiritual? Shouldn't she see a dentist before it was too late?*) but she lacked coping strategies, and eventually, no matter how pleasant or luxurious the trip, always ended up beaten down.

We got all dressed up that first night to go to the Orion dining room. Mom lurched unsteadily down the port hallway; if she lost her equilibrium one of us grabbed her arm to steady her. "ARE THERE WAVES," she said on the elevator, prompting looks from the other passengers. "Ma, you're being loud," Arlene whispered. She wobbled a little to the left, then pressed her fingertips against the wall of the elevator as though performing a sacrament. "I FEEL MOVEMENT," she said. "*Ma*," repeated my sister, "you're being *very loud*."

"I'M LOUD?"

"Ma, you're screaming," I said.

"I'M NOT SCREAMING."

The elevator doors opened and I walked ahead of my mother, who wobbled down the port hallway navigating turbulence both real and imagined. She careened through the maze of tables in the dining room, which was huge; it took a long time to get anywhere. It was decorated in shades of gold and cerulean. On the center of the ceiling was a polar-projection world map: a token reference to the name of the ship, I supposed, which was the *Galaxy*—even if the world was not the galaxy—the motifs on the ship in general seemed confused.

The maître d' seated us at a table near the galley, we had to share it with a squat midwestern couple and their daughter.

The father wore tweeds; he was bearded and had an owlish face. The daughter, like her mother, wore lace-fringed Laura Ashley. Her dress had a ribbon near the sleeve and a deep border of embroidery.

"SO WHERE ARE YOU FROM?" screamed my mother quite suddenly, as though she was broadcasting into a loudspeaker. Her volume made the father's chalk-white face turn scarlet.

"Minnesota," he said.

"YOU LIKE IT THEH?"

"Oh ya. It's nice," the wife said.

"I JUST HAD BRAIN SURGERY," my mother said, not to anyone in particular. "I HAD SOMETHING CALLED AN ACOUSTIC NEUROMA."

"Ma," Arlene chided, "they don't want to hear about your acoustic neuroma." Arlene eyed the family, half in complicity with them. Like my sister, I tried to give subtle nonverbal clues to the midwestern family that I was in solidarity with them, that I too was mortified by the loud overbearing presence of our mother, who didn't appear to notice our discomfiture—or if she did, she didn't care. She was going to be sociable and have a *good time*!

Our table was near the silverware station, and for some reason my mother, who was otherwise mainly deaf, was acoustically extremely sensitive to the sounds of tines and spoons and all manner of silverware—a point she needed to emphasize with absolute clarity every couple of minutes by declaiming things like "ITS SO DAMN LOUD!" and "SHUT UP WITH THOSE *FORKS* ALREADY!" When our waiter refilled my mother's wineglass she became inexplicably livid, and demanded he pour the wine *back into the bottle* because she hadn't *asked* him to pour the wine into the glass, and as part of her extensive reprimand, demanded that this one bottle of

Pinot Grigio be kept for her "in the back" and that at every dinner thereafter the waiter was to pour her "ONE GLASS PER NIGHT."

By the time dessert came I had a migraine, and my sister had gotten so anxious she was unconsciously pulling the kinks in her hair and ripping at her eyebrows. I felt badly for the midwestern family, who'd collectively sunk into a quiet capitulation. They tensely sipped their ice water, careful not to clink the ice or touch their silverware or do anything that would incur further umbrage from my mother. When we got back to the cabin I took two Advil, put in my earplugs, and went right to bed—but I couldn't sleep. I lay in my trundle bed all night planning my escape.

After that night, though, we actually started to have fun together. My mother learned to adjust her volume so she wasn't shouting all the time. We had breakfast and disported ourselves in deck chairs. We sunbathed while a band played music and people served us ice cream sundaes and candy and alcohol. We loitered at the duty-free store, watched movies, made desultory trips to the casino. The ship had a touristy gaudiness, but I didn't mind that; in fact I found a kitsch enjoyment in all the gold and marble and Muzak. Arlene was picked—one of just a few passengers—to be in a fashion show. She modeled outfits from the boutique to Robert Palmer's "I Didn't Mean to Turn You On" standing on plinths, slinking blankly and modishly around the shuffleboard area. The Caribbean sun really *was* hotter than other kinds of sun—my mother was right—and on the second day I got badly sunburned. My sunburn was painful but I liked the way it looked on me, pink and bright. When I angled myself a certain way in the tinted mirror of the elevator I looked distinguished. The cruise prompted vain reflections: I kept looking at myself, thinking about myself. I felt improbably rugged on the ship, whipped by austral winds on sundecks and

mezzanines, my hair slicked in place by condiments and waxes. I felt, for the first time in my life, almost gallant.

I kept having fantasies that some steward or epaulet-studded sailor would pick me up on some deck, which didn't happen. Then, one afternoon, I found myself being unmistakably cruised in the locker room. The guy couldn't have been older than twenty-two or twenty-three. I noticed him at the pool the day before. He was wearing a black Speedo, and had just finished swimming. As he reclined in his deck chair, droplets of water trickled down his torso and stomach in spotty rivulets before quickly evaporating in the heat. Now he was standing before me in a towel. His flesh was studded with goose bumps, nipples pinched and purple. He looked plucked, like a duckling. I wanted to suck him off right there in the shower but I was scared we'd be caught—and we couldn't risk going back to my foldout sofa. "I know a place we can go," he said. He got dressed and walked me around the side of the ship, then up a small staircase. He brought me to a tiny enclave near the lifeboats, which were harnessed in rows about the deck. We started kissing and I could taste the brackish white film on his cheek. Neither of us seemed to care if we got caught having sex: we were caught up in the fantasy of the cruise, where only pleasant things could happen, especially in an open-air vista. Afterward we leaned against the guardrail, pensive and happy. "I'm Jim," he said.

"I'm David."

I shook hands with him and we both kind of laughed.

"Are you traveling alone, or are you with someone?" I asked.

"Well . . . I'm not alone exactly. A priest from my college brought me with him."

I'd never heard of a priest taking college students on cruises. "Are you *sleeping* with the priest?" I asked, not very delicately.

"No . . . no, he's just nice."

"Nice?"

"I know it sounds weird," he said. "But he's *very* straight. We're just friends."

The boy was so unscarred and young. I'd never been young in that way. His innocence was boring but it gave him any appeal he had.

"What do you do?" he asked.

He was compulsively biting slits of fingernails already chewed to the base.

"I'm a playwright," I said. "I'm starting grad school in the fall. I'm going to the Iowa Writers' Workshop." I kept trying to bleed whatever prestige I could from my Iowa acceptance, but he didn't seem to have the vaguest idea what it was.

"What kind of plays do you write?"

"Huh? Oh. Well—they're all different."

"But do you have, like, one main theme or style?"

The truth was I had no idea what my plays were about. I had no comprehensive vision for the kind of writer I wanted to be. "They're sort of comedies," I said, trying to sound like I had it all together but wanted to downplay it.

"That's cool. What made you become a writer?"

I didn't like being interrogated about my as yet undeveloped writer self; the boy made me nervous. I'd been trying whenever I had a free moment to rest on laurels that weren't yet mine; I told anyone who would listen I was in the Iowa Writers' Workshop, but the truth was I couldn't understand how I'd gotten in. I wasn't sure I had any talent and was terrified of being found out. I was driven to be an artist, but I wasn't exactly sure what art was or what it was for.

I knew, from books I read, and weekend classes I'd taken at St. Mark's Church with Irene Fornés—who was a very famous playwright—that when you wrote a play you were meant to connect to something inside yourself, and that whatever it was

you connected to would lead to characters speaking. This never happened to me. When Irene gave us an in-class exercise I tried opening the channel to let the characters speak, but it was eerily silent. That day I became so panicked by my lack of creativity I left the class and never returned. My life consisted of borrowing and discarding identities from books and films: what was inside of *me*? I had no idea, and was terrified to find out. And now the conversation with the young man who was likely having sex with his priest made me feel intensely *nervous*— and like my mother, I couldn't rid myself of the nervous feeling. So I parted ways with the boy. I went to the bar and had a drink. And with my drink, my terrors started to dissipate, and I was able to relax.

The midwestern couple asked to be transferred to another table after that first night, and we were moved away from the noisy silverware station to a banquette on the other side of the dining room, which pleased my mother. The waiter appeared with her *one glass of wine* poured from the bottle they had stored for her "in the back" and she thanked him—calmly—her manners now surfacing again. The dinners were pleasant. We ate from china plates and drank from crystal goblets. My mother and Arlene got along for the most part. And while Arlene couldn't fully enjoy the kitsch aspects of the cruise, and while the salmon wasn't as good as that place she'd been to in Soho, she accepted it for what it was. After dinner we'd retire to the Fortunes casino, or to a rock concert in the Stratosphere lounge—there was an Air Supply tribute band. Or we went to karaoke, or to the movie theatre, midnight breakfast, dancing in the discotheque. The salt air gave my mother's hair a helmet-like frizz, and she wobbled from port to starboard in groggy disequilibrium, wrapped in sarongs and cover-ups. It had been almost two months since she'd smoked. "I don't even *want* a cigarette,"

she'd declaim with an almost drugged incredulity as she spooned bananas Foster or sipped wine and breathed in the dustless air of the stateroom. She boasted about her own comfort. "Well, *I'm* relaxed," she'd rejoin to no one if her velvety enthusiasms went unacknowledged. The pleasure she took in her relaxation made her a little smug, even if it was unintentional; she'd simply achieved a kind of Zen state, a parochial enlightenment, that made her more moral than nervous people.

She was up early, usually at the crack of dawn, to get a head start at relaxing. I'd find her at eight or eight thirty on her shaded deck chair, supine in nautical enjoyment, slathered in 100 SPF and perusing with diffuse, gentle concentration the information booklets and quarterly newsletter from the Acoustic Neuroma Association she'd gotten in the mail a few weeks earlier. When she saw me approach, she'd lower her sunglasses, her expression hinging ineffably between stated and catatonic. "Isn't this *relaxing*?" she'd coo from her pelagic pulpit, caressing each syllable of each word as she spoke it as though it were a glistening jewel. She felt safe in the hermetic envelope of luxury the cruise ship provided. She felt protected by its splendors. Being on the cruise inspired in my mother a sudden, fleeting duty to teach her children how to live—not just survive, but really *live*. She kept offering us things, plying us with comestibles and gifts: "This drink is *unreal,* Dave. You want me to get you a *drink*?" She wanted to show us that luxury was the extension of a greater overarching philosophy, that there was a secret nested in it, a spiritual mystery—and that she would bestow upon us, her children, its precious gift. It reminded me of when I was a little boy and she walked me through the hallowed atriums of the Met and the Guggenheim to expose me to Culture. My mother wanted my sister and me to taste expensive liqueurs and eat caviar. She wanted us to absorb copious amounts of vitamin D, which you got by lying in the sun.

She made appointments for us to get shiatsu massages in the spa. I had never gotten a massage before and I wasn't particularly interested in it: I didn't need to relax, and in fact prized my agitation as a kind of survivalist wakefulness—I didn't want to be lulled into the seductive slumber of calm and repose—but my mother insisted. "Massages are *very important*," she told me. "You're supposed to get a massage once a month. Otherwise you could have *real problems*." I liked the slightly regressed feeling I got when she talked to me this way; my mother knew best, I had to listen to her for my own good.

Arlene and I walked over to the spa together for our massages and they separated us. I went into the men's side. They had me prepare for the massage with a shower. The locker room was luxuriously outfitted with soft towels and liquid soaps and fragrant lotions. The showers were pebbled with glittering stones, seafoam and celadon. After my shower, I put on a plush white robe and was ushered into a small twilit room studded with small candles. I disrobed and got under the sheet, and the masseur told me to put my head into an upholstered oval slot on the table. I felt the blood pool in my face as he worked the tension out of my back and neck and legs. My mother was right: it *was* relaxing, and the luxury was edifying. And there was something nice about someone touching you and unknotting your tension, something almost holy about the intimate connection between strangers. I forgot all about Kurt and my despair about relationships. After my massage, it was like the sound had been turned off and I was floating through a silent world with vivid colors. I felt like a ghost hovering over the decks and starboards. I felt like a baby gently rocked by small waves lapping against the boat's hull. I felt the inexplicable joy I imagined the dead might feel once they were unchained from their bodies. I passed the frozen yogurt bar, and saw my sister

on a nearby bench staring out at the horizon. I was excited to compare massage stories and took my seat beside her. "God," I said, "I feel so *relaxed*."

"I *don't!*" said my sister, who launched into a litany of complaints about my mother. They ran into each other after my sister's massage—which she enjoyed, it relaxed her, just like my mother said—and she tried to thank my mother, but my mother intercepted her thanks and started in on one of her rants: Did Arlene want to be alone for the rest of her life? Did she want to be *poor* and *suffer*? Didn't she want to lose a few pounds? And why did she change her hair, didn't she think it looked better with layers? My mother continued to batter her with small, needling complaints, reminding Arlene that this was on her mother's dime so her *mother* got to call the shots—that was a perk she gave herself, a gratuity. She could give or withhold gifts like massages. She could decide when they'd wake up, who got to shower first. Arlene was the little girl and my mother was the grown-up, and that dynamic would always give my mother a little boost and would always make Arlene feel like shit.

When my sister turned forty-nine she went to the Landmark Forum because her friend Danielle said it changed her life. The Landmark Forum counselors gave everyone tasks and during the break between sessions people had to call someone to confront them about something painful. The Landmark Forum participants filed out of the main auditorium toward the bank of pay phones. Arlene decided to call my mother. And when my mother picked up the phone Arlene said, "Why don't you love me?" My mother was, of course, taken off guard. She said, "What are you talking about?" She tried laughing it off, but my sister was sobbing audibly on the other end. My mother maintained over her sobs and shudders that she did love Arlene, to stop being ridiculous, to stop crying. But Arlene couldn't stop

crying and kept repeating over and over, "Why don't you love me? *Why don't you love me?*" When my mother found she couldn't stifle Arlene's cries she became glacial and hard, the way she'd been when Arlene cried as a girl. She commanded her to STOP CRYING ALREADY. She hammered into her that she loved her and that Arlene was being ridiculous.

I knew my sister felt unloved. I tried to be there for her as films of salt from the ocean air condensed around our lips and cheeks and we were rocked by waves. We walked back in silence to the cabin. That night Arlene didn't speak very much at dinner; she left for the room before dessert. My mother admitted they'd had an argument and I pretended not to know anything. I didn't want to take sides because I didn't want to get triangulated into their argument because there was no winning. By the time we got back to the cabin Arlene was asleep. The following morning we had breakfast and she barely spoke. She gazed expressionlessly at ceilings and empty skies. When she left, my mother cracked open a packet of Sweet'N Low and emptied it into her cappuccino.

"That girl is too sensitive."

"You could be a little bit nicer to her," I said, breaking my silent vow not to get involved.

"Honey, she knows how I am. Why does she have to wear that outfit in front of me?"

"Because she's a grown woman and she can wear whatever she wants, that's why."

She picked up a tiny silver spoon and stirred her cappuccino. "Well, you didn't see what she was wearing."

"I did see it, and I thought it was fine but that's *not the point—*"

"And then she walks off, no goodbye, no nothing?"

"Because she's mad at you! She doesn't want to be critiqued all the time."

"Is this how I raised her? No. I raised her to have class, not to wear shit outfits."

My mother's aggressive superficiality was starting to drive me nuts.

"Why do you care so much about people's outfits?"

"*Honey*," she replied, "this isn't some garbage cruise. This is a very elegant ship."

"Arlene is broke. She can't afford expensive outfits. She's a single mother, she's been through hell—you know what she's been through!"

She repositioned herself in her seat and lifted her head slightly. "She can still put some effort into her appearance." Her face had an oily sheen; her forehead was so shiny, it gave off almost a reflective glare.

"I know you don't see it," I said, "but sometimes you can be really harsh."

"Oh *please*." She lightly rolled her eyes.

"All Arlene wants is to be loved, so why can't you just give her that?"

"You're being ridiculous."

"It costs you *nothing*."

"I'm going back to the cabin."

"Don't you want a real relationship with your own *kid*? Doesn't that matter more than her *outfits*?"

My mother took another sip of her drink.

She looked out through the tiny port window. Her eyes were milky and distant. "Honey. I am who I am," she said. "I'm never going to change."

The ship landed in Barbados the following morning and we took a shore excursion for the day. Arlene lagged behind my mother and me. I could hear her parlous sighs, the punishing clomp of her sandals as she followed us from place to place.

Barbados was steeped in poverty; the sidewalks were unattrac-
tively pitted and pebbled, they were lined with Barbadians beg-
ging for money. Their destitution contrasted harshly with the
kitsch and artifice of the cruise and broke the illusion we were
collectively trying to engender of unimpeded luxury. There was
a Hilton down the road, but when we got there it seemed aban-
doned. Calypso Muzak played in the elevator. Indoor wooden
footbridges took you from one quiet, deserted area to another.
The beach we found behind the hotel was rocky and inhospi-
table but we found a small lounge area, and lounged in abut-
ting identical plastic lounge chairs. The sky was dull blue and
dotted with wispy cirruses. My mother slathered zinc oxide on
her nose and ordered drinks. Women combed the empty beach
like minesweepers, selling their beaded necklaces and rings. My
mother bought one necklace for herself and one for Arlene—
who was still not speaking to her but wore the necklace any-
way. No one was very relaxed. My mother made conversational
gambits with my sister, she hazarded a compliment or two,
doctored her criticisms so that they seemed like encourage-
ment, but Arlene just sipped her drink and rolled her eyes.
Maybe Arlene might want to play shuffleboard later on the
ship, my mother opined. "I'm not *in the mood*," replied my
sister, burnishing her disillusionment into a kind of chamber
opera. My sister could squeeze with remarkable economy whole
epochs of rage into a single sentence; I felt the intense magnifi-
cation of her unhappiness as though it were being projected
onto a giant screen. But then she was laughing at something,
and before I knew it the two of them were laughing and talking
as if nothing had happened.

The next day the ship debarked in Antigua—which Howie
used to talk about all the time. He'd been there in seventh
grade, and detailed his exploits in those long notes he passed to

me between classes. His family stayed at a beautiful and somewhat secret place called the Half Moon Bay Hotel, and I decided we should go there on our day excursion. Just outside the ship a bunch of aggressive cabdrivers were jockeying for customers. I made arrangements with one, and we started walking to his cab when another cabdriver started yelling at my mother, who'd evidently made some kind of loose arrangement with him, and now he felt she was reneging. I didn't like how he spoke to her and told him to back off. But my manliness was not sufficiently intimidating. "What are you going to do about it, *faggot?*" he said. I had been called a faggot before, but never in front of my mother and sister, who just stood there, horrified—probably, I assumed, because they didn't want to be affiliated with a faggot, they wanted a man, a man to protect them and negotiate aggressively with cabdrivers. All the other cabdrivers had momentarily been intercepted by the threat of potential imminent violence and I felt their eyes on me. "You gonna fight me, faggot? Huh, faggot?"

Everybody knew I was gay by then; my sexuality was treated like a dirty secret we felt obliged to keep buried. A few months before her operation, when I was dating Kurt, I tried to introduce her to him—it seemed like something grown people might do. I knocked on her bedroom door one morning, and when I suggested we all have dinner together my mother looked shocked, as though she'd been plunged very suddenly into a bath of ice water. She stared at me for a moment, tightening the belt on her sateen bathrobe, the one with the birds and mint-hued sunsets. The lines in her face all tightened. Then she flashed a very unexpected look of defiance, to let me know she had some mysterious upper hand in the situation. A hint of a smile pushed through her pursed lips. "No, *thank* you," she said, her voice deepened by all her endless smoking, "I don't want to

meet your *boyfriend*. I don't want to meet any of your *boy-friends*, so don't bother introducing them to *me*."* I felt her loathing in the diacritical emphasis she gave the word "boy-friend." Instinctively, I tried to match her rejection with indifference. I said something like "Fine by me" and, before I knew it, she'd slammed the door in my face. Though it wasn't terribly violent, and people did things like slam doors in other people's faces, it hurt me. But I had to compromise if I wanted some sort of relationship with her—and I genuinely did. I couldn't discuss my breakup with her; she couldn't alleviate my pain and would probably never really know or see me, but I still loved my mother.

As we drove to Half Moon Bay, we sat in awkward silence, and our cabdriver—who was genial and felt bad (it seemed) that I was called a faggot by the other cabdriver—tried to regale us with stories about the island, but I was too riled up to properly pay attention, or if I did I affected a bunch of grunts and low-octave manly responses like "huh" and "no kiddin'." I was stung, but I had to conceal my hurt, and that effort curtailed my ability to address the hurt, so it continued to burn and sting. I felt inept at hiding the pain I felt for being humiliated in front of my mother and sister. My illusions of gallantry were ruined. I didn't expect a consoling word or a hug; I knew that we were all netted in this feeling of shame, that everyone was bound by the shame I brought upon us.

For the remainder of the cab ride my mother prattled nervously about the landscapes and how pretty everything was.

* Once the culture's ideas about gay people started to pivot, my mother became more accepting of my sexual orientation, but even her acceptance was fraught. "Don't you want to *meet* someone?" she'd ask, in the same accusing tone she used with my sister, or with me as a small boy, when I didn't have fun or play. "Do you want to be *all alone*?"

The driver let us off at the hotel—which it turned out had been shuttered, probably for a decade or longer. The walkways were abraded with splinters, the wood mulchy and moldering under our feet. There was just a desolate beach, a gray-white granular crescent. By the time we figured it out, we were stuck; the driver was gone and wouldn't be back for hours. We had the beach to ourselves, though, and my mother found that prospect relaxing; she always fantasized about owning her own private beach. She talked at length about the sound of the waves and if we found them relaxing.

The beach was bordered by short grassy hills that came up to our necks. Down by the water were little cave-like formations of dark rocks that glittered in the light. There were reefs teeming with tiny hermit crabs, and in the water, schools of translucent fish swam at hard angles. The restaurant in the hotel was closed but we managed to find a small concessions area stocked with soda and candy. We made a lunch out of that. An hour or so later, we spotted an interloping couple on the opposite side of the crescent. The presence of the couple marred the proprietary fantasy my mother had of owning her private beach, mitigating against the relaxing properties she was determined to attribute to it, but she was so calmed it didn't matter. She reapplied sunscreen and zinc and propped herself on a towel.

I was surprised by the nothingness of beaches. I hadn't really ever liked them but I assumed that had to do with age, and that when I got older I would feel more serene on them and they might tender gentle epiphanies. But after the initial overture of turquoise water and clay-white sand they all seemed apocalyptic and eventless. I wondered if I had the capacity for apprehending beauty. I wondered if there was something deficient in my constitution.

Arlene had taken a meaningful-looking private walk along

the shore and seemed to be contemplating deep things. I watched her trace the contour of the shore and it reminded me of that spiritual poem "Footsteps" my mother had on her dresser near her perfumes. It was the one about God carrying the beleaguered suffering person on the beach—which explained to him, the vaguely querulous speaker in the poem, why there was only *one* set of footsteps on the beach instead of two—thereby affirming the presence of God to the speaker and, I assume, my mother. She kept the laminated poem upright against a mirror on her dresser.

Years later, I noticed it was gone.

I joined my mother, who was basting on her towel, asleep. Not having brought a towel myself (I defied her warnings) I lay next to her on the bare sand. I looked at my hands, and a dense jam of sweat and dirt had congealed under my fingernails. I looked at my mother's fingers, stained with nicotine. I looked at her plump face, then down at the creased and crumpled flesh of her legs and thighs as she lay asleep on her towel, perfectly content, a priestess in the shrine.

We'd been at the beach for hours; I didn't have a watch but it felt too long. The combined effect of the heat and the planetary vastness of the beach and the hypnotic lull of the waves made me lightheaded. I felt hungry but also slightly queasy. After a while I started to feel restless and sat up again. I forgot my sunglasses and felt almost blinded. Colors were bleached and shapes were vague. I squinted and looked to see where my sister had gone. I could make out a tiny figure on the other side of the crescent, far away, at the edge of the water. I could feel myself in this pocket of stillness. I felt a sense of entrenched permanence, as if we would never leave this beach and had never been anywhere else. As if my mother, my sister, and I were lifted from earth and had become our own planet, and were at the same time the sole inhabitants of this planet. The water

crested up the shore, slipping and ebbing. The sand gleamed in the unscattered light, it looked soaked with crushed diamonds. I heard a soft voice, almost a whisper: "Isn't this so *relaxing*?"

My mother was awake again. Her tone conveyed both affliction and its easement; now that she'd found peace, traces of her prior distresses stood out in relief. She lay propped on two elbows, staring at the water. Soon she would fall back to sleep, lulled again by the siren call of the waves. Her imperial cravings were sated. The sea was her glittering prize.

BOOK IV

THE FUTURE, AGAIN

TWIN

I WAS EATING PANCAKES at a tungsten-lit Perkins directly across
from a video arcade, where, minutes earlier, I was spooning
with a strange man in a darkened booth. "I really have to go,"
I told the man, who wore a wedding ring and seemed desperate
for an intimacy I couldn't offer. "I just love to hold you," he
said in a woozy voice. Porn clips flickered over our faces from
a tiny screen-like light from a stained glass window. The video
arcade had the overchlorinated odor of a swimming pool that
hadn't been cleaned, and there was a mortuary odor too, like
the chemical smell that pervaded hospital corridors. "Sorry," I
said, before disentangling myself. "Nice meeting you." I slipped
out of the booth and into the open air, where it was thirty de-
grees in the middle of October. It didn't feel odd transitioning
from the dark cavities of sex clubs to pancake houses, it was
simply part of my new Iowa lifestyle.

"Pass that boysenberry syrup," said Kendra. She had on
denim overalls and wore her hair in cute springy braids—she
looked about fifteen years old. The syrup was a flashy violet
color in the jar but when she poured it onto her pancakes it
brightened into something slightly reddish, like Robitussin. Her
plate was drenched in it.

"That looks so disgusting, yuck."

"*Mmmm*," she cooed, taking giant overstated bites.

The mortuary smell of the sex shop was in the Perkins, too. It combined as if alchemically with the taste of the pancakes, so that the pancakes tasted like hospital, and the sex club reminded me of the pancakes, and everything resonated with everything else.

"How was your sex club?" Kendra was chirpy and positive, the default style for all the playwrights in the program.

"Good," I said, disgorging pats of butter from plastic mini tubs.

Her eyes widened with encouragement. "Oh that's *good*."

The incommensurate robustness of her responses tickled me. Kendra was from New England and was raised to be intensely polite, even in circumstances that strained her to the breaking point. Racist people, clueless yobs—she treated everyone with the same genial interest. I took a perverse enjoyment watching her suck in her lips like a goldfish and nervously chew the insides of her cheeks to keep from breaking up when someone in the program brought some wildly inappropriate play to class— like Enzo, who wrote a play about a gay Jew (clearly based on me) who gets eaten by a mountain lion; or Sharon Bell, a progressive white woman who wrote Afro-womynist collages patterned on the work of Ntozake Shange, and always cast Kendra (the only black woman in the program) as "Witchgrass" or "Calendula" or something you could get at an apothecary.

Not all the plays were bad—there were some good writers in the program. But I came to find that all playwrights were essentially crazy people. Playwrights were people who walked around talking to themselves, or barely spoke, or prattled in chirpy near-hysteria to avoid falling apart. We were screwed up and psychodevelopmentally wounded. Most, if not all the people in my program, had been abused and were in various stages of post-traumatic stress from parents who strangled or molested them, or burned them with cigarettes, or threw them

down the stairs. Most were children of alcoholics: three weeks into our first semester Caitlyn's mother (who drank so much, she'd been hospitalized three times in a single year) developed a blood clot in her brain and died. A few months later, Julie's father had an alcoholism-related stroke and then *he* died. We were all on the verge of going sort of nuts, and different people had different ways of concealing it. Julie erupted in squeals of chirpy affirmation, Melissa went into strange spacey fugue states. Sharon Bell was prone to having emotional breakdowns in the middle of writing exercises. Ten or fifteen minutes in, she'd excuse herself and slump toward the door in grief-stricken slow motion—a Hummel figurine broken and reglued and crumbling in tiny fractures with every step.

Even though the playwrights were eccentric and troubled, I seemed to fit in with them—but my peers were elusive. Sometimes they agreed to hang out, but they were all either in relationships, or neurotically private, or protective of their time because they needed to write. By default, Kendra and I (both fairly social as far as writers went) spent nearly all our free time together. On weekend nights we sat on a bench across from a bar on the main drag gossiping about people in the program. We walked from one end of the mall to the other and watched all the straw-haired Christian teenagers going on dates, chewing on lobes of Auntie Anne's pretzels and slurping Orange Julius. We observed the little tweens ice-skating indoors and gamboling around, their tiny pink fingers sticky with Cinnabon icing. We ate weird disgusting renditions of ethnic foods: Pad thai that was brown and tasted like vulcanized rubber, cylinders of tuna maki piped with a grayish-lavender stuffing. ("All tuna is gray," the waiter informed me, careful not to put too fine a point on it.) On Sunday mornings we held our noses to escape the gastric stench of vomit-streaked sidewalks as we made our way to some brunch spot—usually a diner betraying

a link to Swedish ancestry, or one of those living rooms in Victorian houses midwestern people made into restaurants. During tornado warnings we hunkered in our respective clawfoot bathtubs talking on cordless phones until the batteries ran out. I adored Kendra—I thought she was the most pleasant human being I'd ever met in my life. But my attachment to her was slightly unhealthy.

When we finished up our pancakes, I didn't want the night to end. "What should we do now?" I asked with a vague sense of doom, for I knew what was coming.

Kendra's eyes widened in sympathy. "Oh *my*," she said. "I think I have to go home."

"Already?"

"We just sat in a Perkins for two hours!"

"But, Kendra, I'm so *bored*."

"Go work on your play!"

"It's Saturday *night*!" I said with zealous insistence, as if I were a person who had to stay out late on weekends.

"But I have to work," said Kendra. "My reading is in three weeks."

"I thought you already finished that play."

"The second act is a mess, I need to rewrite it."

Kendra was intensely disciplined. In the past year she'd written three full-length plays and was now working on a fourth—a Gothic horror she was planning to submit for Playwrights Festival. That was the year-end culmination of everything we'd done. It was our debutante's ball: agents and producers came to offer critiques, but also to scout for talent and build relationships with young writers. It was a chance to get to the "next level" (whatever that was, no one really knew) but we all felt the rapacious drive to "make it in the industry." Every writer was represented in the festival, but a handful of plays were selected for full productions, and those were (for obvious rea-

sons) better positioned than plays selected for readings, though the administration tried to play down the competitive aspect.

I was certain Kendra would get a full production—I envied her discipline. She wasn't afraid of writing, but I had practically a phobia of it. At Iowa we were instilled with the notion that to write a good play you had to risk something, you had to be honest. And though I wanted to be honest, and my favorite plays and films and books were all excoriating and true, the prospect of writing *my* truth terrified me.

I couldn't have admitted this back then. I told myself I was deep, and sensitive (I cried easily! I liked Rilke!) but I was terrified of being exposed—and not just to other people, to *myself*. I was a Lot Six: a freak and an oddity. Who would want *my* truth? No one.

I wanted to please people with my writing. I tried writing comedies with clever dialogue. If the comedies got too honest, I backed away. When the anxiety around writing became too much, I avoided it altogether. Festival submissions were due in early December and I had nothing—I hadn't written a word in months. I gave feedback in workshops and did all the assigned reading and that was the extent of my participation in the program. I suspected I might be kicked out, but for some reason my teachers were all weirdly patient with me. Each week I came without pages to Naomi Iizuka's class (she was the visiting instructor) and each week she pretended not to notice.

Tom Hauser—the man who ran the program—was the same way.

The writers all adored Tom, even if he was beleaguered by some kind of adult social anxiety and would sometimes go out of his way to avoid us—or, at other times, linger a little *too* long with us and talk a little *too* much until it became awkward for everyone. His bumbling insecurity endeared him to us. He was a typical midwestern specimen: padded in his wool

sweaters, waistline ballooning in baggy corduroy pants. He was doe-eyed and chinless, unrugged and soft-voiced. On cold days his nose turned bright red. When he made one of his bizarre jokes about Maeterlinck or Meryl Streep's character in *A Cry in the Dark*, he blushed scalding pink. Sometimes he could be very heady. My first week of school, he sat me down in his office. He said, "What is Adjmi-esque?" I found this to be an absolutely terrifying question. Tom was pushing me to look at myself, and I wanted to bury my head in the sand.

I was, without question, the least productive writer in that program, but I was not alone in my anxieties. We were all dealing with all the bleak uncertainties of a future in the theatre.

One afternoon, Kendra and I ran into Jean Endicott getting soused in an Italian restaurant in Coralville. Jean was single, in her early forties, and lived with her grandmother in Cedar Rapids. She'd graduated from the program in the 1980s and still wrote plays but worked as a physical therapist in Quad Cities for her day job. "Hello there, Jean!" said Kendra, who was in a chipper mood.

"Did you hear the *news*?" said Jean. She smiled, but her face flashed an almost citric distaste.

"What news is that?" I asked.

"Oh, you didn't *hear*?" There was a sudden tooth-decaying sweetness in her voice, but her bulbous nostrils flared contrastingly with what seemed like rage. "Ellen Nadler on Broadway," she said a little too loudly. "Isn't it *great*?"

Ellen Nadler was Jean's former classmate, and that morning Jean saw online that Ellen's new play was going to open on Broadway in the spring. Jean was not having a terribly easy time with this, and it was understandable. Unlike Ellen, who went on to have a successful career in England, and won a Genius Grant, Jean wasn't famous, not by the most generous stretch. "Maybe they'll let me be a popcorn girl!" she said, tak-

ing tiny aggressive bites of her chicken Caesar salad. "Oh—no. I could *usher*! Do you think they'll let me *usher*? Ha ha ha."

Kendra and I drove back to Iowa City that afternoon in a silence undergirded with the acute awareness that either of us could turn into Jean Endicott—in fact, it wouldn't take much. Playwrighting didn't pay, and it was nearly impossible to achieve any sort of success doing it. We could go mad and be eaten with jealousy and petty rivalries and become consumed by our own failures. I didn't want to fail—but I didn't want to tempt fate by trying to succeed, either. I just wanted to snuggle into a delightful little limbo, one with no responsibilities or consequences, where reality couldn't get at me. The future, previously my sole font of hope, was now a kind of boogeyman: it was *coming for me*—and the closer it got, the more my fraudulence and ineptitude would be revealed, so even as I moved toward it, I kept pushing it away.

I searched for new ways to procrastinate. I went to bookstores and cafes by myself. I drove around under skies striated by thin-branched trees. By November it was too cold to fuck—the closeted men all seemed to go into hibernation, chatlines were dead, video arcades across from the Perkinses conspicuously vacant—so I jerked off compulsively to slow-loading dial-up porn. I'd trudge from freezing street to dead-grassed plain, past hay bales and wind turbines and tall poles pleached with black wires. It was all so empty and American and I loved it. I loved the Hamburg Inn and the goopy cheese sauces they slathered on everything. I loved the drugstore down the street from me where they served milkshakes at the counter. I'd been dreading the move to Iowa, I didn't think I'd survive it; stripped of all the predicates of leisure-class existence, without decent sushi options and luxe gym chains, *who would I be?* But the truth was, the banality of the Midwest suited me. I felt no pressure to look good. My body became some vestigial organ, I

didn't care what happened to it. My hair fell out. I stopped exercising. I stopped dating. I gained twenty pounds I had no intention of losing. I subsisted on a diet of Auntie Anne's pretzels and Cinnabons and cheese sauce. I shopped at discount outlets at the mall, and wore a uniform of sweatshirts and khaki pants that bunched unattractively at my thighs and calves. When I started going bald, I bought a jar of Dippity-do for three bucks, scrunched up whatever was left of my hair with it, and walked around like a crazy person, my gluey flaps of hair cracking stiffly in the frozen air.

I felt free and unburdened of expectations, but it was lonely. The other writers had spouses or were preoccupied with writing—the whole point of *being* in Iowa, obviously—but I did everything I could to avoid my work.

I rented a lot of movies during this period. The public library had lots of old movies and semi-obscure foreign ones I had trouble getting ahold of, like the ultra-rare *Martha* by the German director Rainer Werner Fassbinder. Weinberger used to talk about him all the time, so I'd watched a few of Fassbinder's films and loved them.

In this one Margit Carstensen (I knew her from *Fear of Fear*) played Martha, a woman driven to greater and greater extremes to please her impossibly sadistic husband. Helmut (the husband) is a substitute for Martha's recently deceased father,* who treats her like garbage, but rather than escape this abusive dynamic with the father, Martha feels the irresistible compulsion to reinvent it with Helmut. There's something destined about their horrible relationship, and how the past informs the present—it's like Greek tragedy. In the famous

* During filming, Fassbinder, who was rather infamous for abusing his actors, was rumored to have dressed like his abusive father, on whom the character of Helmut is reputedly based.

360-degree tracking shot where the two lock eyes for the first
time, the camera encircles the couple, laminating them in an
optic seal. The visuals encode it right at the outset: Martha is
trapped. Not long into their marriage Helmut becomes insanely
controlling. He controls her eating, her phone use, her social
activity. She is forced by Helmut to listen to music she hates,
to memorize a technical manual on building dams. Helmut is
a completely over-the-top asshole, and the film plays as bone-
dry comedy, but at the same time it was sickening to watch.
Martha works endlessly to make herself into the psychic void
Helmut wants her to be, and Margit plays this to the hilt, with
her waxwork expressions and doll-like movements. *Martha*
had resonances with Ibsen's *A Doll's House* (which Fassbinder
filmed for television as *Nora Helmer*), a play I was teaching*
that year, but it was more extreme, and not quite so humanistic
a vision. Seeing the main character contort herself into a psy-
chic pretzel to appease the very man who objectified and tor-
mented her reminded me of, well, *myself.*

My own father infantilized me the way Helmut did Martha,
and—like her—I ended up in a relationship with a control freak
(Kurt) and became involuted and self-loathing. I felt magne-
tized to this film, the way Martha feels magnetized to Helmut
in that famous tracking shot. *Martha* wasn't entertaining,
exactly—it was perverse, and depicted perversity—but the per-
versity felt true, and the truth of it felt cleansing to me. It took
emotions I felt, and lived with, and hid from the world because
they filled me with inexpressible shame, and made them the
center of a film. Fassbinder was brave enough in *Martha* to
depict a kind of human ugliness I could never depict in my own
writing, even though I was afflicted by it in life.

* I had a teaching assistantship as part of my financial aid package.

I'd given up any hope of having a relationship with my father. We hadn't spoken in over a year. My pilferage of his roll of quarters had *genuinely* upset him, it turned out. (I'd learned this from conversations with my sister, with whom he registered his many complaints about me.) And one day, just before I left for grad school, he called—not drunk, but in a foul mood. His voice sounded lower and tougher than usual—but the toughness sounded fake, a stencil of the bravado fathers were supposed to have with sons. He started on one of his persecuted rants about how no one called him or loved him enough. "I haven't *heard* from you," he sniffled. "I'm sure you've been *too busy* to call me." But this time, instead of playacting the guilt and shame and helpless passivity he seemed to always want, I fought against it. I asked why he didn't call *me*—was he too busy for *me*? My father then hastened to say that the reason for his call was to let me know the onus for our relationship would, from here on in, lie exclusively with me; that if I wanted a relationship with him, *I'd* need to call *him*, and that he would not be calling me ever again. "Thanks for letting me know," I replied coolly, instantly determined not to lose any ground to him.

"You're very *welcome*," he said, without missing a beat.

The sarcasm in his tone was new, and it bordered on contempt. He'd been angry with me before, but he'd never spoken to me with actual disdain. "And those *credit* cards," he continued, gaining momentum, "you can rip *those* up."

"Okay—I *will*."

"You're a *man*. You're old enough to support yourself."

"You're right," I said, maintaining my benign indifference, to show him he lacked the power to punish me—but this only made him more contemptuous, only lent further support to his supposition that I was snide and ungrateful.

"And there's your *analysis*, too," he pressed ahead, his voice getting lower and meaner. "It's too damn expensive. You're a *man* now—you can pay for your own analysis from now on!"

At the mention of my analysis I felt myself instantly weaken, but I was too proud to let him know he'd hurt me. "That's fine," I said over and over against his repeated postulations that I was a *man* and had these manly duties and responsibilities, but the way he said the word "man" was like an unsheathed knife—it was dripping with locker room sweat, and Aramis, and liquor and curse words. The subtext was that *men* worked jobs they hated. *Men* were people who were unfulfilled. Being a *man* was a kind of punishment: he'd been punished by it and now it was my turn, and my father seemed to take a malicious pleasure in passing the poison-dipped baton. And though everything he was saying to me was in fact perfectly reasonable, and any neutral observer would agree that, yes, a twenty-five-year-old *man* should be responsible for his own life, the sanity of what he was saying to me belied the *insanity* of everything that preceded it—the endless skein of emotional bribes, the decades of hobbling promises that he would take care of me forever—so that I could only experience his divestiture as a punishment. I felt it not as a divestment of money, but *love*, which was what he wanted. He was cutting every cord that bound us now to intensify the effects of his punishment, to prove the ruinous effects of his absence.

Not a week after seeing *Martha,* I got a voice mail from my uncle Meyer, whom I barely knew—I met him I think a total of three times. He sounded exactly like my father; they had the same booming, masculine baritone; and when I heard his voice my heart stopped. "*David?*" said the frightening voice, "I don't know if you remembah me. It's ya Uncle Meyeah." I could hear a sucking candy intermittently clicking against his teeth as he

spoke, probably a Tic Tac or a Sucret. "Ya fatha had me call you," he continued. "VERY IMPOHTANT. He wants you to send in these forms. VERY. IMPOHTANT. *You heeh me?* Make sure you do it. And take care a that registration!" He rattled off bureaucratic details of forms I had to fill out for my car, addresses to which I must send checks *right away*. And he repeated over and over *how important* it all was, as though I'd been entrusted with government secrets. The message was so coldly delivered, so openly antagonistic. Even his casual remarks sounded freighted with minor threats. The very gesture of him leaving this message felt like an act of violence—like something out of *The Godfather*. When I hung up the phone I broke out in a sweat; I was soaked. It wasn't merely his tone, it was the whole aggregate of passive aggression compacted in the message—the fact that my father was so sickened by me he had to send his consigliere to leave me voice mails. Though I wasn't on speaking terms with him, my sense of entrapment was no less pronounced. I felt extreme terror about sending away the checks. I was like Margit Carstensen, hysterical about making sure all the forms were mailed off right away so Helmut wouldn't chastise or abuse me. I was trapped forever in the maw of this sadistic, cold relationship, and I would never be free.

The very next morning I started looking for a new shrink—a nearly impossible task in Iowa, where people didn't require analysts because they were so sensible and well adjusted and went to malls and church. I, however, was not in that privileged majority, and there were no licensed analysts anywhere near Iowa City.

I called Catherine for advice—that was what Cathy called herself now.* She was living in Chicago. She'd been released

* In the mental hospital one of the nurses chastised her and told her Cathy

from the mental hospital (the combination of therapy and medication seemed to have helped, she was like a different person) and was getting her MFA in creative writing. Catherine was seeing a great analyst in Chicago, and thought he might be able to help me. I called her shrink, who said I was in luck: that there was *one* licensed analyst he knew of who'd *just* moved to town; she'd relocated from Stockholm. I made an appointment for the following week.

Karin's office was a forty-minute drive from campus, at the back of her home, which resided up a winding pathway in a wooded area not far from the main highway. To the side there was a tiny garden bisected by a stone path and little stone statues of Buddhas. There were chimes, even a koi pond. Everything seemed designed to prompt sylvan reflections and quiet epiphanies. I stepped into the waiting room, which felt like an Agnes Martin canvas, all pleasantly muted monochromes and dimmed lighting. For someone who just moved from Sweden, she worked fast. In a matter of seconds, Karin appeared. "I am Karin," she said, rather bluntly. She sounded like she'd just learned English from a Berlitz tape. Was she even fluent in the language? Her hair was so straight and blond it looked like blanched needles. Her face was framed by thick black glasses; her body was wrapped in a sort of stylish Iroquois quilt. She wore lapis lazuli earrings, and a necklace made from round amber lozenges that swung heavily from her neck when she moved. "Come," she said, ushering me into the office. There were quilts and macramé hanging on the wall. There were hanging crystal pendants. She led me to the now exceedingly familiar leather chair with armrests. "So," she said, "tell me what I can do for you."

As I recounted my life story it had the worn familiarity of an

was a stupid name, a little girl's name, so she changed it.

old Irish yarn, a tale parents told young children on a stormy
night. I cranked it out as if by rotogravure, having told it more
times than I could remember to God knows who: friends, other
therapists. The plots were streamlined: the climaxes had a bra-
vura quality. There were a few new details but the story of my
life otherwise felt set in immovable typeface.

For a psychoanalyst, Karin's responses were startlingly hu-
man. When I joked, she smiled. When I was upset, her face
shone with fluid empathy. I noticed the subtle heave of her chest
as she exhaled in frustration on my behalf, her thin lips tilting
into a frown. She was distressed when it was normal to be dis-
tressed, she laughed when she felt like laughing. She made sup-
portive comments like "That must have been painful for you"
and "You didn't deserve to be treated that way"—comments
that for me bordered on unprofessionalism, for I was by then
inured to the masculine seriousness and harshness of Boris
Fischer. I initially found her humanness unnerving, but the reg-
istration of her caring satisfied some desire I had, a deep need
for nontransactional caring from another human being. I didn't
have to reciprocate or do anything for her, but she had to sym-
pathize with me—and not just had to, but *wanted* to, was
nourished by the experience of sympathy. And even though all
of this frightened me (it was so foreign and, as I said, bordered
on the unprofessional), a part of me was starved for love and
caring: an eye pleading for a gaze.

Over the next two weeks, I learned more about Karin than I
learned about Boris Fischer in two years. I learned about her
hometown, and these gross-sounding native licorice candies
that obsessed her. I learned about her husband, who was Amer-
ican and transferred to Iowa for work. I learned her theories
about America, how fast food and malls made us all paunchy
and junky and stupid. Though she was disdainful and blunt, she
possessed a strong Swedish maternal warmth, a stark contrast

to all those Bergman and Strindberg women I knew from plays and films. Karin was kind to me. It felt so strange to be treated with kindness—without qualifiers or conditions. I was used to people like my parents, who made nonnegotiable demands, and who, if you rejected any of the demands, berated you or stopped speaking to you altogether. Though I started to relax into the feeling of someone I didn't know caring about me, I sometimes wondered if I wasn't being intellectually lazy, if the postures were unearned. Could you just love someone without knowing them? Was love just extending oneself in a gesture of love? I decided for the time being it was: that there was a kind of intimacy you could have without history, a connection you could make with a stranger that was profound in its own right.

Karin's Swedish training felt more holistic and, for lack of a better term, *Eastern*, than what I was used to. She seemed to have a Jungian bent, which I found sort of cheesy. When she impelled me to journey into my "inner world"—which involved my being shepherded to a chaise where I had to lie down while she attempted, despite my lack of auto-suggestibility, to hypnotize me—I always cringed and resisted it. But no matter how many times I petitioned her, she insisted it was therapeutic. "Come now," she'd say, extending her arm like a *vicomtesse* in some eighteenth-century novel, as though inviting me to waltz or do a quadrille. "Let's go into your inner world." And then she'd lead me over to the chaise where I'd lie perfectly supine while she counted backward. If I giggled, which I sometimes did out of discomfort, she did what any good therapist would do: she looked at me with a warm gravity that meant nothing was funny and that inner worlds needed tending. But my inner world was either absent or somehow beyond reach. She asked me questions about what I saw or felt when I accessed this putative inner landscape, but I didn't have anything to report back. There was something dead and fallow inside me—the

same dead feeling I had in the Irene Fornés workshop when I ran out of the St. Mark's Church.

Maybe it was in the sheer repetition of Karin trying to coax out my supposed inner reality session after session, but now I felt its absence outside her office. I started to notice it in my writing, which felt increasingly thin and one-dimensional. I was working on something finally—a dark comedy with deadpan one-liners—but it was slow going, and the writing was very self-conscious. I was parroting things that seemed to contain intelligence and wit, but the pages felt rote and empty. The deadline for the Playwrights Festival came and went; I was the only person in the program not to have submitted anything, but I still had to turn in a draft of something for the workshop. I'd signed up for the last slot of the semester, just before Christmas break.

When I brought up my neurotic terror of writing to Karin midsession, she slowly rose from her Eames chair, the satiny fabric of her kimono dress shifting in stiff fulgent squares, and extended her arm toward me. "Ugh," I thought silently—but it wasn't silent, because she'd heard me. "*Come on,*" she said, somewhere between a nudge and a direct order. I reluctantly shuffled to the chaise and lay flat on my back. "Now we will go into your inner world," she said in one of her arch Berlitz language school moments.

Too weak to fight her, I shut my eyes and waited for the countdown.

"What do you see in your mind's eye?" she asked.

I told her I saw a series of symmetrical bowers that reminded me of something in Spenser's *Faerie Queene*, which I'd been reading in this medieval literature class I'd been auditing. I wasn't sure if I really was visualizing this or if it was something I made up because she was prompting me and I felt the need to propitiate people so as not to lose their affection.

"Is there someone in the bowers?"

"Yes," I said, "there is someone here."

"What does he look like?"

"He looks like me," I said. "He's like my twin."

"A twin," echoed Karin, and I saw this piqued her Jungian interests. Karin asked me about my twin: what was he doing and saying, could I approach him and give him a hug? I said yes yes yes. I would do anything she asked, but I sensed it was all false and made up.

That evening I came home and tried working on my play, but as I crafted my clever boutades and witty little sayings I found myself feeling incredibly sad. Out of nowhere I began to sob. When I finished sobbing, I went back to my lapidary little comedy and wrote a few lines, but then I started sobbing again. I tried to write more of my comedy as I sobbed, polishing the clever one-liners. I tried to push through it, tried to be efficient, be a good worker, but my nervous system was shot; I could feel my hand shaking as I typed, I couldn't catch my breath. I lifted my shaking hand and stared at it, almost through it, with its sheath of tendons flexed and straining. The veins and little hairs, the half-moon cuticles and tiny wrinkles around the knuckles. I felt my own body as an object, almost a kind of puppet or marionette. What was this thing attached to me? Who was I? What was I writing, and why was I doing it? Why was I even *alive*? I shut off my computer, got under the covers, and sobbed in mourning for the inner world I would never have, never know. I sobbed for the uselessness and emptiness of my whole shitty unrewarding life.

In November, I got a call from my sister.

"*So*," she began—and I could already tell I was going to hate this phone call—"did you hear the *news*?" Her voice had that curdled half-amusement against the battering disappointments of life I knew well by then. "What news?" I asked.

"Your fathah got married to *Cookie*."

"What?"

"Isn't that *lovely*?!"

"When?"

"You know how I heard about it? From my freakin *mani-curist*."

"Did they elope?"

"No, they didn't *elope,* they got *married*. In an *actual wedding ceremony* that we were not *invited* to!" She exhaled. "Oh well . . . I guess we're not sharp or *high-line* enough for him."

Arlene was teetering on that hysterical cusp where squelched resentment could turn at any moment to voluble rage. I didn't care if my father got married or not, he wasn't part of my life, but I didn't want to disappoint or inflame my sister with my indifference, so I peppered her with arbitrary questions as a way of showing I cared: Where was the wedding held, who was there? Was Richie invited? My sister took a single exasperated breath: "Are you not listening to me? *Richie* wasn't invited, *you* weren't invited. The only one of his kids he invited was *Stevie*. He made Stevie his *best man*. They're both full of shit, and now they're best friends, *and good for them*!"

Once I hung up, I instantly forgot the details of the conversation. It didn't distress me, it was a nonissue. I nearly forgot to mention it in therapy that week, but near the end of the session it slipped out. Karin was aghast. "He didn't mention his wedding to *anyone*?" I shook my head.

"I know you're not on speaking terms with him," she said, "but what about your sister?"

"She speaks to him. Everyone speaks to him but me."

"But no one was invited?"

"Well, he made Stevie his best man."

"His best *man*?"

"My sister only found about the wedding because her manicurist told her."

"Her *manicurist*?"

Karin's entire face scrunched up like she was solving an impossible math problem. Then she threw her head back and burst out in a quick capriccio of laughter. Her hair was done up in a bun held in place by a helix of chopsticks that bobbed up and down like antennae. Eventually the laughter subsided, and her good humor about it curdled very suddenly.

"What is his *problem*?" she said.

I found her sudden anger a little jarring. "Well," I said, "he does have every right to get married. And we aren't on speaking terms anymore so—"

"No no no," interrupted Karin, who seemed like she might catapult herself from the Eames chair right out the window, "that's *bullshit*."

Her reaction startled me. "I probably make him sound worse than he is."

"You don't make him sound worse than he is. You wanted something reciprocal and mutual, you wanted to be seen as a human being with needs, and he wouldn't allow that."

"Well, I did steal that roll of quarters from him."

"Because he is an *asshole*!"

Maybe it was out of reflexive loyalty but I didn't like Karin cursing my father; it struck me as unsavory. "He's not that bad," I said.

"He's an *asshole*!"

"I don't care if he got married!"

"Yes you *do* care. You *care* or we wouldn't be sitting here talking about it."

"I haven't spoken to him in over a year. We don't have a relationship anymore!"

"You *wanted* a relationship and he wouldn't allow it—and you tried to talk to him but he was too cowardly to have an honest conversation. He doesn't want a son, he wants a *mirror*—a mirror that makes him look wonderful. If the mirror shows him anything but his own perfection he throws it in the trash, and *that's* what he did to you. That is not *love*."

Karin was right. I did want a relationship with him—even now. Even after everything I'd been through with my father, there was a part of me that would cut out my own heart to be loved by him. I would debase myself, hurt myself—I would do anything to win my father's love. It sickened me to see my own feelings denuded like this. They weren't rational, and I *wanted* to be rational. I was a man, and an adult, and needed to be self-sufficient—and he was a terrible father, and a pathological liar, but none of that mattered. I suddenly felt my entire life shrink down to a concentrated pinpoint: the only thing that existed was my need to be loved by this horrible man who was incapable of love.

"God *damn* him," said Karin, like she was in some Swedish movie about adultery. "That *bastard*!"

"You know *what*?" I said. "He *is* a bastard."

Karin's spine lengthened. She nodded lightly. "My father is a bastard," I repeated. Karin's outrage awakened something in me. "He is a *bastard*," she echoed. It was like we were in church, whipping one another up. I felt elated to hate him with her.

The warlike agitation from my therapy session carried over through my car ride back to Iowa City, and when I got home, I marched to the phone and dialed my father's number. The instant he picked up I launched my attack: "Did you get *married*?"

"Oh, it's you," he muttered, lightly dislocated, as though he were trying to remember who to be with me. "Nice to finally *hear* from you."

"Arlene said you got married. She said you didn't invite

anyone except for Stevie. *Is that true? IS IT?*" I was surprised by the aggression in my voice. I was like a guard dog—I was about to jump through the phone and start biting out the veins in his neck. My father fumbled for words. "It was a small wedding," he said. "We just had a few people."

"*Bullshit*," I barked. "We're your fucking *kids*!"

"I wanted to invite you. I couldn't find your address."

"You *what*?"

"I couldn't get ahold of your mother."

"Did you ever hear of a *phone book*?" I snapped. "I'm not in a fucking *witness relocation program*!"

I slammed down the phone. I was furious, but underneath that anger, I felt invigorated. Something released inside me. I'd never confronted my father with actual feelings. I'd been like a prostitute, pimping my own feelings and needs and making myself agreeable—not just to my father, to *everyone*—but now something inside me was cracked open. And though I could not produce my inner reality for Karin on her little fainting couch in the house with all the wind chimes and Japanophile flourishes I could feel it now, in my tiny studio apartment on Linn Street, in the middle of Iowa City.

Near the end of that fall semester, I was home for Thanksgiving break when suddenly I felt wild with inspiration. Something that had been building invisibly in me burst open, like millions of tiny buds opening and flowering all at once. I was walking up Tenth Avenue when I began hearing dialogue for a play—it was uncanny. There were people *in my head*, and the people were saying *actual sentences*; the words were clear as a bell. This was the sort of thing Irene Fornés talked about in her workshop, the sort of thing that was supposed to happen to writers all the time—only it never happened to *me*. But now the portal opened. My inner world spontaneously unlocked. The occurrence was so unprompted—so numinous and weird—that

at first I decided to ignore it. I kept walking, hoping the voices would shut up—the whole scenario creeped me out. I felt like the telekinetic children in *Escape to Witch Mountain* or Kirk Douglas's son in *The Fury*. I'd always wanted a bizarre occult power, but now that I had one, the power felt unwieldy and rogue—and there was something invasive about people having a conversation in your head.

As I was crossing Tenth Avenue, though, I felt a surge of urgency; I remembered my professor at Iowa saying you had to strike while the iron was hot, so I did. I hurriedly pulled my notebook out of my JanSport and crouched in the middle of the street to jot down the dialogue. When the light turned green, I sprinted back to the sidewalk—I had to write quickly, the words were gushing out in complete sentences. I'd heard about composers writing symphonies in complete blocks of music, but nothing like this had ever happened to me—I was no longer *me*: I'd merged with some spirit that took possession of me there on the sidewalk. Then, as suddenly as it began, my ecstatic state ended. The characters stopped speaking, the dialogue stopped flowing. I hadn't the vaguest idea why I'd become inspired, or why the inspiration stopped, or what I could do to make it happen again.

I didn't dare look at or touch my notes until I was back in Iowa City that Monday—at which point I had exactly three weeks before my workshop reading. I didn't know that I could finish a draft of a full-length play in three weeks. Some writers could. Kendra, for example, was famous for her prodigious output—and Fassbinder would shoot a film during the day, work on the script for another during breaks, and in the evening would be in postproduction for yet another (granted, he was a coke addict, and the drugs fueled in large part his prodigious output, but he was able to do it). I, on the other hand,

procrastinated; I dragged my heels and doubted myself. But my crazy feat of inspiration on Tenth Avenue gave me courage. And I could hear Karin's voice in my head: "You can do it! Have *faith*!"

I boiled some water for my coffee. I measured the grounds for my French press and let the coffee steep. When I took my notebook out of my backpack, the phone rang.

"*Hello*," I said, hysterically.

"David?" trilled a sweet little voice. "It's *Kendra*!" She sounded so optimistic, like Little Mary Sunshine. "Do you want to go to the mall and see that Albert *Brooks* movie?"

I felt suddenly desperate to see the Albert Brooks movie, go to the mall, do *anything* but write, but I had to resist the siren pull of the Coral Ridge Mall.

"Kendra, I'm *writing*!" I replied harshly—in a tone that shocked even me. Kendra's spotless manners kicked right in.

"Oh my goodness," she said. "*Go write!*"

I had my notebook and pens, my earplugs safely nestled in my earholes. I prepared for this moment the way priests prepared for communion—I wanted it to feel holy and sanctified—but when I sat to write, there was nothing. The inner world that fulminated so suddenly on the corner of Tenth Avenue just a week earlier was void again. Maybe it was just a one-time thing. Maybe it was the creative equivalent of epilepsy and the seizures came and went with no way to induce or stop them.

The weeks flew by, and I couldn't figure out how or what to write. I spent the weekend before my reading agonizing over it. Sunday morning I woke up in a panic: my play was due in just over twenty-four hours and I hadn't written *a single page*.

In an act of desperation I pulled out my Harcourt Brace teacher's manual and opened to the section on *A Doll's House*. I made the spontaneous decision to turn the fragment of

dialogue I'd written in Chelsea that afternoon into an adaptation of Ibsen's play. I boiled down the events in the play based on the plot summary, numbered them, and began to write. Whenever I didn't know what to write next I looked at my numbered list and used it as a loose guide. I wrote at hydroplaning speed. There was no time to think up clever boutades and one-liners. I didn't have time to overthink anything—I *wasn't* thinking. I felt myself surrender to the chaos, the cacophony of surging detail. It was like a flame was lit from inside me that burned away the mundane borders of the self, the particulate matter I identified as me.

The characters who appeared were an odd combination of those voices chatting away inside my head that day on Tenth Avenue, and parts of *me*, but not the parts I liked. They were saying things I hated, things that were not clever and lapidary, but crude and idiotic. They were riddled with anxiety and hysteria. And though parts were funny, the humor was unstable, and the play was mainly scary and upsetting. My protagonist reminded me of Margit Carstensen—with her angular and hard-edged performance style, her sudden outbursts of emotion, the wild shifts and baroque extremes. The play evoked *Martha*, but also *Fear of Fear* when Margit's character has a breakdown listening to Leonard Cohen's "Lover Lover Lover" on the record player. I also had flashes of Julianne Moore (in *Safe*, but also her coke binge with Heather Graham in *Boogie Nights*) and Lisa Kudrow in *Friends*, and Catherine Deneuve in *Belle de Jour*. These influences all vibrated inside of me like a tuning fork and helped me find the pitch of the play. Instead of trying to *become* these characters in books and films, I was starting to channel them into my writing.

Ten minutes before class started I sped to the theatre building, parked my car, ran into the office, and printed copies of the finished play for everyone. Minutes later we were in Room

41 reading it aloud. I had no idea what I'd written—I hadn't had a chance to censor or change anything, and you could feel that in the writing: it was raw and unrefined, but that was its appeal. Susan read the main character, and she instinctively got the character's mix of bubbliness and chirpy hysteria. The critique afterward was short—it was the final class of the semester, people were leaving town for the holidays—but people seemed to like it.

After a short break, Tom and Naomi announced the selections for the Playwrights Festival, and, even though I'd missed the deadline, they picked my play for a full production. They bent the rules to include it. I was shocked—and thrilled. I surrendered to those crazy voices in my head, I allowed myself to write without controlling every little piece of punctuation, and they actually liked it.

Rehearsals started in April, and three days in I wanted to hurl myself out a window. The play *was not good*. It wasn't the theatrical cubism I imagined, with all the fabulously jagged turns and angles of a Margit Carstensen performance. The undergraduate actors had trouble with those shifts, so the rhythms were all off. The style seemed insane. I was collapsing under the weight of all the harsh judgments I spared myself when I wrote the draft; I went from being a Zen observer of flawed humanity to a narcissistic parent carping endlessly about his kid's ugly haircut. I began nitpicking like crazy. I endlessly rewrote scenes that were probably fine to begin with, and days later decided it was better the first way. I began picking fights with my director—the mania and hysteria of the play infected me, I'd made myself too vulnerable and I wanted to take it all back. My characters were demented—they were unappealing and hysterical. My play was ugly and I felt ugly showing it. I scheduled a meeting with Tom Hauser to see if I could cancel,

but he told me it was too late for that. Not having the option to cancel it made me feel out of control. The lack of control made my back hurt. The knots got tighter, so I got a bottle of Doan's and used an old canister of Tiger Balm Kurt had given me, but nothing seemed to help.

Two weeks into rehearsal, in the middle of a relatively sound sleep, I was jolted awake by a shooting pain up my spine. The muscles in my back began to spear and contract in sharp involuntary seizures. When I stood to relieve it, the pain only got worse. I bunted, I squatted, nothing helped. It was 4:30 in the morning but there was no way I could wait around for a more civilized hour so I picked up the phone.

"Hello?" croaked Kendra—who never seemed to be asleep (she often recounted stories of finding herself plopped headfirst on the keyboard or on the floor during an all-nighter). I could barely hold the receiver to my ear, it made the spasms worse. "*I need to go to the emergency room,*" I eked out before dropping the receiver onto the floor. I could hear Kendra's tiny voice in the receiver: *Are you okay? David?!* I tried to speak down into the dropped phone but I was in so much pain my words came out as screams. Twenty minutes later Kendra was outside my building. "Oh my goodness," she said lightly, chewing the inside of her lips and puckering them into the familiar goldfish shape as she led my poor wincing, sobbing self into the passenger seat of her car.

At the emergency room, the doctor prescribed me tiny little pills, and, handing over the prescription, warned me how strong they were. Once we filled the prescription, I shook one from the bottle. The yellow pill was the size of about an eighth of my fingernail—and I was supposed to only take a quarter of *that*. *How strong can these be?* I thought. Within minutes of my taking it, I found myself glued to a chair in my rehearsal room— where I remained all that day. I was paralyzed. I couldn't stand

or move. It was disconcerting, but the pain in my back was gone.

With the pills, I was finally able to relax. Watching the actors rehearse, I could accept the play's innumerable flaws, accept my lack of artistic ability, accept that the people of Iowa City would see how strange and stupid and neurotic I was. The play I wrote revealed to the world my essential worthlessness as a person, but there was no taking it back now—and with the help of opioids I was able to take my loss with congenial acceptance. Even if my play was awful, there was a certain pathos in failure. When the initial wave of druggedness wore off I became ambulatory and, in my opiate numbness, I felt life brighten quite suddenly. I staggered through the streets of Iowa City, my lungs contracting in the wonderfully cold air. I felt the world pass by in a colored haze. I wandered under gray skies and scudding clouds, my Dippity-do-coiffed hair flapping hard in the wind like inverse stalactites.

That week, I went on my first press junket. I did interviews with the student newspaper and the *Press-Citizen*. I had a radio interview with a sweet octogenarian lady named Dottie Rae—it was part of a long-standing tradition in the theatre department to be interviewed in the geriatric home where she broadcast her show. "Will there be sets?" she trilled. "*Costumes?*"

Yes, Dottie! Yes, yes! I replied, high on opiates, and thrilled to be interviewed at all, for I'd never been on a radio program.

The morning of the performance I awoke with a grim determination. I took my quarter of a pill. I had my coffee. I stumbled to the Italian restaurant in town, devoured a plate of gnocchi, then drove to the theatre building where the audience was filing into Theatre B. I took my seat. I grabbed onto the handrest. The lights went down and the play began.

Though the drugs calmed me, I could still sense I was living a nightmare. No one laughed or moved a muscle for the entirety

of my play. The audience was dead silent. The theatre was like a funeral home, like a crypt. It was worse than anything I could have imagined. When the play ended I lumbered out of Theatre B. Kendra approached me with outstretched arms and gave me a hug. The pills made my back feel like a thick piece of rubber. "The audience hated it."

"David, it was *good*!"

"Kendra, that was the deadest audience I've ever seen."

"Because they were listening to your *play*." Kendra directed my gaze to the ticket booth. Scores of people were exiting the theatre and making a beeline to purchase tickets to the second show. "I'm telling you," she insisted, "it was *good*."

Just then, Eric Abrams, the dean of the theatre department, approached me from the other end of the lobby. He had tears in his eyes. He grabbed me by the shoulders—a gesture of deep tenderness, even if it was rough and felt a little like an assault. "*Oh my God*," he said. He looked like he'd just been in a car wreck. His bulbous features reddened and swelled. "Look what you *made*." Eric was overcome with feeling, and it was like a blast of frenzied CinemaScope—his emotion took me over completely. His face was like a giant mural unfurling before my eyes. I'd never known another human being to look at me this way, a look of anguish and joy and gentleness all knotted together. "Look what you *did*," he repeated over and over, until I started to tear up too. I was stained and ugly before him but he saw me as beautiful. Other people began clustering around me, to offer their congratulations, but Eric and I just stood for a moment, looking at each other in rapt silence, and the silence spoke volumes: *I feel what you feel*, he was saying. *I know this pain and this loneliness. I know what it is to be alive.*

IN DREAMS

O N THE MORNING of September 8, I walked through the plaza at Lincoln Center. Past the granite-rimmed fountain, and the New York City Ballet, and the soon-to-be-deracinated City Opera. Past the State Theater, where my mother took me to see *The Nutcracker*—and the Vivian Beaumont, where I saw *Six Degrees of Separation*. Whiplash swirls of pastel blue and cadmium peeked through slits in geometric mazes of rimmed glass nested inside high-vaulting panels that formed the façade of the Opera House, where I made a right turn, walked past a reflective pool, ascended some steps, traversed a second small plaza, and entered the Juilliard School.

The beige brutalist cube of the exterior yielded to a strangely uninviting interior; it bore the phenotype of late-1960s modernism with its blunt geometrics, its token homages to abstract art and primitivist sculpture. I gave the security guard my ID, walked through the turnstile, and wended a series of hallways toward the conference room where I was to meet Wallace and Gloria, the heads of the playwriting program. It was a two-year postgraduate program with no formal degree—and quite small, only eight students in toto. The program was only a few years old but already extremely prestigious. David Auburn, a recent graduate, won the Pulitzer that year, and David Lindsay-Abaire (whom I knew from Sarah Lawrence) wrote *Fuddy Meers*, which

was a big hit. I'd gotten an agent my last year at Iowa, and I'd won prestigious residencies, but was still what was called an *emerging* playwright. The days when producers like Joe Papp would take risks on unknown writers were long gone; funding dried up, the climate was more conservative, and most writers did not get New York productions. Playwrights had to be vetted in advance, and Juilliard was considered a golden ticket.

Inside the building everything was wood paneled: the elevators, the classrooms. The chairs and sofas were all upholstered in browns and dark oranges. There were windows but no one ever looked out of them—what was the point? The building was a monument dedicated to its own exaltation. The hall was a glittering procession of platonic forms: ballerinas and ringlet-haired Adonises, alabaster-skinned girls in Capezio. Everyone seemed sculpted from marble. Everyone looked like a Caravaggio, or a Degas sculpture.

I entered the conference room, whose walls were flanked with giant paintings of august-seeming historical people. The two other first-year fellows were there, Frances and Jenny, and we introduced ourselves and made small talk. Eventually Gloria and Wallace breezed in, chatting as they walked, slowly, whispering like the people in the library. They sat at the other end of the large boardroom table, not acknowledging us. I kept waiting for them to do something cute—wave or wink, something that would undercut the formality of the august boardroom, but no such respite came. They were as famous as playwrights could get. Gloria won a Tony Award, and I adored Wally's plays since Cathy introduced them to me back at USC.

Wally had a belly and wore a long-sleeved oxford shirt and khaki pants. His graying, neatly trimmed beard framed his jesuitical features. He looked a little like a monk, and Gloria looked like Nefertiti. There was something Egyptian and regal in her carriage. She wore a gold mesh bracelet and a gold chain around

her neck; her earrings were gold, too. All that gold looked good on her. It made her seem burnished, added to the hieratic splendor she seemed to want to cultivate—even her makeup sparkled. She wore that pearlescent lipstick my mother's friends had. She even wore one of those inevitable Loehmann's-curated slacks-and-top affairs they all had—and she had The Purse, with its scaly, asymmetric patches. But where those women lacked ambition, Gloria had the imperious toughness of a self-made woman. Her face was carved with tiny lines, indices of some spiritual hurt I imagined she'd endured. Clearly this was someone who knew about pain, but she gave the impression of having transcended or transmuted the pain into a sort of Egyptian glamour.

The two of them continued to whisper privately for a while, and when Gloria turned her attention to us it was like a conductor tapping a baton. The writers all sat up; we adjusted ourselves in the high-backed chairs. We had to tell them what we had done with our summers and what we were working on. Julia spoke first. She told us she had developed her play at a conference earlier in the summer. "*What* play?" Gloria demanded. "What *conference*? Be *specific*." Then I talked about my residency at the Royal Court Theatre—a guest instructor at Iowa gave them my *Doll's House* adaptation, and I'd spent that whole summer in London seeing British theatre and workshopping my play. "Who was the director?" asked Gloria. "What was the *setup*?" The whole orientation proceeded along these lines, with Gloria batting questions in her coldly juridical way while Wallace sat alongside her, quiet and somewhat recessed. At some point (and it felt arbitrary) Gloria rose slowly, signaling wordlessly that our time was over. She exited and Wallace trailed behind. Once they left, there was the sense of oxygen entering the room again, like we were shaking off a dream.

The literary manager, Rob Cortlandt, entered with his mop of freshly shampooed hair and ushered us into a large

gymnasium where the second-year actors were delivering monologues. The rafters were packed with silvery young people. The second-years bounded around the room with calisthenic vigor. They seemed so young, like children. They had the unnatural ablated openness of people in cults—their skin seemed ripped off and all the raw nerves exposed. Each time someone finished a monologue, people whooped and hollered and stomped. Then someone else would spring to the center of the room and the actors would shriek and stomp and bang their fists at the air. Jessica Chastain was there—she had her hair in cornrows and did her monologue from *Romeo and Juliet*; when she finished, everyone screamed tribal, lung-shredding screams and stomped their feet so hard the floor tremored. Everything was overly heightened, too delirious. I started to settle into the delirium and its rhythms when the exultation suddenly gave way to misery and despair. The students were keening and wailing, the room now throbbing with collective anguish. The actors had all clustered together in a group hug, a cirrus of Capezio and Lululemon. The teachers became somber too. Then everyone started to sing a song, something in honor of some person they all knew, we couldn't make out the details. I looked over at the other playwrights who seemed, like me, slightly dislocated. "Can we leave?" Jenny whispered.

"I don't know," I said.

"What's *happening*?"

Jenny managed to sneak out a side door, and Frances and I eventually followed suit.

"Jesus Christ," said Frances.

We all looked at one another and broke out laughing.

Outside, people disported themselves on mezzanines and toted string instruments in large black cases. The sun was round and pink and gave off a delicate heat. I looked out over the mezzanine to the Opera House, where they were preparing

for the MTV Music Awards. "I wonder if we can get a free ticket to that," I said to Jenny. I was already plotting new ways to leverage my status as a Juilliard student. I was important, after all. My success felt inevitable: a fruit ripe for plucking. I felt the sunlight beating on my skin that beautiful warm day as I contemplated all the treasures in store for me, treasures heaping with glorious spoils.

Three days later, on the eleventh, I was supposed to have my first class, but instead I spent the day glued to video clips of towers crumbling, human beings falling to their death, people sheeted with ash and trawling like zombies through lower Manhattan. Outside my mother's house a thick oyster-gray ash covered the lawn. There was a constant blare of sirens. People were sobbing on the streets, on the subway—they just spontaneously broke into sobs.

A month later, when we finally had our first class, it felt bathetic and pointless. No one wanted to think about writing plays. We were traumatized. People sobbed all through class. When Gloria asked someone to volunteer to bring in pages to read the following week, no one raised their hands. Eventually, if only to puncture the awkward silence I agreed to bring something in, though I had no new pages and was, frankly, nervous about showing my work—to Gloria in particular.

I kept thinking about something she said at orientation: "At Juilliard, *we* write very quickly." The *we* was not a royal *we*, it was prescriptive, an ordinance. "And *we* don't rewrite our plays," she continued. "Playwrights write *one* draft. You can make a few changes and that's it." This sent me into a minor panic: what if I needed to write more than one draft? I chafed at the rigidity. I was back at the yeshiva again with all its rules and protocols.

My instinct, then and now, was to rebel, so the following week I ended up bringing in ten pages of the most

experimental, crazy thing I'd ever written. As soon as we read the pages aloud, I knew I'd made a terrible mistake. The writing was deliberately awful, in a "conceptual" way: there was no plot, the characters were dehumanized zombies. When we finished, Gloria reached into her purse and fished around abstractly for her cell phone. There was a weirdly long silence as she checked her messages. Then she flipped the phone shut. Her overlong fingernails plucked the surface of the table with an aggressive clack. "*Well*," she trilled, "do you actually *need* comments on this, or can we just move on?"

The whole experience was humiliating, but I'd learned my lesson—and I felt certain I could redeem myself. The following week during class, Dawn expressed concern that the protagonist in her new play was not likeable enough, and Gloria began to give her advice on how to make characters more likeable, but I interrupted her. I felt I had an interesting gloss, a provocative take on the subject. I thought this would be my opportunity to earn my slot in the program: I could offer a nuanced yet heterodox view of drama. "I actually don't think writers should *try* to make their characters likeable," I said. "Lady Macbeth isn't likeable but she has a strong action to play, and that makes her compelling!" Gloria canted her head slightly; the slits of her eyes began to narrow. I briefly scanned the table: everyone seemed vaguely distressed.

At Iowa we were taught to challenge one another—there was an easy colloquy between students and teachers—but apparently at Juilliard it was considered a faux pas to violate the teacher-student hierarchy. I felt myself panic but struggled to finesse it in the moment: "Or like Medea . . ." I continued. "She also . . . you know, she's not really likeable." But as I continued the fatal slope of my argument I felt the room grow submerged in an awful, tumid silence. I waited for one of my colleagues to rush in with an affirming *Yeah!* or *Well, on the other hand . . .* but

they were all too savvy to get involved. Gloria was now glaring down at her purse through her nostrils, the vaguest hint of a smirk tilting her expression. I wasn't fully aware of it, but the smirk was an omen: my fate in the program had been sealed.

A few weeks in, Gloria began to strike a greater intimacy with the class: she regaled us with anecdotes about her life and famous writers she knew, she offered little aperçus about the business and life, semi-self-ratifying speeches about what she cynically referred to as "the industry"—warnings about how we were not to let anyone take advantage of us, that she was looking out for our best interests. And this was essentially true: she cared about the other writers. She'd make coy mention of plays she saw with Noah or Dawn, drinks they had together over the weekend. Once, I overheard her making plans with everyone for some barbecue at her house in the Hamptons to which I wasn't invited. But Gloria and I had no personal relationship. I knew I was not the intended audience for her filigreed compliments and cautionings.

When I talked in class about a play I'd loved, she dismissed the writer as a hack. When I had a copy of some book I was reading on the seminar table, Gloria ambled over lightly, curled around the edge of the table like a kitten, picked up the book, and gave it a cursory look. "Who'd ever want to read *that*?" she growled, before dropping it indifferently back on the table.

It was five or six weeks after my first go-round before I found the courage to bring new pages to class. I had just the beginning of something—it was rough, but it had a nice raw energy. We read it aloud in class and people laughed, they seemed to like it. I tried to avert my gaze from Gloria, but it was impossible not to look at her; she drew the gazes of the room to her as if by a magical thread. Her face seemed plastered in a frown. "Are you *trying* to write cardboard characters," she said. "Or are you trying to write *people*?"

The way she said the word "people" made it sound like I wasn't really a person, how would I even remotely know the workings of the species?

"People," I replied with a slight aphasia—I was afraid to say too much, as it was so easy to say wrong things that would incur more cruelty—but something in my response caused Gloria to break out laughing. I didn't know if the laughter was malign or if there was something in my terse reply that was genuinely funny to her. I smiled an awkward smile to smooth over my humiliation, but the smile only redoubled it. Jets of adrenaline blasted into my blood. I wanted to speak up. I could say things, *smart things*, but my thoughts were now frozen and remote. I scanned the table, soundlessly beseeching my peers to save me, fight for me. After an excruciatingly long interim, Wally spoke. "It's stylized writing," he said. "It's not psychological, and it isn't cardboard. It's something else."

With that, Gloria's smirk dissolved, the storm clouds vanished.

"*Great*," she said, chewing on a gummy peach.

Wally successfully diverted the current of her thoughts. Or maybe she got bored by her own predation—the cat dropping a half-chewed mouse for a piece of bright string.

Later that night the writers all went out for drinks at Nick & Toni's.

"She's hard on you because she *cares*," Jeanette intoned solemnly.

"Gloria can be tough," said Dawn, who was picking from a tiny bowl of glossy black olives.

"She's a strong personality," said Rebecca. "And it's a tiny program. Not everyone is the right fit."

"Yeah, like Sam," said Noah.

"Who's *Sam*?" I said.

"He wasn't asked back," Noah said.

Juilliard was officially a one-year program but most students, practically all, were invited to return for a second year. It seemed like a terrible snub not to be asked back.

"Sometimes it turns around, though," said Rebecca. "Cindy Morton and Gloria didn't have the best chemistry at first, but then Cindy became her favorite."

"Maybe one day I could be her favorite," I said, clinging to whatever shreds of hope I could. "Because right now I feel like our chemistry isn't so great."

Rebecca practically choked on her martini. "OBVIOUSLY," she screamed, gasping with laughter.

I laughed too.

The following week I saw the new Coen brothers movie in Chelsea with Brian, a playwright who'd gone through the program a few years back. Afterward we had coffee at Big Cup, and I spilled my guts. "She hates me." I swirled my coffee around in the ceramic mug with a tiny spoon. "I keep trying to make it better and it keeps getting worse."

"You can't fight Gloria," Brian cautioned. "You'll never win."

"What should I do?"

"Write the kind of play she likes."

I thought Brian's advice was a little cynical, but he was right. I had to be pragmatic. I wasn't interested in another lonely pyrrhic victory. Gloria was a gatekeeper, and the theatre world was small and gossipy—and I didn't want to end up thrown away like that mythological *Sam* person the writers talked about. I didn't want to end up like Jean Endicott, munching angrily on chicken Caesar salad and rankled by the success of my peers. I wanted to go to Tony Award parties, and have extended runs of my plays at Playwrights Horizons. I wanted success.

Gloria told us our job as playwrights was to "let the audience know when they can go home and have their dinner," which I found incredibly depressing at the time, but maybe she

was right. It was a capitalist society and plays were commodities. You had to market yourself to survive. You had to be *likeable*.

When I got home that night I deleted the new play from my hard drive. If there was something I could do to grease the wheels of equanimity—if I could hold up an olive branch, *anything*—I would do it. I tried looking for common ground. I knew Gloria liked musicals (she had written a few, and she'd been working with a composer on something new, she talked about it in class) so I decided to see one. I hadn't been to a Broadway musical for a decade, maybe longer. I got a half-price ticket way up in the mezzanine to something called *Thoroughly Modern Millie*.

As I watched the musical, I kept thinking about Gloria and how much she would like it. I laughed along with my fellow audience members, and hummed the songs, and felt myself situated in the very epicenter of the human experience. The musical was likeable, and by liking it, I myself felt likeable. With every shimmy of Sutton Foster's beaded dress, with every clack of her heels, I felt more and more there was an order to life and that I had my likeable place in it; the likeability was a breastplate to shield me from attacks. The likeability of the musical would saturate my very essence, and when the seroconversion was complete, I could write from that place of likeability, and my stories could be *universal*. From my velvet-cushioned seat at the Marquis Theatre I could feel an invisible chain linking me to the farthest reaches of the stratosphere.

I strutted into the classroom the following week beaming with useless pride. When we got to the moment, as we did every week, when Gloria asked us what plays we'd seen, I raised my hand—practically exploding with excitement. "I saw *Thoroughly Modern Millie*," I said, "and I thought it was *fantastic*!"

Gloria looked at me like she'd swallowed arsenic. "How

anyone could ever like something like *that*," she said, "is completely dumbfounding to me."

The warm liquid joy I felt just seconds earlier froze over into a block of ice. And it was suddenly as if *I too* had swallowed arsenic, and *I too* was poisoned by some strange intransitive property, some principle of necromancy. It was like a Shakespearean tragedy with two poisoned lovers dead at the end, for seemingly no good reason—except we *weren't* lovers, and it wasn't tragic for Gloria because, like Juliet, her arsenic *wasn't* really arsenic, it was just a bad taste in her mouth. She changed the subject, smiled again. It was just a tiny snag, a useless detail she could flick away, a stray ash. But I was poisoned. As I sat there across the acre of polished table, the chasm of planked wood that separated us, I felt the poison spreading inside me, coursing through my blood. My eyes began to shut; I could hardly keep them open. I felt drugged, more tired than I'd ever been in my life. After class I staggered to Times Square. I tried to shake off the bad feeling. I walked through Shubert Alley, with all the posters and oversized placards I loved as a boy, but now it felt tainted and debased. I was sick to death of this city with its giant monuments and shining lights and marquees. I staggered to the subway. On the ride back to Brooklyn, I could barely stay awake. The cells of my body felt desiccate and sick.

I couldn't save up money to rent my own place, so that year I needed to live with my mother—who'd gotten more rigid than I remembered. Her tics and habits were more pronounced, her behaviors engraved as if by stylus: I needed to keep everything *spotless*. I couldn't leave a single utensil in the sink for fear of reprisals. And her routine was shockingly unvaried. Night after night she was transfixed to her giant-screen TV, reading glasses glued to her nose, shelling peanuts and watching her crazy kickboxing movies with the volume turned up. From my room

upstairs I could hear the sound of blaring sirens and people be-
ing kicked and punched.

I tried confiding in her about my situation at school, but she
was terrible at dispensing advice, which generally consisted of
either berating me for making bad decisions or launching into
soliloquies of inflamed righteousness in which she lobbed threats
and curses at the people who wronged me. She'd say things
like, "How *dare* she treat you that way" and "Tell her, '*I'm not
your punching bag, Gloria!*'" I knew she felt protective of me,
but her diatribes left me feeling lonely and drained.

Paul, a writer I'd met at some playwriting conference the
previous year, moved to New York—he lived a few blocks from
my mother's house, and in my misery I clung to him. I took him
on tours of the neighborhood. I showed him where Howie*
lived, and Hildy Tasimowitz. I showed him the corner where
Masha Bendikowski administered the punishment assignment
and called us Disgusting Individuals. I traced for him the sites
of all my old wounds and hurts as though it were a kind of
negligible ruins. I pointed out SY girls when they passed. Over
the years they'd proliferated in grim facsimile—hair-twirling,
gum-chomping specters of denim and spandex. Paul became
adept at spotting them on his own. "Ooh, is *that* one?" he'd
ask, as though we were touring the Sinharaja with binoculars,
looking for rare birds. It was fun, but I knew the fun was tem-
porary, a diversion. I felt a queasy sensation in the pit of my
stomach.

* Howie was up at Yale—living with his boyfriend and studying to become
a lawyer. I came out to him as "bisexual" my sophomore year of college, and
he came out a few years later—once he fell in love with a waiter who worked
with him at a restaurant downtown. Howie's mother wrote long handwrit-
ten prayers to *hashem* and left them under her pillow and in her sweater
drawer begging for *hashem* to please please make her son marry a girl, but
when it was clear *hashem* wasn't going to intervene, she came to accept it.

The confidence I'd built at Iowa was gone now, a dream whose details disappeared with no remaining trace. I couldn't write. I was depressed. I was flat broke. I wanted desperately to nap or sleep, but when I tried I just lay in bed, my joints tensed and swollen like crabbed knuckles. I'd already gained a bit of weight at Iowa, and now the pounds were piling on. I got very good at making macaroni and cheese, and anything with gooey cheese and carbs. My mother would chide me for wanting to cook because it entailed making "a mess" so I was forced to be nocturnal: I'd start my mise en place around one in the morning. For dessert, I'd usually polish off two pints of ice cream in one go.

I hadn't watched television in over a decade; now I needed its anodyne comforts. My mother's television set took up a whole wall. It had an oppressive material presence, like the obelisk the chimps worshipped as a deity in Kubrick's *2001*. There were several remotes, each arrayed with innumerable buttons and consoles, none of which I could work (I figured out the channel changer and the volume buttons, that was enough). I had to keep the sound low or my mother might wake up. With my open pints of dulce de leche and pralines and cream I'd fall into a kind of trance, enveloped in the artificial warmth of the darkened room, lulled into a hypnotized state by the play of images on the screen. The scherzos of color and sudden irruptions of light during commercial breaks created an illusion of movement in the dark and made the room seem like a flickering twilight. I'd press the soft microfiber blanket to my chest and curl up in its silky chrysalis, dangling a foot over the edge of the sofa and tracing the cold Formica base of it with my heel as I slurped huge spoonfuls of ice cream. When I'd overeaten sufficiently and gorged myself to near numbness on marathon episodes of *Friends* and *E! True Hollywood Story*, I'd stagger up the creaking stairs to my room in a somewhat pleasant

somnolent haze, but my dreams were nearly always plagued with horror: cataclysms I couldn't stop or thwart, terrorists living in my basement, floods in the attic. Gloria was a terrorist, she worked at the yeshiva, she was trying to murder me. I'd wake in the middle of the night, heart exploding in my chest, shaking and tremoring until the sun came up. I was no longer a human being. I was a slave to my anxiety.

That autumn, I had one small flicker of hope: the Royal Court Theatre called to commission a short play for their human rights festival. It was my first-ever commission, I was ecstatic—but my artistic compass was jiggered and thrown off. I wasn't sure how or what to write. To counter what felt like an impending writer's block, I ended up writing *everything that came into my head*. After a few weeks of this crazy graphomania, I culled ten pages I thought were good and brought them into class one week. In the frenzy of all that writing, I hadn't thought to steel myself against Gloria's criticisms, but as soon as we read the pages aloud it started again: she unflipped her cell phone, waggled her pen between her forefinger and thumb. She dug noisily into her handbag, pulled out candy, chewed peremptorily on some gummy worms. She checked her watch. She sighed helplessly—and actually *left the room* for several minutes. We finished reading, then sat around looking at one another, wondering what happened to Gloria. She eventually walked back in and sat in her chair. "Well!" she chirped perkily. "Since this play was an assignment, I think we should show David how to *write* an assignment." She proceeded to go around the room, writer to writer, extracting possible plot scenarios, since apparently I couldn't come up with my own.

After class I shuffled despondently onto Broadway with the other playwrights—who seemed to genuinely pity me. They said nice things about my play, and gave me some ideas. Phil felt I should focus on the character of the older woman in the play,

and Jenny agreed—she suggested I try expanding that charac-
ter's short monologue to a full ten minutes, and maybe I could
give that to the Royal Court. With all the playwrights fussing
over me, I started to feel a bit of hope. When I sat the next
morning to rework that section into a monologue, something
clicked immediately, and the play just came out whole-cloth.
Like my *Doll's House* adaptation, this felt prewritten, like I
was transcribing a speech broadcast from some ether or other
realm. The character had her own autonomous life, and I was
taking dictation.

But then my blessed state took a weird turn.

My character began channeling *Gloria*.

In a recent class, she'd spoken about an accident she had
the previous year. She broke her foot and had to wear a cast.
She couldn't move—she was completely dependent on other
people for her most basic needs—and this sent her into a crush-
ing depression.

"I was up late one night," she said. "I was depressed and
couldn't sleep, and I was watching the Nature Channel, and
there was this show on. They were showing these gazelles,
and how when gazelles are hunted by predators, when some big
terrifying creature is about to rush up and murder a gazelle, the
gazelle doesn't run away. The gazelle doesn't panic. It doesn't
move. It just sort of . . . stands there, and it tilts its neck, like
this . . ." She illustrated for us the way a gazelle might tilt its
neck were it to submit to a predator. "As if it's saying, *yes*," she
continued, "I'm going to die, and I *accept* that. I *accept* my
own death." There was something mesmerizing about how
Gloria embodied the ecclesiastic gazelle. It was like the gazelle
had entered the classroom and was standing before us. Gloria
was like a Virgin Mary from some Renaissance painting. There
was a salvific grace in her eyes. "I was like that," she said. "*I
was one of those gazelles.*" As Gloria spoke these words, some

dormant feeling in me was violently slapped awake. I felt a sudden intimacy with her, as if her soul were momentarily exposed. There was something pained and despairing in the story of the gazelles, and through it, I felt an unexpected pang of love for Gloria. She wasn't just tough and steely and self-made, she was like me: on the verge of immolation and surrender, broken by life. We were both artists, and this was the condition of all artists; it was *this* that connected me to her, not some goofy Broadway musical—but the pain of *life*.

The story of the gazelles had burrowed deep in my unconscious mind—and as I was writing, I found my character invoking *the exact language* Gloria used that day, even going so far as to tilt her head to show the gazelle's posture of submission to her predators. The play was in some sense *my* act of submission, a way my unconscious found to compromise with Gloria—but it also became *about* the act of submission. It was about losing oneself to a dominant force, an ideology so huge and overwhelming you don't even know you're lost. In it, the main character, Alice (a white, wealthy, Upper East Side doyenne) makes a glib and frightening argument for the use of political torture. But then she starts comparing herself to Gloria's doomed gazelle, as though she herself were a victim. And she was, in a way. She'd been destroyed by a way of thinking.

I couldn't tell at the time that Alice was a self-portrait—that in some respect, I was writing a cautionary tale to myself. *I* was that gazelle, who would sacrifice what was fragile and beautiful in itself because it believed it was doomed, and wanted its struggle to be over. On some level, I simply wanted to merge with Gloria in a way that would make me unpunishable.

I was running late to class that week, but managed to catch the elevator just as the doors were closing. When they opened again, there was Gloria. She was standing erect like a monarch and glaring at the lit display. "Hi, Gloria," I said in an oddly

girlish voice, but she didn't respond. The mask of her face was pulled tight. The cords in her neck were tensed like unplucked strings in a cello. I could see the bluish pulse in her neck flickering under her skin. I could feel myself as a speck in her peripheral vision. I imagined us shot from an aerial view, the way they did in movies to foreshadow a murder. *Why wasn't she saying anything?* I knew she hated me, but were we beyond simple pleasantries? Was she really going to ignore me when we were the only two people in a small enclosed space?

I increasingly felt pressure to fill the silence in the elevator, and, out of nowhere, blurted, "Remember that thing you said about the gazelles?" Maybe I thought my mentioning gazelles might lull her back to the time when she felt vulnerable, when she had a big cast on her foot and needed care and love. Maybe if I offered myself as a receptacle, if I openly displayed my weakness and asked permission, she might take pity on me. I blathered on about how the gazelles just slipped into what I was writing, how the image was so arresting, how my character just started *saying these things*. Gloria glared mercilessly at the elevator doors, head jutting ever so slightly. "So anyway," I continued in my slobbering panic, "I wanted to ask permission to . . . to get your okay with all that."

Gloria remained an obelisk, blank and unyielding. Then, the tiny muscles in her face began to shift, the glittering lips began to part, and I felt my entire being pulled toward her with anticipation, like she was a magnet. "Actually," she said, her gaze transfixed to a series of wooden panels on the wall of the elevator, "that image is the centerpiece of my new article for O magazine." Her tone and the brevity of her declaration conveyed both punishment and disinterest. I felt like a slick of slime left in the wake of some slug. And I was confused: was she saying I *couldn't* use the image? What did O magazine have to do with anything? Did I have to cut the gazelles out of my play or not?

Paul was adamant I keep them in.

"But don't you think it would be antagonistic?" I said, picking around my not very good biryani—after class that night we ate dinner at one of those cheapo restaurants on Sixth Street.

"It's *your* play," said Paul.

"Yes, but I already made that token gesture at getting her approval in the elevator."

"So?"

"So isn't that in itself an admission of guilt?"

"Guilt over what? You didn't do anything wrong."

I emailed the play to Wally and he too said I hadn't plagiarized Gloria. He said writers took things people said all the time and made these into plays and books. We were in the world, he said, and the world we lived in affected us, and our writing should reflect that. I told him I still felt uncomfortable bringing the play into class. In response, Wally asked if I would have dinner with him before class that week. It didn't seem like a portent of anything bad, it was a sweet gesture, so I agreed to go.

We met at Orloff's, a Jewish deli across from Lincoln Center where the walls were festooned with posters from old, obscure Broadway plays like *The Mystery of Edwin Drood* and *Cold Storage*. "So I'm going to be honest," he said, "I'm concerned about you."

"How come?" I asked, sipping my black cherry soda through a plastic straw.

"I'm not sure what's going on between you and Gloria," he said. "It seems perhaps there's some tension between you two."

Wally was raised Catholic and though he abjured all religion, he still had a Jesuitical reserve. He used endless qualifiers and often began sentences with "I feel somehow that . . ." or "It seems perhaps that . . ." so as not to be too pointed or direct. I could see him trying to delicately massage every word so as

not to be inflammatory, but the more he made intimations, the more I wanted to share the true depth of my suffering, the more I needed to break through the façade. "*Wally*," I said, practically shrieking, "I'm becoming *blocked*!"

Wally's eyes relaxed slightly, as if he'd been temporarily blinded.

"Well," he said, "I wonder if maybe it might be unproductive for you to continue to bring work into class." He told me he'd discussed it with Gloria, and they'd come up with an idea: instead of my bringing in my work in five-page increments over the course of the semester, I could bring in a *complete* play at the end of the school year. I felt slightly insulted by this. None of the other writers needed a special arrangement. But I couldn't help but feel relief at not having to deal with Gloria and her flip phone and gummy candies.

I tried to cut my losses and focus on this new play I had to write. At first, I wanted to write something political. Then I decided to write a light comedy, something inoffensive. But I worried Gloria might think a light comedy was too flimsy, so I tried making it dramatic and august, like her plays. Then I began to resent the augustness—as though it was imposed upon me—so I tried to make the play more subversive and political. But then I flashed forward in my mind to the critique (the simpering disdain, the mastication of gummies) and felt paralyzed and overcome with proleptic terror. The play felt like a referendum on me as a writer. It *had* to be good, but I couldn't tell what was good anymore. I didn't know what to write or who to be.

To calm my nerves I took frequent breaks. I went for long walks, ambiting the colonnades of Ocean Parkway, past Jewish girls who wore long Lycra skirts and silver bangles and chewed gum, and up Avenue J past Jewish bakeries, fruit stores crammed with customers hysterical about getting the best

cantaloupe. I walked past the awful ketchuppy kosher pizza shops, the forlorn-looking wig shops for Hasidic women, the yeshiva—now gated like a citadel. When I sat back at the computer I'd stare blankly at the screen, my legs melting to rubber, heart crumpling in a systolic crush.

I somehow managed to finish the play that spring—but I didn't write it as much as assemble words that vaguely conformed to human logic. I'd been torn in my process between trying to make myself into the sort of writer Gloria might like and violently rebelling against her, so the tone flipped incomprehensibly between good-natured observation and perverse vitriol. It was misshapen and warped, a Frankenstein monster of all my neuroses. Rob cast the reading, as he did with all the plays, but it was held in a room I'd never been to: dim, musty with desuetude, maybe someone had been violently murdered there. There a was single fluorescent light fixture, and the concussing flickers of light cast the room in a washed-out, bluish pall. The playwright readings were generally lively tournaments teeming with young actors cheering and stomping, but in this case there were just the other playwrights, Gloria and Wallace. Gloria introduced the play and then sat down and looked through her purse for candy while the actors read their parts, and it all seemed to go on forever. The play was painfully unfunny, and tendered not a single truthful word or moment or observation. Afterward there was no conversation, no critique, and as we filed out of the strange, unused, bluish-lit classroom my stomach burned with humiliation. I hated myself. I couldn't imagine writing another play ever again.

Just after the New Year, Elyse Dodgson from the Royal Court emailed. They wanted to program *Elective Affinities* (that's what I called the monologue) for two nights in March in some

festival for new writing. I tried retaining my newly awakened bitterness toward theatre, but it was no use—this was too exciting.

I flew in for rehearsals the week before we opened. When I got to the theatre, Edith Vickery, my director, stood near the stage door, clad in black from head to toe. She had on dark sunglasses and walked with short, hieratic steps down the cobbled walkway.

We knew each other a little. She'd directed the workshop of my *Doll's House* play at the Royal Court the previous summer. She approached me with distracted aplomb like a movie star, and dispensed comme il faut kisses on both cheeks. "There's coffee up in the room," she said, "and Jane brought some crumbly British thing." She walked me past the guard and up to the rehearsal room to meet Jane Asher, who, everyone kept explaining to me, was the British Martha Stewart. She was playing Alice: the charming, wealthy, and deliciously unlikeable woman in my play who advocates for political torture. The idea for the casting was Edith's. That would be a sly bit of legerdemain, she said, to have this happy woman who baked cakes on telly turn on the audience and exhort them to torture and murder.

Edith was a musicologist before she went into the theatre, and knew everything about Bach and Prokofiev. In my script I indicate that the character listens to one of Chopin's nocturnes, and she was like a martinet: "*Which* nocturne?"

"Huh?"

"It says in the stage directions that she plays *a* nocturne. Which one?"

"Uh," I said, my pulse pounding, "I'm not sure exactly."

"So you haven't made a decision about it?"

"Well, I . . . have to look and see."

Edith craned her neck. "Chopin composed twenty-one noc-
turnes. They're all *completely* different. Do you mean to say
you don't care which one we use?"

My imprecision with regard to Chopin haunted me for the
rest of the rehearsal. Whereas Edith had the Wagnerian tro-
pism toward obsessive detail and order, I was lazy, a dilettante.
I made it all up as I went along. I wasn't *serious*.

During the break, Jane Asher and I went down to the restau-
rant in the basement of the Royal Court and split an order of
fish and chips. I liked Jane right away, but we didn't have very
much to say to each other. There was a long silence as we nib-
bled on chips and drank our beers. Then Jane, in her perfect
British deadpan, quipped, "Edith is quite *scary*, isn't she!" and
we both erupted in fits of laughter.

The night of the performance I had a tingle in my spine as the
safety curtain came up. Jane was funny and genuinely frighten-
ing in the role. People in the audience were asking to buy copies
of the script; they seemed to love it. Some other writers I knew
were there, and we drank and ate cucumber sandwiches. It was
one of the happiest nights of my life.

The next morning Edith picked me up at my hotel to get
breakfast in Covent Garden. Edith was the complete obverse of
Gloria. They both had intense charisma, they were both staunch,
but Edith was smarter and wittier. She was an aesthete, which I
loved, and though she could be severe, it was the Nietzschean
severity for which I still retained vestigial admiration.

On our way to the restaurant, she asked me how I liked Juil-
liard. I told her about Gloria, and her flip phone, and her gummy
peaches. "Oh, blow it out your ass, *Gloria*!" Edith said, erupt-
ing in an insolent cackle. The way she said Gloria's name I could
still hear a hint of a New York accent. "I showed my professor
an early draft of one of my plays when I was an undergraduate

at Yale. He said, 'You are an extremely disturbed person. You need to see a psychiatrist.' Seven years later they did the play at the National."

I walked alongside Edith in silence for a while, until I found the courage to say what I'd been thinking. "I think Gloria's blocking me," I told her.

"Well, don't let her do that. Just write what you want to write."

"But . . . I don't know what that *is* anymore," I said, vaguely ashamed. "I feel like I'm losing my own taste."

Edith didn't respond, and we walked in silence the rest of the way. I felt certain she was repelled by my weakness. Edith had a surety I lacked, a kind of gunmetal toughness—the same toughness Gloria had, a toughness one needed to be in the world. Edith was an artist, and all I could do was curate experiences that seemed prestigious. I couldn't choose a Chopin nocturne and I couldn't choose what to write. The artist's job was to choose, and I'd become a suppliant.

Wallace wanted me to use *Elective Affinities* for my presentation on Playwrights Night—an evening where big-time producers came to suss out new writers. It was the only thing I'd completed all year, but I was still too scared to encroach on Gloria's gazelles. I'd thumbed through every issue of O magazine, rooting around public libraries for months, searching for the putative article Gloria referenced that day in the elevator, but I couldn't find it. Maybe O magazine didn't like it. Maybe Gloria lied to me and there *was* no article, or it was some hypothetical article she'd been musing about writing someday in the distant backdrop of the future, and she was securing the gazelle image just in case.

I called my friends for advice: should I cut the gazelles?

Should I change gazelles to something else? *Giraffes? Elk?* Everyone felt I was being neurotic and overthinking things. Nobody seemed to feel I was immoral or a thief, so I kept it in.

Marian Seldes was cast as Alice. I wrote the monologue with her in mind, but I never thought she'd actually play the role—she was a theatre legend. She initially told Rob she was hosting some party for Lauren Bacall that night and wouldn't be able to do the reading, but when she read the play, she said she'd push back the party a couple of hours. I was elated.

The day of the presentation Marian showed up early to rehearsal. I imagined she was early to everything; she was famous for never missing performances or taking sick days. She was sitting on a folding chair in the middle of the room. She wore a violet-colored dress with lilac lozenges and a grape chiffon scarf tied around her neck—demure, a girl at a prom. She was very tall, even sitting, and had the shoulders of a linebacker. When I approached, she stood slightly hunched, as though her towering length caused her to buckle. "Thank you for doing this," I said. Marian half curtsied, then took my hand with a quiet urgency, as though vouchsafing some impossibly wonderful secret. She whispered when she spoke, so that you had to come close and strike a familiar intimacy whether you wanted to or not. "Oh, darling," she said, gazing into my eyes, "I love the play." The filaments in her irises were stellated with dimension, like a cosmos was shining inside her.

My piece was programmed to go first so Marian could make her Lauren Bacall party. I sat down in the audience to watch it, but I wasn't watching Marian, I was watching Gloria. She sat next to Wally a few rows ahead of me with her perfectly erect posture. When Marian uttered the word *gazelle*, the muscles in Gloria's back contracted slightly, her posture seized. It was straight out of a melodrama, like the scene in *Rebecca* where Joan Fontaine shudders at the mention of Rebecca's name and

we see it from behind—a small dorsal convulsion up near the shoulder blades. Paul was sitting next to me, he saw it too. We tittered nervously, exchanged crabwise looks. Marian finished, and as the audience applauded she stood up and searched for me in the audience. "David?" she said, blocking the glare of the stage lights with her palm, "I hope I *did* it right!" And then she was whisked away by some regal wind.

The play was well received that night. Afterward there was a party and a bunch of the actors and faculty came up to me and tendered their congratulations. Gloria didn't even mention the gazelles—in fact she *praised* me. The tension between us seemed to have evaporated completely. Maybe people liked my play and told her so; maybe they asked "Who's this David Adjmi? That kid's got something!" and she preened confidently, realizing I was a potential jewel in her crown. Or maybe it was what Rebecca had said, and that the people she picked on in their first year went on to become her favorites.

After our final class of the year, we all walked over with Wally and Gloria to the bar at the Empire Hotel for a valedictory drink. Everyone was happy and in a good mood. It felt glamorous, having drinks across from Lincoln Center, our first year at Juilliard safely behind us. We talked about our plans for the summer, and what readings we had coming up at which theatres, and how we were going to get agents or switch agents. I felt relaxed, buoyed by the success of Playwrights Night, which eclipsed, at that golden moment, the whole rotten preamble of the first eight months of the program.

After about an hour, Gloria and Wally stood to make their exit. Wally waved, and Gloria went down the line, saying her goodbyes, cordially wishing everyone a happy summer. But when she got to me, instead of saying goodbye, she came very close to my face—it wasn't cordial; the proximity was jarring. For a brief instant I thought maybe she was going to tell me she

was proud of me, that she was sorry for misjudging me, that it was all a test and I *passed*—but as she got closer, I felt the proximal horror of her nearness, I felt my own position on the earth's surface. I could smell the makeup on her face. I could hear the soft clank of jewelry against her clavicle. My synapses fired wildly, my heart was beating like crazy—and before I knew it Gloria's lips were on mine, kissing me. It wasn't sexual, but seemed instead to carry fatal import, like a mafia don sending a doomed consigliere to his death. "Goodbye, David," she said, a combination of sweetness and rue in her expression. She and Wally left the bar, and the playwrights all had a nervous titter. *What the hell was that?* And as I laughed and tried to make light of it I realized the muscles in my abdomen were clenched tight. I couldn't stop trembling. And the whole nightmare yawned awake again.

I sprinted out of the bar into the lobby, and Frances rushed after me.

"Are you *okay?*"

"*They're kicking me out!*" I screeched with resurging madness. I was confident I was right—why else would she *kiss* me? Now all the pieces of the puzzle began to fit: she was nice to me on Playwrights Night because she was tolerating me. She was kind to me because she'd gotten rid of me.

I got my dismissal letter in July, signed by Wally and Gloria, saying that I was talented but not responsive to their teaching style. It wasn't untrue (if anything, it was an understatement) but it wounded me. I felt I'd failed at some terribly important and determinative test.

I didn't write a word all that summer, or later that year, or the following year. I saw my classmates go on to great success. They had their plays produced, and won awards, while I floated from one temp job to another. In 2003, Wally nominated me for an award, which came with a $20,000 cash prize. I felt guilty

accepting the money. I didn't know if I was a writer anymore. My mother urged me to invest it, but instead I used the money to move to Berlin, thinking I would overcome my block and write a bunch of plays there, and maybe relocate permanently. I did end up starting a few plays, but I couldn't finish anything I started. Eventually my money ran out, and I came crawling back to my mother, asking if I could move back home. "You better get your act together," she told me, and she was right. I had nothing to show for my life—no partner, no savings, no career. I was thirty-one years old, single, and living with my mother. It was the worst-case scenario, and it was my reality.

To pass the time, I'd walk to Ocean Parkway and sit alone on a bench for hours, staring at the rows of familiar brick houses, watching the endless cortège of Mercedes and Jaguars. One afternoon, a bunch of teenage Syrian girls passed by with their laminated hair and Lester's outfits, their spray tans and gold jewelry. They were speaking SY slang and chewing gum. They sat a few benches away, and I couldn't help but stare. They were plucked from my memory, unchanged and unretouched. They would be this way for all time, I thought, and so would I—like in mythological Hades, where nothing changes, nothing grows or dies, and all life is preserved in its undying sameness forever.

THE CHAMP

THE APPLAUSE DIED down, the lights went up. As the audience filed out of the theatre, in the wake of ushers collecting used playbills and discarded ticket stubs, there, near the exit doors, I noticed a tiny quorum of young women no older than twenty or twenty-one. They were dressed identically, with identical hair and boots and clothes. Their stances were identical, their hands identically positioned on their hips or brushing invisible strands of hair from their identical faces with the tips of their manicured nails. They could've been pulled from the stage; they looked just like the girls in my play. They were huddled and whispering, until one momentarily broke from their unison and, with her eye, scanned the back of the house up the length of the raked stairs to where I sat in the last row. When she spotted me, she jerked her head and whispered something to the others and they all turned to look at me. Their looks seemed to wind together into a trebled stare, like a swarm of insects forming a single opaque black cloud.

"Oh no," I said under my breath as one of the girls, whom I recognized as Stevie and Debbie's daughter, Frieda—in fact, my own niece, I hadn't seen her in years—waved a tiny wave with her tiny hand that was wreathed with rings and jewelry. She began climbing the stairs toward me. As she made her tormented ascent she smiled a wobbly smile, and with each ago-

nized step her gold bangles crashed loudly like high-pitched cymbals. Once she got to the top, she gave me a stiff awkward hug. "Congratuleetions." I could smell her perfume, the same clove and allspice bomb my mother wore in the eighties.

"Thanks for coming," I said, aiming for a casual sangfroid, even though our relationship was strained and my play was essentially an indictment of the Syrian Community and her entire way of life. "Hey, how did you even know this was happening? We're just in our third preview."

"My mothah."

"Oh yeah? How's she doing?"

"Everyone's good. Giselle's getting married."

"I heard. Congrats!"

"You have to come to the wedding," she said.

"Is your dad doing okay?"

"He's good," she said. "He has a new job."

For some reason, I turned to my assistant, Carmen. "Do you know my niece, Frieda?"

Carmen gave me a weird look. "Nice to meet you," she said.

Frieda pulled a chunk of her hair and strummed it with her fingers as though playing a string instrument. "So wheh do you live now?"

"Brooklyn Heights. I have a little studio apartment."

"Very shahp . . . Your play was very different," said Frieda. "The main girl looks just like my friend Selma. It's so funny."

We stood for a moment in tense, smiling silence. Her swarm of friends viewed us from their fixed position near the exit doors like the maudlin chorus in a Greek play.

"Well, thanks for coming," I said, and we hugged once more like two rigid planks. I watched as she and her friends clanked and clomped their way out of the theatre.

Carmen shut her laptop. "That was so *weird*," she said. "That was like the most awkward thing I've ever seen in my life."

"Carmen, my heart is pounding. I didn't think Syrians would come to this."

"Why?"

"Because I didn't think they went to plays!"

"But they're gonna come see it if it's *about* them. How many plays about Syrian Sephardic Jews are out there?" Carmen laughed. "Dude, you're the canon!"

I wrote *Stunning* three years after I was dismissed from Juilliard, thinking it would never get done, and certainly not at Lincoln Center. It was a suicide note—my one last missive to humanity before hurtling myself like Anna Karenina onto the train tracks at McDonald Avenue. The play was about a sixteen-year-old SY girl pressured by her family to marry a controlling older man, who turns out to be a con artist. The main plot was loosely based on *A Streetcar Named Desire*. Blanche is a gay, semiotics-obsessed, African American housekeeper. She takes a liking to Lily, the SY girl, and tries to expose her to culture, to life outside the bubble of the Syrian Community. The two end up falling in love, but The Community won't stand for it, and Lily's family threatens to excommunicate her. ("Don't you dare come crawling back to me on your hands and knees," warns Lily's sister, "because I'll kick you *right in the throat*.")

I had written a play I believed was unproduceable. Not only did it skewer a community no one had ever heard of, but it was crazily stylized: it clashed together genres and tones in a way that was not exactly in vogue. It was bleak, it was harsh, and there was no redemption in it anywhere. One main character kills herself, and the other—like Gloria's gazelle—submits to her predator and is psychically destroyed. I knew no artistic director in New York would put on this sort of bleak, crazy play. It wasn't marketable, and American theatre was driven by the desires of subscribers—those people Gloria talked about

who wanted to know when they could go home and have their dinner. What use would those people have for me?

But since I knew no one would ever see it, the block around my writing lifted. The writing was intensely cathartic—I sobbed uncontrollably writing the end, the way I sobbed watching *Six Degrees of Separation* and *Streetcar*. I cried for my characters and my family and the whole brutal, broken world.

I gave *Stunning* to my agent, thinking it would vanish in a stack of unproduceable plays, but he liked it. He sent it to New York Theatre Workshop—and *they* liked it. They put together an in-house reading. Then Manhattan Theatre Club did a reading. Then the woman who curated *that* reading was hired to run a new program at Lincoln Center, and, a few months later she offered me a production at Lincoln Center: Where I'd seen *Six Degrees of Separation*. Where I'd gone to Juilliard and been kicked out—just like I'd been kicked out of the Syrian Community; now, like the prodigal son, I would make my return!

After my niece's surprise appearance at the preview, though, I began to fear reprisal. I'd only been brave enough to write the play because I thought no one would see it—but they *would* see it. I started going to the theatre ninety minutes early to avoid SYs. I hid in the greenroom. There was a monitor from which I could watch the audience—and with each performance they started to proliferate: bangle-wearing women with shellacked hair, olive-skinned men dressed in Armani. They hearkened from the red-bricked depths of Midwood to see for themselves my act of dirty laundering. The audience mirrored the actors on stage every night—it was like a crazy dream.

The play was a succès de scandale. Performances began selling out, and we started keeping wait lists. The wait lists got longer and longer. The lobby got so crowded before performances it became a fire hazard. It wasn't just SYs coming to the

show, ordinary theatregoers showed up in droves—and fancy playwrights, and movie stars, and Hollywood producers. Two weeks in, we sold out the run, and the theatre announced an extension. The extension sold out, and they announced *another* extension—and then *that* sold out. I had no real experience with success, so I registered it as a kind of pain or anxiety—I was overstimulated. I couldn't write, I couldn't sleep. I felt a kind of frantic exhilaration.

Old relatives started cropping up at the theatre—second cousins, long-lost aunts. Every so often, as I skulked up to the greenroom to hide, I'd hear a piercing cry of recognition that sent shivers of horror down my spine: IS THAT YOU, DAVID? REMEMBAH ME? And whoever it was would embark on a long, snaking genealogy that linked them in some thrice-removed way to my brother, or my aunt, or her ex-husband, or his father.

The future had arrived—but like one of those process shots in *Vertigo*, I was sucked backward and forward at the same time. Like a spell I'd cast without knowing it, I summoned the very past I'd wanted to annihilate.

Before I knew it, I was back in Midwood, touring a reporter from the *New York Times* past my old haunts as part of a profile they were doing on me. We had pizza at Di Fara's, the unkosher place Howie and I used to sneak to on weekends. Later in the day, a photographer from the paper managed to sneak a quick photo of me on the outside steps of the yeshiva before a security guard chased us away.

Howie saw the profile in the *Times*, and he called me. He was working at a snazzy law firm, and living on the Upper East Side with his boyfriend. "Well, *Daaave*," he said, resuming his campy impersonation of my mother like it was a worn glove, "you finally became *shahp*."

My mother went to a late preview with Arlene and my

uncle Ralph. I begged them not to go—I told them they'd hate it, that the play was bleak and painful—but this only stoked their curiosity. I also knew that my mother and sister were, in some sense, muses for this play: it wasn't a roman à clef but there were aspects of their lives in it, and I was scared of what they'd think. I stayed away from the theatre that night. I wandered around Brooklyn Heights, worried, and feeling very exposed. Around 10:30 I started checking my phone, but no one texted or called. Nothing.

The following day I had lunch with Arlene at a Chinese restaurant on Montague Street. I tried mining her for information.

"What did Mommy say about the play?"

Arlene picked at a plate of kung pao seitan with her chopsticks. "Your play made everyone kind of uncomfortable."

"Did she say if she liked it?"

"She was very quiet afterwards."

"Did she hate it?"

"She didn't really say anything." Arlene was being unusually pithy and withholding all afternoon, which led me to believe that she was hiding something—that I'd been subjected to some kind of scorching invective by my relatives, and she was trying to protect me.

"What about Uncle Ralph?"

"He was crying afterwards. Your play flipped him out."

I'd never seen my uncle Ralph cry. "Why was he so flipped out?"

"I think Sammy is gay," said Arlene. Sammy was Uncle Ralph's son—he was a few years older than me. When we were kids, he used to get me to watch *Playboy After Dark* with him, and he had a poster in his room of a giant-breasted woman named Cherry Bomb. I told Arlene all this, and that it was highly unlikely that Sammy was gay, but she doubled down. "He's *gay*, David—I'm telling you! He's never had a girlfriend.

He moved to Las Vegas, and now no one even mentions his name—it's just like your play. And it freaked out Uncle Ralph."

She chugged her entire glass of iced green tea, then set the glass down.

"The food here is unreal," she said.

There was a rattle of classical music in the background. I bit into my egg roll.

"So what did *you* think?"

"About the play?"

"Yeah. Did you hate it?"

"No," she said, forcing a smile. "It was great." Her voice was suddenly tiny, like a child's voice. "It just made me really sad." Arlene's eyes filled with tears. She looked away from me, and out the huge domed window of the restaurant. When she finally opened her mouth to speak, her voice dwindled to a whisper: "Why is everything *so fucked up*?"

Arlene wasn't talking about the play, she was talking about life: the two were helixed together in some new unsavory way I hadn't anticipated. I felt guilty for making her weep in the Chinese restaurant. I didn't want to flip out my Uncle Ralph* or upset my mother, but art was a kind of violence. I was looking for some kind of wholeness from art, which was a dumb thing to want. Art didn't make you whole, it broke things. Having this play out in the world was a nightmare.

Stunning made me a persona non grata with SYs. My sister said people were impugning me at the manicurist on Kings Highway; she said my mother went to some engagement party in Deal and was given the silent treatment. And I heard stories

* Of course it turned out Sammy *was* gay. I became Facebook friends with Sammy later that year and saw he'd posted all these photos with his partner. I gathered that my sister was probably right, and my uncle really was distressed by the content of my play.

from my actors—how audience members heckled them, jeering and shouting *fucking disgusting* in the middle of scenes; how, in the middle of one performance, two SY women chanted "Dyke, dyke" during a love scene and had to be escorted out of the theatre.

For some Syrians—particularly those who were Out of The Community—I was a minor celebrity. They were leaving notes for me at the theatre: closeted Syrians, Syrians who wanted to be writers—who were artists and, like me, decided to reinvent themselves. They were finding my email address and trying to set up coffee dates. They wanted to reconnect. They stalked the lobby looking for me. It never occurred to me that there would be this subculture inside my own marginal subculture, but there they were. I gave them a voice—people who were in some way like me. That felt good.

One afternoon after a matinee, a cousin I barely knew found me outside the theatre. I was listening to music on my iPod. "It's *me*!" she proclaimed. "*LINDA!*" Before I could take out my earbuds, she attacked me with the boundary-effacing affection I remembered from childhood. "YOU DON'T *REMEMBA* ME? I'M YA *COUSIN!*"

"Oh, hi," I said.

"I knew you when you wa *little*!" she continued. "You used to go to Bradley Beach and weah ya bathing suit with the tic tac toe on it! HA HA HA!"

Linda dragged me into the Pax Deli next door to say hi to Aunt Joyce, my father's older sister whom I hadn't seen in at least a decade. Linda presented me to her like an oblation: "Look what I found outside, *Ma*!" Then she took a few steps back like she was performing a magic trick. Aunt Joyce stood near a rack of Fritos. She wore a white tracksuit and white sneakers. She was still and eagle-faced, her features etched into an expression of such seething contempt it startled me. "*Ma!*"

said Linda in a rousing voice. "It's *David*! Uncle Ray's *son*!" Linda was rapt and smiling her snaggletoothed smile—she kept saying MA! MA! as Joyce held my gaze unblinkingly, her mouth drawn down in a punishing scowl. "So great to see you," I said, in an attempt to minimize the soul-crushing awfulness of the encounter. Then, I bent to give my frightening aunt a kiss on her cheek. It was cold and thin and had the powdery softness of an uninflated balloon. As I was backing away, she got close to my face. "Go see *ya fathah*," she said in a menacing pianissimo.

What Aunt Joyce meant was that my father was sick and I hadn't been to see him. I hadn't spoken to him since the day I berated him on the phone in Iowa City. A year or so earlier my father had a bad fall at his house in Turnberry, and since then it was all quickly downhill. X-rays revealed a growth in his brain; they needed to operate. The doctors were able to get it out, but after the surgery he was moved to hospice care in Cookie's house. He walked with a cane—when he *could* walk— and even then it was only going up and down stairs. When I heard about all this, I felt only the tiniest prick of regret, but things accelerated quickly. A few weeks after my Pax Deli encounter, Arlene called. Dad was getting weaker, she said. He was probably dying, and he wanted to see me. I felt I had to go.

Arlene and her boyfriend drove me to Cookie's house, where my father was asleep in a hospice bed set up in the living room. Cookie was there, and some nurse who'd become close with everyone—the crisis of my father's now-hastened demise had made them all family.

Cookie wasn't the fluttering, nervous bird I'd met eleven years earlier. She had on the same dark eyeshadow and mauve lipstick, but the subdermal wrinkles on her face had broken into a pattern of hard cracks. Her poufy hair was now up in a sort of matronly bun. She, too, had become my father's nurse, and though it appeared to exhaust her, she also seemed more

self-possessed. She explained, in expurgated fashion, in between weary sighs and with gently depressive affect, the status of my father's current medical situation. "I'm very tired," she repeated again and again. "It's a lot with your father."

After a few minutes she wanted me to go and talk to him.

"I don't want to wake him," I said.

"No, no—go wake him up. He wants to see you."

I stood up and tiptoed over to my father's bed. The baseball cap was slumped on his bald head at an infelicitous angle, presumably to cover his scar from the surgery. "Hi, Dad," I whispered, softly, so it wouldn't wake him—I was hoping to avoid an actual encounter and use his illness as an excuse—but his eyes opened right away. He was suddenly *completely alert*, looking at me very intently, like he was going to jump from a burning building into my arms. He was small, smaller than I ever saw him, like a tiny flicked ash. His lips were thin and whitish. The hollows around his eyes gaped, and the whites of the eyeballs had a feverish yellow gleam. He really was dying, I could see it. "David?" he said, and I replied, "Yes, it's me, Dad, I'm here," and then my father reached out and clasped one of my hands. He said he knew about my play, that he'd read about me in the paper and was proud of me. I knew he'd despise the play if he saw it but I just clenched his hand and let him talk. He wasn't fully capable of a conversation, he was on pain medication that made him fade in and out, but he never took his eyes off me. We talked for about five minutes. It felt rushed, like we were already out of time and had to hurry up and reconnect before he passed out again. Near the end of the five or so minutes I noticed his yellow eyes get watery.

"I'm *sorry*," he said. "I don't know what I did, but whatever it was, *I'm sorry*."

It was the first time my father ever said he was sorry to me—and though the apology was vague, it was more than I

ever expected from him. He really *was* sorry; I'd never seen a person look as sorry as my father did in that moment. The vulnerability in those beseeching eyes filled me with hideous, awful pain, a pain that welled up from some hidden font in me. I didn't know I had any feeling left for my father. I tried to break away but he wouldn't let my hand go; he was clasping it tightly and gazing at me with those jaundiced, gleaming eyes. They were filled with despair—a despair he'd always masked, but the mask suddenly dropped away. I almost couldn't recognize him. There was another person living inside the person I knew as my father, and he emerged quite suddenly as a sad, lost child. The jolting intimacy I felt with this small, terrified orphan boy frightened me. I wanted his bravado back, I wanted the numbed, deadened person that wouldn't make me feel anything for him. I said, "It's fine, it's okay"—I said anything I could to stop him from *looking* at me. It was terrible to see him so raw, so nakedly sorry.

When he lost consciousness moments later I slipped away to Cookie's bathroom down the hall. There was a hand towel hanging from a bar and I pushed it into my mouth. Once the towel was safely in I unleashed a torrent of sobs—sobs that came from a place of grief so fathomless I couldn't recognize it in myself, just as I couldn't recognize the small, frightened child looking at me through my father's eyes. I was practically screaming into the towel. I was so weak I could barely keep upright. When it was over I took the towel out of my mouth. I could taste the penetrative scent of attar of roses in my mouth. There was a dotted-line horseshoe on the towel where my teeth bit down. I looked at my tearstained reflection in the bathroom mirror. My vision blurred through the glaze of tears. The pink splotches, the sadness and wetness communicated my own feeling back to me in a way that felt consoling—just as I'd felt consoled as a small child playing scenes of loss and death, when

I sputtered "Wake up, champ," and fused with the small blond archetype of Ricky Schroder. But I wasn't preemptively mourning my father's death. I was sobbing because he would never know me. His apology was moving, but it was like he'd given me a blank check. He didn't know what went wrong, or what the apology was for, and now he would never know. He erased his life as he was living it, and I'd been erased along with the rest of it. Now I was just a weird phantom presence in his wife's bathroom. After I stopped crying I continued staring at myself in the mirror until I stopped seeing myself. I looked disembodied: a series of pentimenti, curves and angles. I stared at myself like this for a long while, until the pink, indistinct outlines filled themselves in, and I began to resemble a person again.

Two weeks after my opening, Dad was back in the hospital; they'd hooked him up to machines and tubes. He told Arlene he wanted to see us together as a family one last time. Richie said I could stay at his place for the night—he was living in Jersey now, he owned his own furniture store—so I quickly packed a few things and took the train back down to Jersey. I had to go, I knew that, but I knew I'd have to see my extended family, and by this point I was widely considered the Benedict Arnold of Syrians. I worried they might attack me openly—who knew what these people would do to me? On the train I shuffled nightmare scenarios in my mind. I envisioned something like the end of *Dangerous Liaisons* when everyone at the opera booed Glenn Close—she was banished from society, her life was ruined, a single tear cascaded down her cheek and we faded to black.

Cookie picked me up from the train station and we drove to the hospital. When we got there, I spotted Stevie in the parking lot walking toward us. I'd only seen him a handful of times in the past thirty years. He was balder than I remembered; he'd

lost a lot of weight. More than anyone in my family, Stevie had become Syrianized.* He and Debbie lived in Jersey, just a short drive from Cookie's house. He drove a flashy sports car, was president of his synagogue, probably a Republican. "Hello, brother," he said, with a slight trace of what appeared to be warmth but upon closer inspection edged something like regret. "How ya doin?"

I'd come out in the *Times* profile, and I could see in his eyes that I disgusted him with my now-public gayness, with my off-Broadway play that mocked and critiqued his life. I could see he didn't want to feel the disgust, that he was at bottom a caring person, yet I'd stretched his capacity for caring to a breaking point. I violated everything my brother held sacred: his religion, his community. We were at odds in life, and there was no way for me to finesse it. My play was a large speaker that broadcast my identity. It made me visible to these people— people who'd known me all my life—for the first time. Now that people could see me, they could have opinions about me, they could judge and hate me. But there was something so phlegmatic in his hatred of me; it didn't feel like hatred, it felt like pity. "I'm good," I replied, feeling like the awkwardness of the whole thing might kill me right there in the parking lot. My brother went to hug me, and as I stood momentarily in that flaccid embrace, I felt a wave of self-loathing wash over me; it

* A few years earlier he nearly went to prison for fraud. In 2001 Stevie opened a furniture store in Jersey (he'd switched from electronics, he'd wanted to try something new) and the store was an instant hit. In 2002 he opened a second branch. He and Debbie were living the SY dream, they were the toast of Deal. But customers began filing complaints with a consumer affairs organization, claiming their furniture hadn't been delivered to them. And in 2005, Stevie and his partners were indicted and arrested on charges of fraud. He eventually pleaded guilty to third-degree corporate misconduct charges and was sentenced to five years probation.

was a reflex, a magnetic pull. I hated the way he saw me. I hated the way he touched me, like I was contaminated. I wanted to say something, to fight back, but I hadn't been attacked.

Stevie walked to his car, and Cookie took the elevator up with me. She seemed to know where she was going; I followed her down a long hall littered with Stevie's friends—he seemed to be hosting everyone in the hospital, even in absentia. His friend Moe was there, and Eddie Azrak, and Debbie, who stood watch outside Dad's room, half concierge, half traffic cop ("Joey's in the waiting room, they're ordering kosher pizza!" "The bathroom is down the hall to the right!"). Debbie's mother was there with her drapey rayon shirt, and my cousin Linda (with whom Stevie was close) and a bunch of others who seemed chagrined or at best mildly indifferent to my presence.

Cookie led me to a large visitors' room, where I was relieved to spot Arlene and Richie splayed out on adjacent sofas. They seemed strangely relaxed, like they were at the beach. I picked a spot on the floor between them. "Hi, Dave," said Richie.

Arlene thrust a bag of popcorn at me. "Can you believe how nauseous I look?"

"You look fine," I said, scooping some popcorn with my hand.

"*Ert*," said Arlene. "My whole face is broken out in cystic acne. But the male nurse hit on me anyway—isn't that *insane?*"

"Maybe the male nurse has a cystic acne fetish," joked Richie, which made Arlene laugh like crazy.

Cookie landed across the room and was speaking with an older woman with dyed blond hair whom I vaguely recognized as one of my father's sisters. The woman gave me a strange look, and when I noticed her staring she didn't look away. She looked like she might walk over and punch me in the face. "Should we go and see Daddy?" I said.

"Daddy is completely out of it now," said Richie. "He's unconscious."

"Daddy's in bad shape," said Arlene.

"Maybe he'll wake up again," I said, but the truth was I didn't want my father to wake up. I wanted to remember him the way I'd seen him when he apologized. It was a last-minute linchpin in our relationship, and the moment stayed with me, like the one great scene in an otherwise forgettable play. I replayed the scene over and over in my mind, and with each inscription it got more removed from the actual event, like a laser burning a holographic image. The moment became a ghostly replica of itself; a live encounter only would diminish it.

But *because* he was unconscious—and I wouldn't have to risk anything—I decided to go over to Dad's room. Debbie was inside, interrogating one of the nurses. "His finger is green," she said. "Is that normal? I don't like the look of this *finger*!" When she saw me, her face sort of blew up; her features all expanded like she'd been inflated with an air pump. "How ya *doin*, Dave?" she said. "Look at you with the shaved head: *cute*!" Debbie was smiling, but the smile felt like it might crack at the edges. I tentatively went to hug her, but stopped myself. I could still feel the phantom chill of my brother's hug moments earlier.

"How is he?"

Debbie shook her head. "Not good."

I looked at my father lying unconscious on the hospital bed. He was hooked to tubes that flowed endlessly with pale green mucus suctioned from his throat by a machine.

"You must be exhausted," I said.

"It's a lot with the engagement."

Debbie was toggling my father's unsteady demise with an engagement party she was preparing for her and Stevie's daughter, Giselle—a huge deal, as a Syrian mother's *raison* was to

marry off her daughters; it was true for Claudia Terzi in 1980 and truer still for Debbie—but she was forced to multitask between planning the engagement and tending to my father. In a way, this was where she shone: hospitals, weddings—places where one needed to visibly assume some familial onus. Now that Dad was dying she swooped in for the final coup de grace, but I could sense a contrasting undulation, the pull of some wordless anxiety tugging at her—and ultimately, though she couldn't speak openly about it, there was the underlying question of whether my father's death would screw up Giselle's engagement party. Because it was clear Dad was about to die *any minute*, and they'd already put down the requisite deposits: the banquet hall, the florists, the caterers. Richie told me Debbie had been to see a rabbi to get the exact ordinances straight: exactly how many days would they have to wait after my father's death before they could have the engagement party? What was the minimum? Could they do it two days later? *Three?* If they had to, could they do it *the day after* the funeral—or was that crass? Every rabbi had a different take. She was lost in a farrago of conflicting details, and I could feel her pulled in different directions.

I realized I hadn't acknowledged Giselle's engagement, and now that it was mentioned as a subject, I offered a mealymouthed congratulations. "Thanks, *Dave*," replied Debbie, whose eyes looked like they might explode from their sockets. "Did you get your *invitation?*"

"Not yet," I said, though I suspected Debbie hadn't actually sent me an invitation—but that night we each felt the obligation to support each other's phoniness. There was something very cordial about it, actually.

Debbie left for a meeting she'd scheduled with one of the doctors, so I was suddenly alone with my father. I wasn't sure

what to do—I had no impulse to kiss or talk to him the way I'd seen people do in movies. After a few minutes I decided to go. Just as I was making my exit, a well-dressed, middle-aged man with curly hair and shiny black eyes entered the room. *"David?!"* he said. "It's *Ronnie*!"

I had never seen this man before, and found his enthusiasm jolting.

"Oh, hi," I said.

Ronnie laughed gruffly. "Whaddaya mean *oh, hi*? You don't remembah me? I'm ya *cousin*, asshole! I used to change ya diaper!" He slapped me on the back and shook my hand. I got a huge whiff of his cologne—bright and citrusy, a real nostril cleaner. "I saw ya play."

"Oh, you did?"

"I brought my wife. We liked it very much."

"Thank you. Thanks a lot."

"I mean, there were some problems," he said. He cocked an eyebrow and swayed back and forth, like a boxer reading a punch. "There were problems, if you don't mind my saying, in the third act."

"Right," I said.

"You need to do some rewriting in that part. But, ya know, it was overall well done."

"Well, thanks again," I said. "It's good seeing you."

"My wife's a writer," Ronnie said—and now I feared this might go on for a while. "She writes short stories. She takes classes at uh, whaddayou call it . . . not the New School, the othah one. She's like you, very artistic. Not the norm. You two would like each othah."

"I'd like to meet her."

"She's more mainstream than you," he added. "You're a controversial person."

I took a deep breath. "Yeah, I've heard."

"Some people are unhappy with you. But you wanted that, right?

"What do you mean?"

"Well, you wanted to be disturbing."

"I wanted to be truthful," I told him.

"But your truth is not everyone's truth."

"No, it's not."

"I'm just saying you're controversial."

"I'm just showing what's in *life*," I blurted, the anger rising up quite suddenly. "There's a difference between being disturbing and exposing aspects of life that are disturbing."

"It's not a bad thing."

"Obviously, you think it is!"

"No."

"The whole point of theatre is to reveal people *to themselves*. Not everyone has to like it!"

Ronnie's eyes suddenly widened. He looked hurt. "But I *did* like it," he said. "I think you're so talented." There was a sweetness in his voice that short-circuited my anger.

After I apologized for ranting and Ronnie apologized for busting my balls, I went back to the visitors' area to find Richie—it was time for me to go—but he and Arlene had vanished. The room was packed now; it was a real scene. People were gabbing heatedly and I didn't know a soul. I wanted to leave, but I was stuck. I sat in a small plastic chair and nibbled a slice of kosher pizza covered with a dull sheen of grayish cheese and waited. Cousin Linda appeared holding a Birkin and sipping from one of those sixty-ounce sodas they sold at the 7-Eleven. "Aren't you hot in that *shirt*? I'm *sweating* ovah heeh!" She fanned herself briefly with her collar.

"Hey, do you know where Richie and Arlene went?"

"*Ca-an*,"* said Linda, "I thought they were with you!"

"Maybe I'm better off taking the train home."

She checked her watch. "The last one leaves in a half hour."

"You think I have enough time?"

"You gotta leave now. I'll drive you to the station."

I hurriedly got my stuff—I'd packed some clothes in a vinyl Target bag I'd been gifted with at some benefit. We walked over to the elevators together, when she turned to me. "Is that your *fag bag*?" asked Linda with her snaggletoothed smile.

I stopped in my tracks and glared coldly at her.

"Excuse me?"

Linda slapped me playfully on the shoulder, signaling a closeness she imagined we shared. "I'm just *sketching*!"

I was about to tell her off—I was going to storm off and call a cab—when I noticed the fear in her eyes. She was smiling but her eyes beamed terror. I recognized that fear. It was the fear I carried with me most of my life, the same unanchored terror that followed me everywhere. This recognition was so unexpected, it stemmed whatever outrage was brewing in me, and I felt a surge of empathy for my weird remote cousin. Linda couldn't comfortably inhabit the world—and I knew what that was like. She was impersonating a woman who was cheerful and urbane and made cute in-jokes to gay people, but underneath all that she had no idea what she was doing, really. This made me feel for her. And as I stood gazing in my cousin's eyes before the bank of mirrored elevators, under the dull hum of fluorescent long bulbs, fag bag slung over one shoulder, I felt a sudden parallax, a shift in my own conception of myself. Without really knowing it, I'd fought some crazy decades-long battle—and *won*. I knew I'd won because I no longer felt that

* SY phrase that loosely translates to "Yeah, whatever."

terror, that queasy sense that I would always be an impostor in the world. I was able to accept some fundamental oddness in myself. I was a Lot Six—it was the essential, unchanging part of me. I'd grudgingly come to accept this about myself, but it wasn't until that day in the hospital that I was able to *embrace* it, that I was able to see clearly how this queerness, this strangeness—which wasn't just about being gay, because my alterity was deeper and weirder than that—had actually *saved* me. I'd always wanted a comfortable life where I could fit in, but I would never fit in, because I was a Lot Six: it was my suffering and my redemption. It made me a writer. It gave me a play at Lincoln Center. It gave me a *life*. It turned my nightmares into dreams.

Arlene dug her fork into a tiny rectangle of *pommes dauphinoises*.

"And I'm hysterical crying in the middle of the street—"

"What *street*?"

"Ma," said Arlene, "I'm trying to tell you."

Mom's cheeks were crimson. She had a gauzy expression from all the Sauvignon Blanc; she was stealthily working her way through a whole bottle.

"I thought you went to Stevie's house?"

"Mommy, I ran *out* of the house, you're not listening to me."

"Uch, I'm busting," said Mom, who interrupted everyone constantly and floated from subject to subject with no segue, it was just how she was. She pushed a pinkish hunk of meat to the edge of her plate. "You want to take the leftovers home, Dave?"

I lightly rolled my eyes. I'd eaten too much already.

The shiva for Dad ended that day, and to help along our convalescence, Mom took Arlene and me for dinner at the swanky Minetta Tavern in the West Village. We all shared a giant platter of *côte de boeuf*—a splurge, but my mother could afford the

indulgence now. She sold the house—Dad did ultimately take her to court, but she won it as part of the settlement—and was renting a sweet one-bedroom on the Upper West Side, where she had all the culture she wanted. She was near the museums, Zabar's. She quit her receptionist job and joined the Reebok gym. She bought a swanky computer and took classes at the Apple Store to learn how to work the internet. She found some Canadian black-market operation online that sold cartons of cigarettes at a discount. She fed birds in Central Park with bread she crumbed by hand. The birds fluttered to her, they adored her—they festooned her limbs, fringed the length of her out-stretched arms like she was a statue of St. Francis.

My mother found peace, the peace she'd been searching for all her life.

Mom paid her respects to Dad; she went to the shiva a few days earlier with her sisters, but I skipped out on all of it. The funeral was held in Jersey the morning he died at nine *sharp*, and I'd only woken up at eight thirty, and they refused to wait for me. Once I missed the funeral, it seemed pointless to go down for the rest. I didn't want to publicly grieve a father I barely knew with a bunch of people I barely knew. And what would I even grieve? In some sense my father was still alive for me when he died; he was still the same phantom self, living in his same phantom zone. His death wasn't really final—it was more a nonexponential decay, like radioactive chemicals undergoing half-life.

Arlene had been there for all of it, though, and the details she shared about the funeral over dinner were harrowing.

An hour or so before the ceremony my father's immediate family convened at Stevie's house to drive over together. I didn't know these people, but Arlene did—she was expecting a bittersweet reunion, but everyone was cold and distant. No one hugged, or consoled, or even spoke to her. For comfort, she

tried turning to Debbie, but Debbie was in her own private hell, for after all her hand-wringing and preemptive courses of action, as if by some diabolical postscript of his existence, my father died *the very morning* of Giselle's engagement party. The deposits were forfeited, everything was wasted—the flowers, the food. Debbie was too emotionally distraught to comfort Arlene, so she was really on her own. At one point she caught Aunt Joyce standing behind her, laughing and making corkscrew spirals with her index finger to indicate that Arlene was insane—a gesture so shocking and hurtful to my sister that she ran from Stevie's house to some semiprivate area outside near the curb to sob, at which point Claudia Terzi's daughter, Betty (who ended up marrying some other guy but was now divorced and single with kids she couldn't support, stresses she couldn't really sustain) spotted her, and after my sister, in between convulsive sobs, explained what had happened, Betty marched into my brother's house and raised hell: "This woman's *father* just died," she said. "She needs solace, not *ridicule!*" Betty put them all in their places, and Arlene thought that would be the end of it. She drove to the funeral home without incident—but when she arrived, more Syrians clustered around her to critique her for being a bad daughter and a rotten person.[†] Our cousin Sherry adjured her to "beg your father's corpse for forgiveness." Sherry's mother joined in, urging Arlene to "kiss your father's casket" because it's "not too late to atone."

[*] But then the next morning, when Arlene called Betty in gratitude for her support the previous day, Betty fulminated in an out-of-nowhere tirade: "Don't you thank *me!*" she shouted. "You need to stop being so *selfish* and learn to *forgive!*" Arlene lobbed as many insults as she could and hung up, shuddering and sobbing at the craziness and cruelty of these people.

[†] Since Arlene hadn't gone out of her way to minister to a father who treated her like crap, they all saw her as a sinner and a shitty person.

Arlene was too weak to respond—she couldn't tell them she had a horrible pathological lying father who cut her out of his life because she was divorced and had shitty clothes. She just sobbed and nodded. But the *very instant* the funeral ended she bolted from the funeral home—she had to get away from these people. A small phalanx of cousins and aunts chased after her shouting, "Arlene! *Arlene!*" but she outran them.

At the shiva Arlene shakily navigated people's under-the-breath obloquy, braced for the judgmental once-overs as she prepared crudité platters or made radial cuts in a cantaloupe, for she was the much bruited-about "bad daughter" who lacked solicitude and filial warmth and treated her father like shit. She said that when anyone asked of my whereabouts, Debbie violently denounced me, loudly decrying that my PLAY WAS DISGUSTING and that she HOPED I *FAILED* and to *NEVAH* MENTION MY NAME IN HER HOUSE *AGAIN*! I knew she was exhausted, and traumatized from the botched engagement, and that she felt an overarching compulsion to police the respects people did or didn't pay to my father, but it hurt to hear.

As she relayed the events of the week, my sister looked like she'd been in a catastrophic accident. Every so often while speaking she'd freeze—the muscles in her face would constrict like she was about to sneeze—then she'd burst into hysterical sobs. The sobbing would last a few seconds, then the anguish would disappear completely, and she'd continue where she left off, as though nothing happened. It went on like that all night, the alternating currents pulsing and shifting inside her like a botched electrical system. The narrative branded upon her by her family was so punishing, so unfair, but at the same time she couldn't help but see herself as this rancid piece-of-shit daughter. Arlene's entire sense of self was still bound up with my

father. She was even living in his old apartment—the one on Kings Highway he'd given her before moving to Deal—and it still had the phantasmal trace of his presence: the 80s mirrored closets, the then-modish marble floors, palimpsests of the era, but now it was falling apart like the rest of her life. The elevators were teeming with roaches, doors were coming off hinges, squares of marble bulged up from the floor. Arlene had become a ghost of a life he'd built for her—but this was in some way true of all my siblings.

Stevie had become a facsimile of my father. Richie was still working to be obedient and pious: he'd slipped into that numbingly predictable pattern of men who became religious when their fathers died. He was being hectored to grow a beard and join a group of men from the synagogue, where Stevie was still president, to pray for my father's soul to "ascend to heaven." (Some rabbi told them the soul was stuck in some interim cosmic layer, and that without continual chants and prayers, it would stay stuck for all eternity.)

My feelings about my father were complicated, but listening to her, I was grateful that I'd removed myself from that cycle. I felt badly for my sister, though. By the time Arlene was finished unpacking for us all the horrible anecdotes and details around the shiva, she was drained. She excused herself to go to the restroom. My mother shook her head. "A girl's father dies and this is how her own family treats her?"

"I dodged a bullet, I guess."

"You did, honey," she said. "You never belonged with these people. That's why I kept you away from them. I wanted you to have a good childhood."

"Well, we know how that turned out," I said, snickering at my little joke—but when I looked up at my mother she wore a stolid expression. Without taking her eyes off me, she drew

herself majestically up in her seat. She sat with her absurdly perfect posture, staring at me from across the table. "You *had* a good childhood," she said, with an odd sternness in her tone.

"No, I didn't."

I was still smiling from my joke, but the smile felt like a relic from some other conversation. We sat in silence for a moment, just looking at each other.

Then, in a sudden mutinous burst, she mashed her fists against the table: "It was a *great* childhood!"

My mother's face shone a pale lunar white. There was a strange mixture of alacrity and deadness in her eyes.

"Mom," I said, "I did not have a great childhood."

"You were very *happy*," she insisted.

"I wasn't happy."

"Yes you were."

"No, I was suicidal from the age of eight. I thought about killing myself all the time."

"You did?"

"And remember in college I bought all those sleeping pills?"

She was anxiously fingering her necklace, rolling one of the coral stones between her thumb and forefinger. "I don't remember that," she said. There was a compelling gloss of self-reproach in her expression. Then a hint of a smile broke through—and, as if obeying some inscrutable maternal instinct, she leaned toward me: "Well, you know how I am," she said. "I block things out." She began to laugh. The laugh felt disarmingly intimate— an inside joke between us from some long-buried past. There was something so charming about her ability to poke fun at herself. Even though I was upset, I found myself laughing along with her, I couldn't help it.

She took a sip of wine, gazed at the grid of caricatures above our booth. Her smile dissipated slowly but not completely. She looked around the room. I could sense her uprooting the parts

of the night she wanted to keep as memories, editing and re-touching like they did in the movies: captionless photographs of smiles and dim light. Black specks of Tahitian vanilla in rich custard. The pleasant din of voices. A feeling of contentment and beauty and pleasure.

Even thought it was night, it was light outside, the tail end of summer. Thin spokes of yellow light poked through the shutters.

The waiter brought over dessert for us to share. With the back of her spoon, my mother cracked the burnt-sugar crust of the crème brûlée. As she dug into the ceramic dish and scooped out some of the custard, I caught myself staring at the cuticle moons in her fingertips. The tops of her hands were knotted with pale blue veins, her fingernails sparkled with coral polish. She wore a clunking gold watch, some Cartier present my father gave her a hundred years ago, but it was too big and kept slipping over her wrist.

"You want to take the rest of the steak or should I feed it to the cat?"

"Huh?"

"You want the steak or no?"

"Give it to the cat," I said.

Where the hell was my sister? I worried she'd had a panic attack or passed out in the bathroom.

"Did you hear anything about your play?" said my mother with a mouthful of crème brûlée. "Is it transferring to the bigger theatre?"

"Charlayne has to go back to LA for a movie," I said. "Lincoln Center only wants to move it if the entire cast can go."

"Why does she have to go to LA?"

"She has an acting job."

"Can't she just tell them 'I'm in a hit play'?"

"No, because she has a contract."

"Oh," said my mother, enunciating the word so it broke into

several syllables. She breathed a small sigh of despair. "Well," she said, "you had a good run."

"We did."

"My son, the *playwright*!" she exclaimed, a little too loudly. "Some people aren't going to like it, and it's not their cup of tea. But you had a very good production. That main actress—what's her name?"

"Cristin."

"Very talented girl." She poured herself another glass of wine, emptying the bottle. "Very intense play," she said, sipping her wine. "A little depressing." She swung her head heavily in my direction like it was a deadweight. "But, *honey*? You were always very different. You always had to put your own spin on things." I could see her getting swept up by a wave of nostalgia probably occasioned by my father's death; she seemed to feel the need to cap an era. "Remember when I used to take you to the theatre when you were little? You always loved the theatre. Remember when I took you to see *Pippi Longstockings*?"

"No."

"*Honey*," she loudly announced, so vehemently it caused her head to bob like a dinghy, "I took to you see *Pippi Longstockings* at the Trump *Village*. I took you to everything. You have no idea what I did for you. I schlepped you everywhere with me. What mother takes a five-year-old kid to all these Broadway plays? Remember when I took you to that *Sweeney Todd*?" She laughed in her raspy contralto. "I don't know how I did it. He gave me no money, I had no one helping me. Thank God for me."

My mother held the glass by its tall stem with just the tips of her fingers. She swirled the wine for a moment, raised it to her lips, then set the glass back down on the table so the pale

amber liquid slid back down the insides in reticulate veins. "Can I ask you a question?"

"What's that?"

She turned to me and looked in my eyes. "Is your play about me?"

"What?"

"The girl in the play . . . is that me?"

My mother's face was obscurely lit by a single dim candle. She looked impossibly young, almost a child. She had the out-sized, practically cartoonish features of a 1940s movie star: her cheeks were two raised aureoles, her eyes were too big for her face. Her expression was gauzy from all the Sauvignon Blanc but her skin was milky and perfect, smooth like a mar-ble bust.

When I was young she kept a tiny framed black-and-white photograph of herself near her bed—she couldn't have been older than four or five. She was like an angel. She was in a field somewhere, her hair fell in loose ringlets—but she looked ut-terly lost, like no one in the world would ever know her, ever find her. When I asked, she told me she didn't know who took the photograph, or where she was. Like so much of her life, the facts and details were gone: there was no family lore, no stories about what she endured; she blocked it all out.

Her life wasn't grand or important, which was why she couldn't see those works of art in museums as having anything to do with her. Caryatids and weeping angels, boys with tan-gled curls and azure eyes: art was for someone else. Culture was there to commemorate lives that mattered. Because her life never mattered, she was a woman without a story.

I was the inheritor of that nonstory. I believed my life was meaningless, that I was worthless in the eyes of the world. But maybe the task of my life was to make a story, so I could it give

to her—like one of those sword-bearing travelers from mythology, returning back home bearing a gift. Or at least that was what I felt on that dreamy summer night, as my mother sat across from me, bathed in soft candlelight, eyes tucked inside sleepy lids, waiting with fragile expectation for my answer to her question: *Is that me?*

Amor fati (Love your fate)
—Friedrich Nietzsche, *The Gay Science*

ACKNOWLEDGMENTS

Thanks first and foremost to Paul Rusconi, who painstakingly went through every draft of every chapter of this book and had endless conversations with me about nearly everything I'd written—to the point that it was probably not entirely healthy. I don't know that I would have gotten to the end of this book without him. My deepest thanks as well to Olivia Laing, who read all my early drafts and was so encouraging to me from the outset.

I'm grateful to my agent, Susan Golomb, who helped me shape the tangled mess of my thoughts into a book. And to my theatre agent, Emma Feiwel, who read endless drafts of this thing, and worked tirelessly to support it.

I am indebted to my early readers for their generosity and deep intelligence: Sheila Callaghan, Leland Cheuk, Melissa Febos, Madeleine George, Adam Greenfield, Nathan Heiges, Liana Liu, Alejandro Morales, Hanna Pylväinen, Suzanne Scanlon, Heidi Schreck, Victoria Stewart, Kathleen Tolan, Mindy Walder, and Ginny Wiehardt.

Thanks to Mary Gaule and Hannah Wood and everyone at HarperCollins. Special thanks to Trina Hunn, my dauntless legal counsel. This book wouldn't exist if not for Claire Wachtel, who approached me out of the blue to write it. Jonathan

Burnham provided me with vital editorial guidance and explained to me what a book needed to do to call itself a book; I'm grateful for his patience and support.

For their constancy and care over the course of the many years it took to write this, I want to thank Rachel Aedan, Ayad Akhtar, Karole Armitage, Daniel Aukin, Claudia Ballard, Robbie Baitz, Grace Baley, Renee Baley, Sarah Baley, Tanya Barfield, Sarah Benson, Art Borreca, Bella Brodzki, James Bundy, Will Butler, Hannah Cabell, Eddie Cahill, Zoe Caldwell, Gaby Calvocoressi, P. Carl, Tony Charuvastra, Diane Cook, Justin Craig, Marta Cullberg Weston, Michael Davis, Jon Dembrow, Gordon Dahlquist, Maria Dizzia, Christopher Durang, Kip Fagan, Philip Gates, Karl Gajdusek, Jackson Gay, Simon Green, Julia Greer, Jason Grote, Kirsten Greenidge, Jennifer Haley, Gerri Hanan, Corinne Hayoun, Ann Marie Healy, Laura Heisler, Riccardo Hernandez, Philip Himberg, Lucas Hnath, Naomi Iizuka, Marin Ireland, Morgan Jenness, Addie Johnson, Aditi Kapil, Sibyl Kempson, Jennifer Kiger, Joe Kraemer, Jo Lampert, Penney Leyshon, Todd London, Sarah Lunnie, Joy Meads, Geoffrey Macdonald, Alan MacVey, Carol MacVey, Kim Marra, Jim McCarthy, Sabrina Meglio, Cristin Milioti, Emily Morse, Donald Moss, Phyllis Nagy, Brett Neveu, Gloria Peterson, Larry Rand, Duncan Riddell, Joel Ruark, Jenny Schwartz, Angeline Shaka, Oliver Laks, Ruby Laks, Sophocles Papavasilopoulos, Sarah Ruhl, Ryan Rumery, Jennifer Scappettone, Howard Shalwitz, Mona Simpson, John Steber, Aaron Stone, Rebecca Taichman, Daniel Talbott, Alice Tolan-Mee, Sarah Tolan-Mee, Rachel Viola, Francine Volpe, Xuan Juliana Wang, Anne Washburn, Matt Wolf, Charlayne Woodard, Carmen Zilles, and Bob Zimmerman.

Thanks to my parents and my siblings.

Thanks to Patricia Masters for her foresight, acuity, and caring.

The writing of this book was made possible in part with funding from the Mellon Foundation, the John Simon Guggenheim Foundation, Soho Repertory Theatre, the Harold and Mimi Steinberg Charitable Trust, and the Whiting Foundation. I am deeply indebted to them, and grateful for their generosity. Major portions of this book were written at the American Academy in Rome, the Bogliasco Foundation, the Brown Foundation/Dora Maar House, the Djerassi Resident Artists Program, the MacDowell Colony, the Millay Colony, New Dramatists, the Sundance Institute, and Yaddo.

Fran Offenhauser and Michael Mekeel took great care of me during the process of writing this book. I could not have completed it without their support. Thanks as well to my generous pals Eric Anderson and Lizzie Simon, for offering me space and time to write. And finally, to the great Marian Seldes, whose spirit permeates every page of this book; thank you for teaching me what it means to be an artist.

ABOUT THE AUTHOR

DAVID ADJMI was called "virtuosic" by the *New York Times* and was named one of the Top Ten in Culture by the *New Yorker* in 2011. His plays have been produced and developed by the Royal Shakespeare Company, Soho Rep, Lincoln Center, Steppenwolf, and many others. His play *Stereophonic* will premiere on Broadway in the spring of 2021. He was awarded a Mellon Foundation grant, the Guggenheim Fellowship, the Whiting Writers' Award, the Kesselring Prize for Drama, and the Steinberg Playwright Award (the "Mimi"), among others. He lives in Los Angeles.